ARTIST'S MANUAL

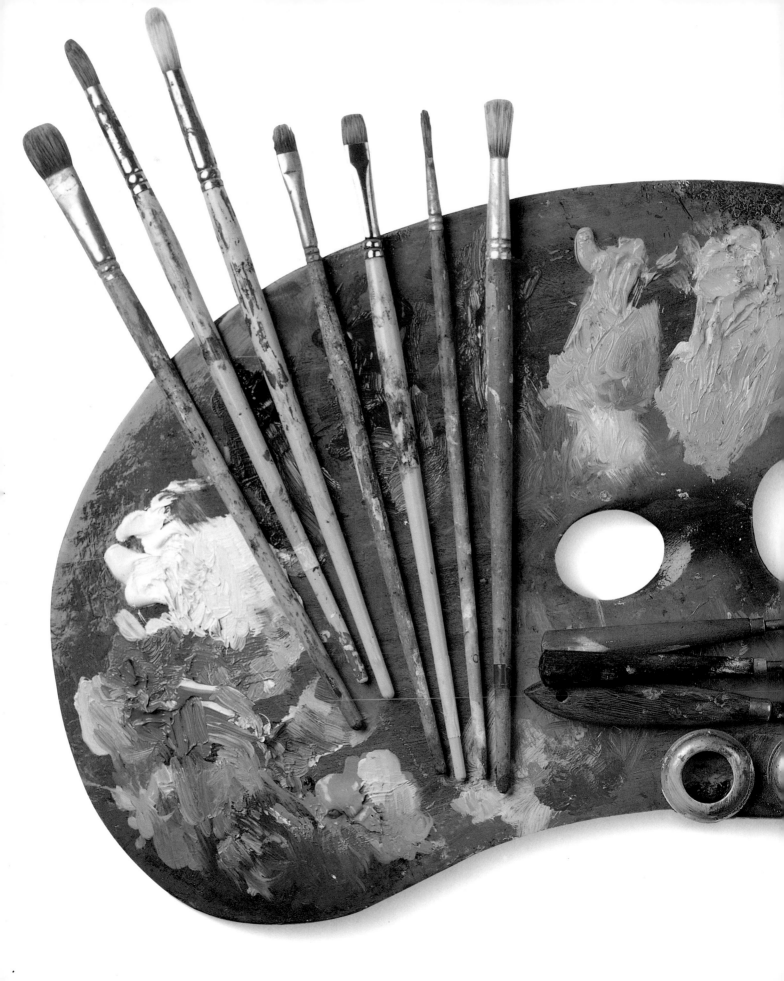

ARTIST'S MANUAL

A Complete Guide to Painting and

Drawing Materials and Techniques

Edited by Angela Gair

CHRONICLE BOOKS

SAN FRANCISCO

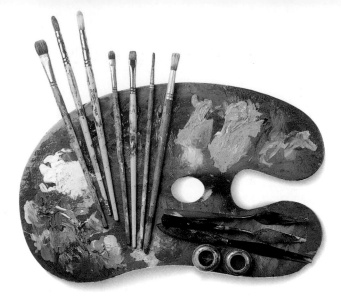

First published in North America in 1996
by Chronicle Books.

Concept, design, and editorial direction: Simon Jennings

Produced, edited, and designed at Inklink,
Greenwich, London, England

Text and consultant editor: Angela Gair

Illustrators: Robin Harris and David Day

Studio photography: Paul Chave

American text editor: Melissa Stein

Cover design: Pamela Geismar

ISBN 0-8118-1377-0

Library of Congress Cataloging-in-Publication
Data available

Printed in Italy

Distributed in Canada by Raincoast Books
8680 Cambie Street, Vancouver, B.C. V6P 6M9

10 9 8 7 6 5 4 3 2

Chronicle Books
85 Second Street
San Francisco, CA 94105

Web Site: www.chronbooks.com

INTRODUCTION

Renoir once observed that "painting isn't just daydreaming, it is primarily a manual skill, and one has to be a good workman." Too often it is forgotten that painting is a craft as well as an art – and a difficult craft to master, at that.

At first sight, dipping a brush into paint and applying it to a surface seems easy enough. But there are traps for the unskilled: an inadequately prepared surface or support may warp or buckle; the wrong support can adversely affect the way the paint handles; ill-chosen colors turn muddy when mixed together; poor-quality or fugitive colors will fade in time. By understanding the materials and techniques at his or her disposal, the artist can avoid such pitfalls and increase the pleasures of making art.

In recent decades, art schools have tended to dismiss basic skills and techniques as "irrelevant," and they have been neglected in favor of "freedom of expression." In so doing, teachers have thrown the baby out with the bathwater, for without a thorough technical grasp of materials and methods, students of art have no real freedom to express their ideas – it is like asking someone with no knowledge or concept of grammar or syntax to write a novel.

Of course, this is not to imply that a good craftsperson is necessarily a good artist. Manual dexterity and technical know-how are meaningless if an artist's work is deficient in thought and feeling. Along with a learning hand, one must develop a seeing eye – and for many people, this is the most difficult part. In the desire to produce a "finished" picture, the impatient student often overlooks the two things that are fundamental to all art: drawing and observation. It is vital to train your eyes by really looking at the world around you, and to keep sketching and drawing all the time. When you draw what you see, you develop your powers of observation and analysis. Your mind absorbs many details – for instance, the way light and shadow create form, how tone and color alter with distance – enabling you to draw a surprising amount from memory and from imagination.

Art, like music or dance, is all about the partnership between personal vision and technical ability. These two partners – poetry and skill – must hold each other tightly, or the dance will come to an end.

The purpose of this manual, then, is twofold. First, by providing an in-depth examination of the skills and techniques involved, not only in painting and drawing but also in preparing a support and in choosing and mixing colors, it endeavors to encourage a pride in the craftsmanship needed to produce a work of art. Second, using a wide range of work by respected professional artists as a source of inspiration, it aims to help you develop your personal vision of the world and to find your own voice in interpreting that vision.

ANGELA GAIR, CONSULTANT EDITOR

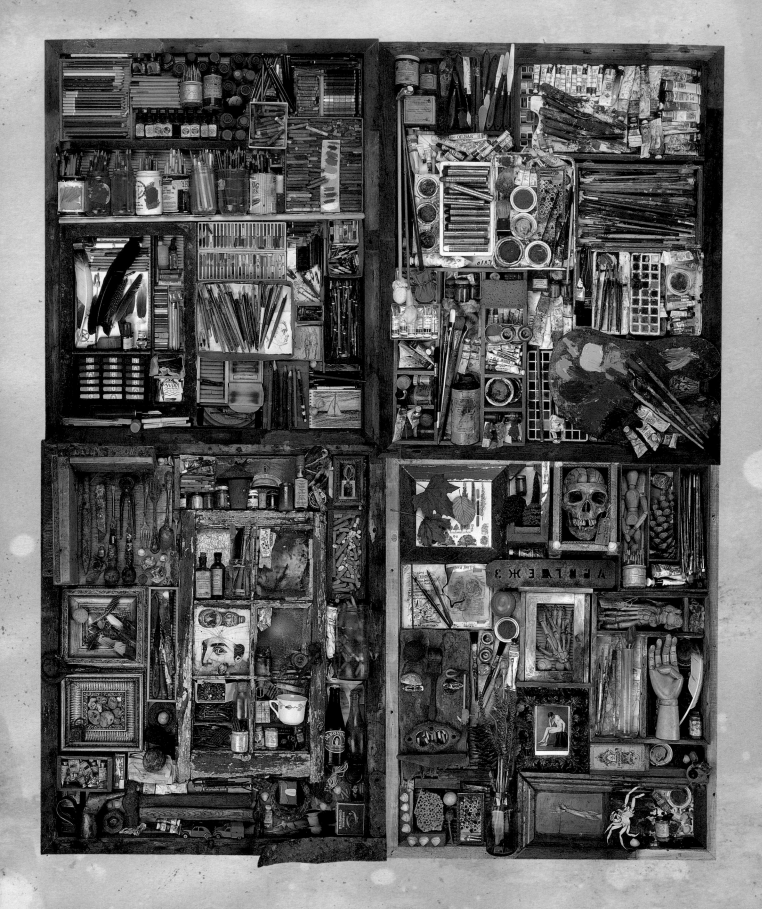

••••••••••CONTENTS••••••••••

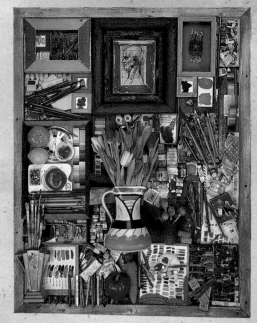

ACKNOWLEDGMENTS

This book is the work of many hands, and is the result of several years' planning and preparation. The designers and editors of the Artist's Manual are indebted to all who have contributed and have given freely of their time and expertise.

CONSULTANTS

Trevor Chamberlain,
ROI, RSMA
David Curtis,
ROI, RSMA
John Denahy, NEAC
John Lloyd, technical adviser, Daler-Rowney
Terry McKivragan
John Martin
Ian Rowlands
Brian Yale

With special thanks to
Ken Howard,
RA, ROI, RWS, NEAC,
and
Emma Pearce
(technical adviser at Winsor & Newton), for their invaluable contributions, and to
Daler-Rowney Ltd, for the use of the majority of art materials used in the demonstrations and photographs.

Grateful thanks also go to the following, who generously loaned samples of materials, artworks and transparencies, and who provided much time, advice and assistance.

ARTISTS

Victor Ambrus
Nick Andrew
Penny Anstice
Paul Apps
Barry Atherton
Gigol Atler
Valerie Batchelor
Joan Elliott Bates
Richard Bell
John Blockley
Jane Camp
Sarah Cawkwell
Trevor Chamberlain
Terence Clarke
Tom Coates
Jill Confavreux
Grenville Cottingham
Edwin Cripps
James Crittenden
Fred Cuming
David Curtis
Derek Daniells
David Day
John Denahy
Sarah Donaldson
Roy Freer
Kay Gallwey
Annabel Gault
Geraldine Girvan
Peter Graham
Gordon Hales
Roy Hammond
Robin Harris
Desmond Haughton
Andrew Hemingway
Ken Howard
Michael Hyam
Pauline Jackson
Simon Jennings
Ronald Jesty
Carole Katchen
Sally Keir
Sophie Knight
Tory Lawrence
John Lidzey
Anna Macmiadhacháin
Pádraig Macmiadhacháin
Donald McIntyre
Alex McKibbin
Terry McKivragan
Debra Manifold
John Martin
Judy Martin
Simie Maryles
Derek Menary
John Monks
Alison Musker
Patricia Mynott
Keith New
Ken Paine
Elsie Dinsmore Popkin
Penny Quested
John Raynes
Jacqueline Rizvi
Keith Roberts
Dennis Mathew Rooney
Leonard Rosoman
George Rowlett
Naomi Russell
Hans Schwarz
Hil Scott
Barclay Sheaks
Jackie Simmonds
Richard Smith
Michael Stiff
Sally Strand
David Suff
Robert Tilling
Shirley Trevena
Jacquie Turner
John Turner
Sue Wales
Nicholas Wegner
Valerie Wiffen
Jacqueline Williams
Anna Wood
Leslie Worth
Brian Yale
Rosemary Young

GALLERIES

Art Space Gallery,
London, UK;
Chris Beetles Gallery,
London, UK;
Browse and Darby,
London, UK;
The Fine Art Society,
London, UK;
Fischer Fine Art,
London, UK;
Kentmere House Gallery,
York, N. Yorks, UK;
Lizardi/Harp Gallery,
Pasadena, California, USA;
Llewellyn Alexander
Gallery,
London, UK;
Montpelier Studio,
London, UK;
Museum of Modern Art,
New York, NY, USA;
National Gallery,
London, UK;
New Academy Gallery,
London, UK;
On Line Gallery,
Southampton, Hants, UK;
Redfern Gallery,
London, UK;
Brian Sinfield Gallery,
Burford, Oxon, UK;
Tate Gallery,
London, UK;
Thos. Agnew & Sons,
London, UK;
Westcott Gallery,
Dorking, Surrey, UK

INDIVIDUALS
& COMPANIES

Jane Foreman,
Acco-Rexel;
Carolyn Raven,
Arnesby Arts;
Sally Bulgin, Editor,
The Artist magazine;
John F. Storrs,
Berol;
Rob Orsi,
Bird & Davis;
Ken and Richard Bromley,
**Ken Bromley's Perfect
Paper Stretcher;**
Clifford Burt,
R. K. Burt & Co.;
Olivier Athimon and
Michael Holm,
Canson;
Jon Prudence,
Chroma Colour;
Dave Willis,
ColArt;
Nicholas Walt,
L. Cornelissen & Son;
John Gilboy, Liz Hauxwell,
John Grice, John Lambert,
Robin Clark and John Keel,
Daler-Rowney;
Gabrielle Falkiner,
Falkiner Fine Papers;
David Hall,
Frisk Products;
Angela Caird,
Inscribe;
Jörgen Krabbe,
Intertrade International;
David Finney,
Jakar International;
Nigel MacFarlane,
Khadi;
Edward A. Murray,
Koh-i-Noor;
Michael Kreienfeld,
Letraset UK;
Janet Finch-Taylor,
A. Levermore & Co.;
Mike Bicknell,
Liquitex UK;

David Lloyd,
**David Lloyd
Picture Framers;**
Mike Gorak,
Martin/F. Weber Co.;
Linda Rudd,
Osborne & Butler;
Alan Pitt,
Pentel;
John Wright,
Philip & Tacey;
Roy Thompson,
Pro Arte;
Mark Segal and
Gary Thompson,
Project Art;
Gary Bowles,
**C. Roberson
& Co.;**
Jean-Roch Sauer and
Janine le Gallais,
Raphaël & Berge;
Alan Crouse,
Rotring UK;
Bernadette Ward,
Royal Sovereign;
Jane Thorp,
St Cuthbert's Paper Mills;
John Corr,
Tate Gallery Publications;
Gordon Love,
Tollit & Harvey;
Kate Hersey,
Unison

PHOTOGRAPHERS
& PICTURE SOURCES

All special photography by
Paul Chave
*at Inklink Studios, London,
except for:*

*pp. 12 (top right), 22 (top
right), 30 (top right), 46
(bottom right), 170 (top
left), 171 (middle right),*
Shona Wood;

*pp. 25 (bottom left), 116
(top left), 150 (middle
right), 203 (bottom left),
225 (top right),*
Simon Jennings;

*p. 38 (top right), courtesy
of* **Acco-Rexel Ltd;**

*pp. 46 (bottom right), 104
(top right), 105 (all),
111 (top right), 170 (top
left), 171 (middle right),*
John Couzins;

*pp. 109 (all), 126 (all),
130 (top right), 132 (bottom
right), 143 (bottom), 150
(top center),*
Ben Jennings;

*pp. 112 (top right), 113
(bottom), by Veronique
Terrien, courtesy of*
Raphaël & Berge SA;

*p. 171 (top right), courtesy
of* **Daler-Rowney Ltd;**

*p. 233 (bottom right),
courtesy of* **IKEA Ltd.**

COLOR SWATCHES
& DEMONSTRATIONS

Watercolor & gouache:
Ella Jennings, BA;
Oils & acrylics:
Alan Marshall, BA;
Gouache & drawing media:
Robin Harris, MA and
David Day, MDes (RCA);
Watercolor:
John Denahy, NEAC;
Subjects (trees):
Laurence Wood, MA (RCA)

NOTE
*The images in this manual have
been printed to the highest standards
of color reproduction. However, the
limitations of the offset-litho-
printing process mean that many of
the paintings, drawings and color
swatches can only show a fraction of
their surface energy, depth of color
and texture. To appreciate and
enjoy art as it is meant to be seen,
there is no substitute for seeking out
and viewing the original works.*

SUPPORTS

BEFORE STARTING *a painting or drawing, it is worth spending time* CHOOSING *and* PREPARING *the* SURFACE, *or support, as this will have a great bearing on which medium you use, and the effects you are able to achieve with it. Although the range of* CANVASES, PANELS *and* PAPERS *may seem bewildering at first glance, finding the right support for your purpose is not very difficult when you understand the properties of each one.*

A PROPERLY PREPARED SUPPORT *will greatly increase the* LONGEVITY *of a work and, in addition, you can derive a lot of* PLEASURE *and satisfaction from this aspect of the artist's work – never let it be said that the craft of painting is dead.*

CANVAS

In painting, canvas is still the most widely used foundation or backing, here called a support. Stretched-and-primed canvas is taut but flexible, and has a unique receptiveness to the stroke of the brush. The two most common fibers for making canvas are linen and cotton, although hessian and synthetic fibers are also used. Each of these fibers differs in durability, evenness of grain, ease of stretching and cost.

SEE ALSO
Stretching canvas, page 14
Sizing for oils, page 20
Priming, page 22
Oil paints, page 64
Acrylic paints, page 148

Ready-prepared supports
You can buy ready-primed and stretched supports which consist of a piece of canvas mounted on a stretcher. These supports are convenient, but expensive when compared to the cost of stretching, sizing and priming your own canvas.

LINEN CANVAS

Linen is considered the best canvas because it has a fine, even grain that is free of knots and is a pleasure to paint on. Although expensive, it is very durable and, once stretched on a frame, retains its tautness. Good-quality linen has a tight weave of even threads which will persist through several layers of primer and paint; avoid cheap linen, which is loosely woven.

Wet stretched linen canvas and allow it to dry

Preparing linen canvas
The weaving process makes raw linen canvas prone to shrinking and warping when it is stretched, and it has a tendency to resist the application of size. Both these problems can be solved: temporarily stretch the canvas, wet it and allow it to dry. Then remove it from the stretcher bars and re-stretch it; this second stretching creates a more even tension across the cloth.

COTTON CANVAS

Popular artist's canvases
1 Ready-primed cotton-rayon mix
2 Ready-primed cotton duck
3 Ready-primed artist's linen
4 Superfine artist's linen
5 Cotton duck
6 Flax canvas
7 Cotton and jute twill

A good-quality 12-15oz (410-510gsm) cotton duck is the best alternative to linen, and is much cheaper. Cotton weaves of below 12oz (410gsm) are fine for experimenting, but they stretch much more than linen and, once stretched, are susceptible to fluctuations in tension in humid or dry conditions. The weave of cheap cotton quickly becomes obscured by layers of primer and paint, leaving the surface rather flat and characterless.

• Canvas weights
The weight of canvas is measured in ounces per square yard (oz) or grams per square meter (gsm). The higher the number, the greater density of threads. Better-grade cotton canvas, known as cotton duck, comes in 12oz (410gsm) and 15oz (510gsm) grades. Lighter-weight canvases of between 8oz (268gsm) and 12oz (410gsm) are recommended for practice only.

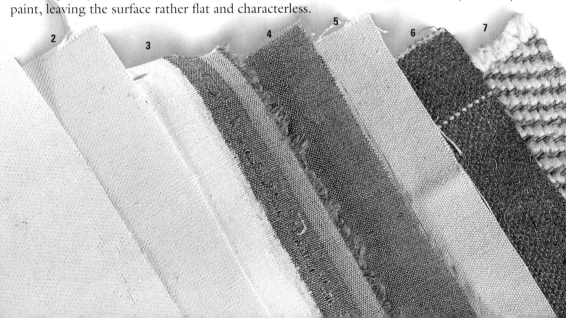

HESSIAN Hessian is inexpensive, but has a very coarse weave and requires a lot of priming. It is likely to become brittle and lifeless in time.

SYNTHETIC FIBERS Synthetic fabrics, such as rayon and polyester, are now used in the manufacture of artists' canvas. These canvases come ready-prepared with acrylic primer and are worth trying out, as they are exceptionally strong and durable, flexible but stable, and resistant to chemical reaction.

CANVAS TEXTURES If you use bold, heavy brushstrokes, canvas with a coarsely woven texture is the most suitable. A smooth, finely woven texture is more suited to fine, detailed brushwork.

Another consideration is the scale of your painting. A fine-grained canvas is best for small works, as the texture of coarse-grained canvas may be too insistent and detract from the painting.

READY-PRIMED CANVAS Ready-primed canvas comes prepared with either an oil- or an acrylic-based primer. It is better to use an oil-primed canvas for oil painting and leave acrylic-primed ones for acrylic paintings, but you can use an acrylic-primed canvas for oils if you paint thinly and on a small scale.

Canvas may be single- or double-primed. The latter is more expensive; it has a denser surface, but is less flexible than single-primed.

BUYING ECONOMICALLY Before buying lengths of canvas, figure out how you will divide up the fabric to make as many pictures as possible with the minimum of waste (canvas rolls come in several widths). When doing your calculations, don't forget to allow a 2in (50mm) overlap all around each picture for attaching the canvas to the stretcher.

• **Acrylic and oil don't mix**
Most of the ready-prepared canvases and boards available in art shops are primed for use with oil or acrylic paint. If you paint in acrylics, take care not to buy supports which are prepared specifically for oils. The linseed oil in the primer repels acrylics, and the paint eventually comes away from the support.

Overlap
Remember to add a minimum of 2in (50mm) of canvas all around, for when you attach it to the stretcher.

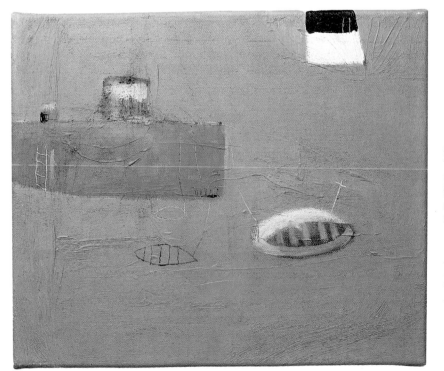

Canvas texture
The formal elegance of this abstract painting is enhanced by the subtle texture of the linen canvas, which appears through the thin layers of oil paint.

Pádraig Macmiadhacháin
BLUE MORNING
Oil on canvas
10 x 12in (25 x 30cm)

13

STRETCHING CANVAS

Stretching your own canvas not only offers a cost saving, it also means you can prepare a canvas to your own specifications.

SEE ALSO
Canvas, page 12
Sizing for oils, page 20

STRETCHER BARS

Wooden stretcher bars are sold in most art-supply stores and come in different lengths. They have pre-mitered corners with slot-and-tenon joints. The face side of each stretcher bar is beveled to prevent the inner edge of the stretcher from creating "ridge" lines on the canvas.

Stretcher bars come in varying widths and thicknesses, depending on the size of support you wish to make. For a work under 24 x 24in (60 x 60cm), use 1¾ x ⅝in (45 x 16mm) stretcher bars. For larger works, use 2¼ x ¾in (57 x 18mm) bars.

• Large canvases
A support larger than 32 x 40in (80 x 100cm) will require an extra crossbar between the two longest sides, to support them when the canvas contracts during preparation, exerting a great deal of force.

WEDGES

You will also need eight wedges or "keys" for each stretcher. These fit into slots on the inside of each corner of the assembled stretcher; if the canvas sags later, the wedges can be driven in further with a hammer, to expand the corners and make the canvas taut again.

CANVAS-STRAINING PLIERS

Canvas-straining pliers are especially useful for stretching ready-primed canvases. They grip the fabric firmly without any risk of tearing, and the lower jaw is beveled to give good leverage when pulling fabric over a stretcher bar; the correct tension is achieved by lowering the wrist as the canvas passes over the back of the frame.

OTHER EQUIPMENT

Use a heavy-duty staple gun and non-rusting staples with a depth of at least ⅜in (10mm) to affix the canvas to the frame. You will also need a ruler or tape, a pencil and a pair of scissors to measure and cut out the canvas; a wooden mallet to tap the stretcher bars together; and a T-square to check the frame is square (or use a length of string to ensure that the diagonal measurements between the corners are the same).

Cutting the canvas
Use pinking shears to cut canvas; they avoid the need to fold the edges over at the back of the frame to prevent the canvas from fraying.

Pliers
Canvas-straining pliers stretch ready-primed canvases firmly and without tearing.

• Tacks
Using a hammer and non-rusting tacks to fix the canvas to the frame is more economical than stapling, but means more work.

Checking for square
Use a T-square to check that all the corners of the assembled frame make right angles. Double-check by measuring the diagonals with a tape measure or a length of string; they should be of equal length. If the frame is out of true measure, correct it by gently tapping the corners with the mallet.

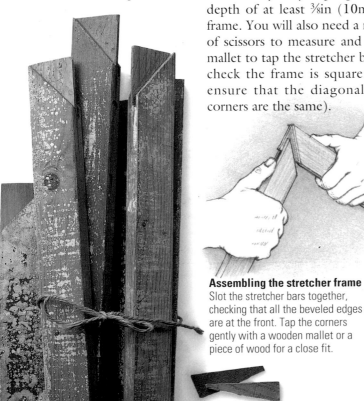

Assembling the stretcher frame
Slot the stretcher bars together, checking that all the beveled edges are at the front. Tap the corners gently with a wooden mallet or a piece of wood for a close fit.

Stretching the canvas

Working on a large table or the floor, lay the frame bevel-side down on a piece of canvas. Cut the canvas to fit the frame, allowing a margin of about 2in (50mm) all around for stapling **(1)**.

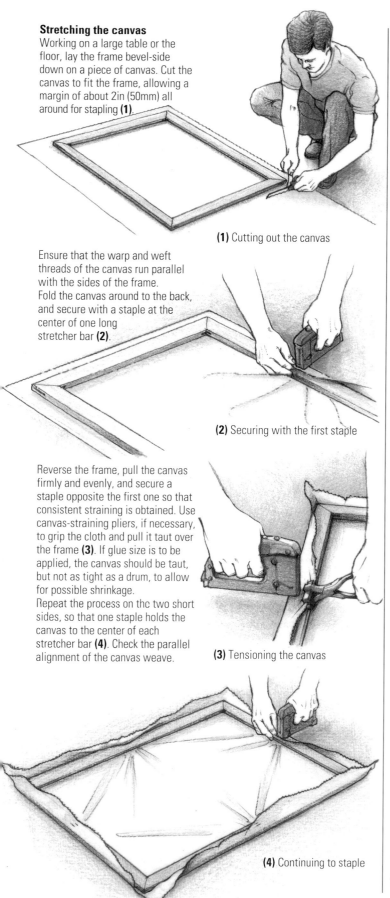

(1) Cutting out the canvas

Ensure that the warp and weft threads of the canvas run parallel with the sides of the frame.
Fold the canvas around to the back, and secure with a staple at the center of one long stretcher bar **(2)**.

(2) Securing with the first staple

Reverse the frame, pull the canvas firmly and evenly, and secure a staple opposite the first one so that consistent straining is obtained. Use canvas-straining pliers, if necessary, to grip the cloth and pull it taut over the frame **(3)**. If glue size is to be applied, the canvas should be taut, but not as tight as a drum, to allow for possible shrinkage.
Repeat the process on the two short sides, so that one staple holds the canvas to the center of each stretcher bar **(4)**. Check the parallel alignment of the canvas weave.

(3) Tensioning the canvas

(4) Continuing to staple

Securing the canvas

Now add two more staples to each of the four stretcher bars – one on either side of the center staples – following the sequence shown in the diagram **(5)**. The staples should be evenly spaced at 2in (50mm) intervals. Continue adding pairs of staples to each side, gradually working towards the corners. Insert the final staples about 2in (50mm) from each corner.
Working systematically out to the corners keeps each side in step with the others. Fastening the canvas completely on one side before doing the next, stretches the canvas unevenly.

Finishing off

The corners should always be finished off neatly; if they are too bulky you will have difficulty in framing the picture. Pull the canvas tightly across one corner of the stretcher, and fix with a staple **(6)**. Then tuck in the flaps on either side smoothly and neatly **(7)** and fix with staples. Take care not to staple across the miter join, as this will make it impossible to tighten the canvas later on. Then fix the diagonally opposite corner, followed by the remaining two. If necessary, hammer the folds flat to produce a neat corner **(8)**.
Finally, insert two wedges in the slots provided in each of the inner corners of the frame; for correct fit, the longest side of each wedge should lie alongside the frame **(9)**. Tap the wedges in very lightly. The canvas is now ready for sizing and priming.

(5) Stretching and stapling

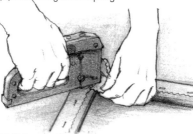

(6) Fixing the first corner staple

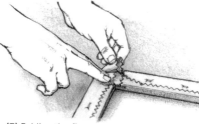

(7) Folding the flaps

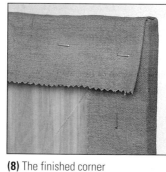

(8) The finished corner

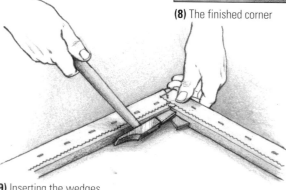

(9) Inserting the wedges

15

BOARDS AND PANELS

Man-made boards are cheaper to buy and prepare than stretched canvas; they are also easier to store and transport, and provide a more durable support than canvas.

SEE ALSO

Sizing for oils, page 20

Priming, page 22

Watercolor papers, page 26

Supports for pastels, page 32

Oil paints, page 64

Watercolor paints, page 104

Gouache, page 141

Tempera, page 144

Acrylic paints, page 148

WOOD PANELS Wood, for centuries the traditional support for oil and tempera painting, can no longer be relied upon to be well seasoned, so tends to split and warp. It is also heavy to transport, and is now largely superseded by economical composition boards.

MASONITE Masonite or compact board is inexpensive, strong and lightweight. It is available in two forms: tempered and untempered. The tempered variety is suitable for oil paints and primers, and does not require sizing. For acrylic painting, however, it is best to use untempered board, which has no greasy residue. Also look for variations on Masonite that are lightweight and slightly more porous than the standard, and provide a good tooth or "key" for size and primer.

Masonite has one smooth and one rough side; the smooth side is used most often. The rough side's texture resembles coarse canvas, but because it is very mechanical and over-regular, it is only suitable for heavy impasto work.

Masonite is prone to warping, particularly in humid climates, but this risk is reduced by priming the front, back and edges of the board. Paintings larger than 45cm (18in) square should additionally be braced with a framework of wood battening across the back (see right).

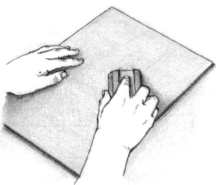

Keying Masonite
Before painting on the smooth side of Masonite, lightly sand the surface to provide a tooth for the application of primer.

PLYWOOD Plywood comes in various thicknesses and has smooth surfaces. It does not crack, but it can warp. To keep the sheet stable, size and prime it on the front, back and edges. Large sheets should be battened or "cradled" by gluing wooden battens to the back of the board (see right).

PARTICLEBOARD Particleboard is made from wood particles compressed into a rigid panel with resin glue. Thick panels of particleboard are a sound support as they do not crack or warp and don't require cradling, but they are heavy to transport. Another disadvantage is that the corners and edges may crumble, and, being absorbent, they need to be well primed.

MEDIUM-DENSITY FIBERBOARD [MDF] MDF, well-known in Europe, is made from pressed wood fiber and is available in a wide range of thicknesses and in standard board sizes. It is a dense, heavy, but very stable, material and has fine, smooth surfaces. MDF is easily cut by hand or with machine tools. Large, thin panels may need to be cradled, to help keep them flat (see right).

• Preparing a panel
To save time, an artist will periodically prepare a batch of panels at once, all cut from one sheet of board. For example, from a sheet of Masonite measuring 4 x 8ft (120 x 240cm) you will be able to cut thirty-two 12 x 12in (30 x 30cm) panels, or thirty-eight 10 x 12in (25 x 30cm) panels. Most lumber yards will cut board for a small fee, or you can cut it yourself.

• Cutting panels
Mark out the sheet with ruler and pencil, making sure all corners are square, and saw along these lines. Now "dress" the edges of each panel with a sanding block to remove any burrs from the saw cuts. To provide tooth for the size or priming coat, lightly sand the surface of each panel. Use a light touch; too much downward pressure may create depressions in the board.

Cradling boards
Cut two battens 2in (50mm) shorter than the width of the board. Chamfer the ends and secure the battens to the back of the board, using wood glue for man-made boards or woodscrews for solid wood or thicker boards.

CARDBOARD Degas and Toulouse-Lautrec painted on unprimed cardboard on occasions; they used its warm brown color as a middle tone, and produced a matte, pastel-like effect on the absorbent surface. However, a finished painting must be framed under glass if it is to last. Cardboard must be sized on both sides and on the edges, to prevent warping and to stop impurities in the cardboard from leaching into the paint.

ILLUSTRATION BOARD Heavy illustration board, or pasteboard, is available in a range of colors and has a smooth surface suitable for painting in acrylics and gouache, particularly when thin washes and glazes are applied. It is also used for pen-and-ink drawing. Always choose museum boards for work that is intended to last, as this is guaranteed acid-free.

WATERCOLOR BOARD Watercolor board consists of a solid core faced with good-quality watercolor paper. The board provides extra strength and stability, and dispenses with the need for stretching paper prior to painting. Check that the core of the board, as well as the paper, is acid-free. Watercolor boards also perform well with pastel and charcoal.

PASTEL BOARD Pastel paper mounted on board is available in a range of sizes, colors and finishes, from soft velour to a high-tooth, abrasive surface.

• Gesso panels
Gesso panels are the traditional support for egg-tempera painting; they can also be used for oil, acrylic and watercolor painting, but are quite difficult and time-consuming to prepare. Ready-prepared gesso panels can be bought from specialist art stores, though they are expensive. Gesso boards have an exceptionally smooth, brilliant-white finish which particularly enhances the translucence of tempera colors.

Cardboard and Masonite
Cardboard's warm color brings a mellow harmony to Toulouse-Lautrec's oil sketch (below left). Note how the brush drags on the absorbent surface. Tom Coates used the reverse side of unprimed Masonite for his bravura painting (below). There is a lively interplay between thick impastos and thin, drybrushed marks, with the paint catching on the tooth of the board.

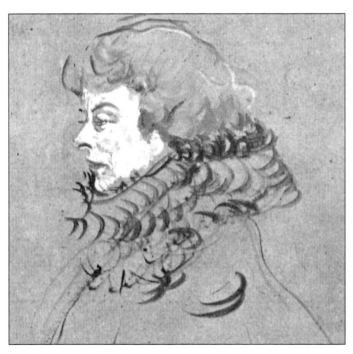

Henri de Toulouse-Lautrec
(1864-1901)
WOMAN IN PROFILE (detail)
Oil on cardboard

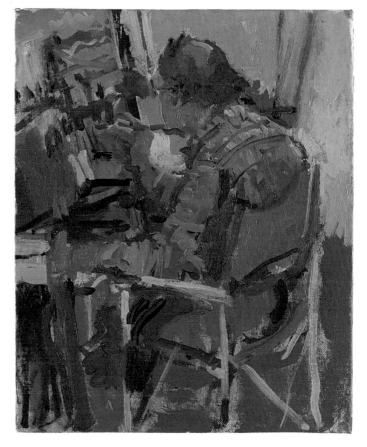

Tom Coates
ALFRED DANIELS PAINTING
Oil on panel
10 x 8in (25 x 20cm)

CANVAS BOARDS AND PANELS

SEE ALSO
Priming, page 22

Commercially prepared canvas boards and panels consist of acrylic-primed cotton canvas mounted on rigid board. They come in a range of standard sizes and surface textures, and are a good choice for beginners. Because they are compact and lightweight, they are ideal for painting outdoors. Cheaper-quality canvas boards with an imitation-canvas surface have an unsympathetic, mechanical texture and a rather slippery surface priming, and the backing board is prone to warping.

Marouflaging board

Many artists prepare their own canvas boards by covering them with canvas or muslin – a method once known as "marouflaging." Fabric glued to board provides a surface which combines the unique feel of working on canvas with the greater stability of a firm surface which is not prone to movement under atmospheric changes. Any natural fabric can be used, such as worn linen, cotton sheets or table-cloths, unbleached calico, butter muslin or canvas offcuts.

Method

Check that the board is cut square and true. Dress the edges and lightly sand the smooth side to provide a key for the glue. Brush away all sawdust. Lay the board over the fabric, then cut the fabric to size, allowing a 2in (50mm) overlap all around (1).

With a household paintbrush, apply size to the face and edges of the board (2). Smooth the fabric over the board with an equal overlap all around (3). Ensure that the warp and weft threads lie straight and parallel with the edges, as any distortion in the weave will show in the finished picture and be visibly distracting.

Apply more size to the cloth, brushing from the center outwards and smoothing out any creases or air bubbles. When the size has dried, turn the board over and trim across the corners (4).

Size a margin around the edge of the reverse of the board, wide enough to stick down the overlapped cloth, which should not be pulled too tight, or it may cause the board to warp. Smooth down the flaps of material and fold the corners over neatly (5). Add a final coat of glue over the reverse side to prevent warping. Leave to dry flat overnight before priming.

Marouflaging a board

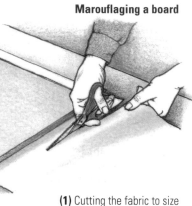

(1) Cutting the fabric to size

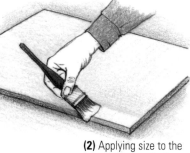

(2) Applying size to the face and edges

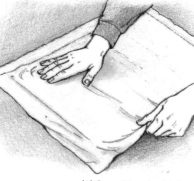

(3) Smoothing the fabric

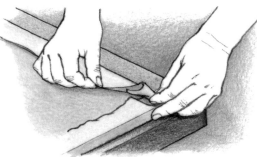

(4) Trimming the corners **(5)** Folding the corner

• Preparing canvas board

If you dislike the slippery surface of some commercially primed canvas boards, simply apply a further coat of alkyd or acrylic primer, to give a more absorbent surface. Matte household paint may be used for sketches or practice work.

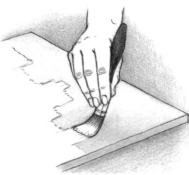

Priming for oil paint

To provide a sympathetic surface for oil paint, prime a marouflaged board with alkyd or acrylic primer. If you prefer a slightly absorbent, matte surface, thin the primer with mineral spirits (about 10 percent by volume).

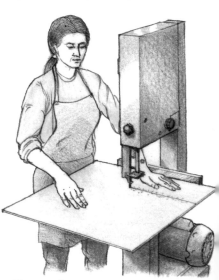

Time-saving

When making up several small boards, you will find it quicker and easier to glue the fabric to a large piece of board. Leave it to dry and then cut it up into the required number of boards, using a band- or handsaw. As long as the fabric is glued down firmly, it won't matter that some edges have no overlap.

18

SEE ALSO
Sizing for oils, page 20
Watercolor papers, page 26
Oil techniques, page 87
Acrylic techniques, page 160

PAPERS FOR OILS AND ACRYLICS

Paper is a perfectly satisfactory support for small-to-medium-size paintings as well as preparatory sketches, as long as it is a heavy, good-quality one with plenty of tooth to grip and hold the paint. Thin papers will buckle when sized or primed.

PREPARATION

Paper must be sized before oil paint is applied, to prevent the oil binder from being absorbed and leaving the paint film underbound. The paper may be sized with rabbitskin glue, PVA glue or acrylic matte medium, or primed with acrylic primer. Sizing is not necessary for acrylic paints.

TYPES OF PAPER

Watercolor paper

Heavy, rough-surfaced watercolor paper or handmade Indian paper can be used as a support for oil and acrylic painting. The paper's texture shows to advantage when the color is applied in thin washes. For extra strength, the paper can be mounted onto Masonite.

Oil-painting paper

Sheets of paper, textured to resemble canvas and primed ready for oil painting, are available in fine or coarse grades. Cheaper-grade oil-sketching paper comes in pad and block form. This is convenient for sketching outdoors and economical for practice work, but you may find the surface greasy and unpleasant to work on, like that of the cheaper painting boards.

Paper for oil painting
Size this with rabbitskin glue, PVA glue or acrylic matte medium, or coat with acrylic primer.

Indian paper (top) and canvas-texture paper (bottom)

Acrylic-sketching paper
This comes in the form of spiral-bound pads of embossed, acrylic-primed paper, which are convenient for small paintings and sketches.

Painting on paper
Paper is an excellent and economical support for painting. It will accept most media, as long as you follow the rules of preparation. This painting is in acrylics, worked directly onto a good-quality, heavy-weight watercolor paper. A toned wash of thinned acrylic was applied first, to tone down the white surface and to act as an extra size for the support.

Dennis Mathew Rooney
HAUNT OF ANCIENT PEACE
Acrylic on watercolor paper
15 x 21¼in (38 x 53cm)

Sizing for Oils

Supports for oil painting must be sealed with a thin coat of glue size before the application of a priming coat. Do not prepare the canvas with glue size if you are going to use an acrylic ground or acrylic paints.

SEE ALSO

Canvas, page 12

Boards and panels, page 16

Priming, page 22

Avoiding problems, page 87

Underpainting, page 89

FUNCTION OF SIZE

Size seals the pores between the fibers of the support, making it less absorbent. This prevents the oil binder in the priming and paint layers from sinking into the support, leaving the paint film underbound and susceptible to sinking, flaking and cracking.

RABBITSKIN GLUE

Rabbitskin glue has traditionally been used for sizing oil-painting supports, as it has good adhesive strength. It comes in the form of granules, and is available in most art-supply shops. The glue size is made by mixing dry glue with water and gently heating it – but be warned; it smells unpleasant!

PREPARING SIZE

The ingredients should be carefully measured to produce the required strength (see right). If the size is too strong, it forms a brittle layer which could cause the primer and the painting to peel and crack; too diluted a size will produce a weak film which allows oil from the upper layers to sink into the canvas.

Place the dry granules into the top part of a double boiler. Add the water and leave for about two hours to swell. Heat the resulting solution gently in the double boiler until it has melted, stirring until all the granules have completely dissolved, and never allowing the size to boil – this will destroy much of its sizing qualities. If you don't have the use of a double boiler, heat the glue in a bowl standing in a pan of water.

Leave the glue for a couple of hours, to cool and form a jelly. Keep the container covered to prevent loss of water through evaporation, and to protect from dust and flies. Test the strength of the glue with a finger – the surface should be rubbery, yet just soft enough to split. The split formed should be irregular; if it is smooth and clean, the size is too strong: rewarm it, add water, and allow it to reset. If the size has not set, stir in up to ¼oz (10g) of glue and leave to soak for 12 hours. If you are mixing up a batch for later use, glue size will keep in a refrigerator for up to a week before starting to decompose.

Rabbitskin glue
This is the time-honored size for rendering canvas impervious. It is available in granule form, and is dissolved in hot water.

Recipes for glue size
These measurements are a good starting guide; you may wish to vary them slightly.

For sizing canvas:
you need 2oz (55g) – two rounded tablespoons – glue to 2 pints (1.1 liters) water. (Alternatively, use 1 part by volume of glue to 13 parts water).

For rigid panels:
use a stronger solution of 3oz (85g) of glue to 2 pints (1.1 liters) of water. This recipe will make enough size to cover a support measuring about 4 x 6ft (120 x 180cm).

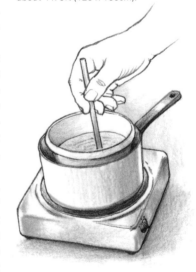

Improvised double boiler
An effective substitute can be made from a bowl or clean tin can heated in a pan of water.

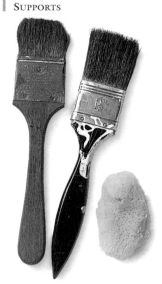

APPLYING SIZE

Rabbitskin glue is a strong adhesive and must be used thinly, or it will crack. One thin coat is sufficient to size a canvas; too thick a layer forms a continuous, level film on the surface, and prevents the subsequent priming layer from bonding with the canvas.

Gently reheat the size until it is just lukewarm and almost jelly-like in consistency. Apply it to the canvas in a thin layer, working quickly before the size begins to dry. Start from the edge, and brush in one direction only – do not make a back-and-forth motion with the brush, or too much size will be applied. Size the back flaps and edges of the support as well as the front. Leave to dry in a dust-free place for about 12 hours before applying primer.

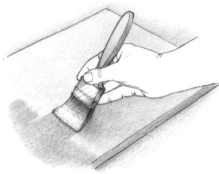

Brush size in one direction only

Temperature

Size may be applied hot to panels and boards, but on canvas it must be applied lukewarm. If it is too hot, it will soak through and glue the canvas to the stretcher, so that you have to pry it free with a palette knife. Hot glue size may also cause the fabric to over-tighten.

SIZING BOARDS AND PANELS

For boards and panels, use the slightly stronger solution described on the opposite page. Thin boards should also be sized on the reverse and edges, to prevent warping. Leave to dry for 12 hours, then sand lightly.

Sizing implements
The best brush for sizing is a flat hog varnishing brush, with a good width and long bristles. Decorators' brushes can be used, but poor-quality ones may shed hairs. Some artists use a natural sponge, which gives more control; gently squeeze out more glue when you feel the surface going dry. It can also be used to mop up any excess.

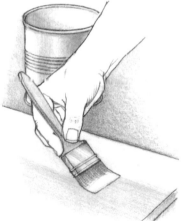

Alternative glue size
A modern alternative to traditional glue size is carboxymethylcellulose (CMC). This expands and contracts at the same rate as the canvas, greatly reducing the risk of cracking. It is also easier to use: dissolve the granules in warm or cold water (using an eight percent solution by volume), leave to swell and apply with a stiff brush. There is no heating involved – and no smell.

Unprimed supports
The warm brown tone of surfaces such as Masonite, plywood, cardboard and linen canvas, provides a middle tone which can be incorporated into the painting. To make them suitable for painting on, while maintaining their color and texture, seal them with a coat of diluted glue size (for oils) or acrylic medium (for all media). Here, Ken Howard uses very thin, turpentine-diluted paint, so that the canvas color shows through. This gives a marvelous impression of reflected light on the model's back.

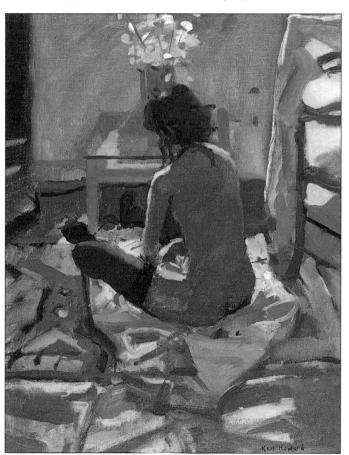

Ken Howard
HOMAGE TO LAUTREC
Oil on unprimed canvas
16 x 12in (40 x 30cm)

PRIMING

The primer, or ground, not only seals and protects the support, but provides a base that will readily accept the application of paint.

SEE ALSO
Canvas, page 12	
Boards and panels, page 16	
Sizing for oils, page 20	
Toned grounds, page 25	
Oil paints, page 64	
Avoiding problems, page 87	
Tempera, page 144	
Acrylic paints, page 148	

CHOOSING PRIMER

"I MAKE THE BACKGROUND OF MY CANVASES WITH THE GREATEST CARE, BECAUSE IT IS THE GROUND THAT SUPPORTS THE REST; IT IS LIKE THE FOUNDATIONS OF A HOUSE."

GEORGES BRAQUE (1882-1963)

There are various types of primer, each with different characteristics. It is important to choose the right one for your needs, as it affects the way paint is "pulled" from the brush, and its finished appearance. For example, if you like to work on a smooth surface, you will require a different ground than someone who prefers a slightly textured, dryish surface giving the paint a matte, chalky appearance.

In addition, it is vital to select the right type of primer for your chosen support. Canvas expands and contracts, and so requires a flexible ground; an inflexible gesso ground is therefore not suitable.

The ground should be absorbent enough to provide a tooth for the paint, but not so absorbent that it sucks oil from it – a common cause of sinking (the appearance of dull patches of paint across the canvas).

Checking primers
Commercially-produced primers may become hard if kept on the shelf for too long, so it is wise to shake a can before buying it, to make sure the contents are still liquid.

OIL PRIMER

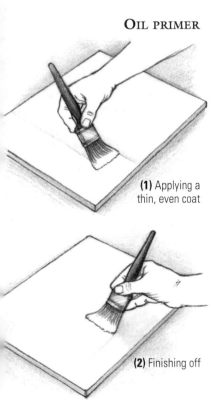

(1) Applying a thin, even coat

(2) Finishing off

The traditional, and best, primer for oil painting, particularly on stretched canvas, is oil-based white lead primer. This is flexible, stretching and contracting with the canvas on changes in temperature and humidity. It dries to form a durable base, which will not absorb too much oil from the paint.

Applying oil primer
White lead primer is quite stiff, and should be thinned slightly with turpentine so that it can be brushed out easily. Apply an even coat as thinly as possible, brushing it in well (**1**). Finish off with a long smoothing stroke in line with the weave of the cloth (**2**). Leave this first coat to dry for two days before applying a second coat.

The primed canvas should either be used while touch-dry (within a week or two) or be left to cure for four to six months before use. If paint is applied between these times, the primer sucks oil from the paint, leaving it underbound and with insufficient adhesion to the support.

Yellowing
The linseed oil in which white lead is ground turns the priming coat yellow if the primed support is stored away from the light for any length of time. The whiteness is restored upon exposure to sunlight.

ALKYD PRIMER

This is a valid alternative to oil primer, as it is flexible, non-yellowing and fast-drying; each coat can be overpainted after 24 hours. Dilute alkyd primer with mineral spirits to the required consistency.

When applying primer:
• Apply it in several thin coats; a thin coat is pliable while a thick coat is likely to crack and may even flake off the support.
• Cover the entire surface evenly. Don't go back over brushstrokes.
• Make sure each coat is touch-dry before any subsequent coat is applied, and before starting to paint.

ACRYLIC PRIMER

Acrylic primer is flexible, durable, water-thinnable, fast-drying and inexpensive. It can be used to prime canvas, board, paper and other surfaces, and can be applied directly to the support without the need of an isolating layer of size. It dries in a few hours.

Acrylic primer is the ideal surface for acrylic paints, providing a bright undercoat which brings out the vividness of the colors and gives added luminosity to thin washes. It can also be used with oil paints on rigid supports, but this is not recommended for canvas painting, except in a thin layer; acrylic is more flexible than oil, and the different tensions may eventually lead to cracking of the paint surface.

Acrylic primer is often referred to as acrylic gesso, a confusing term as it is not a gesso at all; traditional gesso is prepared with animal glue and chalk, and is very absorbent.

Applying acrylic primer

Work from the edges and apply the primer quickly in sections. Use a large brush or a paint roller, and keep the working edge moving, as acrylic primer dries quickly. Leave to dry for a few hours. The second coat should be applied at right angles to the first.

When priming board, you can apply as many as five coats for greater whiteness and opacity. For a really smooth finish, thin the last coat with a little water. For a textured finish, impress a piece of canvas (or any textured fabric) into the final coat of primer while it is still damp. Pull it away, then let the panel dry.

• Acrylic over glue
Never use acrylic primer over animal-glue size, as it prevents the paint from adhering properly to the support.

Paint rollers
It is a good idea to use a paint roller to apply acrylic primer. A roller keeps the paint moving and delivers an even coat; for small supports use a small radiator roller.

Using primer creatively
The lovely, matte, airy quality of Fred Cuming's paint is due in part to the ground he works on. After many years of painting, Cuming still finds the best primer is a good-quality, matte, white undercoat. When the primer is thoroughly dry, he applies a thin layer of linseed oil to the surface and wipes it off immediately, leaving just a trace of oil. When this is dry – after two weeks – the resulting surface provides a sound tooth for the paint, and prevents it from sinking.

Fred Cuming
BATHERS – CAP FERRETT
Oil on panel
24 x 20in (60 x 50cm)
Brian Sinfield Gallery, Burford

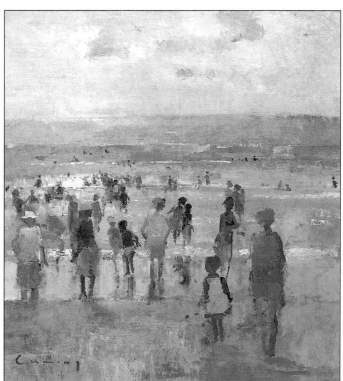

Working sequence
Work in sections; leave primer to dry between coats; apply subsequent coats at right angles.

Emulsion paint
An economical primer, often used by students, is ordinary household matte paint, which provides a sympathetic, semi-absorbent ground. However, such paint should only be used on rigid supports, and not on stretched canvas. Use only good-quality paint – cheap emulsions have a limited life span.

Textured finish
For a textured finish, lay and then press a piece of textured material, such as an old piece of burlap, into the final primer coat.

MAKING PRIMERS

Ready-made primers are adequate for general needs, but obviously cannot be tailored to individual requirements. Making your own primer is economical and gives you greater control over its quality and absorbency.

SEE ALSO
Priming, page 22
Tempera, page 144
Acrylic paints, page 148
Chroma color, page 154

(1) Applying the first coat

EGG-OIL EMULSION

Egg-oil ingredients
• titanium white pigment
• 1 egg
• linseed oil
• glue size
• water

This general-purpose, easily made primer is suitable for canvas and board. It is ready to paint on after two days' drying (see ingredients, left).

Break the egg into a jar. Using the eggshells as measures, add the same volume of refined linseed oil and twice the volume of cold water. Screw the lid on the jar and shake vigorously until an emulsion is formed. Grind a little emulsion with titanium white pigment until it forms a stiff white paste; add the rest of the emulsion to bring the mixture to the consistency of heavy cream. Thin the mixture to a milky consistency with lukewarm glue size mixed 1 part to 12 parts cold water. Brush very thinly onto a sized support.

(2) Adding coats at right angles

TRADITIONAL GESSO

Gesso ingredients
• 1 part Gilder's whiting
• 1 part glue size

Brilliant-white gesso (see ingredients, left), is very smooth and porous, and is the ideal base for painting luminous colors and detail. Gesso is best applied to a rigid support prepared with glue size – it is not flexible enough for use on canvas. It is most suited to water-based paints, such as tempera, acrylics and Chroma colors.

Heat the size, mixed 1 part to 8 parts cold water, gently in a double boiler. Slowly add some warm size to the whiting and stir until it forms a thick paste. Blend without creating excess bubbles. Gradually add the rest of the size until a smooth, creamy mixture is obtained. (Keep the pot of gesso warm and covered, otherwise it will harden, the water will evaporate and the glue will become too strong.) To increase the brilliance, add powdered white pigment. Leave for a few minutes before using.

(3) Leveling off

Sealing gesso
On an absorbent gesso surface, oil paint takes on a matte, airy quality which is pleasing but makes the paint quite difficult to handle. In addition, gesso soaks up much of the oil from subsequent paint layers, leaving it brittle and prone to cracking. To overcome this, the dry gesso surface should be partially sealed with a weak solution of glue size (about half the strength used to make the gesso).

Applying gesso
Apply gesso carefully in thin layers and work quickly: if you go back over an area, streaks will develop. Dampen the brush with water to prevent air bubbles from forming on the surface. Apply the first coat of hot gesso in short, even strokes (**1**), keeping the working edge moving – when the gesso begins to cool, move on to an adjacent area. Apply up to six coats for a dense, white finish; add each coat at right angles to the last (**2**), using short back-and-forth strokes. Each coat should be completely dry before the next is applied. Level off in one direction (**3**). Lightly sand between coats with fine sandpaper (**4**), dusting off the surface before applying the next coat.

(4) Sanding between coats

SEE ALSO
Acrylic primer, page 22
Color harmony, page 183

TONED GROUNDS

Some artists like to paint on a toned or colored ground, as a white ground can be inhibiting; by covering the canvas or paper with a wash of neutral color, you immediately create a more sympathetic surface on which to work.

• Drying times
A toned ground must be dry before you can paint over it. An oil ground takes a day or two to touch-dry; an acrylic ground is dry in minutes. So long as it is applied thinly, you can use acrylic paint for the toned ground and work over it with oils.

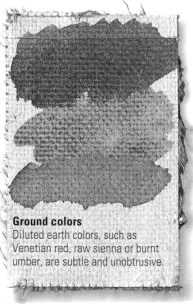

Ground colors
Diluted earth colors, such as Venetian red, raw sienna or burnt umber, are subtle and unobtrusive.

"READING" TONES AND COLORS

A white ground can give a false "reading" of tones and colors, especially in the early stages of a painting, when there is nothing to relate them to. Most colors appear darker on a white surface than when surrounded by other colors, and this creates a tendency to paint in too light a key. If you work on a neutral, mid-toned ground you will find it much easier to assess colors and tones correctly, and you can paint towards light or dark with equal ease.

If the color of the ground is allowed to show through the overpainting in places, it acts as a harmonizing element, tying together the colors that are laid over it.

CHOOSING A GROUND COLOR

The color chosen for a toned ground will depend on the subject, but it is normally a neutral tone somewhere between the lightest and the darkest colors in the painting. The color should be subtle and unobtrusive, so that it does not overwhelm the colors in the overpainting. Diluted earth colors, such as Venetian red, raw sienna or burnt umber, work very well, as do soft greys and greens.

TRANSPARENT AND OPAQUE GROUNDS

A toned ground can be opaque or transparent. With a transparent ground (also known as *imprimatura*), the paint is heavily diluted and applied as a thin wash. A transparent ground allows light to reflect up through the succeeding colors, retaining their luminosity, and is used where transparent or semi-transparent color is to be applied. Opaque toned grounds are used with opaque painting methods, where the light-reflecting qualities of a white ground are not so important.

Applying transparent grounds
Dilute the color until it is thin, and apply it with a large decorator's brush or a lint-free rag. Loose, vigorous strokes give a more lively effect than a flat stain of color. After a few minutes, rub the wash with a clean rag, leaving a transparent stain.

Making opaque grounds
Mix a little tube color into the white priming or gesso before applying it (see left). Alternatively, mix the color with white paint, dilute it a little, and brush a thin layer over the priming. Never mix oil paint with an acrylic primer, or vice versa.

Soft-pink ground
About ¼ tube of burnt sienna mixed with 1 pint (½ liter) of ready-made primer or gesso will give you a pleasing, soft-pink ground, which is excellent for landscape painting. The photograph above shows a blue underdrawing on pink-toned ground.

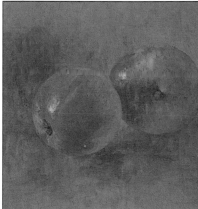

Jacqueline Rizvi
TWO APPLES
Watercolor and body color on toned paper
7 x 9in (17.5 x 22.5cm)

Jacqueline Rizvi rarely works on white paper. The rich, glowing effect of this simple still life is enhanced by the use of toned paper as a base for delicate washes of watercolor and body color.

WATERCOLOR PAPERS

SEE ALSO
Stretching paper, page 31
Watercolor paints, page 104
Watercolor techniques, page 120

> *"FIRST OF ALL, RESPECT YOUR PAPER!"*
>
> J. M. W. TURNER (1775-1851), ON BEING ASKED HIS ADVICE ABOUT PAINTING

A well-known professor of painting used to say that no artist really succeeds until he has found his paper. Today there are plenty of excellent watercolor papers to choose from, and it is well worth experimenting in order to find the one that best responds to your working method.

PAPER PRODUCTION

There are three ways of producing watercolor paper: by hand; on a mold machine; and on a fourdrinier machine.

Handmade paper
The very best papers are made of 100 percent cotton, and are usually made by skilled craftspeople. Handmade papers are lively to use, durable, and have a pleasing irregular texture. They are expensive, but worth the cost.

Mold-made paper
European mills produce paper on cylinder-mold machines. The paper fibers are formed into sheets with a random distribution, close to that of handmade papers. The paper is durable, extremely stable, and resistant to distortion under a heavy wash.

Machine-made paper
Although inexpensive to produce and to purchase, machine-made papers are less resistant to deterioration, but may distort when wet. Some papers also have a mechanical, monotonous surface grain.

CHOOSING PAPER

Watercolor paper is an excellent surface for acrylics, pencil, ink, gouache and pastel, as well as watercolor. The character of the paper, and its surface texture, play a vital role in the finished picture. Very often it is the choice of paper that is to blame for a painting going wrong, rather than any inadequacy on the part of the artist.

Some papers are superior in quality to others, but it does not necessarily follow that an expensive paper will give better results. The important thing is to find a paper that is sympathetic to what you want to do. It is no good using an absorbent rag paper if your technique involves repeated scrubbing, lifting out and using masking fluid; the surface soon becomes woolly and bruised.

Popular papers are available in local art shops. Specialist art shops stock less-common and handmade or foreign papers; some of these are also available directly from the mill through mail-order or through distributors, who can send sample swatches, price lists and order forms.

Once you have settled on a favorite paper, it pays to buy in bulk. The bigger the order, the more you save.

Try before you buy
Trial-and-error can be a costly affair, given the price of the average sheet of watercolor paper. However, most paper manufacturers produce swatches or pochettes – booklets containing small samples of their ranges. These provide an excellent and inexpensive means of trying out several types of paper.

• Paper sizes
Sizes of papers differ from country to country, and it is still common practice for art suppliers to describe paper in imperial sizes. The following table is a guide to imperial sizes and their metric equivalents.

Medium
22 x 17½in (559 x 444mm)
Royal
24 x 19in (610 x 483mm)
Double Crown
30 x 20in (762 x 508mm)
Imperial
30½ x 22½in (775 x 572mm)
Double Elephant
40 x 26¼in (1016 x 679mm)
Antiquarian
53 x 31in (1346 x 787mm)

Texture

There are three different textures of watercolor paper: (from top to bottom) hot-pressed or HP (smooth), Not or cold-pressed (medium grain) and rough. Each manufacturer's range is likely to have a slightly different feel.

Hot-pressed paper

Hot-pressed paper has a hard, smooth surface suitable for detailed, precise work. Most artists, however, find this surface too smooth and slippery, and the paint tends to run out of control.

Cold-pressed paper

This is also referred to as 'Not', meaning not hot-pressed. It has a semi-rough surface equally good for smooth washes and fine brush detail. This is the most popular and versatile of the three surfaces, and is ideal for less-experienced painters. It responds well to washes, and has enough texture to give a lively finish.

Rough paper

This has a more pronounced tooth (tiny peaks and hollows) to its surface. When a colour wash is laid on it, the brush drags over the surface and the paint settles in some of the hollows, leaving others untouched. This leaves a sparkle of white to illuminate the wash.

Experimenting with watercolor papers

Try out different textures and makes of watercolor paper until you find one which suits your painting style. As you become more knowledgeable you will also be able to choose a paper to fit your subject.

In these examples, the artist has chosen a smooth texture for the nude study (top), which is perfectly appropriate for the tone and texture of the flesh. The winter-evening snow scene (center) is perfectly suited for a medium-texture paper which conveys the effect of misty light and captures the subtle grain of the snow. A rough-texture paper (below) communicates to the viewer the solidity of the building and the dampness of the weather.

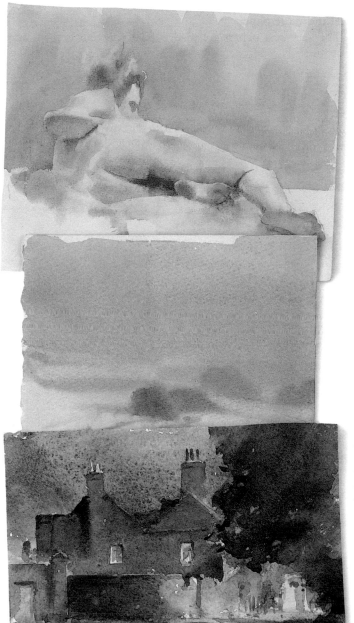

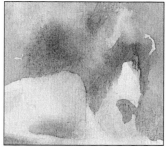

Smooth-texture paper

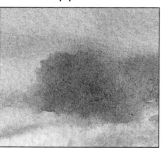

Medium-texture paper

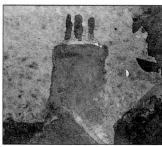

Rough-texture paper

Trevor Chamberlain
(from top to bottom)
RECLINING NUDE
SNOW, LATE-EVENING EFFECT
SHOWERY EVENING,
ISLEWORTH
All watercolor on paper
Various dimensions

Choosing watercolor papers

Choice of watercolor papers is very much a matter of personal preference; one artist's favorite may be another artist's poison. The chart below is intended only as a guide to a versatile selection of widely available papers. They have all been tried and tested by professional watercolor artists; however, your own assessment may be quite different.

SEE ALSO
Watercolor techniques, page 120
Directory of suppliers, page 249

HANDMADE PAPERS

ESPORTAZIONE
by Fabriano
Surfaces – Not and rough
Weights – 200, 315, 600gsm
Content – 100% cotton rag, tub-sized
A robust, textured surface that stands up to erasure and scrubbing; carries washes without sinking. Four deckle edges. Watermarked.

RICHARD DE BAS
by Richard de Bas
Surfaces – HP, Not and rough
Weight – 480gsm
Content – 100% cotton rag, internally sized
A thick, robust paper with a fibrous texture. Washes fuse into paper structure. Four deckle edges. Watermarked.

INDIAN
by Khadi
Surfaces – HP and Not
Weights – 200 and 300gsm
Content – 100% cotton rag, internally sized
A strong paper, able to withstand plenty of wear and tear. Lifting out color is easy, and masking fluid rubs off well.

ARTISTS' PAPER
by Two Rivers
Surface – Not
Weights – 175, 250gsm
Content – 100% cotton rag, tub-sized, loft-dried; buffered with calcium carbonate
Gently absorbent, but robust and firm. Also available in cream, oatmeal and grey. Four deckle edges.

MOLD-MADE PAPERS

ARCHES AQUARELLE
by Canson
Surfaces – HP, Not and rough
Weights – 185, 300, 640, 850gsm
Content – 100% cotton rag, tub-sized, air-dried
A warm white paper with a robust, yet soft, texture. Carries washes without undue absorption. Resists scrubbing and scratching. Lifting out is difficult, and fiber-lift occurs when masking fluid is removed.

LANA AQUARELLE
by Lana
Surfaces – HP, Not and rough
Weights – 185, 300, 600gsm
Content – 100% cotton rag, tub-sized
A good, textured surface. Lifting out and removal of masking fluid are easy. All weights stand up well to washes without undue buckling.

BOCKINGFORD
by Inveresk
Surface – Not
Weights – 190, 300, 425, 535gsm
Content – 100% cotton rag, internally sized, buffered with calcium carbonate
A versatile, economical paper. Robust yet gently absorbent. Lifting out is easy, masking fluid comes away cleanly. 300gsm also in tints.

SAUNDERS WATERFORD
by St Cuthbert's Mill
Surfaces – HP, Not and rough
Weights – 190, 300, 356, 640gsm
Content – 100% cotton rag, internally and gelatin sized
A stable, firm paper, resistant to cockling and with a sympathetic surface. Scrubbing, lifting out and masking are easy.

PAPER CONTENT

Apart from water, the main ingredient in making paper is cellulose fibers, derived from either cotton or woodpulp. Cotton is used for high-grade papers, woodpulp for others. Some papers contain a blend of cotton and other cellulose fibers, offering a compromise between cost and quality.

• Acid content
Papers that contain an acid presence, such as newsprint and brown wrapping paper, are prone to yellowing and deterioration in time. Paper acidity is measured by the pH scale. An acid-free paper does not contain any chemicals which might cause degradation of the sheet, and normally has a pH of around 7 (neutral). All good-quality watercolor papers are acid-free, to prevent yellowing and embrittlement with age. Some are also buffered with calcium carbonate, to protect against acids in the atmosphere.

Cotton rag
The best paper is made from 100 percent cotton. Although the term "rag paper" is still used, the raw material nowadays is natural cotton linters. Rag papers are strong, yet pliable, and withstand demanding techniques.

Woodpulp
Woodpulp produces a more economical, but less durable, paper. Confusingly, papers made of 100 percent woodpulp are sometimes advertised as "woodfree"; this is a technical term meaning wood broken down by chemical means, rather than mechanical ones – it does not signify that the paper has not been made from wood.

Mechanical woodpulp still contains lignin, which releases acids into the paper over a period of time, causing it to yellow and embrittle. The chemical woodpulp used in woodfree paper is processed to remove all the lignin.

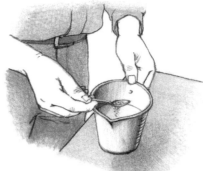

Increasing sizing
If paper is too absorbent, paint sinks into it and colors appear dull. To remedy this, dissolve a teaspoon of gelatin granules in 1.1 pints (half a liter) of water and apply to the surface before painting.

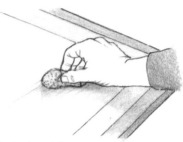

Reducing sizing
If a heavily sized paper does not take paint well, pass a damp sponge over the surface several times. Leave for 30 minutes, then dampen again before painting. Some hand-made papers may need to be soaked for up to two hours in warm water.

WEIGHT

The weight (thickness) of watercolor paper traditionally refers to the weight of a ream (500 sheets) of a given size, most often imperial (about 22 x 30in or 56 x 76cm). For instance, a 72lb paper is a light paper, 500 sheets of which weigh 72lb. However, the more accurate metric equivalent of grams per square meter (gsm) is now common.

Lighter papers (less than 140lb/300gsm) tend to buckle and wrinkle when washes are applied, and need to be wetted and stretched on a board before use. Heavier grades don't need to be stretched unless you intend to flood the paper with washes.

Weights of watercolor paper

Metric	Imperial
150gsm	72lb
180gsm	90lb
300gsm	140lb
410gsm	200lb
600gsm	300lb
850gsm	400lb

ABSORBENCY AND SIZING

All watercolor paper is internally sized to varying degrees, to control its absorbency and produce a more receptive working surface. Heavy sizing produces a hard surface with little absorption and a long drying time; this allows you to push the paint around on the surface, and colors remain brilliant, as they are not dulled by sinking into the paper. Lightly sized papers are softer and more absorbent, with a shorter drying time. Alterations are more difficult because the paint sinks into the fibers of the paper, but absorbent papers are suited to direct, expressive painting methods.

Internal sizing
Internal, or "engine" sizing means that the size is added to the paper at the pulp stage, and is contained in the body of the paper. Internal sizing renders the paper robust and prevents color washes from cross-bleeding beneath the paper surface, even when it has been abraded.

Trying for size
The amount and quality of sizing varies according to the brand of paper. A quick test is to lick a corner of the paper with the end of your tongue: if it feels dry and sticks to your tongue, it is absorbent paper.

SEE ALSO
Watercolor techniques, page 120

Surface sizing

Many watercolor papers are also surface-sized by being passed through a tub of gelatin size (hence the term "tub-sized"). Surface sizing reduces the absorbency of the paper and produces a more luminous wash (on absorbent papers, colors tend to dry far paler than they appear as a wet wash). It also reduces the risk of fiber lift when removing masking material and lifting out washes of color.

TINTED PAPERS

Most watercolor paper is white or off-white, to reflect the maximum amount of light back through the transparent washes of color. However, some manufacturers specialize in tinted papers, and these are often used when painting with body color or gouache.

Always check that the tinted paper you buy is sufficiently lightfast. Good-quality papers will not fade under normal conditions, but cheaper paper may not be as permanent as the colors laid on it, and in time the change could affect the overall tone of your painting.

Many artists prefer to apply their own tint by laying a very thin wash on white paper.

Spiral pads
Watercolor paper also comes in the form of spiral-bound pads, which are convenient for outdoor sketching. They generally contain 140lb (300gsm) Not paper.

WATERCOLOR SHEETS

Watercolor paper is most commonly sold in sheet form. In addition, many mills supply their papers in rolls, which are more economical, and pads.

WATERCOLOR BLOCKS

These comprise sheets of watercolor paper which are "glued" together around the edges with a gum. This bound block of paper is mounted on a backing board. A watercolor block removes the need for stretching paper. When the painting is completed, the top sheet is removed by sliding a palette knife between the top sheet and the one below. Although more expensive than loose sheets, watercolor blocks are convenient and time-saving.

The vital surface
A work of art on paper is an intimate object, in which there is a dialogue between the surface and the marks made on it. In this small study, even the ragged edges of the paper are integral to the visual effect as a whole.

WATERCOLOR BOARDS

Watercolor board is another way of avoiding stretching paper. It consists of watercolor paper mounted onto a strong backing board to improve its performance with heavy washes.

Len Tabner
UNTITLED, OCTOBER 1990
Watercolor on paper
2 x 5½in (5 x 14cm)
Thos. Agnew & Sons, London

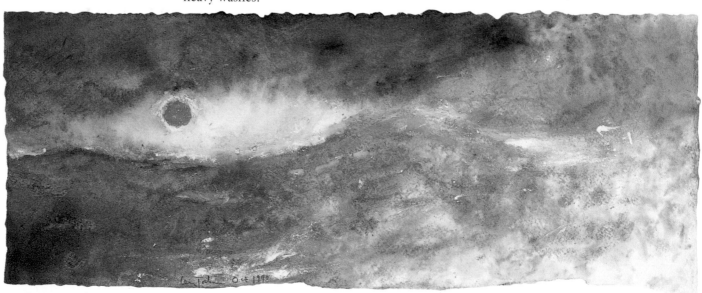

SEE ALSO
Watercolor paper, page 26

STRETCHING PAPER

Wet paint causes the fibers in watercolor paper to swell, and this can lead to buckling, or "cockling" of the surface. To avoid this, stretch paper before starting to work on it.

ACHIEVING A SMOOTH PAINTING SURFACE

The paper is wetted and then securely taped to a board. On drying, it contracts slightly and becomes taut, giving a smooth surface that is less prone to cockling.

With heavier papers (140lb and over) there is less need for stretching, unless heavy, saturated washes are to be applied. Lighter papers always need stretching.

Method

Cut four lengths of gummed brown-paper tape 2in (50mm) longer than the paper. Do this first, to avoid panic at the crucial moment, when wet hands, crumpled tape and a rapidly curling sheet of paper could cause chaos.

Immerse the paper in cold water for a few minutes (**1**), making sure it has absorbed water on both sides; heavier papers may take up to 20 minutes. Use a container large enough to take the sheet without being cramped. For large sheets, use a clean sink or bathtub.

Immerse only one sheet at a time in fresh water, as each sheet will leave a residue of size in the water.

Hold the paper up by one corner and shake it gently to drain surplus water. Place the paper onto the board (**2**) and smooth it out from the center, using your hands, to make sure that it is perfectly flat.

Press a dry sponge around the edges of the paper where the gummed tape is to be placed, to remove excess water (**3**). Moisten each length of gum strip with a damp sponge immediately before use. Beginning with the long sides, stick the strips around the outer edges of the paper, half their width on the board, half on the paper (**4**).

Leave the paper to dry flat, allowing it to dry naturally, away from direct heat. Do not attempt to use stretched paper until it is dry. Leave the gummed strips in place until the painting is completed and dry.

Commercial paper stretchers

For artists who find stretching paper a time-consuming chore, the only previous alternative has been to use expensive heavyweight papers or boards. However, there are now various effective devices available, designed by watercolor painters, which will stretch lightweight papers drum-tight in minutes. Among the ingenious designs, one uses a two-piece wooden frame to hold the paper firmly in place as it dries; another employs a system of plastic gripper rods which are pushed into grooves in the edges of the board, to hold the paper.

Choosing the best equipment
Use only gummed brown-paper tape for stretching paper – masking tape and self-adhesive tape will not adhere to damp paper. A clean wooden drawing board is the ideal surface for stretching paper – traces of paint or ink might stain the paper. Plastic-coated boards are not suitable, because gummed tape will not stick to them.

• Immersion times
These depend on the weight and degree of surface sizing of the paper. Thin paper soaked for too long will expand greatly, and may tear as it contracts; too brief an immersion means the paper will not expand enough, and will buckle when wet paint is applied. The correct soaking time for each paper will come through trial and error, but in general lightweight papers and those not strongly sized should be soaked for 2-3 minutes; heavily sized papers may need 5-10 minutes. (If a fine layer of bubbles appears when the paper is immersed, this indicates a strongly sized paper.)

(**1**) Immersing the paper

(**2**) Smoothing the paper

(**3**) Removing excess water

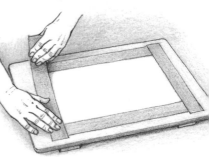

(**4**) Sticking the gummed strip

31

SUPPORTS FOR PASTELS

Some pastel artists like to work on primed Masonite, muslin-covered board or canvas, but most prefer to paint on one of the many tinted papers made specially for pastel work.

SEE ALSO
Watercolor papers, page 26
Pastels, page 46
Color harmony, page 183

EFFECTS

The subtle texture of pastel paper catches at the pastel particles to just the right degree. When the pastel stick is passed lightly over the surface, the color of the paper shows through and gives an interesting broken-color effect; when the pastel is pressed firmly into the tooth of the paper, solid patches of color are obtained.

TYPES OF PAPER

Canson Mi-Teintes
A machine-made paper produced in France. A lightly sized rag paper with a neutral pH, it has a fairly soft surface, suitable for pastel, charcoal and chalk. It is available in a wide range of colors.

Ingres
A mold-made paper produced in Italy, Ingres is one of the most widely used papers for pastel work. It has a hard surface and a laid finish, with a neutral pH. Suitable for charcoal and chalk, it also has a wide selection of colors.

Velour paper
Also known as velvet paper, this has a soft surface like velvet, which produces a rich, matte finish more like a painting than a drawing. It is best not to blend pastel colors too vigorously on velour paper, as this may spoil the nap of the surface.

Sand-grain paper
This has a pronounced tooth which grips the pastel particles, and there is enough resistance to the drawn line to make it very pleasant to work on. The rough surface of sand-grain paper is suited to a bold, vigorous approach. It is, however, an expensive surface for large-scale work, as it shaves off the pastel fairly rapidly.

Sansfix
The unique tooth of this paper, similar to very fine sandpaper, is made from a thin layer of fine cork particles, which eliminates the need for fixative. Similar in feel to Mi-Teintes paper, it has a light posterboard backing, and is acid-free. It is ideally suited to pastel work.

Charcoal paper
This inexpensive paper is useful for rough pastel sketches. However, it is rather thin and fragile, and you may find its regular, linear surface texture too monotonous.

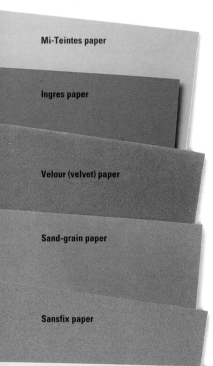

Mi-Teintes paper

Ingres paper

Velour (velvet) paper

Sand-grain paper

Sansfix paper

Charcoal paper

• Watercolor papers
Watercolor papers are excellent for pastel painting, as they stand up to a lot of wear. Choose a Not (medium surface) or rough surface; hot-pressed papers are too smooth for pastels. It is best to use a tinted paper, or to tint your own (see right), since white paper makes it difficult to judge the tones of your colors.

Tinting papers
There may be times when you wish to tint your paper by hand. For instance, you may find the colors of pastel papers too flat and mechanical, and prefer the more painterly look of a hand-tinted ground. Or you may want to work on watercolor paper because you like its texture, but white paper doesn't show the vibrant colors of pastel to best advantage – it makes them look darker than they actually are.

Using a teabag

Methods for tinting papers
Watercolor, acrylic or gouache paints can be applied with a brush, sponge or spray diffuser to leave a pale tint of color. You can modernize an ancient Chinese method by rubbing a damp teabag across the surface of the paper; this creates a warm undertone.
Another technique is to save the broken ends of pastels and crush them to a powder with a heavy object. Dip a damp rag into the powder and rub it over the paper. When the paper is dry, tilt the board and tap the surplus powder off.

Using crushed pastels

CHOOSING A SURFACE

A pastel painting is very much a marriage of medium and paper. The two work side by side, creating an exciting fusion of texture and color. When choosing a surface for pastel painting, there are three factors to be considered.

Texture

Texture is a vital part of pastel work, and the choice of surface can make or mar the finished picture. Smooth papers allow you to blend colors smoothly and evenly where a soft, delicate effect is required; rougher papers break up the color and provide vigor and sparkle.

Color

Pastel paper is available in a wide range of colors. In pastel painting, areas of the paper are very often left untouched, and contribute to the picture. For example, the paper can be chosen to harmonize with the subject, or it can provide a contrast.

Tone

The tone of the paper has considerable importance. "Tone" refers to the relative lightness or darkness of the paper, regardless of its color. In general, a light-toned paper emphasizes the dark tones and colors in a painting. For dramatic effects, use light pastels on a dark paper.

Carole Katchen
AFRICAN SMILE (detail, below left)
Pastel on Mi-Teintes paper

Andrew Hemingway
RED OILCAN, PEACHES, PLANT POTS AND EGGS (detail, below right)
Pastel on velour paper

James Crittenden
THROUGH THE OLIVES II (detail, bottom left)
Pastel on Ingres paper

Judy Martin
DOWNS VIEW (detail, bottom right)
Pastel on watercolor paper

• Using rough paper
If you work in a bold, vigorous style, with thick layers of color, choose a rough-textured paper such as sand-grain, or a rough-textured watercolor paper. The hollows in rough paper are capable of holding enough pigment for you to apply several layers of color without the surface becoming "greasy." The rough texture of the paper also contributes to the visual effect of the painting: pigment catches on the ridges of the grain and skips the grooves, creating a sparkling, broken-color effect.

• Using smooth paper
Smooth papers are best suited to fine details and linear work because the shallow grain quickly fills up with pastel particles, and the surface becomes greasy and unworkable if too many layers of pastel are applied.

• Using mid-toned papers
These are generally the most sympathetic for pastel drawings. They make it easy to judge how light or dark a particular color should be, and provide a harmonious backdrop for most colors.

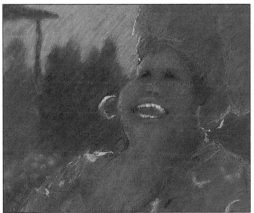
Detail on rough Mi-Teintes paper

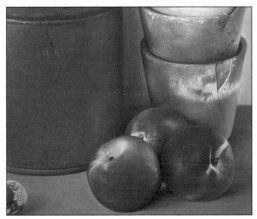
Detail on velour paper

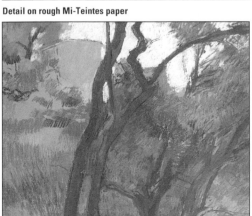
Detail on toned Ingres paper

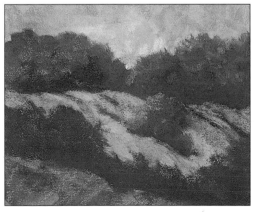
Detail on watercolor paper with colored-acrylic tint

Working on pastel papers
Choosing and exploiting the qualities of a particular paper is one of the pleasures of working with pastels. These examples (left) show how different textures, tones and colors interact with the pastel pigment, creating a range of expressive effects.

DRAWING PAPERS

No matter what your chosen medium, the paper you draw upon plays an important role in the success of the finished work.

SEE ALSO
Watercolor papers, page 26
Drawing media, page 38
Drawing & observation, page 194
Sketching, page 196

TYPES OF PAPER

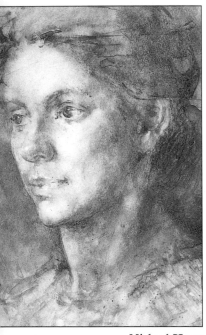

Michael Hyam
STUDY OF BERNADETTE
Ink on Japanese paper
10 x 7in (25 x 17.5cm)

Michael Hyam uses Japanese paper for many of his preparatory portrait studies. The thin, absorbent texture helps him achieve great sensitivity of line and wash tone.

Drawing or sketching paper
Drawing paper is a good general-purpose bond paper. Poor-quality paper is lightweight, with little or no sizing, and tends to yellow with age; heavier drawing paper is more versatile and is likely to be acid-free.

The surface of drawing paper varies between brands. It is usually fairly smooth, but with a fine-grained texture. Its color varies, too, ranging from a bright white to a mellow cream.

Bristol paper
Bristol paper, or Bristol board, is made from two or more layers of paper bonded together to make a thick sheet. It has a smooth surface ideal for fine line drawing, and is also perfect for pen-and-ink work.

Japanese papers
Specialist paper shops offer a range of Japanese handmade rice papers suitable for drawing, watercolor and gouache techniques. These papers are very thin and delicate, with unusual surface patterns. Japanese papers are very absorbent; they tend to soak up ink or paint, creating hazy, soft-edged shapes of a delicate and elegant nature.

Indian papers
Handmade Indian papers are more robust than Japanese papers, with a surface similar to rough watercolor paper. They are inexpensive and come in a range of tints as well as white and cream. They make an excellent support for soft drawing media such as charcoal, and for wash drawings.

Making paper by hand
Handmade papers are produced by pulping cotton fibers and sizing agents in a vat of water. The paper maker places a wooden frame, or deckle, over a flat screen made of wire mesh; this is lowered into the pulp and lifted out horizontally. Water drains out through the holes in the wire screen, leaving the fibers in the pulp deposited as a flat sheet on the mesh surface. The deckle is then removed; fibers trapped under the frame produce the "deckle edge," a feature of most handmade paper. Each wet sheet is transferred onto a piece of woollen felt and, when a number of sheets have been sandwiched into a "post," they are pressed to remove excess water. The sheets are then laid out on screens to dry (some makers use the traditional method of drying over ropes). This is known as loft drying, and results in paper with better dimensional stability than machine-made papers, because humidity is released at a slower rate.

Naomi Russell
SKETCHBOOK
Ink on paper
6 x 4in (15 x 10cm)

Sketchbooks
Sketchbooks with a spiral binding can be held easily in one hand while drawing; some have tear-off, perforated sheets, while others come in book form so you can work right across the spread. A small sketchbook, about 6 x 4in (15 x 10cm), fits conveniently into a pocket and can be taken out whenever inspiration strikes; a larger book, though bulkier, offers more scope for large-scale studies, such as landscapes.

TEXTURE The texture, or "tooth" of the paper has a direct influence on the character and appearance of the drawn marks. An uncoated, unpressed paper, such as Ingres, has plenty of natural tooth to bite and hold powdery drawing media like charcoal, chalk and pastel. Rough textures are also suited to bold work, as they emphasize the drawn marks and become part of the drawing.

For fine pencil work and pen-and-ink drawing, a smooth surface is preferred; pen nibs can snag on a rough surface and the ink will spread, preventing clean lines.

COLOR The choice of color and tone can make a positive contribution to the picture when using colored drawing materials such as pastel and colored pencil. Toned papers provide a good middle ground from which to work up to the lights and down to the darks.

• Weight

Heavy papers made of 100 percent cotton are preferred for permanent work, since they are sturdy and can take a lot of working and erasing without damage; they are also less prone to wrinkling when using ink and watercolor washes. Cheaper woodpulp and lightweight papers, some of which are now made from eco-friendly, recycled paper, are fine for sketches and practice work.

Supports and media
These drawings on very different types of paper demonstrate the importance of the support.

In Kay Gallwey's lively sketch (right), beige Ingres paper provides a soft mid-tone which shows through the drawn marks, tying them together.

Naomi Russell used colored tissue paper, crumpled and then smoothed out, for this charming study (below).

The rough surface of handmade Indian paper imparts an attractive texture to the watercolor washes in the still life by Sarah Donaldson (below right).

Kay Gallwey
MR BILL
Charcoal, chalk and wash on paper
5 x 8in (12.5 x 20cm)

Sarah Donaldson
STILL LIFE WITH PUMPKINS
Watercolor on Indian paper
16 x 11½in (40 x 28.5cm)

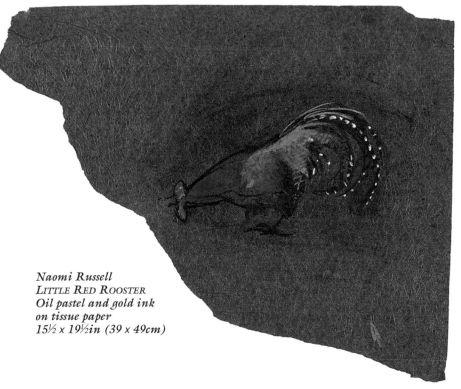

Naomi Russell
LITTLE RED ROOSTER
Oil pastel and gold ink on tissue paper
15½ x 19½in (39 x 49cm)

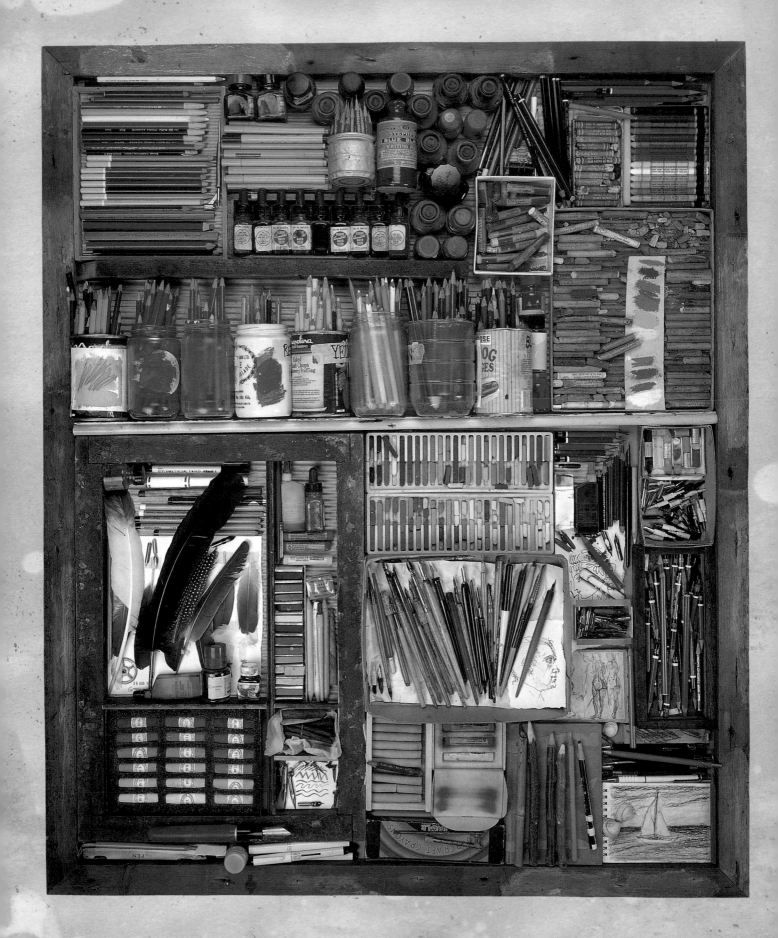

DRAWING MEDIA

ANYTHING THAT MAKES A MARK *can be used as a drawing tool, but over the years the versatility of* certain materials – in particular, PENCIL, PASTEL, CHARCOAL and INK – *has made them enduringly popular among artists of all abilities.*

No one DRAWING MEDIUM *is intrinsically superior to another. One artist may enjoy the broad handling that is possible with charcoal or* SOFT PASTEL, *while another may prefer the control and precision of a harder point, such as* PENCIL *or* PEN *and ink. The best course is to experiment with different materials and techniques until you discover which ones allow you to* EXPRESS YOUR ARTISTIC VISION *most fully.*

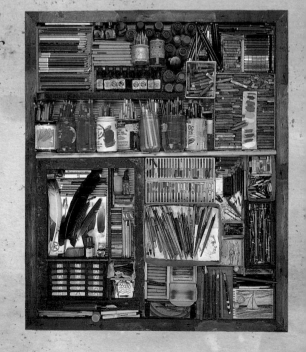

PENCILS

Equally capable of producing a quick sketch or a finely worked drawing, the pencil is the most immediate, versatile and sensitive of the drawing media. It can be used, on one hand, for great subtlety and delicacy, and, on the other, for striking boldness and vigor; you can produce a soft, velvety quality or a crisp sharpness. One of the pencil's most attractive characteristics is the ease with which line and tone can be combined in one drawing.

"DRAWING IS THE TRUE TEST OF ART."

JEAN-AUGUSTE-DOMINIQUE INGRES (1780-1867)

SEE ALSO
Supports, page 34
Accessories, page 59

Manufacturing pencils

HOW PENCILS ARE MADE

In graphite, or "lead" pencils, natural graphite is reduced to a powder and blended with clay in exact proportions, then kneaded into a stiff paste. To make the leads, the paste is compressed and extruded into thin strips, which are dried before being fired in a kiln. After firing, the leads are impregnated with waxes to ensure that they draw smoothly. They are then encased in shafts of cedarwood which are finished with one or more coats of paint.

GRAPHITE PENCILS

Drawing pencils come in a range of grades, from "H" for hard to "B" for soft. The hardness of the lead is determined by the relative proportions of graphite and clay used: the more graphite, the softer the pencil. Typically, hard pencils range from 9H (the hardest) to H, and soft pencils range from 9B (the softest) to B. Grades HB and F are midway between the two.

A very soft lead will produce rich, black marks, and is excellent for rapid sketches and expressive line-and-tone drawings, especially on textured paper. Hard leads make grey, rather than black marks. They are suitable for precise lines and details because they can be sharpened to a fine point. Although a single pencil of grade HB or 2B gives you considerable scope for expression, many artists use several grades of pencil in one piece of work, creating a rich interplay of line and tone.

Graphite sticks
These are made of high-grade compressed and bonded graphite formed into thick, chunky sticks. They glide smoothly across the surface of the paper, lending themselves to bold, expressive drawing and to large-scale work. Marks can be varied by using the point, the flattened edge of the point, or the length of the stick.

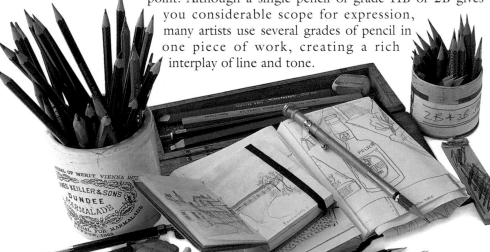

Linear marks

The weight, quality and nuance of a pencil line can be varied and controlled by the grade of pencil chosen, its sharpness, the degree of pressure applied, and the texture of the paper surface. A soft graphite lead gives considerable control over the tone and thickness of a line, which may be graded to describe the contours of a form and the play of light.

Shading

Continuous gradations of tone can be created by shading with soft pencils. These areas are first drawn in broadly, using the edge of the lead, working from the lightest to the darkest tones or vice versa. The marks are then carefully blended together using a paper stump, as here, the fingers, or an eraser.

Hatching and crosshatching

Areas of tone can be built up with hatching – roughly parallel lines drawn close together. These can be straight and mechanical or free and sketchy. Altering the direction of the lines describes shape and form. In crosshatching, lines are criss-crossed on top of one another to create a fine mesh of tone. The lines may run in any direction – vertical, horizontal and diagonal.

The density of tone can be varied, as is demonstrated here: the closer the lines, the blacker the pencil used and the more pressure applied, the deeper the tone.

Build up hatched and crosshatched lines gradually; too much deepening of tone early on can make the finished drawing dark and heavy.

Valerie Wiffen
MODEL AND ARTIST (right)
Graphite pencil on paper
8½ x 5¾in (21 x 14.5cm)

PORTRAIT I (above left)
Graphite pencil on paper
5 x 5in (12.5 x 12.5cm)

PORTRAIT II (below left)
Graphite pencil on paper
5 x 5in (12.5 x 12.5cm)

Drawing with an eraser

Erasers can be used as drawing instruments. In this lively study, line and areas of tone were laid on the paper with a soft pencil, then drawn into and modified with a kneadable eraser. This is a form of "negative" drawing, in which the image emerges gradually from dark to light.

Pauline Jackson
SNEAKERS
Graphite pencil on paper
13½ x 10in (34 x 25cm)

COLORED PENCILS

Colored pencils are made from a mixture of pigment, clay and filler, bound together with gum. The colored sticks are soaked in wax, which gives them their smooth-drawing properties, before being pressed into rods and encased in wood. Since David Hockney set a precedent in the 1960s with his series of colored-pencil drawings, this medium has become increasingly popular with fine artists.

SEE ALSO
Supports, page 34
Pencils, page 38
Water-soluble pencils, page 43
Mixing colors, page 178

CHOICE AND VARIETY

Of late, there has been an enormous increase in the variety of colored pencils available on the market. Not only has the range of colors been vastly expanded, but the colors themselves are now much more consistently lightfast than before. You can also obtain watercolor pencils which allow you to dissolve or partially dissolve the colors on the paper with water.

• Buy the best
For fine-art work, look for the best-quality pencils. They should have strong, lightfast and rich colors that come out uniformly and vividly, with no feeling of grittiness.

Clean, quick and portable, colored pencils are very useful sketching and drawing tools. They allow you to work with the accuracy of pencil while involving color; they are soft enough to allow delicate shading, and they can be sharpened to a point for controlled lines.

BUYING COLORED PENCILS

Colored pencils are available individually or in sumptuous-looking sets with dozens of colors. Brands vary considerably in the range of available tones and in the quality and proportion of pigments, binders, clays and waxes they contain. Some brands have hard, waxy "leads" that can be sharpened to a long, fine point; others are soft and crumbly, producing a broader, more grainy mark.

Fine or broad
Most pencils have a color core ⅛in (3.5mm) in diameter, which is particularly suitable for finely detailed drawings. Some ranges also carry pencils with a 5/32in (4mm) diameter color strip, which allows for broad strokes and strong lines. As with ordinary lead pencils, they can be obtained in round or hexagonal wooden shafts.

Building up color

In many ways, colored pencils work like watercolors. When they are used on white paper, the marks they make are transparent or semi-transparent, which means you can put down one color on top of another, building up hues, tones and intensities until you achieve the result you want.

Making the paper work

As with watercolors, the secret is to make the white of the paper work for you. Rather than applying dense layers of color – which quickly makes the surface greasy and unworkable, preventing any further build-up of color – it is best to deepen the color by degrees, allowing plenty of white paper to show through the lines.

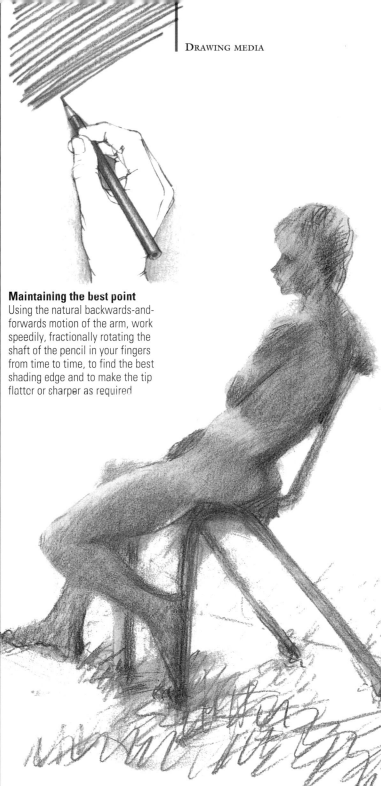

Maintaining the best point

Using the natural backwards-and-forwards motion of the arm, work speedily, fractionally rotating the shaft of the pencil in your fingers from time to time, to find the best shading edge and to make the tip flatter or sharper as required

Optical color mixing

You can use hatching and cross-hatching techniques to create colors and tones. Lay lines of different colors side-by-side, or overlay lines at right angles to one another to create the illusion of a third color.

Working with toothed paper

Colored-pencil drawings are characterized by a certain delicacy, softness and clarity, due to the effect of the grain of the paper. Unless you press hard with the pencil, the pigment particles catch only on the raised tooth of the paper, leaving the indents untouched; these tiny flecks of white paper reflect light, and this lends translucency to the colors.

Sarah Donaldson
SEATED NUDE
Colored pencil on paper
16¾ x 12in (42 x 30cm)

Colored pencils produce a translucent effect that allows you to layer colored marks to create subtle tones and hues. Here, the figure's solidity is achieved through lightly hatched lines. The illumination is suggested by highlights, using the white paper.

41

SEE ALSO
Colored pencils, page 40
Watercolor techniques, page 120

WATER-SOLUBLE COLORED PENCILS

These offer all the advantages of colored pencils, but include a water-soluble ingredient in the lead, so that it is possible to thin out their color into a transparent wash.

Color applied dry

Dissolved with wet watercolor brush

Dissolved with wet sponge

Dissolved with wet finger

Dry point on wet paper

Point dipped in water, on dry paper

Combined with other materials

USING WATER-SOLUBLE PENCILS

You can apply the color dry, as you would with an ordinary colored pencil, and you can also use a wet watercolor brush, a wet sponge, or even a wet finger, to loosen the pigment particles and create a subtle watercolor effect. When the washes have dried, you can then add further color and linear detail, using the pencils dry. If you dampen the paper first, the marks made by the pencil will bleed slightly and produce broad, soft lines.

This facility for producing tightly controlled work and loose washes makes water-soluble pencils a flexible medium, and they are very appropriate for rendering natural subjects. They are often used in combination with watercolors, felt-tipped pens, pencil or pen and ink.

TECHNIQUES

Apply the colors with light, hatched strokes, then use a soft brush, rinsed regularly in clean water, to gently blend the strokes and produce a smooth texture. This can take a little practice, as too much water will flood the paint surface and make it blotchy, while insufficient water will prevent the colors from blending well; the ideal result resembles a watercolor wash. Heavy pencil strokes will persist and show through the wash.

TEXTURES

Interesting textures can be created by building up the picture with multiple layers of dry pigment and water-dissolved color. When adding dry color over a dissolved base, however, the paper must first be completely dry; if it is still damp, it will moisten the pencil point and produce a blurred line, and the paper may even tear.

Colored and water-soluble pencils

These pencils offer a surprisingly varied range of techniques and effects.

Anna Wood uses water-soluble crayons – thicker and juicier than pencils – which suit her spontaneous way of working. Suggestions of form, texture and space emerge from the accidental marks left as the color washes spread and dry.

The astonishing detail and beautiful texture in David Suff's drawing are built up painstakingly with tiny strokes, applied layer on layer.

Michael Stiff's work has a similar sense of heightened reality. He blends pastel dust into a smooth layer to produce the basic tonal areas, over which he applies finely hatched strokes of colored pencil.

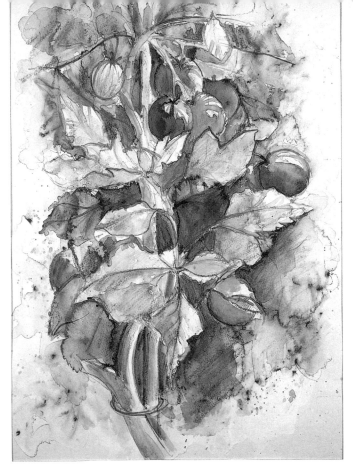

Anna Wood
TOMATOES
Water-soluble pencil on paper
20 x 14in (50 x 35cm)

David Suff
THE HISTORY GARDEN
(TWA CORBIES) *(below left)*
Colored pencil on paper
36 x 36in (90 x 90cm)

Michael Stiff
DETAIL, GREEK-THOMSON
CHURCH, GLASGOW
(below right)
*Colored pencil and pastel
on paper*
10 x 8in (25 x 20cm)

43

CHARCOAL

Charcoal has been used for drawing since prehistoric times: using soot and sticks of charred wood from the fire as drawing tools, early cavemen covered the walls of their caves with images of the animals they hunted. Since then, charcoal has never lost its popularity.

SEE ALSO
Accessories, page 59

A USER-FRIENDLY MEDIUM

Charcoal is an excellent medium for beginners, as it encourages the student to treat subjects in broad terms and not become lost in detail. At the same time it is a forgiving medium, very easy to erase and correct by rubbing marks off with a finger or a wad of tissue.

CHARCOAL STICKS

Stick charcoal is made from vine or willow twigs (beech is also used in Europe) charred at high temperatures in airtight kilns. Willow is the most common type; vine is more expensive, but makes a richer mark. 6in (15cm) lengths are available in boxes, and vary in thicknesses and degrees of hardness. Soft charcoal is more powdery and adheres less easily to the paper than hard charcoal, so it is better-suited to blending and smudging techniques and creating broad tonal areas. The harder type of charcoal is more appropriate for detailed, linear work, as it does not smudge so readily. The only drawback with stick charcoal is that it is very brittle and fragile, and tends to snap when used vigorously.

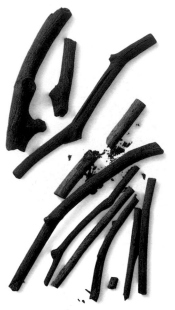

Vine, beech and willow charcoal

COMPRESSED CHARCOAL

This is made out of powder ground from charcoal, mixed with a binder and pressed into short, thick sticks. Compressed charcoal is stronger than stick charcoal and does not break so easily. It produces dense, velvety blacks, but is not as easy to dust off as natural charcoal.

CHARCOAL PENCILS

These pencils are made from thin sticks of compressed charcoal encased in wood. They are cleaner to handle and easier to control than stick charcoal, and have a slightly harder texture. Only the point can be used, so they cannot produce a broad side-stroke, but they make firm lines and strokes. Charcoal pencils come in hard, medium and soft grades; the tips can be sharpened, like graphite pencils.

Detailed work
Easily sharpened, pencils are perhaps the best form of charcoal for detailed drawing.

VERSATILITY

Charcoal is a wonderfully liberating medium, so immediate and responsive in use that it is almost like an extension of the artist's fingers. Simply by twisting and varying the pressure on the stick, you can make fluid lines that vary from soft and tentative to bold and vigorous. Rich tonal effects, ranging from deep blacks to misty greys, are achieved by smudging and blending charcoal lines with the fingers or with a paper blending stump, and highlights can be picked out with a kneadable eraser.

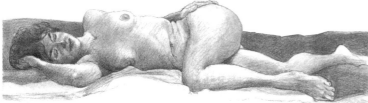

Tonal effects

The most effective method of achieving these is by smudging and blending charcoal lines with fingers or with a paper blending stump.

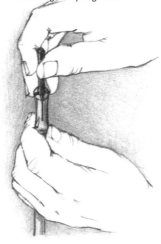

Highlights

These can be picked out with a kneadable eraser.

Exploiting the grain of the paper

One of the most interesting characteristics of charcoal is that it is sympathetic to the texture and grain of the paper, allowing it to show through and contribute to the surface interest of the drawing. This is especially the case when the charcoal stick is used on its side and swept lightly over the surface.

Fixing charcoal

The soft nature of charcoal makes it messy to handle, and strokes may be accidentally smeared with the heel of the hand. Keep a damp rag handy, and wipe your fingertips regularly to avoid leaving "prints" on the paper. It is advisable to spray finished charcoal drawings fairly liberally with fixative to protect them from smudging.

Working at a distance

Charcoal works well for large-scale drawings executed at the easel. You need to stand far enough back from the easel that your drawing arm is not cramped and you can view the drawing as a whole through each stage of progress.

Attaching charcoal to a cane

Working at a distance is made easier by securing the charcoal stick to the end of a cane – a method used by Renaissance painters when drawing images for frescoes. Cut a piece of cane to the required length. At one end of the cane make two 1in (25mm) cuts at right angles. Push the charcoal firmly into the end, leaving a reasonable length protruding, and secure with tape wound around the cane.

Sarah Cawkwell
HAIR PIECE (below)
Charcoal on paper
59 x 47½in (147.5 x 118.7cm)

Rosemary Young
RECLINING NUDE
Charcoal on paper
14 x 18in (35 x 45cm)

Charcoal is a painterly medium, allowing a rich patina of marks to be built up with line and tone. Both of these artists' drawings evolve gradually, the final image being enriched by the previous alterations. Rosemary Young works at an easel, using charcoal attached to a length of cane to allow her greater mobility.

Let the buyer beware
Since the degree of softness varies noticeably from one brand of soft pastel to another, try out individual sticks from different manufacturers until you find the one that suits you best. Only then buy a full range.

PASTELS

Pastels are made from finely ground pigments mixed with a base such as chalk or clay and bound together with gum to form a stiff paste. This is then cut and shaped into sticks and allowed to harden. There are four types of pastel available: soft and hard pastels, pastel pencils and oil pastels. They are available in different shapes – round or square, thin or chunky.

SEE ALSO
Supports, page 32
Accessories, page 59

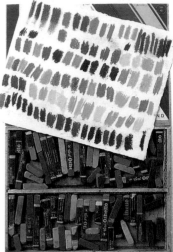

Permanence
Reputable manufacturers provide the names of lightfast pigments, such as burnt umber, that are used in pastels. Pastels in cheaper ranges often are given romantically descriptive names which, however, give no indication of the nature or permanence of the pigment.

TINTS AND SHADES

Pastels are made in a wide range of tints and shades, derived from a selection of full-strength pigment colors. The tints are achieved by adding more base and white pigment to the original color, and by repeating this process to produce a series of increasingly lighter shades.

The tonal range of each color is usually indicated by a system of numbering which corresponds to the various strengths of each color; for example, in some ranges burnt umber has No. 1 against its lightest shade, and No. 8 against its darkest. This system of numbering, however, is not standardized from one manufacturer to another, so it is worth checking catalogs and color charts.

SOFT PASTELS

Soft pastels are the most widely used of the various pastel types, because they produce the wonderful velvety bloom which is one of the main attractions of pastel art. They contain proportionally more pigment and less binder, so the colors are rich and vibrant.

The smooth, thick quality of soft pastels produces rich, painterly effects. They are easy to apply, requiring little pressure to make a mark, and they can be smudged and blended with a finger, a rag or a paper blending stump.

The only drawback of soft pastels is their fragility. Because they contain little binding agent they are apt to crumble and break easily, and they are more prone to smudging than other types of pastels. A light spray with fixative after each stage of the work will help to prevent such smudging.

HARD PASTELS

These contain less pigment and more binder than the soft type of pastels, so although the colors are not as brilliant, they do have a firmer consistency. Hard pastels can be sharpened to a point with a blade and used to produce crisp lines and details. They do not crumble and break as easily as soft pastels, nor do they clog the tooth of the paper; they are often used in the preliminary stages of a painting, to outline the composition, or to add details and accents in the latter stages, sometimes in combination with other drawing and painting media.

Pastel pencils
Thin pastel sticks are available encased in wooden shafts, like pencils. Pastel pencils are clean to use, do not break or crumble like traditional pastels, and give greater control of handling. They are suitable for line sketches and detailed or small-scale work, and can be used in conjunction with both hard and soft pastels.

Versatility

Pastels are both a painting and a drawing medium. Working with the side of the crayon creates broad, painterly strokes that can be blended and smudged or built up in thickly impasted layers, with the solid, buttery appearance of an oil painting. Working with the tip of the crayon, you can make thin lines and crisp marks that create a very different feel.

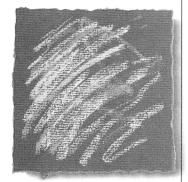

Working with the tip

Blending

One of the attractions of a powdery medium such as pastel is that it is easily blended to create soft, velvety tones and subtle gradations from dark to light. Blending has many uses – in softening fine lines and details, suggesting smooth textures, modeling form with degrees of light and shade, lightening tones, and tying shapes together.

To create an area of blended tone, either apply lightly scribbled strokes with the point of the stick, or use the side of the stick to make a broad mark, but do not press too hard – if the mark is too ingrained it will be difficult to blend. Then lightly rub the surface with the tip of your finger or a rag, tissue or paper stump, to blend the marks together and create an even tone. Repeat the process if a darker tone is required.

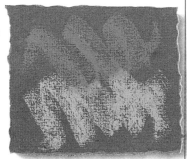

Working with the side

Line and tone

You can use blended tones alone, or mix blended and linear techniques to add variety and texture. Another approach is to create an area of soft blending and then overlay it with linear strokes. Here, the blended tones act something like an underpainting, adding extra depth and subtlety to the image, while the strokes tie the image together.

Blending with a fingertip

Scumbling

Scumbling modifies the color of a tinted paper or a layer of pastel by applying a thin, semi-opaque layer of another color over it. Loose, circular strokes are applied with the side of the stick to create a thin veil of color which does not entirely obliterate the one underneath. Scumbling not only creates subtle color effects, it also gives a very attractive surface texture. Use it to give depth and luminosity to your colors, and to soften and unify areas of the drawing.

Lines over soft blending

Scumbling

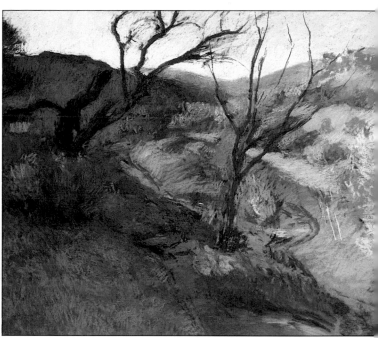

James Crittenden
WINDY DAY
Pastel on paper
26 x 30in (65 x 75cm)

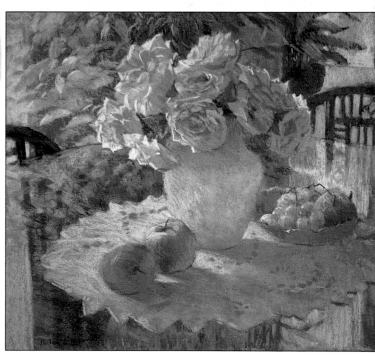

Among the many ways of applying pastel, the "painting" and "drawing" disciplines can be used alongside each other to create a breathtaking range of effects. These two pictures show some of the varied textures that can be produced, from broken, grainy strokes to delicate "washes."

Jackie Simmonds
THE GLASS TABLE
Pastel on paper
18 x 24in (45 x 60cm)

OIL PASTELS

SEE ALSO
Mixing colors, page 178

Oil pastels are made by combining raw pigments with animal fat and wax; this makes them somewhat different in character from soft pastels, which are bound with gum. Whereas soft pastels are known for their velvety texture and subtle colors, oil pastels make thick, buttery strokes, and their colors are more intense. Oil pastels are also stronger, harder and less crumbly than soft pastels; since they tend not to smudge, they require little or no fixative, but they are more difficult to blend.

Diluents for oil pastels
Turpentine and mineral spirits dissolve oil pastel and can be used for blending colors and obtaining painterly surface effects. Your initial drawing can be modified using a brush dipped in a diluent and worked over the surface.

USING OIL PASTELS

Working with a robust medium like oil pastels encourages a bold and direct approach that is of enormous benefit in developing confidence in drawing and using colors. In fact, oil pastels are not ideally suited to small-scale, detailed work; the sticks are too chunky for this, and fine blending is not possible. It is far better practice to exploit the tactile qualities of the medium and to work on a large scale, using vigorous, textural strokes and building up a rich patina of waxy color. As with the other types of pastels and crayons, optical-color mixtures can be created by techniques such as hatching, crosshatching or gentle shading with superimposed colors.

Simon Jennings
UPSTREAM GREENWICH
Oil pastel and graphite pencil
on paper
16½ x 23in (41 x 57.5cm)

Oil pastels work particularly well in combination with other media. Here, the artist emphasized the sky and the dramatic sweep of the river with lines and flecks of oil pastel, which were then blended with turpentine. The details of the buildings in the foreground were added with graphite pencil, which glides easily over an oil-pastel ground.

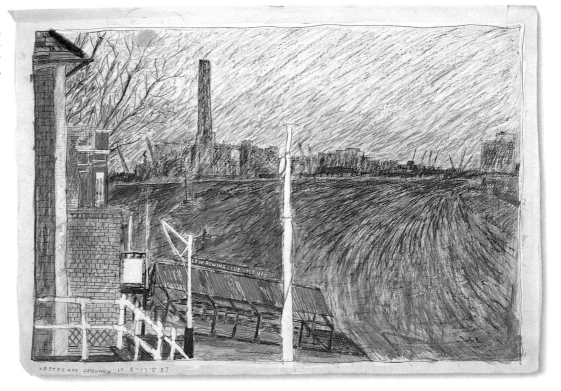

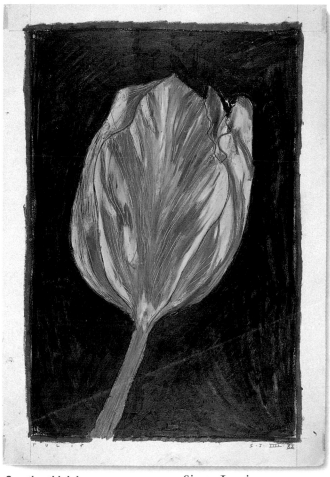

Blending and mixing

Because of their waxy texture, only a minimal amount of blending is possible with oil pastels. The colors can, however, be applied to the support and then spread and blended with a brush, rag or tissue dipped in mineral spirits or turpentine. As the pastel mixes with the turpentine it dissolves and takes on the quality of thinned oil paint, and the colors become richer and darker. When they are dry, you can work over the "painted" areas with linear strokes of dry oil pastel to add textural variety.

Blended oil pastel

Dry oil pastel on blended pastel

Finger blending

The drawn surface can be smoothed and blended with a wet finger. Because oil and water are incompatible, a dampened finger will not pick up the color from the paper but just smooth and blend the surface of the oil pastel

Blended with a wet finger

Sgraffito

A layer of solid color can be built up, and the waxy surface scratched into with a sharp tool, to create lively patterns and textures – a technique known as sgraffito. Further interest is added by applying one color over another and then scratching back through the top layer to reveal the color beneath.

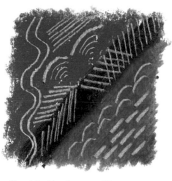

Scratched back, or sgraffito

Wax resist

Oil pastel can be used with watercolor paint to build up a lively surface or to suggest natural textures. The paint adheres to the paper but is resisted by the waxy pastel marks, and results in a random, mottled effect. A more pronounced pattern can be achieved by working on rough-surfaced paper.

Wax-resist

Creating thick layers

A painterly surface was built up using oil-painting techniques, which included blending into thick layers of color, scraping back with a knife, blending and smudging with fingers and scratching in lines with a pointed paintbrush handle. The oil-paint shine that resulted can be seen in the surface reflection.

Simon Jennings
PORTRAIT OF A TULIP
Oil pastel on paper
23½ x 16½in (58.7 x 41cm)

49

CONTÉ CRAYONS

These crayons were invented by the Frenchman Nicolas-Jacques Conté, who was also responsible for inventing the modern lead pencil in the eighteenth century. Made from pigment and graphite bound together with gum and a little grease, conté crayons are similar to pastels in consistency and appearance, but are slightly harder and oilier. They are available in pencil form, and in the original form of square-section sticks about 3in (75mm) long.

SEE ALSO
Supports, page 34
Pastels, page 46
Accessories, page 59

TYPES AND COLORS

Conté crayons are similar in effect to charcoal, but because they are harder they can be used for rendering fine lines as well as broad tonal areas. Although conté crayons are now available in a wide range of colors, many artists still favor the restrained harmony of the traditional combination of black, white, grey and earth colors – sepia, sanguine (terracotta red) and bistre (cool brown). These colors impart a unique warmth and softness to a drawing, and are particularly appropriate to portraits and nude-figure studies. The traditional colors also lend to drawings an antique look, reminiscent of the chalk drawings of Leonardo da Vinci, Michelangelo, Rubens or Claude.

FINE AND BROAD STROKES

As with pastels, the most practical method of using conté crayons is to snap off small pieces about 1in (25mm) long. This way, you can rapidly block in tonal areas with the side of the stick and use a sharp corner at the end for drawing expressive lines.

BLENDING CONTÉ

Conté is soft enough to blend colors by rubbing them together with a finger, soft rag or paper blending stump. But because they are less powdery than chalk and charcoal, conté colors can be mixed by laying one color over another, so that the colors beneath show through.

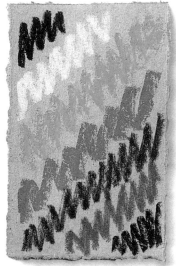

Traditional colors

Colored conté
There is now a wide range of conté colors available, in addition to the time-honored ones.

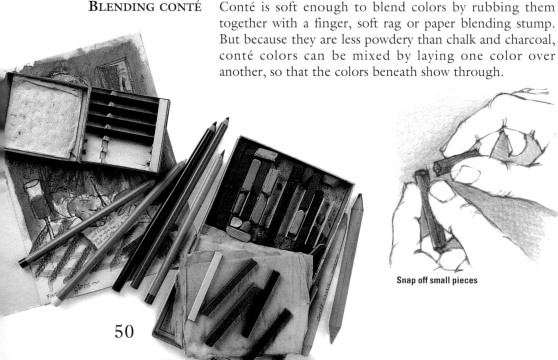

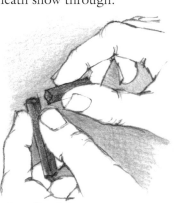

Snap off small pieces

Modern, pencil-form colors

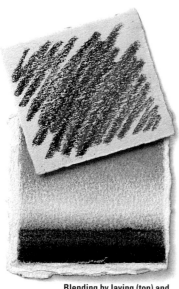

Blending by laying (top) and rubbing colors

Conté work

Like pastels, conté crayons are used to their best advantage on tinted paper with a textured surface, which brings out the distinctive qualities of the marks.

John Raynes skilfully uses white conté to capture the crisp highlights on his model's white shirt (middle).

The two drawings by Victor Ambrus (top and bottom) demonstrate the surprising range of textures that can be achieved by using only black or colored crayons on a cream-colored paper.

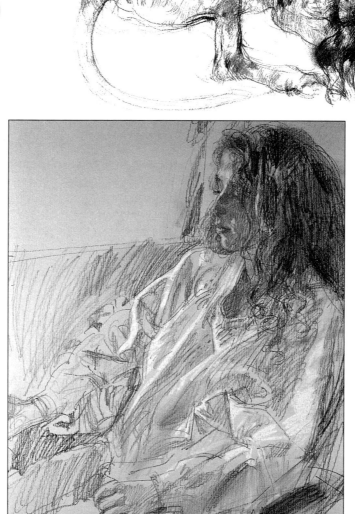

Victor Ambrus
DOROTHY'S DOG, LALLA
Black conté crayon on paper
30 x 22¼in (76 x 56.5cm)

John Raynes
PORTRAIT OF A GIRL
Colored and white conté crayon on tinted paper
20½ x 13½in (51 x 34cm)

Victor Ambrus
MORAG
Colored conté crayon on paper
22¼ x 30in (56.5 x 76cm)

51

PEN AND INK

Pen and ink is a delightful and flexible medium which has been popular with artists since ancient-Egyptian times. The medium is capable of an enormous range of techniques and effects, but the materials required are very simple. The choice available of drawing pens and nibs is large, but falls into two distinct categories: dip pens and refillable ink pens.

Ink for metal pens

Metal pens can be used with any type of ink – waterproof or water-soluble – because there is no mechanism to clog up. However, the nibs should be cleaned regularly under running water to prevent the ink from caking.

DIP PENS

Reed, quill and metal pens (metal nibs set into holders) are all classified as dip pens, as they are loaded by being dipped directly into the ink. The nib retains a small amount of ink, which is held in place by its own surface tension. Dip pens produce very expressive lines which swell and taper according to the amount of pressure applied to the pen.

Nibs

The nib itself is known as the "pen," and the main shaft is the "penholder." A great variety of nib shapes and sizes is available. Each nib makes a different range of marks, and the more flexible the nib, the more varied the thickness of line it makes. Since they are so inexpensive, it is worth trying several before buying.

Metal pens

Dip pens with metal nibs have long been the traditional tool of pen-and-ink artists and illustrators. Inexpensive and versatile, these pens consist of a holder and an interchangeable steel nib.

Mapping pens

Mapping pens have a very fine, straight point for detailed drawings. Because the metal nibs are flexible, you can vary the thickness of line to a considerable degree.

Crow-quill pens

Crow-quill pens (a type of mapping pen) also have a delicate point for producing detailed work, but can be less flexible than mapping pens.

Bamboo and reed pens

Bamboo and reed pens may have declined in popularity since the availability of more sophisticated pens, but many artists still use them. Their blunt, coarse and slightly irregular strokes make them ideal for bold line drawings, and their appeal often lies in the sheer pleasure that can be derived from drawing with such a "primitive" instrument.

Making a quill pen

Use a stout, round feather, preferably a goose feather. Trim the barbs back (**1**), to make the feather easier to hold when drawing. Shape the tip of the quill with a sharp knife. Make a curved, diagonal cut (**2**), then remove the keratin filling from the quill. Finally, make a single cut, running up from the tip of the quill, to make a channel for ink (**3**).

Quill pens

Quill pens are made from the wing feathers of birds such as geese, turkeys or swans. They are an ideal choice if you want to make fine, responsive lines. However, the nib is fragile, so this type of pen is best suited to small sketches and detailed drawings, rather than large-scale works.

REFILLABLE INK PENS

Refillable ink pens carry ink in a special holder or cartridge and need only to be refilled from time to time, but in general their nibs are less flexible than those of dip pens.

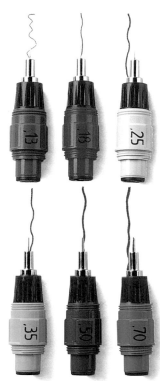

Fountain pens

Fountain pens feel much smoother to draw with than dip pens, and because they produce a steady flow of ink to the nib, they don't need to be dipped frequently. This makes them useful for impromptu sketching. However, since fountain-pen nibs have little flexibility, it is not easy to vary the thickness of your lines. The nib range is also quite limited.

Nib units for technical pens

For most drawings, you need only one holder and several nib units in different sizes.

Ink for fountain pens

To prevent them from clogging, most fountain pens require non-waterproof ink, drawn into the barrel by suction through the nib. An exception to this rule is Indian-ink pens, which are made specially for use with this type of ink and have a choice of two sketching nibs, graded "ordinary" and "bold."

Sketching pens

Also known as "art pens," these combine the expressive qualities of a dip pen with the convenience of a refillable ink pen. In appearance they resemble an ordinary fountain pen, but have flexible nibs designed specially for drawing, which deliver ink smoothly to the paper via a pre-filled ink cartridge.

Colored sketching-pen cartridges

Filler adaptors

"Art pens" also have a filler adaptor which enables you to fill them with a range of liquid colors.

Technical pens

Originally designed for use by professional illustrators and designers, technical pens deliver ink down a narrow tube instead of a nib. This produces a very even line of a specific and unvarying width, regardless of the direction in which the pen is moved. The fine, fragile strokes made by technical pens are appropriate for a controlled, graphic style of drawing. Like fountain pens, they are easily portable and contain their own supply of ink. But, unlike fountain pens, the ink flow is fine and even, and lasts much longer, so you no longer have to carry bottles of ink which can break, leak or spill. The narrow tubular nibs for technical pens, available in an increasing variety of point sizes, are inter-changeable within each range, and can be quickly switched.

Ink for technical pens

Technical pens should only be used with technical-pen inks. These are usually, though not always, lightfast, but are not waterproof. The ink supply is held in a reservoir and can be topped up with a dropper, or from a purpose-made filler bottle. The nibs should not be left uncovered, as the ink will dry in its channel, and they must be cleaned regularly with warm water. If the pens are not to be used for some time, they should be emptied and cleaned.

DRAWING INKS

For monochrome drawings, Indian ink is the favorite choice of many artists, as it is both permanent and waterproof. Sepia and blue-black inks also have their own appeal, and all can be diluted with water to produce a range of light-to-dark tones in one drawing.

SEE ALSO
Supports, page 34
Watercolor brushes, page 112

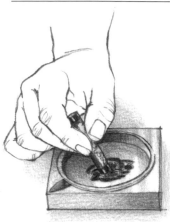

WATERPROOF COLORED INKS

Waterproof colored inks, also called artists' drawing inks, come in a range of about 20 colors. Waterproof inks are essential if you intend to apply a wash or tint on top of a line drawing, otherwise the linework will run. These inks are denser than non-waterproof varieties, drying to a slightly glossy finish that gives the work a precise, painted quality. Unfortunately, the shellac that is added to the ink to make it waterproof also makes it clog up easily, so be sure to clean brushes and pens thoroughly after use. Never use waterproof ink in fountain pens or technical pens.

Asian inks
Chinese and Japanese inks come in solid-stick form and are usually supplied with an ink stone. The ink stick is rubbed down on the stone, with a little water being added until it reaches the desired consistency.

NON-WATERPROOF COLORED INKS

These contain no shellac, and are primarily used for laying washes over waterproof-ink drawings. They are fine for line drawings, too, as long as you don't overlay them with washes. Non-waterproof inks sink into the paper more than waterproof types, and they dry to a matte finish.

• Restoring flow
If ink evaporates slightly while uncorked during a day's work, the color becomes deeper and the ink thicker. Adding a little distilled water will thin it again and restore an even flow.

SOLUBLE INKS

If you want the flexibility to be able to dissolve and blend lines, choose a soluble ink such as Chinese ink (see right), which is also more delicate than Indian ink.

• Permanence of inks
Only black and white inks are permanent. Colored inks consist of soluble dyes rather than pigments, and are not lightfast. To minimize fading, protect finished drawings from prolonged exposure to light.

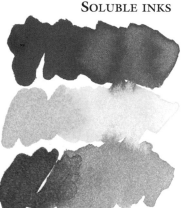

Diluting colored inks
Colored inks may be diluted with distilled water, not only to improve their flow, but also to produce a range of lighter tones. The inks can also be mixed with each other, but it is advisable to stick to the range of a single manufacturer, because brands of ink vary in consistency and in the surface finish they produce when dry. Pigment in ink settles at the bottom of a jar if left unused for some time, so the jar should be shaken before use.

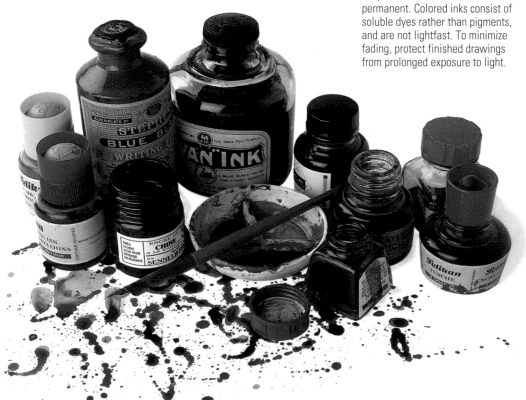

LINEWORK Pen-and-ink drawings are usually composed of lines; hatching, crosshatching, stippling, dots and dashes, spattering and scribbling are just some of the techniques which can be employed to convey form and volume, texture, light and shade.

FIRST STROKES Do not begin pen-and-ink work until you have tried drawing and practicing movement and line with a pen or a brush. Work on a smooth paper, and learn to use a minimum of pressure to get an even flow of ink from the nib on to the paper. If you are practicing with a dip pen, learn to judge when the ink will run out, so that you are not in the middle of a long unbroken line when it happens.

SPONTANEITY It is a great advantage to make a very light preliminary design with a soft pencil if you want an accurate pen-and-ink drawing, rather than a quick sketch. But once the technique of pen-and-ink drawing becomes more familiar, spontaneous free-flowing lines and observations translated instantly onto paper often make a far more exciting ink drawing than one which is premeditated. An ink drawing must be completely dry before preliminary pencil lines are erased or any washes added. Drying time is at least 12 hours, and even longer for a thick layer of ink.

"DO YOU REALIZE WHAT WILL HAPPEN TO YOU IF YOU PRACTICE DRAWING WITH A PEN? – THAT IT WILL MAKE YOU EXPERT, SKILLFUL AND CAPABLE OF MUCH DRAWING OUT OF YOUR OWN HEAD."

CENNINO D'ANDREA CENNINI
(*FL.* 14TH CENTURY)

Leslie Harris (1906-89)
PREPARATORY STUDIES
Ink and wash on paper
Various dimensions

Pen-and-ink work must be positive to look successful: once an ink mark has been made on paper, it is difficult (and sometimes impossible) to erase, so there is no room for hesitation. Ideally, you need to have had enough drawing practice to know exactly what you want to put down before you start.

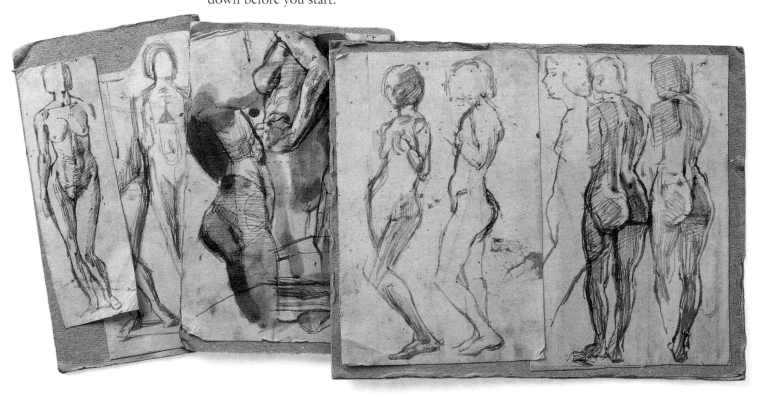

SEE ALSO
Supports, page 34
Watercolor brushes, page 112
Watercolor washes, page 120

• Line and wash

Line-and-wash drawings are highly expressive, suggesting more than is actually revealed. The secret is to work rapidly and intuitively, allowing the washes to flow over the "boundaries" of the drawn lines and not be constricted by them. The combination of crisp, finely drawn lines and fluid washes has great visual appeal, capturing the essence of the subject with economy and restraint. Line and wash also helps improve your drawing skills because it forces you to be selective and to develop a direct, fluid approach.

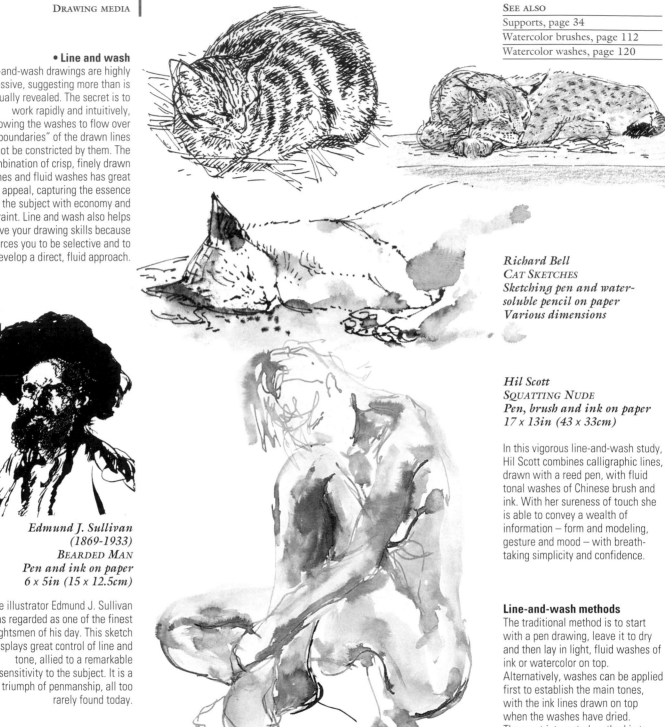

Richard Bell
CAT SKETCHES
Sketching pen and water-
soluble pencil on paper
Various dimensions

Hil Scott
SQUATTING NUDE
Pen, brush and ink on paper
17 x 13in (43 x 33cm)

In this vigorous line-and-wash study, Hil Scott combines calligraphic lines, drawn with a reed pen, with fluid tonal washes of Chinese brush and ink. With her sureness of touch she is able to convey a wealth of information – form and modeling, gesture and mood – with breath-taking simplicity and confidence.

Edmund J. Sullivan
(1869-1933)
BEARDED MAN
Pen and ink on paper
6 x 5in (15 x 12.5cm)

The illustrator Edmund J. Sullivan was regarded as one of the finest draughtsmen of his day. This sketch displays great control of line and tone, allied to a remarkable sensitivity to the subject. It is a triumph of penmanship, all too rarely found today.

Line-and-wash methods

The traditional method is to start with a pen drawing, leave it to dry and then lay in light, fluid washes of ink or watercolor on top. Alternatively, washes can be applied first to establish the main tones, with the ink lines drawn on top when the washes have dried. The most integrated method is to develop both line and tone together, so that they emerge as an organic whole. You might begin with a skeleton of lines, add some light tones, then some bolder lines and stronger tones, and so on until the drawing is complete.

PEN DRAWING Using the techniques mentioned earlier, you can create areas of tone, volume, texture and the illusion of light and shade with just pen and ink. Increase your options by adding washes of ink or watercolor – an exciting fusion of drawing and painting which allows you to build up experience of both disciplines.

BRUSH DRAWING

Brushes tend to be overlooked as instruments for drawing, as they are usually associated with painting techniques. Yet many great artists of the past – Rembrandt, Goya and Lorraine among them – produced some of their finest drawings with brush and ink.

Soft brushes

The brush is a very flexible drawing tool. A sable brush with a good point can, in a single stroke, convey line, rhythm, and even the play of light on a subject. It can change direction easily, twisting and rounding corners where a pen or pencil might falter. Sable and other soft-hair brushes are suitable for ink drawing; experiment with various types of brush on both smooth and textured papers, and compare the different marks they make.

Chinese brushes

Chinese bamboo-handle brushes, originally designed as a writing tool, are inexpensive, versatile and very expressive. The belly holds a lot of ink, and comes to a fine point for drawing rhythmic, flowing lines.

Gordon Hales
ON THE ESTUARY
Brush and ink on watercolor board
6 x 9in (15 x 22.5cm)

Richard Bell
CARRION CROWS
Pen and ink on paper
Various dimensions

Speed and fast attack are vital in capturing the telling gestures of a moving subject. Gordon Hales distilled the essentials of the scene with confident brushwork, using dilutions of ink to convey light and movement. Richard Bell sketched his subject with an expressive bamboo-pen outline, filled in with a dense black mass of ink.

57

MARKERS AND FIBER-TIP PENS

Though normally associated with the graphic designer's studio, pens with felt, fiber or plastic tips are now widely used by fine artists as well.

VERSATILITY

The large range of markers and fiber-tip pens available makes them extremely useful for rendering both free, spontaneous sketches and sophisticated, detailed drawings. Colored markers are especially convenient for outdoor sketching, because the colors are consistent and ready to use, and dry almost instantly.

Marker tips
These range from soft felt to hard tungsten carbide. Softer tips make smoother lines; hard ones keep their shape longer.

Fiber-tip markers are fairly firm and smooth-flowing, and come with tips of all shapes and in most sizes.

Plastic-tip markers are hard and durable. They are used for tips that make the finest lines.

Brush pens have resin tips. They are quite flexible and ideal for sketches and color washes.

Roller pens are extremely tough, keeping their shape well. They produce a smooth, fine line.

Tip shapes
Colored-marker tips vary from broad wedges to fine points.

Wedge-shape tips cover solid areas well. Drawing with the thin edge produces fairly fine lines.

Bullet-shape tips are appropriate for bold strokes and solid areas, as well as dots suitable for stippling.

Fine-point tips are similar to technical pens, in that they produce even, fine lines with little variation.

Gigol Atler
SKETCHBOOKS
Various markers on paper
6 x 4in (15 x 10cm)

Markers are ideal for on-the-spot sketching, giving a rapid impression of form, color and atmosphere.

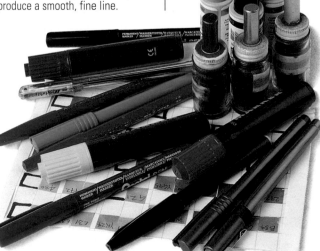

• Color permanence
Markers come in many colors, with intensity and permanence varying according to brand. Since marker colors consist of dyes and not pigments, they tend to fade in time or when exposed to strong sunlight. This doesn't matter for rough sketches, but for permanent artwork, make sure you buy a lightfast brand.

Solvent-based waterproof markers

Water-based soluble markers

Ordinary paper

Bleed-proof paper

Water, spirits and alcohol
Some markers contain water-based ink and are water-soluble; others contain spirit- or alcohol-based inks and are waterproof when dry. If you want to overlay colors, choose solvent-based markers, which are easily distinguished from water-based markers by their smell (alcohol-based ink has less odor than spirits). On a sketch pad, the colors may bleed through onto the next page, but you can buy marker pads in which the paper is formulated to resist color bleeding.

ACCESSORIES

One of the best things about drawing media is that you require very few accessories. The drawing aids described here are all easily purchased and inexpensive.

• Sharpening pencils
Pencil sharpeners are convenient, but sharpening with a craft knife or scalpel produces a longer, tapering cone that exposes enough lead for drawing broadly with the side.

ERASERS
Plastic or kneadable "putty" erasers are best; India rubber tends to smear and can damage the paper surface. These erasers are malleable; they can be broken off into smaller pieces and rolled to a point to reach details. You can also press the eraser onto the paper and lift off unwanted marks by pulling it away. Use it on soft graphite, charcoal or pastel drawings, both to erase and to create highlights.

PAPER BLENDING STUMPS
Paper stumps, also called torchons, are used for blending or shading charcoal, pastel or soft-graphite drawings. They are made of tightly rolled paper, with tapered ends for working on large areas, or a sharp point for small details.

KNIVES AND SHARPENERS
You will need a sharp craft knife or penknife for sharpening pencils and cutting paper. Knives or other blades are also very useful for sgraffito work – scratching lines into an oil-pastel drawing, for example, to create interesting textures.

DRAWING BOARD
You will need a firm support for drawing on sheets of loose paper. Drawing boards are available from art shops, but it is far less costly to get a good piece of smooth board, such as MDF, from a timber yard. If the board feels too hard, place a few extra sheets of paper under the top one to create a more yielding surface.

FIXATIVE
The best way to preserve drawings is to spray them with fixative, which binds the particles of pigment to the surface of the paper. Fixative is available in aerosol-spray form or mouth-type atomizers. Aerosol sprays give an even coat, and are the most convenient to use when covering a large area. An atomizer is a diffuser with a mouthpiece, which is placed in a bottle of fixative. Blowing through the atomizer distributes a fine spray of fixative onto the drawing. Atomizers are ideal for spraying small areas, but it takes practice to get used to them, and they need regular cleaning to prevent clogging.

Blowing fixative through an atomizer

Sharpening with sandpaper
Sandpaper blocks, consisting of small, tear-off sheets of sandpaper stapled together, are handy for putting fine points on graphite sticks, pastels, crayons and lengths of charcoal.

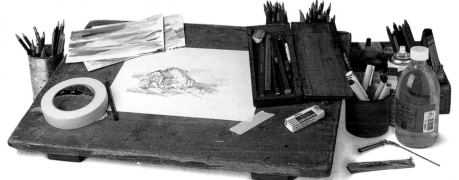

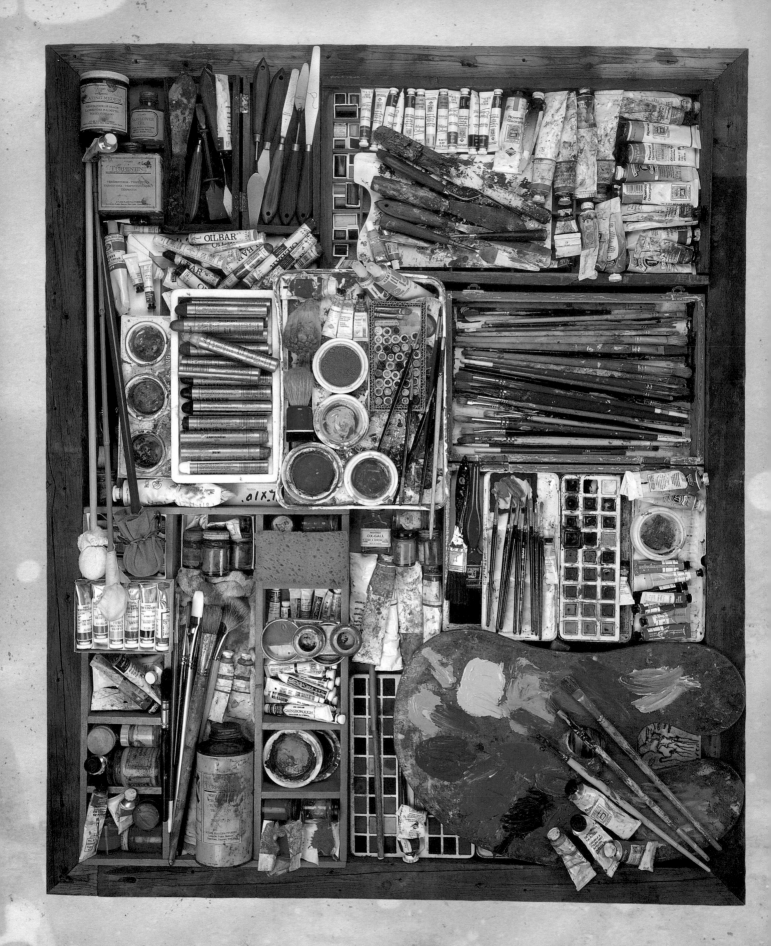

PAINTING MEDIA

PAINTING IS *a TACTILE as well as a VISUAL experience, and in all good pictures there is a fascinating* dialogue between the subject and the way the PAINT *itself is applied and manipulated to express that subject.*

Whether you prefer the delicacy of WATERCOLORS, *the richness of* OILS, *the versatility of* ACRYLICS, *the immediacy of* GOUACHE *or the intricacy of* TEMPERA, *the experience of working with a range of painting media will widen the scope of your artistic expression. Visit art-supply shops to stay in touch with what is new on the market, and* DON'T BE AFRAID TO EXPERIMENT WITH UN-FAMILIAR MATERIALS *and techniques from time to time.*

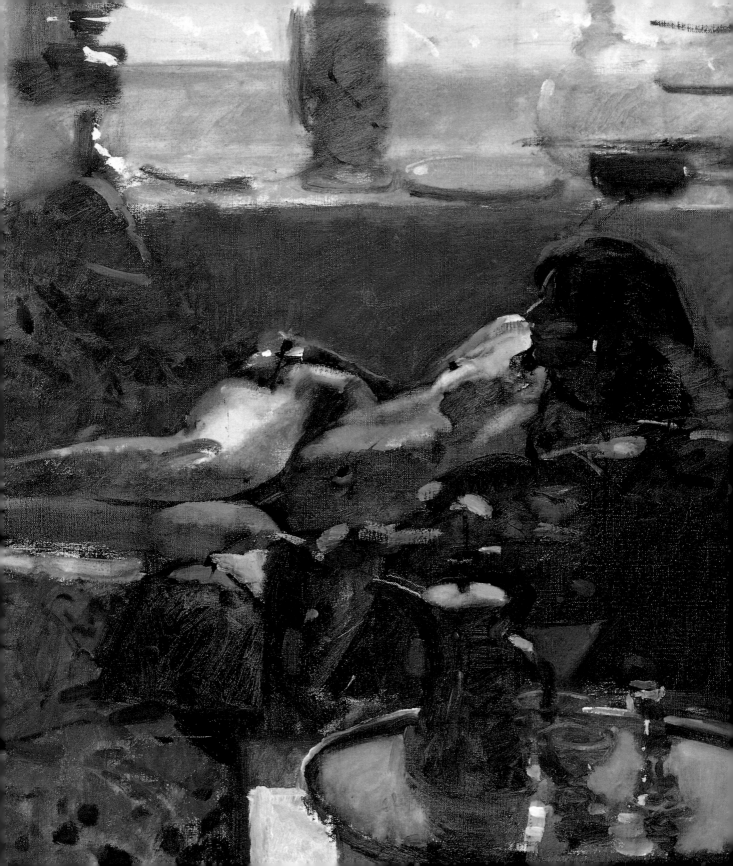

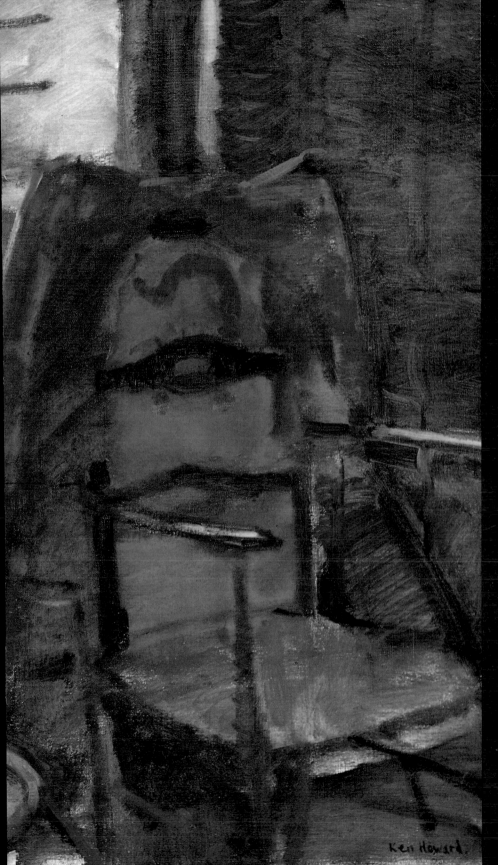

When OIL PAINT was first developed in the early Renaissance, it was hailed as "a most beautiful invention." Since then, oil paint has been the preferred medium of the majority of artists. The smooth, buttery consistency of oils, coupled with their slow drying time, means that they can be manipulated freely and extensively on the support to produce an infinite variety of textures and effects, from thin, transparent washes to thick, textured impastos.

Ken Howard
SARAH ALLONGÉE
Oil on canvas
24 x 48in (60 x 120cm)

PAINTS

Art shops stock an overwhelming range of paints, brushes, mediums, varnishes and assorted oil-painting paraphernalia. The equipment for painting in oils can be costly, but if you choose wisely and according to your own requirements, it need not be so. The basic essentials are 10 or 12 tubes of paint, a few bristle brushes, a bottle of thinners or prepared painting medium, a palette and a surface to paint on. The surface, or support, can be anything from a sheet of top-quality linen canvas to a piece of Masonite.

SEE ALSO
Supports, page 12
Binders, page 74
Mediums, page 76
Brushes, page 78
Pigments, page 108

Caring for your paints
Paints tend to solidify in the tube if left uncapped. Replace the cap once you have used the paint, and make sure the threads on cap and neck remain clean. Stuck caps can be opened with pliers, or by holding the tube under hot running water. As a last measure, stand the tube upside down in turpentine or mineral spirits for a few minutes, so that the cap and top of the tube are covered. Always squeeze a tube of paint from the bottom upwards, ensuring that there is as little air as possible inside the tube.

Avoiding waste
Oil paints are expensive. A palette knife held at an oblique angle and scraped along a finished tube will remove the last scrap of paint.

OIL-PAINT CONSTITUENTS

Oil paint consists of dry pigments ground in a natural drying oil such as linseed, or a semi-drying oil such as safflower or poppy. Some brands of oil paint are matured and then remade with more pigment to achieve the right consistency, but most are given additives, such as plasticizers, driers and wax, to improve flexibility and make them consistent in texture and drying speed. Stabilizers may also be added to keep the oil and pigment from separating in tubes during storage. Most manufacturers offer at least two grades of paint – artists', or first quality, and students', or sketching quality.

ARTISTS' COLORS

Artist-quality oil paints offer the widest range of colors and the greatest color strength. They contain a high concentration of pigment, very finely ground with the finest-quality oils.

STUDENTS' COLORS

Students' colors are cheaper than artists' colors, because they are made in larger quantities and the color range is more limited. The more expensive pigments, such as cadmiums and cobalts, are replaced with cheaper, but equally permanent, alternatives. These color names are suffixed with the word "hue." Students' colors may have lower pigment levels and contain small amounts of fillers, such as chalk, which slightly weaken the color strength of the paint.

A selection of students' oil paints

Combining paints
Students' colors are perfectly adequate for the beginner to practice with, and it is even possible to cut costs by combining the two types, using artists' paints for the pure, intense colors and students' paints for the earth colors, which are often just as good as in the artists' range. Some artists use students' colors for underpainting, before adding artists' paints for the final layers.

A selection of artists' oil paints

SIZE AND PRICE

Oil-paint tubes range from 0.17 fl. oz (5ml) to a generous 6.66 fl. oz (200ml). The most useful size is probably 1.25 fl. oz (37ml), and a larger tube of white – say 1.86 fl. oz (56ml) – works out to be more economical, since white is used more than most other colors.

Artist-quality paints vary in price according to the initial cost of the pigment. In some brands, they are classified according to "series," typically from 1 (the cheapest) to 7 (the most expensive). Earth colors are the least expensive, while cadmium colors will cost four times more. Some pigments, such as vermilion, are prohibitively expensive, and most manufacturers now replace them with modern synthetic pigments. Student-quality colors are sold at a uniform price.

An assortment of tube sizes

DRYING TIMES

The speed at which oil paint dries depends on the color. Some pigments act upon the drying oils in which they are bound, speeding up the drying process; others slow it down (see right). Earth pigments dry rapidly, acquiring a skin overnight, whereas alizarin crimson may need up to 10 days to become touch-dry.

To accommodate these extremes, some paint manufacturers add drying agents to the slower-drying pigments; others grind fast-drying pigments with slower-drying oils, to obtain a paint range with more consistent qualities. Others add no drying agents, allowing the artist to decide whether to use fast-drying mediums.

• Humidity and temperature
Both affect drying time, and thicker layers of paint naturally take longer to dry than thin layers.

Pigment strength
Note the contrast in tint between the two pigments on the left and those on the right, when they have all been mixed with the same amount of white.

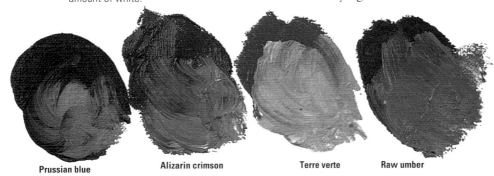

Prussian blue Alizarin crimson Terre verte Raw umber

TINTING STRENGTH

There is quite a variation in the tinting strength of different pigments. For example, Prussian blue and alizarin crimson will produce vivid colors when added in even very small quantities to white, whereas terre verte and raw umber become very pale when mixed with only a little white. When mixing a pale tint using strong color, always add it to the white and in very small quantities – otherwise, you may use up a great deal of paint for little result.

DIFFERENCES

Manufacturers do not formulate their paints in the same ways, so although colors in different brands may have the same names, their contents vary not only in the appearance of the color but also in cost, consistency, handling qualities, permanence and drying rates.

Drying speeds of oil paint
The following is a guide to approximate drying speeds of pigments bound in linseed oil. Drying rates may vary between brands, and colors bound with safflower or poppy oil are relatively slow-drying. When colors are mixed together, their drying rates may be altered.

Fast-drying
(approximately two days)

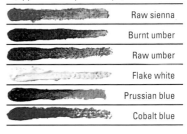

	Raw sienna
	Burnt umber
	Raw umber
	Flake white
	Prussian blue
	Cobalt blue

Medium-drying
(approximately five days)

	Mars colors
	Phthalocyanine colors
	Chrome colors
	Burnt sienna
	Cerulean blue
	Viridian
	Green earth
	Cobalt violet

Slow-drying
(five to eight days)

	Alizarin crimson
	Titanium white
	Zinc white
	Yellow ochre
	Ultramarine blue
	Cadmium colors
	Lamp black
	Ivory black

• Darkening
Oil paintings require a normal amount of daylight while drying. If a painting dries in a dark or dimly-lit room, the colors will darken. If this happens, the colors can be restored by exposing the picture to normal – not bright – daylight for a week.

WHICH WHITE?

The most important pigment in the oil painter's palette is white, because it is used more than any other color. It is therefore essential to use good-quality whites; even if you are using student-quality paints, it is worth buying a large tube of artist-quality white, as it has better covering power than the student grade.

Several whites are available, each with different properties, although as a general rule titanium white is the most reliable and versatile (see right).

Whites ground in poppy or safflower oil should not be used for priming or extensive underpainting. They are slow-drying, and can cause cracking of subsequent paint layers unless allowed to dry thoroughly. Use flake white, which is quick and thorough-drying, or one of the alkyd or underpainting whites.

SEE ALSO

Mixing colors, page 67
Basic palette, page 72
Underpainting, page 89
Pigments, page 108
Health & safety, page 244

Flake white
(also known as white lead or silver white) is a comparatively quick-drying, durable and flexible paint, widely used in underpainting. It accelerates the drying of colors mixed with it. Flake white lacks the opacity of titanium white and the whiteness of zinc white. It is harmful if swallowed, as it contains lead, so keep it out of the reach of children.

Titanium white
(also known as permanent white) is the whitest and most opaque white, which dries very slowly to a soft, chalky film. Its strong covering power is useful for mixing tints, and for highlights and final painting. It is classed as non-hazardous.

A selection of alkyd and water-friendly oil paints

ALKYD PAINTS

These are made from pigments bound in an oil-modified synthetic resin. They handle in the same way as traditional oil paints, but have the advantage of being much faster-drying – in normal use, the paint surface is generally dry within an hour. Alkyds may be mixed with oil paints, which has the effect of speeding up the oils' drying time and retarding that of the alkyds, so that all the colors dry at a fairly even rate. Any supports suitable for oil and acrylic paints may be used for alkyds, once primed with oil or acrylic primer.

WATER-FRIENDLY OIL PAINTS

The Grumbacher company has recently introduced a range of oil paints in which the linseed-oil binder has been modified to mix with, rather than repel, water. This does not affect the use of traditional oil-based mediums and diluents, but means that thinning paint and cleaning brushes can be done with water. Another advantage is that this eliminates the use of solvents, to which many people are allergic, and avoids a possible build-up of potentially dangerous vapors.

Zinc white
has a pure, cold-white appearance which does not darken with time. It is semi-opaque, and is suitable for tinting and glazing, but not for underpainting. Zinc white dries very slowly to a hard, brittle film. It is classed as non-hazardous.

MIXING OIL COLORS

Oil paint is expensive, but don't be sparing with it. Squeeze the paint out in generous mounds, otherwise you will be constantly unscrewing tube caps and mixing up fresh batches of paint, which can become a chore. Any paint left over at the end of the session can always be re-used in one way or another.

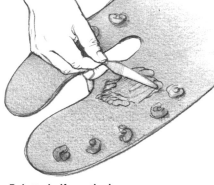

Palette-knife method
A palette knife is convenient for mixing large amounts of paint and avoids damaging your brushes. Use a scoop-and-slide action to mix the colors thoroughly.

KEEP COLORS CLEAN

Try to avoid using more than two or three colors in any one mixture. Any more than this, and the colors become lifeless and muddy. Always have a large jar of turpentine and a rag nearby, so that when you have finished with a particular color you can clean the brush or knife thoroughly and avoid contaminating the next color.

Mixing paint
Fully mixing two colors produces a solid third color (far right); partly mixing them allows the two original colors to still be part of the mixture (right).

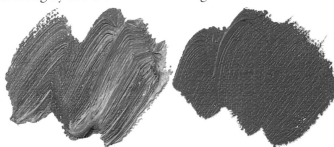

MIXING METHODS

When mixing oil paints on the palette, use either a brush or a palette knife. A knife is preferable for mixing large quantities of paint, and will certainly save a lot of wear and tear on your brushes. When working fast and mixing small quantities of color, however, a brush is more convenient. Old, worn brushes are useful for this purpose – never mix paint with sable brushes, as it quickly ruins them.

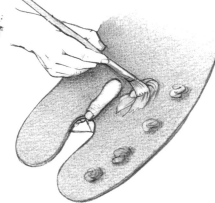

Brush method
When mixing paint with a brush, use gentle sweeping and rotary motions to minimize excessive wear and tear on the bristles.

ADDING DILUENTS

Mediums and diluents should be added to paint gradually, and in small amounts. Including an excess of thinning agent may result in an underbound paint film that is prone to flaking.

• **Reusing oil color**
Scrape paint off the palette with a knife and store in an airtight container for use next time round. Even "palette mud" (the dull color left when many colors have been mixed) can be useful – thin it down with turpentine and use it for tinting canvases and boards.
Paint which has been exposed on the palette for long periods will have begun to oxidize, and is therefore not stable enough for use. If paint feels gummy or requires a lot of thinners to make it workable, it should be discarded.

MAKING OIL PAINTS

SEE ALSO
Binders, page 74
Mediums, page 76
Health & safety, page 244

Until the nineteenth century, oil paints were made by hand in the artist's own studio. Since then, artists' colormen have perfected the manufacture of oil paints to such a degree that, in terms of quality and handling properties, they are considered far superior to those of hand-ground paints. However, home preparation of oil colors is a quite straight-forward process, and allows the artist complete control over the ingredients in the paint.

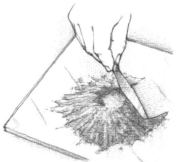

(1) Mix to a stiff paste with a palette knife.

HOME PREPARATION

It is much cheaper to buy the raw materials than the ready-made tube colors, and the larger art-supply stores carry a wide range of raw pigments from which you can mix colors to your specific requirements. Finally, there is undoubtedly a lot of satisfaction and pleasure to be gained from working with colors you have prepared yourself.

METHOD

Spoon a handful of powdered pigment onto the glass slab, and make a well in it. Pour in a spoonful of oil, and mix to a stiff paste with a palette knife (**1**). Ensure that all the pigment is thoroughly wetted, but try to use the minimum of oil to produce the stiffest workable paste. Too much oil may result in yellowing and wrinkling of the paint film.

Mulling
Grind the pigment-and-oil mixture on the slab with a glass muller, using reasonable pressure and a continuous, smooth, circular or figure-of-eight motion (**2**). Your weight should be well balanced over the muller. The aim is to disperse the pigment particles evenly through the binder and to achieve a smooth, glossy paint, free from grittiness. Be warned – mulling paint to the right consistency can take up to an hour, depending on the pigment! It is best to mull a small amount of pigment at a time, moving each freshly mulled batch to the edge of the slab.

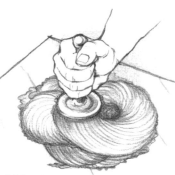

(2) Grind the pigment-and-oil mixture together with a smooth figure-of-eight motion.

Empty collapsible metal tubes

The paint should be stiff enough to be workable while containing the minimum of oil. If the paint doesn't "peak" when lifted with the tip of a palette knife, it probably contains too much oil; add more pigment and re-mull.

Using lightweight pigments
Pigments which are fluffy or flyaway, due to their light weight and fine particle size (for instance alizarin and the quinacridones), need wetting before they can be ground with oil. Saturate the pigment with mineral spirits until all the powder is wet, then leave to dry out a little on absorbent paper before mixing to a paste with oil.

Improving texture
Some pigments, such as ultramarine, viridian and zinc white, make a rather stringy paint. To improve the texture, use 4 parts linseed oil to 1 part poppy oil as a binder.

• Amounts of oil
Some pigments require quite a lot of oil to make a smooth paste – alizarin crimson, for example, needs far more than flake white.

Protective gloves

Filling the tubes

The freshly mulled paint can be stored in empty collapsible tubes obtainable from major art-supply stores. As a guide, roughly 10.6oz (300g) of paint should fill a 5 fl. oz (150ml) tube.

Loosen the cap of the tube a little so that air can escape as you fill it. Hold the tube upright and scoop the paint into the open end, using a palette knife (3). Fill the tube to within about 1in (25mm) of the open end, occasionally tapping the tube on the table to settle the pigment and disperse any air bubbles.

Pinch the tube 1¼ to 1½in (30 to 40mm) from the end to expel any air. Wipe the tube clean, then make a double fold at the end by folding it over the blade of a clean palette knife.

Label the tubes, and paint out a small swatch of each color onto canvas paper as a record for the future.

(3) Pack the freshly mulled paint in empty collapsible tubes. First loosen the cap of the tube a little so that air can escape. Hold the tube upright and fill from the open end with a palette knife (see left).

• Shelf life
Without any addition of stabilizers and preservatives, handmade paint should be used within a few months of making.

SAFETY PRECAUTIONS
**When handling dry pigments, wear a dust mask, to avoid breathing in pigment particles. Do not handle toxic pigments without mask and gloves. Disposable face masks are not adequate; respiratory masks designed for use with toxic dusts are available from major art-supply stores and safety-equipment companies.
Do not eat or drink when working with dry pigments, and keep all materials out of reach of children. Label all dry pigments so that they can be identified in case of accident.**

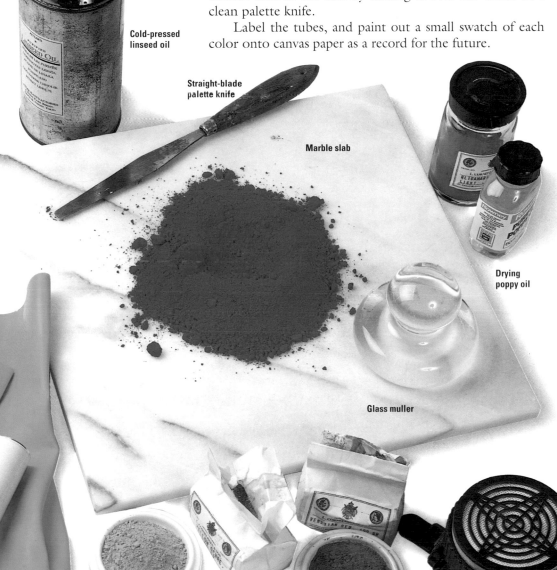

Cold-pressed linseed oil

Straight-blade palette knife

Marble slab

Drying poppy oil

Glass muller

Respirator

Powdered pigments

OIL-PAINT STICKS

A few manufacturers are now producing oil paints in stick form, which are fundamentally different from oil pastels or crayons. They are made by combining artist-quality pigments with highly refined drying oils, into which are blended special waxes which enable them to be molded into stick form.

SEE ALSO

Supports, page 12
Basic palette, page 72
Diluents, page 74
Mediums, page 75
Knife painting, page 96

Types of stick
The selection of oil-paint sticks shown here includes some of the iridescent colors available.

USING OIL-PAINT STICKS

Oil-paint sticks can be considered as either a drawing or a painting medium. They combine the richness of oil color with the freedom and directness of pastels or charcoal. The chunky sticks glide across the support, making expressive, flowing lines. Some brands are thixotropic – they become more creamy in texture when applied with slight pressure, and harden again on the support. The lightfastness rating is the same as for tube oil colors; the range of colors is smaller, but the basic oils palette is sufficient.

BLENDING AND BRUSHING

Different colors can be blended together on the support, using a brush or a painting knife. Alternatively, special colorless sticks are available: these aid the blending process and increase the transparency of the colors. The paint can also be brushed out on the support, using the same solvents and mediums employed with tube oil colors. The end of the stick may be dipped into the medium or solvent before working on the support, thereby improving the flow of color. You can even apply the paint in thickly impasted layers and model it with a paintbrush or knife. The paints remain workable for several hours.

COMPATIBILITY

Oil-paint sticks are compatible with a range of painting and drawing media, including conventional oil, alkyd and acrylic colors, oil pastels and pencil. They can be used on primed canvas or Masonite, acid-free sized paper, fabrics, and other surfaces.

• Outdoor uses
Sticks are particularly useful for painting outdoors, as they remove the need to carry some of the accessories associated with tube oil paints.

• Protective skin
An invisible, dry film forms on the surface of the stick, and helps to keep it clean when not in use. The film is removed from the tip of the stick by rubbing with a cloth, and reforms in a day or two after use to keep the paint from drying out while being stored.

First-time use
Brand-new sticks must have the film removed after the protective wrapper has been taken off.

• Different brands
As with tube oils, there are variations in texture, handling properties and drying rates between one brand of paint stick and another, so it is advisable to sample different brands. Do not mix different brands in the same painting, as the chemicals may be incompatible.

• Using diluents
You can work on a support that has been given a liberal wash of turpentine, or dip the tip of the oil stick into diluent or medium, to create a more liquid line.

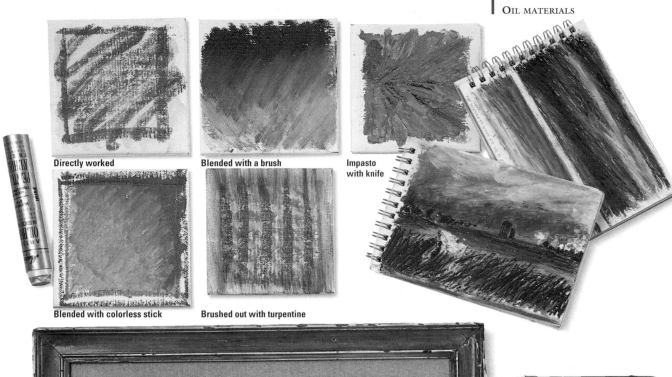

Directly worked

Blended with a brush

Impasto with knife

Blended with colorless stick

Brushed out with turpentine

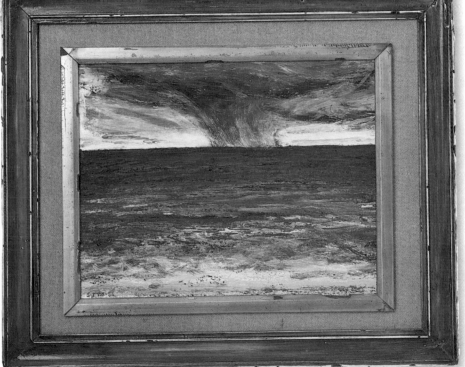

DRYING TIMES The actual drying time depends on temperature and the type of surface being painted, but on the whole, oil paint in stick form dries more quickly than tube oil paints. It is important to note, however, that paint sticks should not be used for underpainting if tube paint is to be applied on top. The reason is that although paint sticks dry faster than tube paints, they dry to a more flexible film, due to their high wax content; if less flexible paint is applied on top, this may lead eventually to cracking of the paint surface.

Oil-stick versatility
The five square-format examples (top left) show some basic oil-stick techniques. The two sketchbook paintings (top right) used oil sticks and oil pastels, brushed out with turpentine. The framed picture (bottom) was worked directly with oil sticks and then blended and brushed out with turpentine.

71

BASIC PALETTES

The twelve colors featured here form the "backbone" of most professional painters' palettes. This palette is versatile enough to cope with a wide range of subjects, and the colors are all lightfast.

• Variations
Pigments may vary in hue and in handling characteristics, according to manufacturer. This applies particularly to the earth colors – ochres, umbers and siennas – which are natural pigments and vary in hue according to source. Some burnt sienna, for example, is yellowish, while others have a reddish tint.

Titanium white
Permanence excellent (ASTM I). A very bright opaque white, with high tinting strength and slow drying time. Mixes well, and maintains its intensity.

Ultramarine blue (French ultramarine)
Permanence excellent (ASTM I). A transparent color, with high tinting strength, medium-to-slow drying time, and a deep, warm blue hue. The most versatile of the blues; mix with burnt umber to make interesting dark shades.

Cobalt blue
Permanence excellent (ASTM I). A transparent color, with weak tinting strength and a fast drying time. It is greener and paler than ultramarine. Useful for skies and for mixing greens; very expensive, but good for glazing.

Yellow ochre
Permanence excellent (ASTM I). A fairly opaque color, with weak tinting strength, medium-to-slow drying time, and a dark yellow hue verging on brown. Indispensable for landscape painting and for toning down mixtures.

Raw sienna
Permanence excellent (ASTM I). A transparent color, with weak tinting strength and fast-to-medium drying time. A warmer hue than yellow ochre. Mixes well, and is excellent for glazing.

Burnt sienna
Permanence excellent (ASTM I). A transparent color, with strong tinting strength, fast-to-medium drying time, and a rich, reddish-brown hue. It is useful for modifying sky colors, and is a good glazing color.

Permanent rose
Permanence excellent (ASTM I). A very transparent color, with very high tinting strength, slow drying time, and a bright pink-red hue with a violet tinge. It is a lightfast alternative to alizarin crimson; though expensive, a little goes a long way.

Viridian
Permanence excellent (ASTM I). A transparent color, with good tinting strength, slow drying time, and a bright, deep green hue with a bluish tinge. Mix with white to make cool greens.

Cadmium red
Permanence excellent (ASTM I). An opaque color, with good tinting strength, slow drying time, and a bright, warm red hue. A strong, pure pigment.

Cadmium yellow
Permanence excellent (ASTM I). An opaque color, with good tinting strength, slow drying time, and a warm hue with a hint of orange. Mix with cadmium red to form cadmium orange.

Lemon yellow
Permanence excellent (ASTM I). A transparent color, with good tinting strength, medium drying time, and a cool, pale yellow hue. Forms delicate, cool greens when mixed with blues.

Dioxazine violet
Permanence excellent (ASTM I). A transparent color, with high tinting strength, medium drying time, and a strong, warm hue. Very useful for modifying blues in skies, and for making greys with yellows, browns and greens.

The ASTM (American Society for Testing and Materials) codes for lightfastness:

ASTM I – excellent lightfastness
ASTM II – very good lightfastness
ASTM III – not sufficiently lightfast

Starter palette

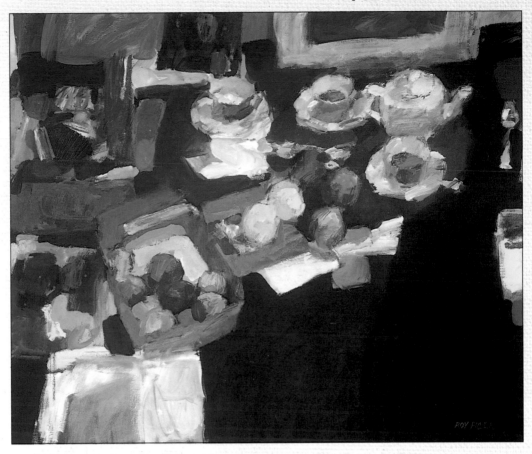

Roy Freer
BLUE PATHWAYS
Oil on canvas
40 x 48in (100 x 120cm)

Roy Freer's work uses rich, saturated hues; he sees his subjects in terms of color, rather than tone. This painting employs his "spectrum palette," consisting of lemon yellow, cadmium yellow, yellow ochre, cadmium orange, vermilion, rose madder, cobalt blue, cobalt violet and viridian.

Auxiliary colors

Should you wish to augment your basic palette with additional colors for particular subjects, you may find some of the colors shown here useful.

Auxiliary palette

Terre verte
Permanence excellent (ASTM I). A transparent color, with low tinting strength, medium-to-slow drying time, and a pale greenish-grey hue. An excellent green for landscapes, best applied in thin glazes.

Raw umber
Permanence excellent (ASTM I). A transparent color, with good tinting strength, fast drying time, and a greenish-brown hue. Raw umber is a useful color for underpainting, as it dries rapidly.

Phthalocyanine blue
Permanence excellent (ASTM I). A transparent color, with very high tinting strength, medium-to-slow drying time, and a very bright, deep-blue hue. More permanent and more intense than Prussian blue.

Alizarin crimson
Permanence very weak (ASTM III). A very transparent color, with high tinting strength, very slow drying time, and a cool, slightly bluish-red hue. Tends to fade in thin washes, or when mixed with white.

Ivory black
Permanence excellent (ASTM I). An opaque color, with good tinting strength, very slow drying time, and a slight brown tinge. Mixing ivory black with yellow makes a versatile green.

73

BINDERS

Binders, mediums and diluents are the various fluids which are either combined with the pigment at the manufacturing stage or added to the tube color to facilitate the application of paint to the support.

SEE ALSO

Making oil paints, page 68

Underpainting, page 89

Varnishes, page 238

BINDER COMPOSITION

Pigments for oil paints are ground into a drying vegetable oil, known as a vehicle or binder. When bound, the pigment particles are suspended in the oil and can be easily brushed onto the painting surface. When the oil has dried by absorbing oxygen, it seals the pigment to the surface.

LINSEED OIL

This oil, pressed from the seeds of the flax plant, comes in several forms, and acts both as a binder and as an ingredient in oil-painting mediums. Linseed oil dries quickly at first, but the complete drying process takes many years. It oxidizes into a tough, leathery film which hardens and becomes more transparent on aging.

POPPY AND SAFFLOWER OILS

These are semi-drying oils which are used to slow down the naturally fast drying times of some pigments. Paler than linseed oil, they are also used for grinding white and light colors, as they are less prone to yellowing.

• Cold-pressed linseed oil
The purest form of linseed oil is extracted cold from the seed and has a golden-yellow color. It maximizes wetting and dispersion of pigment particles during manufacture, and is less likely to become brittle with age.

• Refined linseed oil
Alkali-refined linseed oil wets pigment less easily than cold-pressed. Refined linseed oil is perfectly acceptable as a binder, however, and is significantly cheaper than cold-pressed oil.

• Sun-thickened linseed oil
Sun-thickened oil dries quickly, but is less flexible and more prone to yellowing than cold-pressed and refined oils.

Selection of binders
A typical assortment of binders that can be used for most oil-painting purposes.

Top shelf, from left to right:
cold-pressed linseed oil; purified linseed oil; sun-thickened linseed oil; assorted brushes; turpentine.

Bottom shelf, from left to right:
poppy oil; safflower oil; rags; low-odor thinners; mineral spirits.

• Oils for underpainting
Paints ground with poppy or safflower oil should not be used for underpainting, because they are so slow to dry and are prone to cracking. Drying poppy oil, however, is faster-drying and safe to use for this purpose.

SEE ALSO

Water-friendly oil paints, page 66

Mediums, page 76

Health & safety, page 244

DILUENTS

Diluents, or "thinners," are liquids used to thin down paints to aid their application to the support. They may be used alone, or mixed with oils and varnishes to create mediums for specific purposes. They all evaporate quickly on exposure to air, and they do not alter the characteristics of the paint.

• Disposing of solvents

It is illegal to dispose of solvents by pouring them down a sink, toilet or outside drain. They should be taken to a garage for disposal by specialist waste-disposal companies.

RECTIFIED TURPENTINE

Always use double-distilled or rectified turpentine for painting purposes. Ordinary household turpentine, sold in hardware shops, is not suitable, because it leaves a gummy residue which yellows badly and leaves the paint sticky and non-drying. Turpentine evaporates from paint mixtures at a relatively slow rate, and gives a more viscous mix than mineral spirits.

MINERAL SPIRITS

This refined petroleum spirit dries more quickly than either form of turpentine. Mineral spirits is now becoming more popular than turpentine as a diluent, as it has several advantages: it is less harmful, it does not deteriorate in storage, its smell is less pronounced than that of turpentine, and it is much cheaper. In the past, mineral spirits had a tendency to cause a white bloom on the surface of oil paintings, but with improved formulation this problem has now been eradicated.

• Odorless thinners

Some manufacturers offer low-odor paint thinners as an alternative to mineral spirits. They have the same evaporation rate as turpentine, but do not deteriorate in storage, and have low flammability.

• Storing turpentine

Turpentine thickens and discolors on exposure to air and light, and should be stored in closed metal cans or dark glass bottles filled to the top. Avoid long-term storage.

• Using diluents safely

Turpentine has a characteristic strong smell, and is the most harmful of oil-color solvents. If it irritates your skin or gives you a headache, use mineral spirits. Even small quantities of solvents and thinners can be hazardous if not used with care, because their fumes are rapidly absorbed through the lungs. Many solvents can also be absorbed through the skin. When using solvents, avoid inhalation, and use in a well-ventilated room. Wear rubber gloves or a barrier cream, and do not eat, drink or smoke in the studio.

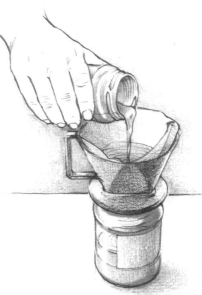

Recycling solvents

Dirty solvents can be filtered and re-used. Leave the used solvent to stand for a few hours, to allow the pigment to settle. Pour the liquid into a clean jar through a coffee filter paper, taking care not to disturb the sediment. Leave to stand again, to allow pigment that may have passed through the filter to settle, then transfer to another clean jar. Repeat the process if necessary.

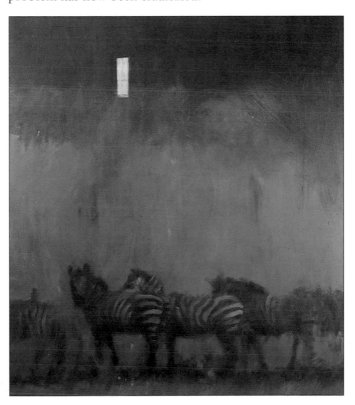

Keith Roberts
WINDOWS
Oil on canvas
60 x 48in (150 x 120cm)
New Academy Gallery, London

This artist intentionally keeps his paintings in a state of flux up to the last moment. Here, the overall tonality is established by a loose but vigorous underpainting of thin paint diluted with turpentine. In the further layers, which are scrubbed on quickly, Roberts mixes the paint with a medium of turpentine, linseed oil and damar varnish.

MEDIUMS

Oil paint used straight from the tube, or diluted with thinners, produces the most stable paint film. However, various drying oils, resins, waxes and diluents, used alone or in combination, allow the artist to alter or enhance the characteristics of the tube color.

SEE ALSO

Diluents, page 75

Avoiding problems, page 87

Glazing, page 92

Impasto, page 94

PREPARED PAINTING MEDIUMS

Manufactured mediums

In the past, it was general practice for artists to mix their own mediums for painting, particularly since they ground and mixed their own pigments as well. Today, almost everything we buy comes pre-packaged for our convenience, and painting mediums are no exception.

Most manufacturers offer several types of medium, some based on traditional recipes, others the result of modern laboratory research. Depending on the ingredients used, these mediums are variously formulated to improve the flow of the paint, alter its consistency, and produce either a matte or a gloss finish. Some are slow-drying; others contain agents to speed up the drying rate.

Bear in mind that prepared painting mediums are not standardized; different brands of glaze medium, for example, may vary in their formulation. Reputable manufacturers include technical notes on the contents and uses for specific painting mediums in their catalogs.

• Using linseed oil

It is not advisable to use linseed oil undiluted, as there is a risk that the paint layer may wrinkle. In addition, the paint becomes so "fat" that it is difficult to apply and dries slowly.

• Using mediums

Mediums are additives and should be kept to a minimum within your technique, as an excess may be detrimental to the paint film. When applying paint in layers and using mediums and diluents, observe the golden rule of oil painting and work "fat-over-lean," using less oil in the lower layers than the upper ones.

William Nicholson (1872-1949)
WHITE TULIPS, 1912
Oil on canvas
24 x 21½in (60 x 53.7cm)
Browse and Darby Gallery, London

Whereas paint diluted with turpentine has a fairly dry, matte appearance, the addition of a painting medium adds a richness and lustre to the paint surface. This beautiful study is reminiscent of the seventeenth-century Dutch school of still-life painting in its use of rich, creamy paint, softly blended forms and lustrous glazes.

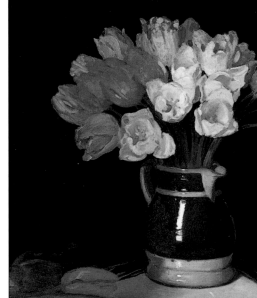

Alkyd mediums

Alkyd is a translucent, synthetic resin which has been oil-modified to make it suitable as a paint medium. Good-quality alkyd mediums speed the drying process and form a flexible, virtually non-yellowing film. They come in various consistencies, from a liquid gel suitable for glazing and subtle blending, to a stiff gel specifically for impasto and texture work. Alkyd mediums may be thinned with turpentine or mineral spirits.

SEE ALSO
Glazing, page 92
Impasto, page 94

MAKING MEDIUMS

Some artists mix their own mediums because it is an economical process. It also gives them more control over the ingredients employed, which can be obtained from most art-supply stores.

TURPENTINE MEDIUM

The most commonly used medium is a slow-drying mixture of refined linseed oil and mineral spirits or distilled turpentine. The two liquids are poured into separate containers so that the artist can add more oil as paint layers are built up. The normal proportions are 1 part oil to at least 2 parts diluent, with increasing amounts of oil added in the final layers, to a maximum of 50 percent oil.

GLAZE MEDIUM (RESIN-OIL MEDIUM)

This gives clarity and brilliance to glazes. It uses stand oil, a thick, viscous form of linseed oil which dries slowly (five days or more in a thin layer), levels out well and dries to a durable, elastic film that yellows less than linseed oil.

Method

Mix 1 part stand oil and 1 part damar varnish (see right), then add 5 parts turpentine. Stir each time it is used. If a more viscid medium is required, use less turpentine.

BEESWAX MEDIUM

This makes oil paints go further, and provides a thick texture suitable for impasto. Use purified beeswax with a natural color; refined, bleached beeswax yellows with age.

Method

Melt 3½ oz (100g) beeswax in a double boiler (or two cans as shown below) over low heat; do not overheat. Remove from heat, add 3 fl. oz (85ml) rectified turpentine, and stir. Leave to cool and solidify, then store in a sealed jar.

Making damar varnish
This varnish imparts a rich, glassy effect to glazes. Because it is resoluble, do not use it straight, but cut with stand oil and solvent. Ready-prepared damar varnish is available, but you can make your own, using small lumps of damar resin. Crush the resin, place it in a muslin bag and suspend it for two or three days in a jar of turpentine (use 1 part by measure of crushed resin to 4 parts of turpentine). When the resin has dissolved, strain the varnish again through a clean muslin bag, and it is ready for use.

Medium-making materials
The selection of materials shown here will enable you to make the mediums described.

Clockwise from top left:
clean cans; linseed oil; turpentine; beeswax; glaze oil; ready-made stand oil; home-made damar varnish.

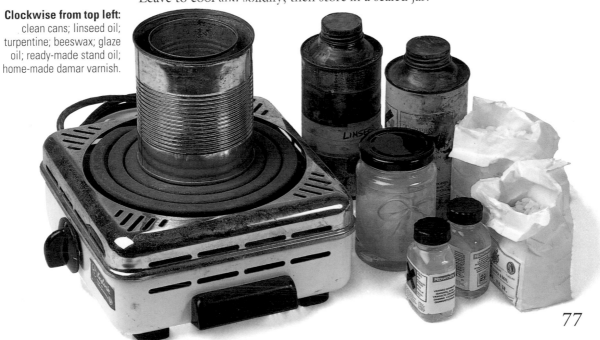

BRUSHES

Oil painting requires responsive brushes that are durable enough to withstand both repeated scrubbing against the canvas, and the effects of solvents used in cleaning. Best-quality brushes are always worth the extra expense, as they hold the paint well and produce a more satisfying mark than cheaper brushes. They also retain their working edge far longer and quickly spring back to their original shape after use.

SEE ALSO
Brush shapes, page 80
Watercolor brushes, page 112

Testing a bristle brush
Press and draw a new brush firmly against a flat surface. The ferrule end of the bristles should not bend too close to the edge of the ferrule.

BUYING BRUSHES

When buying brushes, check that the brush hair is firmly attached inside the ferrule; if there is too big a gap between the hair and the inside of the ferrule, paint can get lodged in the space and make cleaning more difficult. There should be no loose or splayed hairs, and the handle should be balanced to feel comfortable in use.

BRISTLE BRUSHES

Hard-wearing, tough and springy, bristle brushes are particularly suitable for oil painting, as they can cope with the thick, heavy texture of the paint and are robust enough to be worked against the textured surface of canvas. Each strand of a hog-bristle brush splits into several microscopic points, called "flags," at its tip; these help hold the paint to the brush.

Bristle brushes are excellent for ladling on the paint and moving it around on the surface, and for applying thick dabs of color in which the brushmarks remain visible, adding interest to the surface of the painting. When properly cared for, these brushes can actually improve with age, as they soften and become more responsive after a period of use.

• Fitch brushes
On lower-grade bristle brushes the brush head is shaped by cutting and trimming the bristle ends, thus losing the flags, so the brush has less shape and holds less color. These are called "fitch" brushes, and they are perfectly adequate for blocking in large areas of color in the initial stages.

Hog bristle
The majority of brushes used in oil painting are made from hog bristle. The finest bristle comes from the Chunking region of China, and is hand-picked from a narrow strip on either side of the hog's spine.

SABLE BRUSHES

Sable brushes are soft and springy, similar to those used in watercolor painting, but with longer handles. Soft-hair brushes are not vital in oil painting, but they are useful for painting fine details in the final layers of a painting and for applying thinly diluted color. Sable brushes are expensive, however, and for oil painting some artists find synthetic brushes quite acceptable.

Brights
With shorter, stiffer bristles than those on flats, brights are mostly used for textural effects, such as applying heavy impasto or for scraping off wet paint to reveal the layer beneath.

Household brushes
Good-quality decorators' brushes can be used for several tasks other than applying paint. Use wide brushes for applying glue size to stretched canvas, and narrower ones for priming the support.

Fan blenders
These brushes produce a beautiful, "feathered" brushstroke, and produce a crisp line when used edge-on. Dab the brush on and off the canvas to produce unusual textures.

SYNTHETIC BRUSHES

Both soft and stiff-hair types of synthetic brush have been considerably improved in recent years, and make an economical alternative to natural-hair brushes. The most recent development in synthetic-hair brushes is the introduction of interlocking fibers which mimic the make-up of natural hog bristles, giving them better paint-holding capacity than the nylon filaments formerly used. Synthetic brushes are easily cleaned and can withstand repeated scrubbing against the canvas, but the cheaper ones tend to lose their shape more quickly than natural-hair brushes.

Bristle
The best bristles have split ends, known as "flags." These give a softness to the very end of the brush and help the bristles to hold plenty of paint.

Ferrule
This holds the bristles together and shapes them into rounds, riggers, filberts, flats and fan blenders. Good-quality ferrules are firmly crimped onto the handle.

Flats and filberts
Flats are good general-purpose brushes, especially useful for washes and painting in large areas. The softer filberts help soften edges. Both types also produce very fine lines when turned on their edges.

Rounds
Rounds are very versatile; they can be used for soft strokes in basic underpainting, covering large areas, rapid scumbling and impasto, and painting in fine details.

Large soft-bristle brushes
These are at their best when making long brushstrokes, and in applying thin glazes. The large tips are balanced by heavy handles.

Handle
The length of an oil-brush handle allows the artist to work at a distance from the canvas, and helps to balance the weight of the ferrule and tip. The size, series and type of brush are usually embossed on the handle. There may also be a description of the hair used.
Handles are often painted and varnished; this is mainly for cosmetic reasons, and plays little part in protecting the wood, despite manufacturers' claims to the contrary.

Soft-hair brushes
Many artists like to use these as well as bristle brushes, for delicate parts of a painting. Never use them to mix paint. The large brush has wolf hair, the smaller ones, sable.

79

BRUSH SHAPES

Brushes for oil painting come in a wide range of sizes and shapes. Each is designed to make a different kind of mark, but some are more versatile than others. Selecting a brush depends on the effects you wish to achieve, and with experience you will discover which ones are best suited to your own painting style. Rounds and flats are the most useful and versatile to begin with; brights and filberts can be added later.

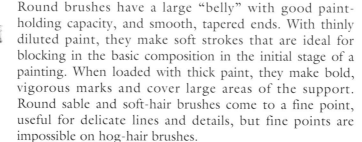

ROUND BRUSHES

Round brushes have a large "belly" with good paint-holding capacity, and smooth, tapered ends. With thinly diluted paint, they make soft strokes that are ideal for blocking in the basic composition in the initial stage of a painting. When loaded with thick paint, they make bold, vigorous marks and cover large areas of the support. Round sable and soft-hair brushes come to a fine point, useful for delicate lines and details, but fine points are impossible on hog-hair brushes.

FLAT BRUSHES

Long flat brushes have square ends and long bristles that are flexible and hold a lot of paint. Used flat, they make long, fluid strokes, and are useful for filling in large areas and for blending. Using the edge or tip of the brush, they make fine lines and small touches.

Brush sizes
Most types of oil-painting brush come in a range of sizes, from 000000 (the smallest) to around 24 (the largest). Brush sizes are not standard between manufacturers worldwide, and there is no relationship between sizes in sable or soft hair and sizes in bristle. The width of the handle is proportional to the size of the brush head, so that the handle of a bigger brush is thicker. The characteristic handle shape, with the wood thickening just below the ferrule, is designed to keep the wet hairs of separate brushes from touching when you are holding more than one brush.

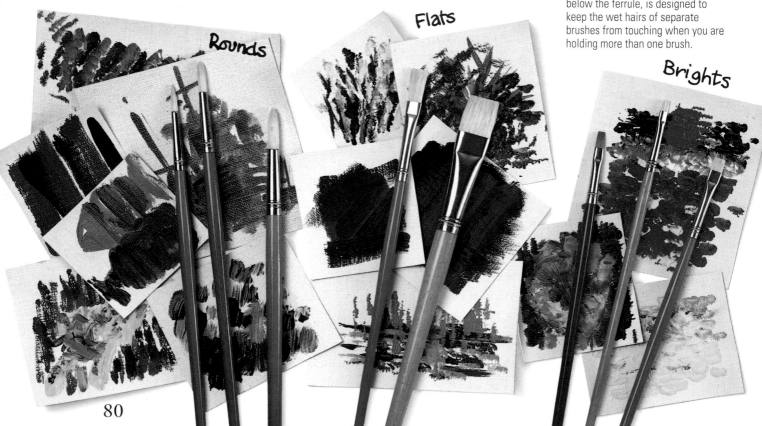

Rounds

Flats

Brights

BRIGHTS

Short flat brushes are often referred to as "brights." They are the same shape as long flats, but with shorter, stiffer bristles that dig deeper into the paint and leave strongly textured, rectangular marks. They are useful for applying thick, heavy paint to produce impasto effects. Because of their shorter bristles, brights are easier to control, making them better than long flats for painting details.

FILBERTS

Filberts are a compromise between flat and round brushes, being shaped to a slight curve at the tip to produce soft, tapered strokes. The curved tip allows you to control the brush well, and is useful for fusing and softening edges.

FAN BLENDERS

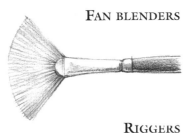

Fan blenders are available in sable, synthetic, badger hair and hog bristle. Where a smooth, highly finished result is required, fan blenders are used to feather wet paint to soften brushstrokes and to effect smooth gradations of tone. Fan blenders are particularly useful for painting soft edges on clouds.

RIGGERS

Riggers, named after their original use in executing the fine detail of rigging on marine paintings, have very long, flexible hairs. These carry a good amount of paint in their belly, yet come to a very fine point for painting long, thin lines. They are available in sable, ox or synthetic hair.

"ONE DAY A FEW HAIRS CAME OUT OF MY BRUSH AND GOT STUCK ON THE PICTURE. I THEN PAINTED A BIRD'S NEST."

PABLO PICASSO (1881-1973)

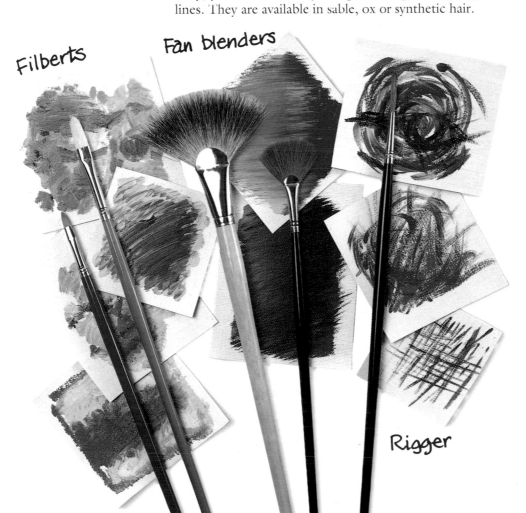

Filberts

Fan blenders

Rigger

Household brushes
Decorators' brushes are inexpensive, hard-wearing and extremely useful for applying broad washes of color in the preliminary stages of a large-scale painting. Good-quality brushes, although more expensive, will not shed hairs as readily as cheap ones. Shaving brushes are a reasonable alternative to using soft blending brushes.

SELECTING OIL BRUSHES

The number of brushes you use and their sizes will depend on the scale and style of your paintings. One artist may use a dozen or more brushes, but another may be perfectly happy with just a few. As a rule, having a good selection of brushes makes the work easier, because you spend less time cleaning them between colors. If you can keep, say, one brush for light colors and another for dark colors, your mixtures are more likely to stay fresh and unsullied.

STARTER SELECTION

In general, it is better to start with medium-to-large brushes as they cover large areas quickly, but their tips can also be employed for small touches. Requirements differ, but a useful selection of brushes to start with might include the following in hog bristle: a No. 10 long flat for roughing in and applying toned grounds; long flats and rounds in Nos 6, 4 and 2; and possibly a No. 4 synthetic soft-hair brush for smooth areas and details. As you become more experienced, you may add filberts and brights to this list and increase the range of sizes you use.

Choosing brushes
A recommended starter selection includes long flats and rounds, and a synthetic soft-hair brush.

MAKING AN EXTENDED PAINTBRUSH

When painting at the easel, especially with a large-scale work, it is important to be able to stand back from the picture so that you can see the whole as well as the details.

Paintbrushes with extra-long handles don't seem to exist, but artists are an inventive bunch, and you can make your own with a few simple tools. Working with a long-handled brush takes a little getting used to at first, but it gives greater freedom of movement to your painting arm and encourages lively brushstrokes.

In the method shown on the right, the brush is joined to the handle of an old, worn brush which would otherwise be thrown away. The handle of the brush to be attached should be slightly smaller in circumference than that of the old brush, because it is pushed into a hole drilled into the wood of the old brush handle.

Joan Miró (1893-1983) using an extended paintbrush

Making an extended brush

1 Use a sharp craft knife to cut the bristles off the old brush.

2 Grip the brush in the jaws of a metal vise. Using a hand drill, slowly drill down through the opening of the ferrule and into the thick part of the wooden handle.

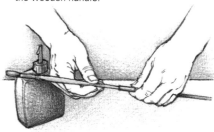

3 Drip some wood glue into the hole and around the end of the new brush handle. Push the end of the new brush firmly into the hole. Wait until the glue has set.

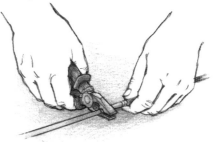

4 With a pair of pliers, squeeze and crimp the ferrule of the old brush around the new brush handle. Bind the join tightly with insulating tape.

MAINTAINING BRUSHES

Oil-painting brushes should be thoroughly cleaned after each session. This is especially important when using sable or other soft-hair brushes. Never leave a brush soaking with the bristles touching the bottom of the container.

CLEANING BRUSHES

To clean a brush, first clean off the residue of paint with a rag or paper towel. Rinse in turpentine or mineral spirits, and wipe with a rag. Then clean the bristles with mild soap and lukewarm running water, rubbing the brush around gently in the palm of your hand to work up a lather. It is essential to remove all the paint that has accumulated at the neck of the ferrule. If paint hardens here, the bristles will splay out. Rinse the brush and repeat the soaping until no trace of pigment appears in the lather.

Give the brush a final rinse, then shake it out and smooth it into shape with the fingers. Leave it to dry naturally, head upwards.

STORING BRUSHES

Always make sure brushes are dry before storing them in a closed container, or they may develop mildew. Moths are attracted to sable, so once the brushes are dry, store them in boxes and use mothballs for extra protection.

AN ECONOMICAL BRUSH WASHER

When cleaning brushes, jars of solvent quickly become dirty and need changing. It is illegal, however, to dispose of solvents such as turpentine and mineral spirits by pouring them down the sink, or even an outside drain. In any case, waste can be avoided by re-using the solvents.

You will need two jars with lids. Clean the brushes in solvent in the first jar, and screw on the lid. By the next day most of the pigment in the solvent will have settled to the bottom of the jar; you can then carefully decant the clear solvent into the second jar, ready to be used again.

Brush washers
These metal containers come in various sizes, and have a coiled handle for keeping brushes suspended in the cleaning agent during soaking. This prevents the bristle tips from being pressed against the bottom of the container.

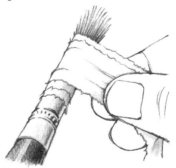

Reshaping brushes
If brushes are beginning to splay out after prolonged use, wrap the bristles with toilet paper while they are still wet; as the paper dries it contracts and pulls the bristles back into shape.

HEALTH AND SAFETY
Wear protective gloves when cleaning palettes and brushes. Avoid prolonged skin contact with potentially hazardous paints, such as flake white and the cadmium colors.

Brush wipes
An old telephone directory is handy for wiping excess paint off your brushes before cleaning. Simply wipe the brush across a page, then tear it off and throw it away, leaving the next page ready for use.

83

PALETTES

Palettes come in a variety of shapes, sizes and materials, designed to suit the artist's individual requirements. A large palette is better than a small one, because you need plenty of space for mixing variations of color. A palette measuring approximately 14 x 18in (36 x 46cm) is a good size, allowing the colors to be well spaced around the edge and leaving plenty of room in the center for mixing colors.

Manufactured palettes
A selection of commercially made palettes suitable for use with oil paints.

Clockwise from left:
large solid-wood kidney-shaped; two medium melamine oblong; medium melamine recessed; two melamine recessed; small ceramic oblong; medium solid-wood oblong.

CHOOSING — Where possible, it is helpful to choose a palette which approximates the color of the ground you are working on, so that you get an accurate idea of how the colors will look on the painting itself. For example, choose a wooden palette if working on a red/brown ground, and a white one if working on a white ground.

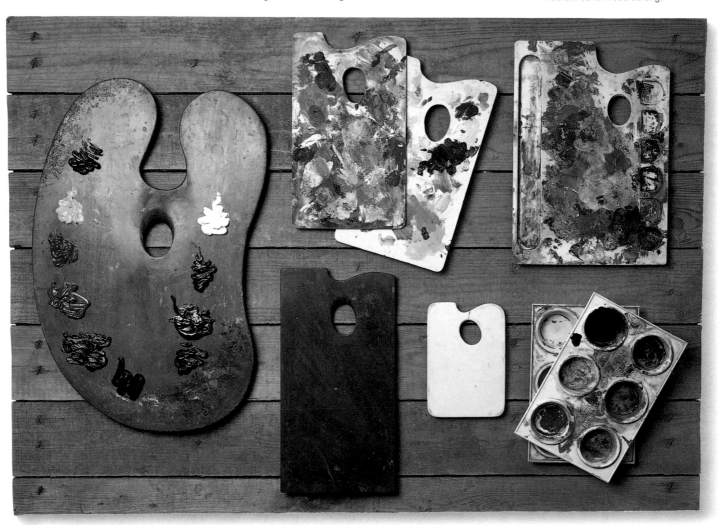

PREPARING WOODEN PALETTES

Before they are used for the first time, wooden palettes should be treated by rubbing with linseed oil. This seals the wood and prevents it from sucking oil from the paint, causing it to dry out too quickly on the palette. It also makes the surface easier to clean after use. Rub a generous coating of linseed oil into both sides of the palette and leave it for several days until the oil has hardened and fully penetrated the wood grain.

TYPES OF PALETTE

Plywood or melamine palettes are economically priced, while those made of mahogany veneer look wonderful and feel very comfortable, but cost a lot more. Before investing in a palette, try several for comfort; the better ones are balanced and tire your arm less.

Disposable palette

Thumbhole palettes
Thumbhole palettes are designed to be held in the hand while painting at the easel. They have a thumbhole and indentation for the fingers, and the palette is supported on the forearm. They are available in a range of sizes, either rectangular (called "oblong"), oval or kidney-shaped.

Recessed palettes
Recessed palettes are available in china, plastic and aluminum, and are used for mixing thin dilutions of paint.

Disposable palettes
Made of oil-proof paper, disposable palettes are useful for outdoor work, and remove the necessity for cleaning a palette after painting. They are sold in pads with tear-off sheets; some have a thumbhole.

Cleaning the palette
If resuming painting within a day or two, cover the squeezes of paint with plastic wrap or foil to keep them moist, otherwise discard them. At the end of each session, scrape off the excess paint onto newspaper with a knife. Wipe any diluent or medium left in the dipper over the palette with a rag until clean.

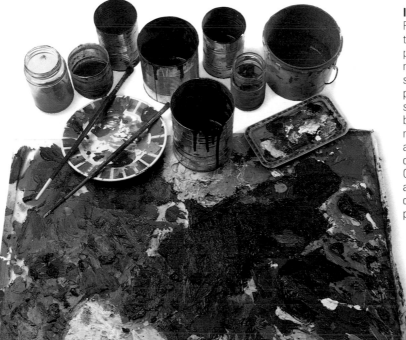

Improvised palettes
For studio work, many artists prefer to use a "home-made," table-top palette, which can be rested on a nearby surface and can be of any size or color. Any smooth, non-porous material is suitable, such as a sheet of white laminate or melamine board, a glass slab with white or neutral-colored paper underneath, or a sheet of Masonite sealed with a coat of paint.
Old cups, jars and cans are perfectly adequate for mixing, and can be covered with plastic film to stop the paint drying between sessions.

ACCESSORIES

Painting in oils can be a messy business, so the most essential accessories are large jars or tins to hold solvents for cleaning brushes, and a plentiful supply of cotton rags and newspaper. The following items are not essential, but some, such as palette knives, are certainly useful.

Accessories
Clockwise from top right: double dipper; single dipper; mahlstick with screw-in extension; painting knives; palette knives.

SEE ALSO
Palettes, page 84

• **Mahlstick**
A mahlstick is a long handle with a pad at one end, which is rested on the support for steadying the painting arm when executing detailed, controlled work.

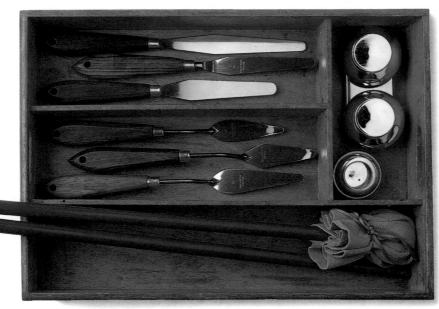

PALETTE KNIVES These are for mixing colors on the palette, scraping palettes clean, and for scraping away wet paint when making alterations to the picture. They have a straight, flat, flexible blade with a rounded tip. The long edges of the knife are ideal for removing wet paint, and the tip for picking up and mixing dabs of paint on the palette.

PAINTING KNIVES Painting knives are for mixing and spreading color directly on the support, and come in several sizes. They have delicate, flexible blades which come in a variety of shapes for making different kinds of marks; the angled handles keep your hand clear of the wet-paint surface while you are working. The angular blade is ideal for applying a variety of marks: use the tip of the blade for making fine details and stippled marks, the flat part for broad strokes, and the edge of the blade for linear marks.

DIPPERS These are small open metal cups that clip onto the edge of a thumbhole palette to hold oils and solvents during painting. You can buy single dippers or double dippers. Some have screw caps to prevent spillage or evaporation of solvents. But in the studio it may be more convenient to use small jars or cups resting on a nearby surface.

Using a mahlstick
If you are right-handed, hold the end of the stick in your left hand and rest the padded end lightly on a dry section of the work, or on the edge of the stretcher, so that the stick crosses the painting diagonally. You can then steady your painting arm on the cane.

Home-made mahlstick
Traditionally, mahlsticks had bamboo handles and chamois-leather padded tips, but nowadays they are usually made of aluminum with rubber tips. You can improvise your own: tightly wrap cotton wool into a ball around the end of a garden cane. Cut a disc of cloth, chamois leather or chamois substitute, larger than the ball, and secure it around the cane with a cord or rubber bands.

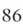

AVOIDING PROBLEMS

Correct preparation of the painting surface is important, and the principle of painting fat-over-lean is also sound technique when painting in layers. The most important thing, however, is not to become enslaved by "correctness," but to enjoy the act of painting.

J. M. W. Turner (1775-1851) THE OPENING OF THE WALHALLA, 1842-3 Oil on mahogany board 45 x 80in (112.7 x 200cm) Tate Gallery, London

WORKING FAT-OVER-LEAN

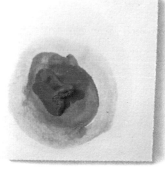

Removing excess oil
If you wish to use an oily pigment in an underlayer, this can lead to problems, as subsequent layers must not contain any less oil. One way to resolve this is to leach out some of the oil; here, alizarin crimson is squeezed onto an absorbent paper towel and left for a short time. It can then be scraped onto a palette and confidently used for underpainting.

The term "fat-over-lean" is synonymous with "flexible-over-inflexible." "Fat" describes paint which contains a high percentage of oil, and is therefore flexible; "lean" paint has little or no extra oil added, and is thinned with turps or mineral spirits, making it comparatively less flexible.

To ensure a sound structure to a painting which is built up in layers, you should apply the fat-over-lean principle, in which each successive layer of paint is made more flexible by increasing the percentage of oil in the paint – the same principle, in fact, used in house-painting, where paint for the undercoat contains less oil to pigment than the final coat.

The reason for this has to do with the way in which the paint film dries. The oil binder in the paint dries not by evaporation, but by absorbing oxygen from the air. During the first stage of drying, it increases in weight and expands. It will then begin to lose weight, contract slightly and harden. If lean (less flexible) paint is applied over oily (flexible) paint, cracking may occur because there is more movement in the lower layers than in the upper layers.

When painting in layers, begin with an underpainting which is thinner, leaner and faster-drying than subsequent layers. For example, start with paint thinned with diluent or mixed with a fast-drying alkyd medium. The next layer may consist of either undiluted tube paint, or paint mixed with diluent and a little oil. Any successive layers may contain either the same or increasing amounts of oil, but they should not contain less oil.

Movement and sinking
In this detail of the painting above left, it can be seen that contrasting drying rates and flexibility in the various paint layers have caused movement and sinking of the surface. This is caused by Turner's sometime practice of using straight oil paint in the lower layers, but subsequently mixing his colors with waxes, resins and bitumens in the upper layers.

• Drying times
Lean paint dries faster than fat paint, and thin layers dry faster than thick ones. If a lean or thin layer is applied over a fat or thick layer, the layer beneath dries more slowly and contracts as it does so, causing the hardened paint on top to crack in due course.

SEE ALSO
Paints, page 64
Mediums, page 76

SINKING OF PAINT FILM

Patches of dull, matte paint across the canvas indicate sinking of the paint film. Sunken patches can occur on paintings which are worked on over a period of time, and are caused by the overlaid layers of color drying out at different rates.

As it dries, a layer of oil paint goes through a sponge-like stage, when it becomes very absorbent. This starts after a few days, and may last for around six months. During this time, if further layers are added they may sink because the absorbent underlayer sucks the oil from the fresh layers, leaving them starved and dry-looking. This can be avoided by working on the painting consistently, so that the paint films are drying together. If you leave a painting for more than a week and then resume work on it, sinking is more likely to occur.

• Additional drying oil
Mixing additional drying oil (such as linseed or poppy oil) with tube oil paints can also cause wrinkling of the paint film, but the inclusion of a diluent should prevent this.

Oil-rich colors
Certain oil-rich colors, such as alizarin crimson, have a tendency to wrinkle when applied in thick layers, because they dry slowly. If a thick layer of paint is required, it should consist of several thin applications rather than one thick one.

REVIVING SUNKEN PAINT PATCHES

Sunken patches can be brought back to life by "oiling out," and this will also prevent subsequent layers being weakened. Mix a solution of 80 percent stand oil and 20 percent mineral spirits and rub this sparingly over the affected area, using a soft, lint-free cloth. Leave to dry for a few days before applying further layers of paint. If small patches remain, repeat the process until all the sunken areas have disappeared.

George Rowlett
THE GREAT RAPEFIELD
Oil on canvas
18 x 24in (45 x 60cm)

• Alternative method
If time is short, the alternative method is to brush a little retouching varnish over the sunken patches. This reduces the absorbency of the paint already on the canvas, while providing a "key" or tooth for the next layer. Apply a small amount of the varnish with a soft brush and leave it to dry for about 10 minutes before continuing to paint.
The drawback with retouching varnish is that it is a soluble resin, which can result in the oil-color film being susceptible to solvents used in subsequent painting, varnishing or cleaning. A paint layer which is touch-dry on top but wet underneath should never be overpainted with retouching varnish, as this may cause cracking.

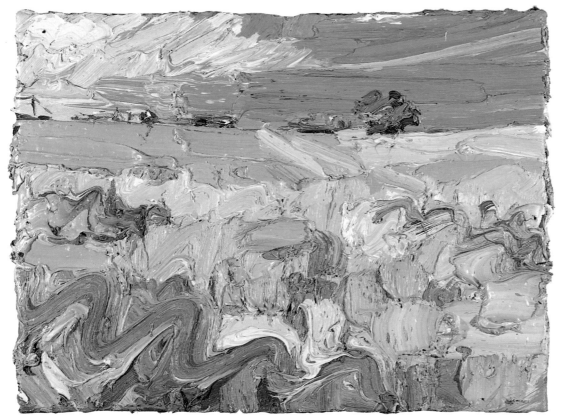

Some of the paint on this landscape is as thick as 1½in (38mm), yet no cracking or sinking of the paint film has occurred. This is because the artist uses pure oil paint, without the addition of any mediums, diluents or binders; he applies a relatively thin underlayer, and then builds up the very thick texture. He does not mix colors, so the potential problems of mixing oil-rich and oil-lean paints are avoided.

UNDERPAINTING

The traditional way of starting an oil painting is to use thin paint to roughly block in the main shapes and tones, before adding the main details and surface color. This underpainting provides a foundation from which the painting can then be developed, as the composition and the relationships of the colors and tones have been made clear from the start.

Tom Coates
CHARLOTTE IN ARABIC
COSTUME
Oil on canvas
50 x 36in (125 x 90cm)

In this unfinished painting, the artist has used the traditional method of monochrome underpainting in neutral greys and browns. These colors form a solid base from which to model the figure.

ADVANTAGES OF UNDERPAINTING

There are three principal advantages to making an underpainting. First, it can subdue the harsh white of a primed support (when a toned ground has not been laid), making it easier to accurately gauge the relative tones of the succeeding colors.

Second, using underpainting as part of the compositional process enables you to check that the picture works as intended, before it is too late to make changes to the overall construction. Because the paint used for underpainting is so thin, any alterations needed can be easily effected by wiping the paint with a rag soaked in turpentine; this will not be possible in the subsequent stages, as you run the risk of overworking the painting.

Third, because decisions about composition and tonal modeling have been dealt with at a preliminary stage, you are free to concentrate purely on the details of color and texture in the later stages.

• Colors for underpainting
Flake white and diluted earth colors are suitable for underpainting, as they dry rapidly and form a hard film.

FAT-OVER-LEAN

Always keep in mind the principle of working fat-over-lean: to create a stable paint film, the underpainting should be thin and fast-drying and succeeding layers should be slower-drying and more oil-rich. Flake white and diluted earth colors are suitable for underpainting, as they are rapid driers and form a hard film with just the right degree of flexibility. They also have a catalytic effect when mixed with other fast-drying colors. Alkyd and tempera paints are suitable for underpainting because they dry rapidly.

Acrylic paints are also suitable, as they are fast-drying, but they must be diluted with a little water (not medium) and applied thinly. The presence of water renders the surface of the paint a little more porous when dry, ensuring proper adhesion between acrylic and oil layers.

If acrylic paint is applied at all thickly, it may cause cracking of the oil layers, because acrylics are so flexible when dry. In addition, a thick acrylic layer has insufficient tooth to adhere well. This applies particularly when painting on a flexible support such as canvas, but less so on panels and boards, where there is far less movement of the paint film. Never apply acrylics on an oil-based ground.

• Colors to avoid
The colors listed below should not be used at full strength in underpainting, because they naturally contain a lot of oil. They may, however, be used for the purpose when mixed with less oil-rich colors. Alizarin crimson; aureolin; cadmium colors; cobalt blue; ivory black; lamp black; phthalocyanine colors; quinacridone colors; viridian.

Michaelangelo Buonarotti
(1475-1574)
MADONNA, CHILD AND ST
JOHN WITH ANGELS, c. 1506
Oil on wood
42⅛ x 30¾in
(105.4 x 76.8cm)
National Gallery, London

The effect of using complementary or contrasting underpainting colors can be clearly seen here; the cool greens enhance the warmth of the subsequent skin tones.

ALLA PRIMA

SEE ALSO
Avoiding problems, page 87

"PAINT GENEROUSLY AND UNHESITATINGLY, FOR IT IS BETTER NOT TO LOSE THE FIRST IMPRESSION. DON'T BE TIMID IN FRONT OF NATURE; ONE MUST BE BOLD, AT THE RISK OF BEING DECEIVED AND MAKING MISTAKES."

CAMILLE PISSARRO (1830-1903)

Italian for "at the first," alla prima describes a painting which is completed in a single session. In alla-prima painting there is often no preliminary underdrawing or under-painting; the idea is to capture the essence of the subject in a bold, intuitive way, using vigorous, expressive brushstrokes and minimal color mixing on the palette or support.

SPEED AND SPONTANEITY

This direct painting method requires confidence, but it is very liberating – the artist works rapidly, using the brush freely to express an emotional response to the subject.

The ability to apply paint quickly and confidently is the key to the alla-prima approach. It is, of course, possible to scrape away and rework unsuccessful areas of a painting, but the danger is that some of the freshness and spontaneity will be lost. It is therefore important to start out with a clear idea of what you want to convey in your painting, and to dispense with inessential elements which do not contribute to that idea. For the same reason, you should stick to a limited range of colors to avoid complicated color mixing, which might inhibit the spontaneity of your brushwork.

• Forerunners
Alla prima first came into favor with the Impressionists and their forerunners, Constable (1776-1837) and Corot (1796-1875). Working directly from nature, these artists introduced a liveliness and freedom of brushwork that was instrumental in capturing the effects of light and movement in the landscape.

• Drying
Although many alla-prima paintings are worked rapidly with thick paint, they are technically sound. This is because the colors are applied in one session, while the surface is still wet. There is effectively only one paint layer, so there is no problem with different drying speeds between layers, which can lead to cracking of the paint surface.

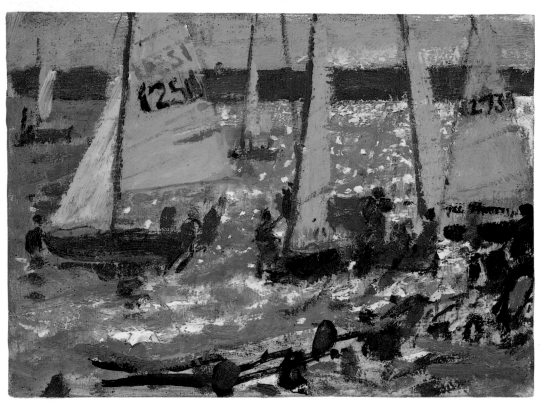

Ken Howard
RACING DINGHIES
Oil on wood
15 x 22.5cm (6 x 9in)

The artist had finished a long day's painting when these dinghies sailed into harbor. Inspired, he quickly unpacked his paints and completed this painting in ten minutes. He was able to do this because he had been painting all day and was "warmed up;" it would have been difficult to achieve the same energy and verve at the beginning of the day.

Arthur Maderson
A FAIR DEAL
Oil on canvas
24 x 28in (60 x 70cm)

Small studies painted on-the-spot have a directness and vigor difficult to achieve in the studio. The lively brushwork here makes an obvious contribution to the character of the painting, and is also highly descriptive; we gain a definite impression of the personalities of these three men engrossed in making a deal.

Annabel Gault
FLAX FIELD
Oil on paper
7⅝ x 10in (19 x 25cm)
Redfern Gallery, London

Intrigued by the drama of the dark, brooding landscape and the luminous evening sky, Annabel Gault worked quickly to distill the essence of the scene, using fingers, the edge of her hand and brushes to manipulate the paint.

GLAZING

Glazing is one of the traditional techniques associated with oil painting. The Renaissance painters, in particular, used glazing as a method of color mixing. Rather than stirring their colors together on the palette, they applied each color separately, in successive glazes of thin, transparent paint. Each glaze modified the color beneath, like sheets of colored glass, resulting in hues of wonderful richness and luminosity.

SEE ALSO
Diluents, page 75
Mediums, page 76
The language of color, page 172

OPTICAL MIXING

With a slow-drying medium such as oils, glazing can be a laborious process, because each color must be completely dry before the next is applied, otherwise they simply mix together and become muddied. Nevertheless, glazed colors have a resonance which is unobtainable by physically mixing them on the palette, because transparent colors transmit and reflect light. Glazing is a method of optical mixing, in which the colors blend in the viewer's eye. Each successive glaze modifies the underlying color, but does not completely obscure it; this incomplete fusion of the colors, combined with the effects of reflected light, is what gives a glazed passage its luminous quality.

GLAZING AND OPAQUE PAINT

Glazes can also be used in conjunction with opaque layers of paint, so long as the latter are dry to the touch. For example, colors which are too cool can be corrected by the application of a glaze of warm color, and vice versa. Similarly, a thin glaze applied over a finished picture will soften any harsh contrasts and bring harmony to the colors, without obscuring the forms beneath.

GLAZING MEDIUMS

Paint for glazing should be thinned with a glazing medium, to increase its flow and transparency. Fast-drying synthetic glaze mediums speed the drying process.

Linseed oil is not suitable as a glazing medium: because a high proportion of oil is needed to make the paint transparent, it will simply run down the support. Turpentine makes the color go flat and dull, and a cracked surface is the result if it is applied over paint containing a high proportion of oil.

Comparative effects
In glazing, a third color is produced by laying a thin wash of color over another, dry, color. Glazed colors appear richer and more luminous than colors mixed on the palette. Here a transparent glaze of cobalt blue applied over cadmium yellow light produces a lively color (top). The same combination of two colors mixed on the palette produces a flatter effect (below).

• Glazing over other paints
Save time by glazing with oils over an underpainting done in egg tempera, alkyds or acrylics, all of which dry in minutes rather than days. Acrylics must be applied thinly, otherwise the oil-paint layer may lack adhesion and there is a danger of cracking. Although oil paint can be applied over acrylic, the reverse is not possible.

Applying a glaze

For best results, choose a transparent color, such as cobalt blue or raw sienna, and avoid opaque colors such as the cadmiums. The underpainting must be touch-dry before a glaze can be applied over it. Mix the paint with glaze medium to the consistency of thin cream; do not over-thin to make the paint transparent. Apply the glaze and leave for a few minutes. If the glaze is too strong, take a clean, dry fan blender (or an old shaving brush) and dab the glaze with short strokes, holding the brush vertically. This process removes some of the paint, leaving a soft, lustrous film through which the underpainting is visible. As paint builds up on the bristles, dab them regularly on a rag to keep them clean and dry.

John Monks
PORTRAIT OF A ROOM
Oil on canvas
110 x 120in (225 x 300cm)

In this interior, the box and chair were painted with a palette knife before earth-color glazes were overlaid. Monks painted the landscape through the windows and then used a soft brush to apply glazes on top. The window frames were painted directly over the glazing, to create depth.

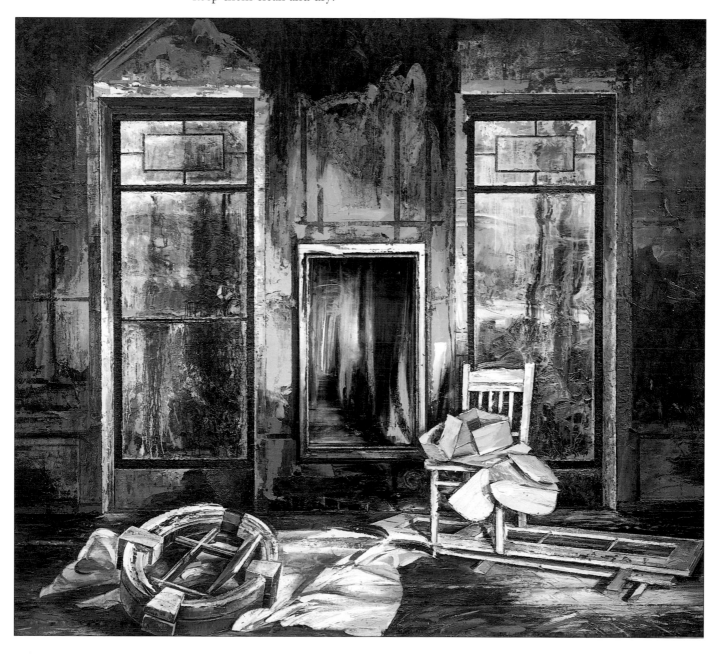

IMPASTO

In contrast to glazing – the methodical building-up of thin layers of paint – impasto involves applying the paint thickly and liberally, so that it retains the marks and ridges left by the brush. Most artists enjoy the expressive and textural qualities which impasto lends to a painting, and the buttery consistency of oil paint lends itself well to this technique.

Straight from the tube
Paint may be used straight from the tube, or diluted with a little medium to make it malleable enough to stand up from the support.

TECHNIQUES

Impasto can be applied with a brush or a painting knife. The paint may be used straight from the tube, or diluted with a little medium so that it is malleable, yet thick enough to stand apart from the support.

When thick layers of paint are left to dry slowly, cracking or wrinkling of the paint film may occur. This can be avoided by using a fast-drying alkyd medium or one of the mediums specifically designed for use with impasto work. These thicken the paint without altering its color, speed the drying process, and make the paint go a great deal further, in the bargain.

Excessively oily paints make it difficult to achieve highly textured, impasto brushstrokes. Squeeze such a paint onto absorbent paper and leave it for a few minutes – not too long, or it will become underbound. The paper absorbs excess oil, and the paint has a stiffer consistency.

Extra texture
Mix sand and sawdust with oil paint to create a highly textured surface. You can also make expressive marks by scratching into the wet paint with a painting knife, the end of a brush handle, or any sharp tool.

Planning

A heavily impasted painting should look free and intuitive, but will need careful planning. Just as color loses its vitality when too thoroughly mixed on the palette, directly applied paint quickly loses its freshness when the pigment is pushed around on the canvas for too long, or carelessly applied. Oil paint has a wonderful tactile quality, and the temptation is to build it up in juicy dollops. The danger is that each new brushstroke picks up color from the one below, and the result is muddy color and an unpleasant, churned-up surface. You can rescue an oil painting by tonking it (see left), or by scraping the wet paint off with a painting knife and starting again. But it is best to avoid the problem in the first place by starting with a thin underpainting and gradually building up thicker layers.

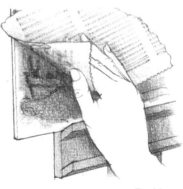

Tonking
If an oil painting becomes clogged with too much paint, the excess can be removed when still wet, by tonking. Place a sheet of absorbent paper, such as newspaper or toilet paper, over the overloaded area and gently smooth with the back of the hand. Peel the paper away, lifting excess paint with it.

Glazing over impasto
Once an impasted layer is completely dry, you can glaze over it, if desired, with a thin film of paint mixed with a glaze medium. The glaze must contain more oil than the underlayers, to prevent cracking.

BRUSHES

Flat bristle or synthetic brushes are best for impasto work, since they hold a lot of paint. Load the brush with plenty of color and dab it onto the canvas, working the brush in all directions to create a very obvious, almost sculptural texture. Be sure your brush carries plenty of paint, apply it with a clear sense of purpose, and then let it stay.

Arthur Maderson
EVENING LIGHT ON RIVER
Oil on canvas
34 x 34in (85 x 85cm)

Impasto
The paintings on this page show just three of the many textures and effects possible.

Arthur Maderson's painting (left) is composed entirely of impasted brushmarks, dabbed and stippled to create a shimmering mosaic of color. The use of complementary colors enhances the vibrancy.

In Ian Houston's coastal landscape (below left), small touches of impasto provide a contrast with the areas of smooth paint. The raised touches appear to come forward, increasing the depth in the picture.

George Rowlett uses an extremely heavy impasto to achieve a three-dimensional, sculptural quality (below right). Note the braid on the right, which ends up off the support.

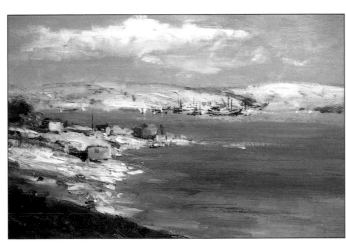

Ian Houston
(above)
SYMI
Oil on canvas
16 x 24 in (40 x 60cm)
Kentmere House Gallery, York

George Rowlett
HEAD OF HANNAH DUNN
Oil on canvas
16 x 9½in (40 x 23.7cm)

95

KNIFE PAINTING

Painting knives may be used instead of, or as well as, brushes, to apply thick impastos of oil paint. Painting knives should not be confused with palette knives, which have stiffer blades and are mostly used for mixing paint on the palette. A painting knife has a shorter blade and an angular handle, to prevent the knuckles from accidentally brushing against the canvas when applying paint. The blade is made of forged steel, giving it spring and flexibility, and allowing sensitive control.

SEE ALSO
Accessories, page 86

Knives for painting
Painting and palette knives, and even a scraper can be used.

• Scraping back
Painting knives can also be used to push the paint into the weave of the canvas and build up a series of translucent stains. Alternatively, scrape some of the paint off the canvas while it is still wet, leaving behind a thin layer of color, a "ghost image," on the support. Further layers may be added and then scraped back, to partially reveal the colors beneath. The finished effect is delicate and subtle, with minimal brushmarks.

MANY USES

Although a painting knife is by no means an essential piece of equipment, many artists enjoy the tactile sensation of applying thick, juicy oil paint to the canvas with a knife, moving it around and partially scraping it off with the edge of the blade, or scratching into the wet paint, to suggest details and texture.

Painting with a knife is initially trickier than painting with a brush, so it is wise to practice until you get the feel of it. By holding the knife at different angles, varying the pressure on the blade and using different parts of the blade, you can achieve quite different strokes and effects. For example, painting with the flat base of the blade, spreading the paint very thickly, produces a smooth surface that reflects the maximum amount of light.

Holding the knife at a slight angle to the canvas and applying firm pressure gives a thinner covering, which allows the texture of the canvas to show through the paint. Using a brisk patting motion with the tip of the blade creates a rough, stippled texture. You can also use the tip of the blade to scratch through a layer of wet paint and reveal the color beneath, a technique known as sgraffito.

Laying in bold, broad strokes

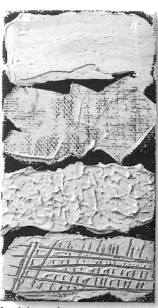

Applying paint
Be generous with the paint, applying enough to fill the grain of the canvas. Take care not to build it up too thickly, or it may eventually crack.

Utilize the flat base of the blade to produce a smooth surface (top). Hold the knife at a slight angle to give a thinner covering and allow the texture of the canvas to show through (second row). Make a brisk patting motion with the tip of the blade to create a rough, stippled texture (third row). Scratch through a layer of wet paint with the tip of the blade, to reveal the color beneath (bottom).

TECHNIQUES

Pick up the paint on the underside of the knife. To make bold, broad strokes, grip the knife handle as you would a trowel, and use the full width of the blade to squeeze the paint onto the surface. Do not move the knife back and forth; set it down firmly on the canvas and spread the paint with a single, decisive movement, lifting the blade cleanly away when the stroke is completed.

To lay in smaller patches of color, grip the handle and push the index finger against the steel shaft; this will give greater control when working over smaller and more delicate areas.

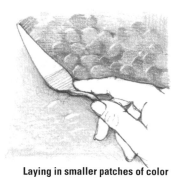

Laying in smaller patches of color

Sophie Knight
SPILT MILK
Oil on canvas
60 x 42in (150 x 105cm)

John Denahy
BOSHAM
Oil on canvas
12½ x 15in (31.2 x 37.5cm)

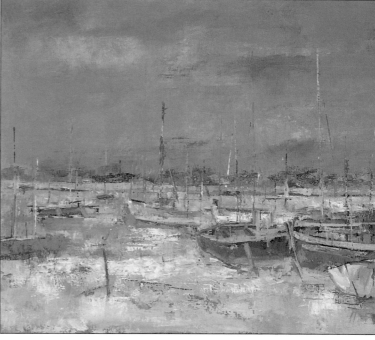

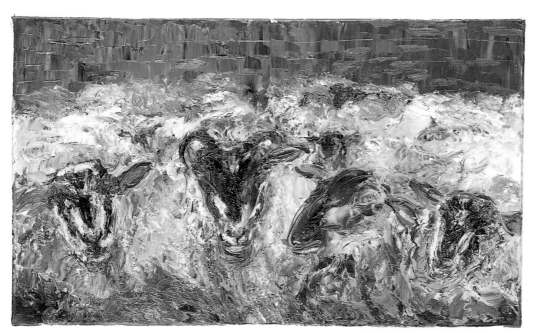

Tory Lawrence
FOUR SHEEP
Oil on canvas
18 x 30in (35 x 75cm)
Montpelier Studio, London

Knife painting

Painting knives are usually associated with thick impasto, but they are capable of detailed and delicate effects.

Sophie Knight combines textures and techniques. For the tabletop and background she used wet-in-wet washes; in contrast, the cakes and spilt milk consist of thick paint, sculpted and smoothed with a knife.

John Denahy uses knives, brushes and scrapers to apply paint, overlaying transparent glazes with broken, opaque passages. In this painting, the thin lines of the masts were made by loading the edge of a knife with paint and pressing it onto the surface.

Knife strokes are always part of Tory Lawrence's painting process. The ridged and smeared features that create a lively texture were built up with knives and brushes, while linear marks were scratched into the paint with the tip of the knife.

97

SCUMBLING, DRYBRUSH & BLENDING

SEE ALSO

Brushes, page 78
Glazing, page 92
The language of color, page 172
Mixing colors, page 178

While oil paints are well suited to thick applications and strong brushwork, they are equally capable of producing subtle textures and softly blended passages in which there is a gradual transition from light to shadow or from one color to another: for example, the gradation of a blue sky from strong color at the zenith to pale on the horizon, or the subtle effects of light and shade in a portrait.

Scumble
A thin film of dry, semi-opaque color on a dry underlayer.

SCUMBLING

Scumbling is an excellent way to modify color while retaining the liveliness of the paint surface. A thin film of dry, semi-opaque color is loosely brushed over a dry underlayer, creating a delicate "veil" of color. Because the technique involves unequal applications of paint, the underlayer is only partially obscured, and it shimmers up through the scumble. For example, white scumbled over a black underlayer creates an optical blue; crimson scumbled over this produces an optical violet.

MODIFYING COLOR

Try scumbling over a color with its complementary (opposite) color. The two mix optically and thus appear more resonant than an area of flat color. Similarly, a color which is too "hot" can be modified with a cool scumble, and vice versa. A scumble should be lighter than its background color; add a touch of titanium white to the pigment to lighten it and make it semi-opaque.

Resonant effect
Scumbling over a color with its complementary color.

TECHNIQUES

Use a bristle or synthetic brush for scumbling. Indeed, an old, worn brush is preferable, because the scrubbing action may damage the hairs of your best brushes if you use the technique frequently. Load the brush with diluted paint and wipe it on a rag to remove any excess. Lightly scrub on the support with free, vigorous strokes, to produce a very thin film of color. The paint can be worked with a circular motion, with back-and-forth strokes, or in various directions. You can also scumble with a clean, lint-free rag.

Brushes for scumbling
Use old, worn brushes, or the scrubbing action may damage the hairs of your best brushes.

Modifying color
A warm or hot color can be modified by scumbling with a cool or cold color.

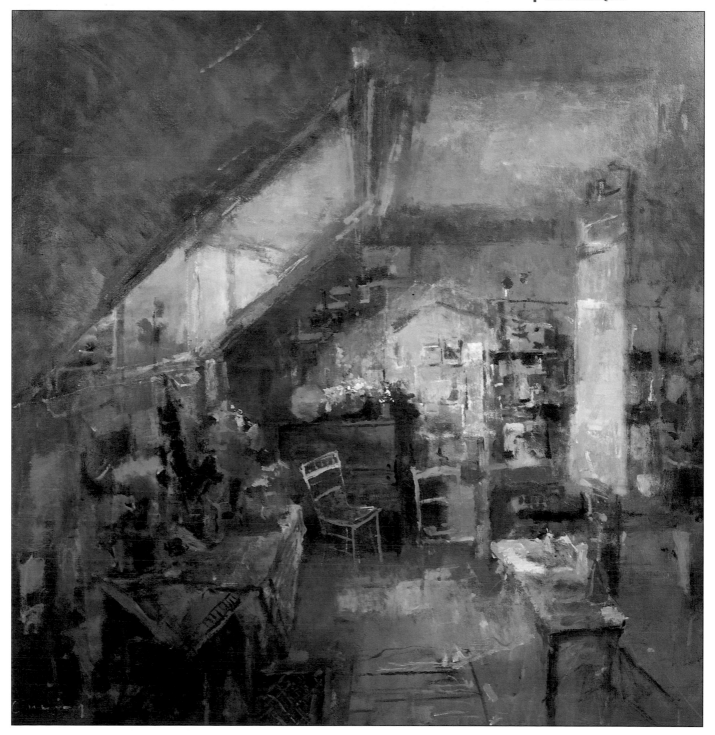

Fred Cuming
STUDIO INTERIOR, EARLY
MORNING
Oil on Masonite
36 x 34in (90 x 85cm)
Brian Sinfield Gallery, Burford

The artist worked over the whole canvas with thin veils of stiff, chalky paint, scumbled and dragged over dried underlayers. The interaction between the two layers produces a soft, pearly effect which is particularly evocative. Each color modifies the preceding one and creates subtle harmonies of tone and color.

DRYBRUSH

This is most successful when there is already some existing texture, either that of the canvas or that provided by previous brushstrokes, which helps to break up the paint. With drybrush, a small amount of undiluted color is picked up on a brush and skimmed lightly over a dry painting surface. The paint catches on the raised "tooth" of the canvas and leaves tiny speckles of the ground, or the underlying color, showing through. The brushstrokes should be made quickly and confidently – overworking destroys the effect.

The ragged, broken quality of a drybrush stroke is very expressive, and the technique is particularly suitable for suggesting and depicting natural textures and effects, such as weathered wood and rock, long grass, or the sparkle of light on water.

Arthur Maderson
POINTING
Oil on canvas
15 x 11in (37.5 x 27.5cm)

SEE ALSO
Brushes, page 78

Drybrush
Two contrasting uses show the technique's versatility.

In Arthur Maderson's painting (below left), dry, chalky paint, deposited on the crests of the canvas weave, creates broken strokes suggesting movement and light on water.

Annabel Gault uses rapid calligraphic drybrush strokes to capture the gestures of windswept trees (below). The economy of line is reminiscent of Asian brushwork.

BLENDING

The soft, pliant consistency of oils, and their prolonged drying time, enable the artist to brush and re-brush the area where two colors or tones meet, so that they merge together imperceptibly.

Depending on the subject and the style of the painter, blending can be achieved simply by dragging one color over the edge of the next so that they are roughly knitted together but the marks of the brush are evident; or it can involve methodically stroking with a soft-hair brush or fan blender, to create a smooth, highly finished join in which the marks of the brush are invisible.

Annabel Gault
TREES
Oil on paper
10⅜ x 14in (26 x 35cm)
Redfern Gallery, London

Derek Mynott (1926-94)
TOWARDS LOTS ROAD, 1990
Oil on canvas
22 x 19in (55 x 47.5cm)

Blending
Both these paintings apply different wet-in-wet blending techniques, to achieve distinctive results.

Derek Mynott's meticulous, separate and distinct brushstrokes blend the wet paint to allow tiny gradations of tone and hue, to create an impression of soft, hazy light (left).

In his striking figure study (below), Richard Smith gently blended paint applied wet-in-wet; this subtle use of tone and color captures the youthful sheen of the model's skin and hair.

Two styles of blending
With rough blending (top), the colors are roughly knitted together, and the brushmarks are evident. In contrast, smooth blending (above) produces a highly finished join in which the marks of the brush are invisible.

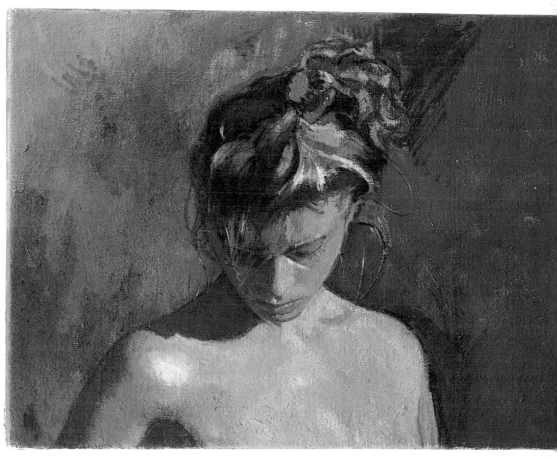

Richard Smith
PENSIVE
Oil on canvas
12 x 16in (30 x 40cm)
Brian Sinfield Gallery, Burford

CCCXV — 10

WATERCOLOR

has a delicacy and transparency that makes it the perfect medium for capturing the subtle nuances of light and color in nature. Because the paint is transparent, the white reflective surface of the paper shines through the colors, and gives them their unique luminosity.

The fluid nature of watercolor makes it less predictable than other painting media, but this is more than compensated for by the range of exciting and beautiful effects it can create – sometimes more by accident than design. The element of chance and risk can make watercolor a frustrating medium, as well as an exciting and challenging one. However, armed with the right equipment – and a basic understanding of how pigments, water and paper interact – you can stay one step ahead of the game.

J. M. W. Turner (1775-1851)
VENICE SUBURB, MOONLIGHT, 1821
Watercolor on paper
8¾ x 12¾in (22 x 31.9cm)
Tate Gallery, London

PAINTS

Paints for watercolor consist of very finely ground pigments bound with gum-arabic solution. The gum enables paint to be heavily diluted with water to make thin, transparent washes of color, without losing adhesion to the support. Glycerine is added to the mixture to improve solubility and prevent paint cracking, along with a wetting agent to ensure an even flow of paint across paper.

SEE ALSO
Pigment and color, page 108
Basic palette, page 110

CHOOSING AND BUYING PAINTS

It is natural to assume that there is little difference in formulation between one brand of paint and another. In reality, the types and proportions of ingredients used by manufacturers do differ, so there are often variations in consistency, color strength, handling qualities, and even permanence between one paint range and another.

It is worth trying out several brands of paint initially, as you may find that one suits your style of working better than another. You don't have to stick to one brand, however; good-quality watercolor paints are compatible across the ranges, and you may discover that certain individual colors perform better in one range than another. Viridian is a good example: in some brands it has a tendency to be gritty, while in other ranges it is perfectly smooth and clear.

• Differences between brands
Colors that are mixtures of pigments (sap green and Payne's gray, for example) show a marked variation in hue between brands because they are formulated differently, so do not expect a familiar color name to be exactly the same color in a different brand.

Using charts
When purchasing paints, don't depend on manufacturers' color charts as a guide to a color's appearance. Most are printed with inks that are not accurate representations of the colors. Handmade tint charts produced with actual paint on swatches of watercolor paper are more reliable; any reputable art supplier should have one which you can refer to.

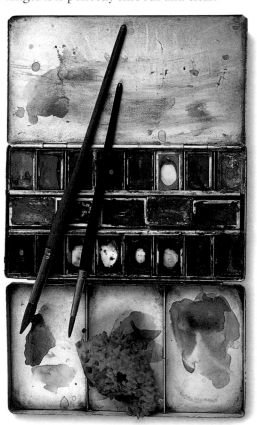

A selection of pans, half pans and tubes

Types of paint
Watercolors are available in two main forms: as small, compressed blocks of color, called "pans" or "half pans" according to size, and as moist color in tubes. The formulations of tube and pan colors are very similar, and which type you choose is a matter of personal preference. Good-quality watercolor equipment will repay you with many years' loyal service.

PANS AND HALF PANS

Pans and half pans

These fit neatly into tailor-made, enameled-metal boxes with recesses to hold them in place and separate them, and a lid that doubles as a palette when opened out. You can either buy boxes containing a range of preselected colors or, preferably, fill an empty box with your own choice. Color is released by stroking with a wet brush; the wetter the brush, the lighter the tone obtained.

Pans are light and easy to use when painting outdoors. The colors are always in the same position in the box when you want them, and they don't leak. They are also economical to use, with minimal waste of paint. However, it takes a little effort to lift enough color onto the brush. Paints also become dirtied when you dart from one to the other without rinsing out your brush in between.

Care of pans

New pans tend to stick to the inside of the lid when you close the box; when you next open the lid, they may scatter out of order. It is good practice to remove excess moisture from pans with a damp sponge after a painting session. Leave the box open in a warm room for a few hours to let the colors dry off before closing the lid, and dry the palette on the inside of the lid before closing it, or the paints absorb the moisture and become sticky.

When using pan colors for the first time, wet them with a drop of water and leave until the water has been absorbed. This will ensure easier paint release when the pans are stroked with the brush.

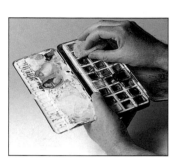

Preventing lids from sticking
After a painting session, remove excess moisture from pan colors with a damp sponge.

Improvised pans
Always replace caps of tube colors immediately, otherwise the paint will harden in the tube. If this does happen, however, cut open the tube and use it as an improvised pan. As long as the paint is not so old that the gum-arabic binder has become insoluble, it should be possible to reconstitute the paint with water.

TUBES

Standard tube sizes

Tubes of color are available in sizes ranging from 0.17 to 0.66 fl. oz (5 to 20ml); the standard size is 0.5 fl. oz (15ml). The smaller sizes are designed to fit into traveling watercolor boxes, but the bigger tubes are more economical for large-scale work. Tubes can be bought singly or in pre-selected sets. Choosing your own tubes means you can obtain precisely the colors you need.

Tube colors are more cumbersome than pans when painting out of doors, but they are more suitable for large-scale work in the studio. Because tube paint is more fluid than the equivalent pan form, it is better for mixing large amounts of paint. Tubes can be more wasteful than pan colors, however, because it is easy to squeeze out more than you need, and paint can leak and solidify if the cap is not replaced properly. Tube color is also prone to settling, as old stock may harden or separate in the tube.

Care of tubes

Always clean the tube thread before replacing a cap, or it may stick – the gum arabic in the paint acts as a glue. Stuck caps can be opened with pliers, or by holding the tube under a hot tap so that the cap expands and is easier to remove. Do not throw away tubes of hard paint, as it is often possible to salvage the contents (see right).

Salvaging tubes
It is possible to bring dried-up tube paint back to its former paste-like consistency. Unroll the tube, cut the end off, and add a few drops of water. Let the hardened paint absorb the moisture, and rework it back to a paste.

SEE ALSO
Pigment and color, page 108
Basic palette, page 110

GRADES OF PAINT

There are two grades of watercolor paint: artists' (first quality) and students' (second quality). Although student-grade oil paints can be recommended for beginners wishing to experiment without breaking the bank, student-grade watercolors are usually a false economy because they lack some of the subtlety and transparency of first-quality paints. Artist-quality paints are more expensive, but they are worth it and, besides, you don't need a truckload of paints in order to produce a good painting.

On the other hand, reputable paint manufacturers go to great lengths to maintain high standards at an economic price, and some artists find students' colors perfectly acceptable for everyday use. Certain student-grade colors may even have particular qualities which you prefer over the artists' equivalent. For example, if you want a bright green, you may find a mixture of student-grade cobalt blue and cadmium yellow better than the subtle green produced by the same mixture in artists' colors.

Students vs. Artists
Mixing student-grade cobalt blue and cadmium yellow may give you a brighter color than that achieved by the same mixture in artists' colors.

ARTISTS' PAINTS

Artist-quality paints contain a high proportion of good-quality, very finely ground, permanent pigments. The colors are transparent and luminous, they mix well, and there is a wide range. Paints are often classified by "series," usually from 1 to 5, according to the availability and cost of the pigments. Generally, series 5 pigments are the most expensive, and series 1 the least.

STUDENTS' PAINTS

Student-quality paints are usually labeled with a trade name, such as "Cotman" (Winsor & Newton) or "Georgian" (Daler-Rowney), and should not be confused with the very cheap paints imported from the Far East, which should be avoided.

Students' paints are sold at a uniform price, offering the beginner an affordable selection of colors. They contain less pure pigment and more fillers and extenders; many of the more expensive pigments, such as the cadmiums and cobalts, are substituted by cheaper alternatives. Such substitution is commonly indicated by the word "hue" after the pigment name. The selection of colors is usually smaller than that of artists' ranges.

Permanence

Watercolor is as permanent as any other medium, provided that permanent colors are used. Always check the manufacturer's permanency rating, which is printed either on the tube label or in their catalog. It is also important to use acid-free paper, and to protect watercolor paintings from bright sunlight. An interesting experiment is to paint a patch of color onto paper, cover half with a piece of cardboard and place it in bright, indirect light for several weeks. When you remove the cardboard, you can judge the color loss. Most good quality paints show little or no fading.

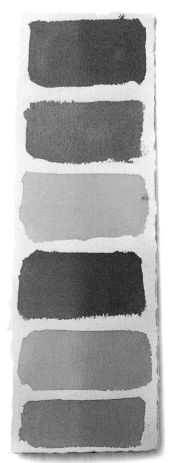

Testing color permanence
This color chart of student-quality watercolors was left taped to a window and exposed to northern light for four months. The effects of fading can be clearly seen.

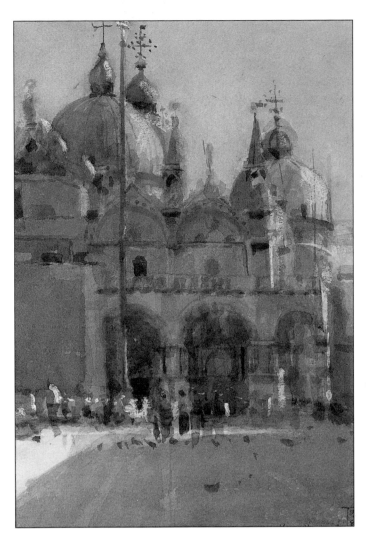

Ken Howard
(left)
SAN MARCO, MORNING
Watercolor on paper
11 x 9in (27.5 x 22.5cm)

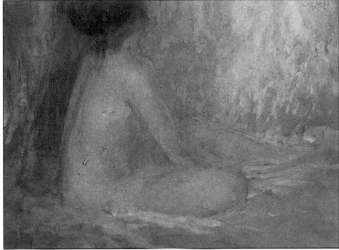

Jacqueline Rizvi
DANAE
Watercolor on paper
11 x 8½in (27.5 x 21.2cm)

Alex McKibbin
(below)
ENVIRONS OF PAMAJERA
Watercolor on paper
22 x 30in (55 x 75cm)

Transparency of color
Three ways of using the unique transparency of pure watercolor, which gives a luminous glow unmatched by other media.

Ken Howard (above left) has captured the haze of early-morning sunlight on St Mark's, Venice, with thin veils of shimmering color, applied one over the other.

Jacqueline Rizvi (above) uses watercolor mixed with Chinese white and applies translucent layers of color very gradually, using fairly dry paint. This delicate and unusual technique maintains the transparent, atmospheric quality of watercolor while giving it a more substantial texture. This study is worked on brown Japanese paper, which provides an underlying warm tone.

Alex McKibbin's aim (left) is always to capture the pulse and energy of nature, and to this end he manipulates brush, pigments and water with great bravura, alternating crisp strokes and drybrush with softer areas. The white surface of the paper plays an integral part, reflecting light through the thin layers of color.

107

PIGMENT AND COLOR

Although watercolor is regarded as a "transparent" medium, pigments fall into three groups: transparent, opaque and staining. The characteristics of each group depend on the substances from which they are derived. Additionally, some colors are intense and have greater tinting strength than others.

SEE ALSO

Watercolor paper, page 26
Wet-in-wet, page 126
Wet-on-dry, page 127
Creating highlights, page 128
Textures and effects, page 132

The list below shows the characteristics of some popular colors. However, because brands of paint vary widely in their formulation, be sure to test the colors yourself.

TRANSPARENT PIGMENTS

Highly transparent colors permit the white reflective surface of paper to shine through. They have an attractive, airy quality which is perfect for capturing the illusion of atmosphere, space and light. Some transparent colors are also strong stainers (see below), though this will not concern you unless you wish to lift out colors.

OPAQUE PIGMENTS

In watercolor, so-called "opaque" colors are obviously far more transparent than they are in oils, particularly when they are thinly diluted. Many opaque pigments are brilliant, while others are beautifully subtle. However, these pigments impart a degree of opacity to all colors they are mixed with – if used carelessly, they create cloudy colors lacking brilliance and luminosity.

STAINING PIGMENTS

Some transparent colors, such as alizarin crimson, are highly staining: they penetrate paper fibers and cannot be removed without leaving a trace of color. Some earth colors, cadmiums and modern organic pigments also tend to stain; if you intend to "lift" or sponge out areas of color, choose non-staining pigments where possible.

TINTING STRENGTHS

The tinting strength of pigments varies considerably. Some are very strong and overpower in mixtures, so only a small amount is needed. Others are so delicate you must use a large amount to make an impact on another color. Knowing how strong or weak each color is will save you a lot of time and frustration when mixing colors together.

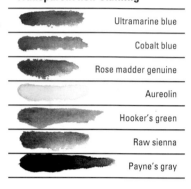

Transparent non-staining

	Ultramarine blue
	Cobalt blue
	Rose madder genuine
	Aureolin
	Hooker's green
	Raw sienna
	Payne's gray

Transparent staining

	Phthalocyanine blue
	Scarlet lake
	Alizarin crimson
	Viridian
	Sap green
	Prussian blue
	Gamboge

Opaque

	All cadmium colors [cadmium red shown]
	Indian red
	Yellow ochre
	Burnt umber
	Davy's grey
	Cerulean blue
	Lemon yellow
	Raw umber
	Chrome oxide green

Strong tints
Colors such as alizarin crimson, cadmium red, phthalocyanine blue and burnt sienna are very strong, and need to be diluted heavily.

Low-strength tints
Pigments with a low tinting strength include raw umber, yellow ochre, cerulean blue and raw sienna.

COLOR MIXING

Cobalt blue
Wet paint (above) compared with a dry example (below).

TRIAL AND ERROR

Always mix more paint than you think you will need; it is surprising how quickly it is used up. It is frustrating to run out of color halfway through a wash and then have to try to remix the exact color again.

One of the keys to good color is to restrain yourself from mixing pigments too thoroughly. If you are blending two colors together, for example, the mixture should show three: the two original pigments and the mixture itself. This gives a livelier vibration to the color.

Another way to ensure that you don't overmix your colors is to apply each one separately, mixing directly on the support. Colors may be applied in successive glazes (wet-on-dry), or allowed to blend on dampened paper (wet-in-wet).

You cannot tell by looking at paint on a palette whether you have achieved the right color or tone: the color must be seen on paper.

Watercolor paint always dries lighter on paper than it appears when wet (see left), so mixing is often a matter of trial and error. When mixing, therefore, it is useful to have a piece of spare paper to hand for testing the colors before applying them to a painting.

Mixing
Pigments should not be mixed too much. Stop mixing while you can still see the original colors along with the mixture. The lightly mixed examples (below, **2** and **3**) can be seen to be livelier and more colorful than the overmixed example (**1**).

1 Ultramarine blue and alizarin crimson overmixed on the palette.

2 The same colors, this time partly mixed on the palette.

3 The same colors partly mixed on wet watercolor paper.

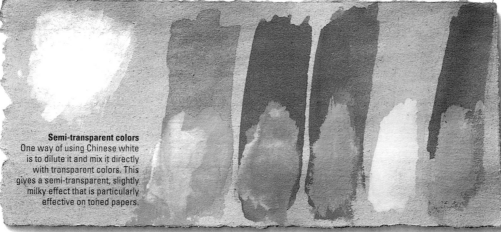

Semi-transparent colors
One way of using Chinese white is to dilute it and mix it directly with transparent colors. This gives a semi-transparent, slightly milky effect that is particularly effective on toned papers.

USING BODY COLOR

Chinese white
A cool white, ideal for tinting other colors.

To purists, the use of opaque paint in a watercolor is nothing short of heresy. A watercolor is supposed to be transparent, they would say, and paler tones are achieved by adding more water to paint, while pure white areas are achieved by reserving areas of white paper. However, most watercolorists take a more pragmatic approach and use opaque paint when it seems appropriate for a particular stage in a painting – when creating highlights, for example.

Transparent watercolors can be rendered opaque or semi-opaque by mixing them with Chinese white to produce what is called body color. Chinese white is a blend of zinc-oxide pigment and gum arabic; it is a dense, cool white which produces pastel tints in mixtures due to its high tinting strength.

109

BASIC PALETTES

The enormous range of pigments available makes it difficult to choose colors in a considered way. Who can resist those endless rows of gorgeous colors in the local art store? Sets of good-quality watercolors are available in boxes, but these are expensive and may contain far more colors than you need. A wiser course is to buy an empty box and fill it with colors of your own choice.

Starter palette

Starter palette
The colors shown below make a suitable starting selection. Color is a highly subjective area; however, the colors here are chosen for their all-around uses and permanence. It is also possible to mix a wide range of hues from them.

The ASTM (American Society for Testing and Materials) codes for lightfastness:

ASTM I – excellent lightfastness
ASTM II – very good lightfastness
ASTM III – not sufficiently lightfast

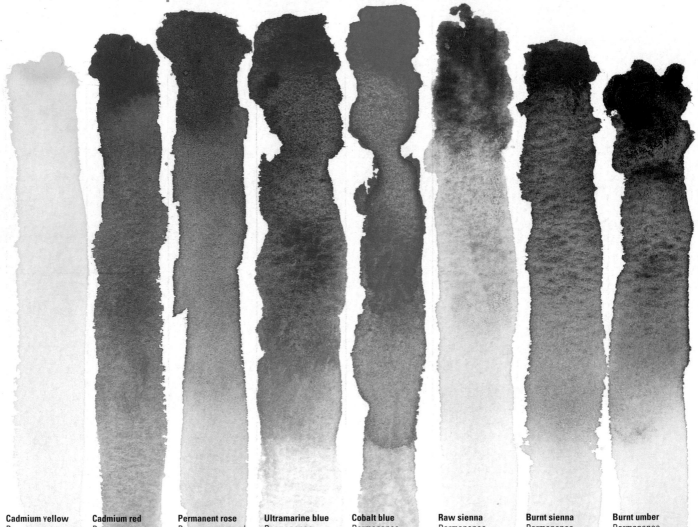

Cadmium yellow
Permanence excellent (ASTM I).
An opaque color with a warm and orange-yellow hue. Very clear and bright.

Cadmium red
Permanence excellent (ASTM I).
An opaque color with a bright vermilion tone. Very clear and bright.

Permanent rose
Permanence good (ASTM II).
A transparent color with a cool pinkish-red hue.
A softer and more permanent alternative to alizarin crimson.

Ultramarine blue
Permanence excellent (ASTM I).
An excellent transparent color with a deep blue, violet-tinged hue. Makes a range of subtle greens when mixed with yellows.

Cobalt blue
Permanence excellent (ASTM I).
A transparent color with a soft blue hue. Cooler than Ultramarine blue.

Raw sienna
Permanence excellent (ASTM I).
A transparent color, excellent for layering washes, with a deep golden-yellow hue. A very lightfast and durable color.

Burnt sienna
Permanence excellent (ASTM I).
A transparent color with a deep red-brown hue.
Mixes well with other pigments, giving muted and subtle colors.

Burnt umber
Permanence excellent (ASTM I).
A more transparent color than raw umber, with a warm brown hue. Excellent in mixtures of pigments.

Preselected boxes

This typical store-bought watercolor-pan box (right) contains the following colors:

Cadmium yellow pale

Cadmium red

Alizarin scarlet

Alizarin crimson

Viridian

Burnt umber

Yellow ochre

Burnt sienna

Light red

Uultramarine blue

Prussian blue

Ivory black

Auxiliary palette

Auxiliary palette

The seven colors shown below have been chosen as a range that will extend your choices for watercolor painting. Apart from the possibilities they provide for further mixing and experimentation, you will find them very useful when painting outdoors, particularly for landscapes.

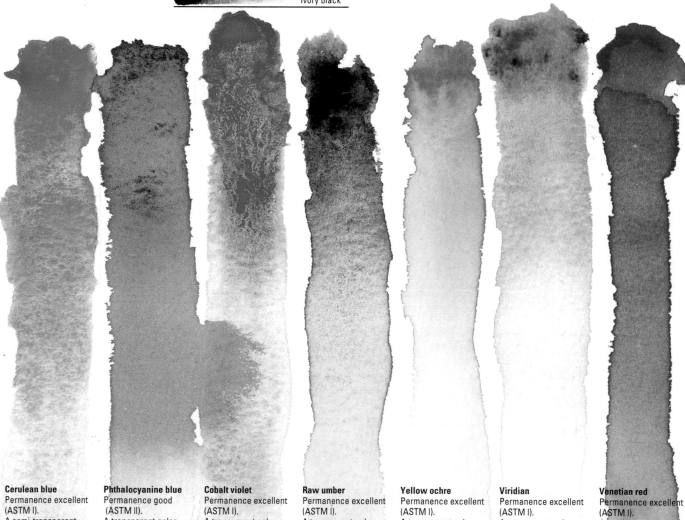

Cerulean blue
Permanence excellent (ASTM I).
A semi-transparent color with a cool and greenish-blue hue.
Ideal for painting skies.

Phthalocyanine blue
Permanence good (ASTM II).
A transparent color with a deep, intense blue hue and a cold, sharp tone.
A strong staining color.

Cobalt violet
Permanence excellent (ASTM I).
A transparent color with a bright, red-violet hue.
A pure violet that cannot be mixed or imitated.

Raw umber
Permanence excellent (ASTM I).
A transparent color with a greenish-brown hue.
Useful in mixes.

Yellow ochre
Permanence excellent (ASTM I).
A transparent color with a soft golden-yellow hue.
Has a calming effect on other colors.

Viridian
Permanence excellent (ASTM I).
A transparent color with a cool bluish-green hue.
Makes a good basis for warm, bright greens.

Venetian red
Permanence excellent (ASTM I).
A semi-opaque color with a warm terracotta-red hue.
Very useful for mixing flesh tones.

111

BRUSHES

Brushes are a very important element in watercolor painting, so it is worth buying the best quality you can afford. Cheap brushes are a false economy, as they do not perform well and quickly wear out.

SEE ALSO
Brush-and-ink drawing, page 54
Brush shapes, page 114
Textures and effects. page 132

A GOOD BRUSH

• Bristles
The bristles should point well. When loaded with water, they should return to their original shape.

• Belly
This should hold a lot of color, and release the paint slowly and evenly.

• Ferrule
A seamless, cupro-plated nickel ferrule is strong and will not corrode.

• Handle
This should be lacquered against water, chipping or cracking, and be comfortable in use. Size, series, and type are embossed on the handle.

12

ROWNEY·S.34

SABLE

A good brush should have a generous "belly" capable of holding plenty of color, yet releasing paint slowly and evenly. The brush should also point or edge well – when loaded with water, it should return to its original shape at the flick of the wrist. The best brushes have a seamless ferrule made of cupro-plated nickel, which is strong and resistant to corrosion. Lower-grade brushes may have a plated ferrule with a wrapover join; with repeated use this may tarnish or open up.

SABLE

Sable hair is obtained from the tail of the sable marten, a relative of the mink. Sable brushes are undoubtedly the best choice for watercolor painting. They are expensive, sometimes alarmingly so, but they give the best results and, if cared for well, will last a lifetime. Sable hair tapers naturally to a fine point, so that brushes made from it have very delicate and precise tips which offer maximum control when painting details. Good-quality sable brushes are resilient yet responsive; they hold their shape well and do not shed their hairs, and have a spring and flexibility which produce lively, yet controlled brushstrokes.

Kolinsky sable
The very best sable is Kolinsky sable; it comes from the Kolinsky region of northern Siberia, where the harshness of the climate produces hair that is immensely strong, yet both supple and springy.

Red sable and pure sable
Brushes marked "red sable" or "pure sable" are made from selected non-Kolinsky hair. They do not have quite the spring and shape of Kolinsky, but are perfectly adequate and more moderately priced. However, beware of buying very cheap sable brushes just because they carry the name "sable" – good-quality sable is springy and strong, while being at the same time fine and soft.

Brush making
Even today, brush making is largely a hand-crafted process utilizing traditional components and natural materials (see bottom right).

Portable brushes
Small retractable brushes, with a "traveling" set of pans, are ideal for making sketches when painting outdoors.

SQUIRREL HAIR This is dark brown in color, and is much softer than sable. Although at first sight much cheaper than sable, squirrel-hair brushes are generally a false economy, as they do not point well and have little resilience. Squirrel-hair "mop" brushes, however, retain a large amount of color, allowing extensive washes to be laid quickly and evenly. This makes them an economical alternative to large-size sable wash brushes.

OX HAIR This hair comes from the ear of a breed of cow and is strong and springy, but quite coarse. It does not point very well and is not suitable for making fine-pointed brushes, but it is a very good hair for use in square-cut brushes. Ox-hair brushes usually have a long hair-length, which increases their flexibility.

GOAT HAIR A type of hair often used in traditional Asian watercolor brushes. The hair is soft but sturdy, and goat-hair brushes hold a lot of water. This makes them ideal for laying broad washes and for working wet-in-wet.

SYNTHETIC FIBERS These have been introduced in an attempt to achieve the performance of natural hair at a cheaper price. Sable-type synthetics are a golden-yellow color, and are made from polyester filaments with tapered ends which imitate the real thing. They can be a little stiff and unsympathetic in comparison to natural hair, and have less color-holding capacity, but synthetics in smaller sizes are a better choice for fine work than, say, squirrel hair.

COMBINATION BRUSHES Some manufacturers offer brushes which combine synthetic hair with real sable, to achieve good color-holding and pointing properties at a reasonable cost.

Components and materials used in brushmaking

Quick guide to watercolor-brush hair

Kolinsky sable
The best: very expensive, immensely strong, yet supple and springy.

Red or pure sable
More moderately priced, springy and strong, yet fine and soft.

Squirrel hair
Softer and cheaper than sable, this does not point well and has little resilience. A less-costly alternative to large-size sable wash brushes.

Ox hair
Strong and springy, but quite coarse, it does not point very well. Good hair for square-cut brushes.

Goat hair
Soft but sturdy, ideal for laying broad washes.

Synthetic fibers
These can be a little stiff and unsympathetic, with less color-holding capacity than animal hair.

Combination hair
The brush shown is a combination of squirrel and goat hair. Other blends of animal hairs are available, as are animal-synthetic combinations.

BRUSH SHAPES & SIZES

*Art-supply stores and manufacturers'
catalogs offer a wide range of variations on
watercolor brushes, but those detailed below
will provide all you need for successful
watercolor painting.*

SEE ALSO
Brush-and-ink drawing, page 54
Brushes, page 112

ROUND BRUSHES The round is perhaps the most useful and most common brush shape. A brush of this type can be used for both fine, delicate strokes and broader strokes and flat washes. Apart from the standard length of brush head, rounds also come in short lengths ("spotter" brushes) and long lengths ("rigger" brushes).

SPOTTER BRUSHES Retouching or spotter brushes have a fine point, and the very short head gives extra control. They are used mainly by miniaturists and botanical artists, for precise details.

RIGGER BRUSHES A long-haired round brush is known as a designer's point, writer or rigger (from when the brush was used for painting the finely detailed rigging on sailing ships). The long shape gives an extra-fine point and good color-holding properties, allowing fine lines and tapered strokes.

MOPS AND WASH BRUSHES These are made from synthetic, goat or squirrel hair, and are used for laying in large areas of color quickly. Wash brushes are generally wide and flat, while mops have large round heads.

Starter selection
For a good starter set, choose Nos. 3, 5 and 12 round brushes.

Care of brushes
Brushes will last longer and be far more pleasant to work with if you follow a few simple rules.

While painting, do not leave brushes resting on their bristles in water for long periods, or you may ruin both the hairs and the handles.

Immediately after use, rinse brushes in cold running water, making sure that any paint near the ferrule is fully removed.

After cleaning, shake out the excess water and gently shape up the hairs between finger and thumb. A little starch solution or thinned gum solution stroked onto the bristles will help them retain their shape; it is easily rinsed out with water when the brush is used again.

Leave brushes to dry either flat or up-ended in a pot or jar. When storing brushes for any length of time, make sure they are perfectly dry before placing them in a box that has a tight-fitting lid — mildew may develop if wet brushes are stored in an airtight container.

Moths are attracted to animal-hair bristles, so protect your brushes in the long term with mothballs or a sachet of camphor. Horse chestnuts also keep moths at bay.

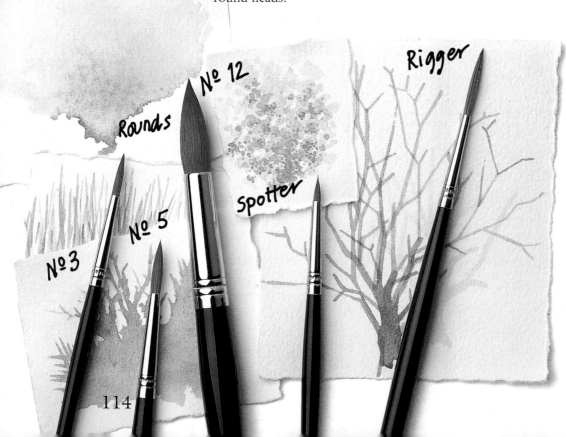

FLAT BRUSHES Flat watercolor brushes are also known as "one-strokes." These square-ended brushes, set into a flattened ferrule, are designed to give a high color-carrying capacity and free flow of color for laying in broad washes, while the chisel end creates firm, clean linear strokes. As with round brushes, a longer-haired flat is available, made from hard-wearing ox hair.

BRUSH SIZES All watercolor brushes are graded according to size, ranging from as small as 000000 to as large as a No. 24 wash brush. The size of a flat brush is generally given by the width of the brush, measured in inches or millimeters. Brush sizes are broadly similar between one manufacturer and another, but they do not appear to be standard – thus a No. 6 brush in one range will not necessarily be the same size as a No. 6 in another.

CHOOSING BRUSHES Experiment with all types and sizes of brush to discover their potential. Eventually, as you develop your individual approach to watercolor, you will settle on a few brushes which are suited to your own way of painting, and which you find comfortable to hold. To start with, a selection of three sable brushes – for instance, a No. 3, a No. 5 and a No. 12 round – should be sufficient.

As a rule, choose the largest suitable brush for any given application, as it is more versatile and holds more color than a smaller version. A fairly large, good-quality brush, such as a No. 12, will cover large areas, yet come to a point fine enough to paint precise details.

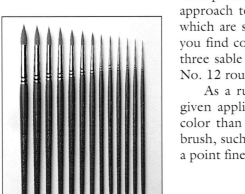

Sable rounds
The brushes shown here range from 000 up to 12; even smaller and larger brushes are available.

Asian brushes
Asian brushes, made from goat, wolf or hog hair set into hollow bamboo handles, are inexpensive and versatile. The thick, tapering head can make broad sweeps of color, and can be drawn up to a very fine point for painting delicate lines. The heads are coated in starch size; remove this by soaking and teasing the hairs in a jar of water for a minute or two.

Orientals

Flats

Mop brush

PALETTES

Watercolor palettes are available in a variety of shapes and sizes, but they all feature recesses or wells which allow you to add the required quantity of water to the paint, and prevent separate colors from running together.

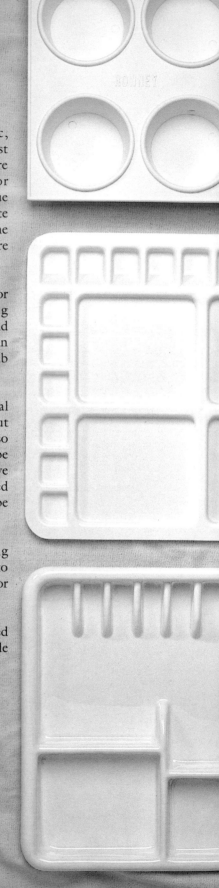

CHOOSING A PALETTE Manufactured palettes are made of white ceramic, enameled metal or plastic; ceramic is perhaps the most sympathetic surface for mixing colors. Plastic palettes are cheap and lightweight; although ideal for outdoor painting, they eventually become stained with paint residue because they are slightly absorbent. Which kind of palette you prefer is largely dependent on personal taste and the scale and style of your work. However, certain types are best suited to particular purposes.

INTEGRAL PALETTES Enameled-metal painting boxes, designed to hold pans or tubes of paint, are particularly useful when working outdoors, as the inside of the lid doubles as a palette and mixing area when opened out. Some boxes also have an integral hinged flap for mixing and tinting, and a thumb ring in the base.

SLANTED-WELL TILES These are long ceramic palettes divided into several recesses or wells, allowing several colors to be laid out without them flowing into one another. The wells slant so that the paint collects at one end ready for use and can be drawn out for thinner washes. Some slanted-well tiles have a row of smaller and a row of larger wells; paint is squeezed into the small wells and moved to the larger wells, to be diluted with water or mixed with other colors.

TINTING SAUCERS These small round ceramic dishes are used for mixing larger quantities of paint. They are available divided into four recesses, for mixing separate colors, or undivided, for mixing a single color.

PALETTE TRAYS When mixing large quantities of liquid paint, you will need a palette with deep wells. These palettes are usually made of plastic or more stain-resistant, high-impact polystyrene.

Improvised palettes

Improvised palettes are cheap and easy to obtain, and artists often prefer them because there is no restriction on size. You can use a variety of household containers, as long as they are white and non-porous. Depending on how large a mixing area you want, a white saucer, plate or enameled pie plate can make a perfectly adequate palette. Hors-d'oeuvres dishes are particularly useful, as they provide several large mixing areas. When mixing large quantities of wash, use old cups, bowls or yogurt pots.

Palettes for watercolor
Shown here and on the opposite page are a selection of manufactured palettes suitable for watercolor painting.

Opposite, from left to right:
Quartered tinting saucer; round cabinet saucers (all ceramic).
Center, from top to bottom:
Deep-well palette tray; large mixing palettes with thumb hole and divisions (all plastic).
Right, from top to bottom:
Enameled-metal painting box with integral palette; ceramic slanted-well tile; segmented white china round palette.

ACCESSORIES

Useful items, such as mediums, masking fluid, scraping tools and sponges, will broaden the range of techniques at your disposal.

SEE ALSO

Watercolor paper, page 26
Flat & graded washes, page 122
Wet-in-wet, page 126
Creating highlights, page 128
Textures and effects, page 132

WATER CONTAINERS

Do not skimp on water when painting in watercolor – use as large a container as you can find, otherwise the water quickly becomes murky as you rinse your brush between washes, and this may spoil the transparency of your colors. Some artists prefer to use two water containers, one for rinsing brushes and the other to use as a dipper when mixing colors.

When painting outdoors, use a plastic water container, which is lighter and less breakable than glass. You can buy collapsible plastic containers with a handle, or simply cut the top off a plastic bottle (see right). You may also have to transport water to your location, and a larger container to decant from will be useful.

• Distilled water
Some watercolor painters prefer to use distilled water for mixing colors, as it contains no impurities.

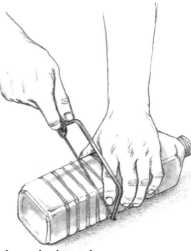

MASKING FLUID

This is a quick-drying, liquid latex used to mask off selected areas of a painting when applying color in broad washes. There are two types available: tinted and colorless. The tinted version is preferable, as it is more versatile and is easier to work with on white paper.

GUM ARABIC

A pale-colored solution of gum arabic in water increases both the gloss and transparency of watercolor paints when mixed with them. Diluted further, it improves paint flow. Too much gum arabic will make paint slippery and jelly-like, but in moderation it enlivens the texture and enhances the vividness of the colors.

Improvised containers
Recycle plastic bottles into useful containers – some bottles have convenient guidelines for cutting. Cut them to the required height with a hacksaw or craft knife; the left-over neck can be used as a funnel.

OX GALL

A straw-colored liquid made from the gallbladders of cattle, which is added to water in jars to improve the flow and adhesion of watercolor paints, particularly for wet-in-wet techniques. It has been largely replaced by synthetic products.

GELATIN SIZE

This liquid, sold in small bottles, may be applied to the surface of a watercolor paper which is too absorbent. Apply with a large soft brush, and leave to dry for a few minutes. The size reduces the absorbency of paper, making it easier to apply washes.

Large for storage

Neck for funnel

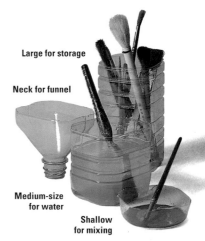

GLYCERIN

You will find glycerin useful when working outdoors in dry conditions. A few drops added to water will counteract the drying effects of wind and hot sun by prolonging the time it takes for watercolor paint to dry naturally.

Medium-size for water

ALCOHOL

This has the opposite effect from glycerin, speeding the drying time of watercolor paint. It is very useful when working outdoors in damp weather conditions.

Shallow for mixing

SCRAPING AND COLOR-LIFTING TOOLS

You can use a single-edged razor blade, scalpel, toothpick, the end of a paintbrush handle, even your thumbnail, for scraping out unwanted areas of still-wet watercolor or for scratching lines into dry paint to create textured effects. Fine sandpaper can be used to rub away some of the color, creating a drybrush-like sparkle. Cotton swabs can be employed for lifting out small areas of still-wet color. Blotting paper is also useful for lifting out color and for mopping up spills.

SPONGES

Natural and synthetic sponges are often used for dabbing on areas of rough-textured paint. They are also used for wetting paper in preparation for applying washes, and to lift out wet paint or mop up paint that has run too much. Natural sponges are more expensive than synthetic ones, but they have a pleasing silky texture and produce interesting random patterns.

Selection of accessories

Shown below is a typical assortment of materials used to create watercolor textures and expand techniques.

Top shelf, from left to right: water container for mixing and wetting; gelatin; ox gall; masking fluid; cotton swabs and toothpicks; natural and synthetic sponges.

Bottom shelf, from left to right: clips for holding paper; gum arabic; glycerin; water container for washing brushes, alcohol; abrasive paper; craft knives and sharpened paintbrushes for lifting and scraping.

WASH TECHNIQUES

Washes are the very foundation of watercolor painting. One of the unique qualities of the medium is the way in which atmosphere and light can be conveyed by a few brushstrokes swept over sparkling white paper.

SEE ALSO

Watercolor paper, page 26
Stretching paper, page 31
Brushes, page 112
Accessories, page 118
Flat & graded washes, page 122
Wet-in-wet, page 126
Wet-on-dry, page 127

Laying washes

CHOOSING PAPER

The following tips will help make successful washes.

The appearance of a wash depends on several factors: the type of pigment used and the level of dilution; the type of paper; and whether the surface is wet or dry when the wash is applied. For example, when washes are applied to an absorbent, low-sized paper, they dry with a soft, diffused quality. On hard-sized paper, wet washes spread more quickly and with less control, but this can create exciting effects. When a wash is laid on dampened paper, the paint goes on very evenly, because the first application of water enables the pigment to spread out on the paper and dissolve without leaving a hard edge. Working on dry paper gives a much sharper, crisper effect, and some painters find it a more controllable method.

Sized paper
The effect of painting washes on low-sized paper (below left) and hard-sized paper (bottom left).

Damp and dry paper
Washes laid on damp paper (below right) and dry paper (bottom right), both medium-sized.

Mix more color than you think will be needed to cover an area — you cannot stop in the middle of laying a wash to mix a fresh supply.

A watercolor wash dries much lighter than it looks when wet, so allow for this when mixing paint.

Tilting the board at a slight angle allows a wash to flow smoothly downward without dripping.

Use a large round or flat brush. The fewer and broader the strokes, the less risk of streaks developing.

Keep the brush well loaded, but not overloaded. Streaking is caused when a brush is too dry, but if your brush is overloaded, washes can run out of control.

Don't press too hard. Sweep the brush lightly, quickly and decisively across the paper, using the tip, not the heel.

Never work back into a previously laid wash to smooth it out — it will only make matters worse.

Low-sized paper for soft and diffused washes

Medium-sized wet paper for softer washes

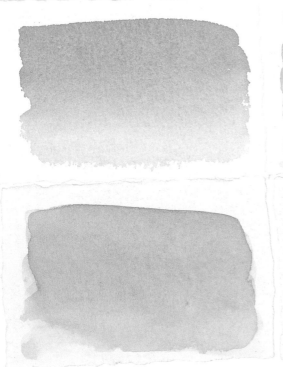

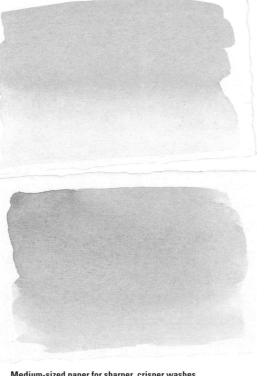

Hard-sized paper for quick-spreading washes

Medium-sized paper for sharper, crisper washes

ACHIEVING SMOOTH WASHES

Wash-laying equipment

Laying a large, overall wash free of streaks or runs requires practice. Where heavy washes are to be applied, the paper must be stretched and taped firmly to a board, to prevent cockling or wrinkling. Opinions vary as to whether large areas of wash should be laid on dry or damp paper. Some artists find that a uniform tone is easier to achieve on dry paper, while others find that the paint streaks. Some feel that washes flow more easily on damp paper, and still others find that slight cockling, even of stretched paper, can produce streaks and marks as the paint collects in the "dips." Results vary, too, according to the type of paper used; the only answer is to experiment for yourself.

Wash-laying equipment

In addition to natural sponges, synthetic-sponge rollers and sponge brushes (left) can be used to lay a smooth wash. For a dense, thick covering, make sure the sponge is filled with plenty of paint. For paler tones or variegated effects, squeeze out some of the paint.

Robert Tilling
ROCKS, LOW TIDE
Watercolor on paper
20 x 26in (50 x 65cm)

Tilling uses the wet-in-wet method to explore the interactions of sky, sea and land. He mixes large quantities of paint in old teacups and applies it with large brushes, tilting his board at an acute angle so that the colors flow down the paper, then reversing the angle to control the flow. When the paper has dried, he paints the dark shapes of rocks and headland wet-on-dry for crisper definition.

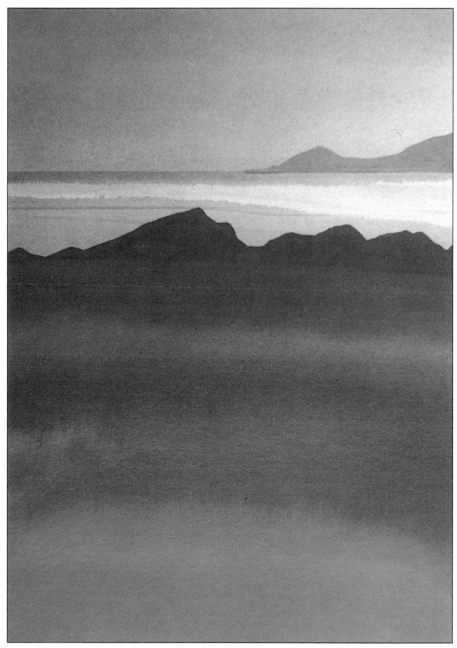

FLAT & GRADED WASHES

There are two basic types of wash: a flat wash is evenly toned and is often used to cover the whole area of the paper with a unifying background color. A graded wash moves gradually from light to dark, from dark to light, or from one color to another. Graded washes are most often used in painting skies, where the color fades gradually towards the horizon.

SEE ALSO
Wash techniques, page 120
Wet-in-wet, page 126
Wet-on-dry, page 127
Skies, page 207

FLAT WASHES

Watercolorists normally employ flat washes as integral parts of a painting, frequently overlaying one wash with another. However, a flat wash is also used merely to tint white paper as a background for body color or gouache.

Laying a basic wash
Here the flat-wash method is used to create an overall sky effect using diluted indigo blue.

1 Mix up plenty of color in a saucer or jar. Place the board at a slight angle, then dampen the paper surface with water, using a mop brush or a sponge.

2 Load the brush with paint and draw a single, steady stroke across the top of the area. The angle of the board will cause a narrow bead of paint to form along the bottom edge of the brushstroke; this will be incorporated into the next stroke.

3 Paint a second stroke beneath the first, slightly overlapping it and picking up the bead of paint. Continue down the paper with overlapping strokes, each time picking up the excess paint from the previous stroke. Keep the brush well loaded with paint.

4 Use a moist, clean brush to even up the paint that gathers along the base of the wash. Leave to dry in the same tilted position, otherwise the paint will flow back and dry, leaving an ugly tidemark.

1 Dampen the paper surface with a sponge.

2 Draw a single stroke across the top.

3 Paint a second stroke beneath the first.

4 Even up any paint that gathers along the base.

GRADED WASHES The method of applying a graded wash is the same as for a flat wash, except that with each successive brushstroke the brush carries more water and less pigment (or vice versa if you are working from light to dark).

It takes a little practice to achieve a smooth transition in tone, with no sudden jumps. The secret is to apply a sufficient weight of paint so that the excess flows very gently down the surface of the paper, to be merged with the next brushstroke.

Wash-laying technique
Here the graded-wash technique is used to create another sky scene. Cobalt blue is diluted with water in each subsequent brushstroke.

1 Dampen the paper as for laying a flat wash, and lay a line of color at full strength across the top of the area to be painted. Allow the color to spread and even out.

2 Quickly add a little more water to the paint on your palette and lay a second band of color, slightly overlapping the first.

3 Continue down the paper, adding more water to the paint with each succeeding stroke and ending with a stroke of pure water. As with flat washes, the brush used to mop up paint along the base of the wash must be clean and moist. Leave to dry in the same tilted position as for flat washes.

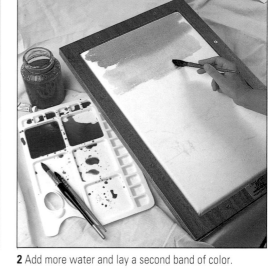
1 Lay a line of color at full strength across the top.

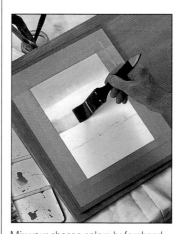
2 Add more water and lay a second band of color.

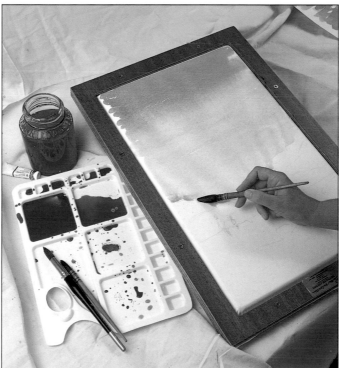
3 Continue down the paper, adding water to the paint with each stroke.

Variegated washes
The technique shown below enables you to lay two or more colors in a wash.

Mix your chosen colors beforehand, and then apply the first line of color along the top of the paper. Always washing the brush between colors, apply another color, partly on blank paper and partly touching the first. Repeat this with any other colors.

123

Sophie Knight
STILL-LIFE REFLECTIONS
Watercolor and acrylic on paper
14 x 22in (35 x 55cm)

John Blockley
SHOP FLOWERS
Watercolor on paper
17 x 17in (43.2 x 43.2cm)

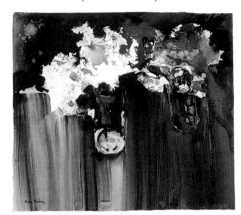

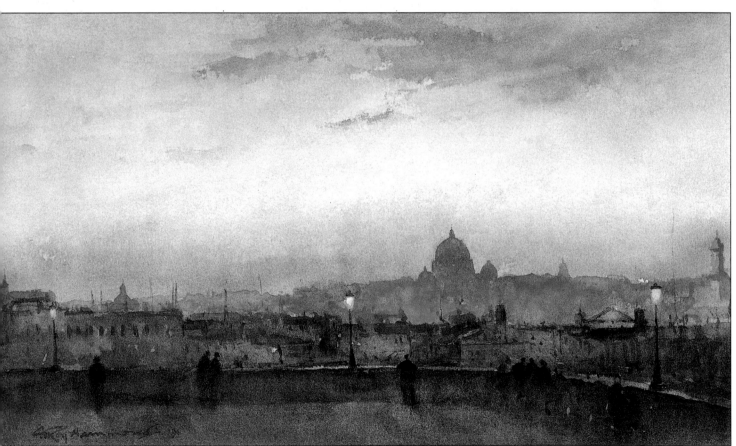

Roy Hammond
LONDON SUNSET
Watercolor on paper
6½ x 9½in (16.2 x 23.7cm)
Chris Beetles Gallery, London

Different approaches
Experiment with watercolor and get to know its characteristics. With experience, you will develop a painting style as unique and individual to you as your handwriting style.

It is interesting to compare the two very different approaches to a similar theme adopted by Penny Anstice and Ron Jesty. Working on damp paper, Anstice applies wet pools of color and allows them to flood together, relishing the element of chance that makes wet-in-wet such an exciting technique.

In contrast, Jesty uses a careful and methodical approach, building up form and tone with superimposed washes applied wet-on-dry. He leaves the painting to dry between stages so that the colors aren't muddied but remain crisp and clear.

Penny Anstice
NECTARINES
Watercolor on paper
12 x 18in (30 x 45cm)

Variety and contrast (opposite)
A flower painting, a table-top still life and a landscape demonstrate some of the variety of technique and contrast of style which can be achieved with watercolor.

The flower painting (above left) belies watercolor's reputation for being a medium for little old ladies. Blockley attacks his subjects with gusto – here using broad household paintbrushes to apply vertical streaks of color in the foreground.

Watercolor is combined with acrylic paint (above right) to give it body while retaining its translucence. Most of the paint is applied wet-in-wet, so that the shapes and colors are suggested rather than literally described.

The evening sky (left) has been beautifully described by means of graded washes of pale, pearly color. The dark tones of the buildings, painted with overlaid washes, accentuate the luminosity of the sky.

Ronald Jesty
THREE FIGS
Watercolor on paper
6 x 8¼in (15 x 20.6cm)

Wet-in-wet

Wet-in-wet is one of the most expressive and beautiful techniques in watercolor painting. When colors are applied to either a damp sheet of paper or an area of still-wet paint, they run out over the wet surface, giving a soft, hazy edge to the painted shape. This technique is particularly effective in painting skies and water, producing gentle gradations of tone which evoke the ever-changing quality of light.

SEE ALSO

Watercolor paper, page 26

Stretching paper, page 31

Wash techniques, page 120

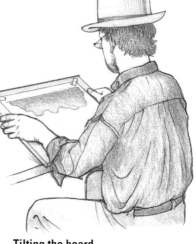

Tilting the board
The board should be tilted at an angle of roughly 30 degrees so that the colors can flow gently down the paper. If the board is laid flat, washes cannot spread and diffuse easily, and there is a danger of colors creeping back into previously laid colors, creating unwanted marks and blotches.

CHOOSING PAPER

It is vital to choose the right type of paper for wet-in-wet. Avoid papers which are too smooth or which are heavily sized, as the paint tends to sit on the surface. A gently absorbent Not (cold-pressed) surface is ideal, allowing washes to fuse into the paper structure. The paper should also be robust enough to bear up to frequent applications of water without cockling. Lighter papers must be stretched and taped to the board. With heavier-grade papers of 200lb (410gsm) or over, you may get away without stretching, but where heavy applications of wash are to be used, it is best to err on the side of caution.

CONTROLLING WET-IN-WET

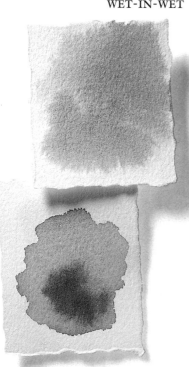

Although wet-in-wet painting produces spontaneous effects, it takes practice and experience to be able to judge how wet the paper and the strength of the washes need to be, in order to control the spread and flow of the paint.

Use a soft sponge or large brush to dampen the paper with clean water. The surface should be evenly damp overall; use a tissue to blot up any pools of water, then take your courage in both hands – and your brush in one – and apply the colors. Work quickly and confidently, allowing the colors to diffuse and go where they will. Some degree of control can be gained by tilting the board in any direction, but only slightly – this is where the interest and creative tension come in. If a wash runs out of control or goes where it shouldn't, lift out some of the color with a soft, dry brush, or gently blot it with a tissue.

Dilution and color

Make sure not to over-dilute paint, as this can make the finished picture appear pale and wan. Because you have wet the paper, it is possible to use rich paint – but not so thick that it doesn't spread. The paint will keep its rich hue as it softens on the damp paper. The color will appear darker when wet and will dry to a lighter shade, particularly where an absorbent paper is used, so make allowances for this when applying paint.

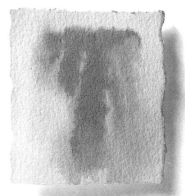

Wet-in-wet effects
Paint applied directly onto wet paper (left, top). Paint applied into wet paint (left, bottom). Controlled single-color paint run on wet paper (above).

WET-ON-DRY

In this classic technique, tones and colors are applied in a series of pure, transparent layers, one over the other; each wash is allowed to dry before the next is added.

SUPERIMPOSED COLOR

The dry surface of the paper "holds" the paint, so that brushstrokes will not distort or run out of control. Light travels through each transparent wash to the white paper beneath, and reflects back through the colors. Superimposed washes of thin, pale color result in more resonant areas of color than can be achieved by a single, flat wash of dense color.

CHOOSING PAPER

The most suitable paper for this technique is one which is surface-sized, presenting a smooth, hard surface that holds the paint well. Working wet-on-dry requires a little patience, as each layer must dry before the next is applied; otherwise the colors will mix and become muddied, and crispness and definition are lost. To speed up the process, you can use a hair dryer on a cool-to-warm setting – let the wash sink in a little first, otherwise it will get blown around on the paper and lose its shape.

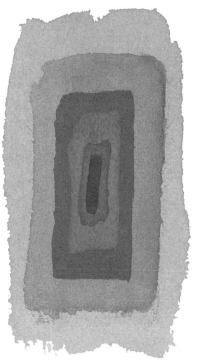

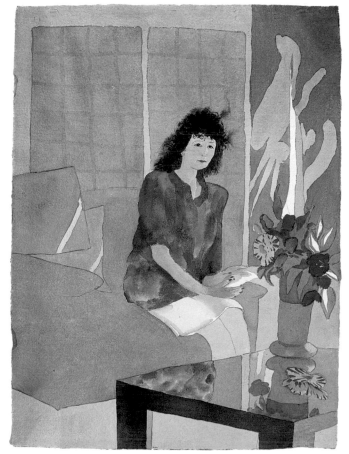

Patrick Procktor
PORTRAIT OF EMIL ASANO
Watercolor on paper
25½ x 18¾in (63.5 x 47cm)
Redfern Gallery, London

The success of this painting relies on the simplicity of the design and the controlled, almost restrained, use of two basic watercolor techniques. A series of flat washes indicates the walls and furnishings, capturing the oriental simplicity of the interior. The pattern of the blouse employs the wet-in-wet technique, successfully conveying the softness and fluid color of the model's costume, which is also reflected in the table top. Note, too, the softness of the hairline against the background, again achieved by working wet-in-wet.

Keeping colors fresh
If you apply too many layers of paint, the attractive delicacy and freshness of the medium may be lost. It is best to apply a few layers confidently rather than risk muddying the painting by continually adding more, so it is advisable always to test colors by layering them on scrap paper (above) before committing them to the surface. Another common cause of muddy colors is dirty water, so always rinse your brush thoroughly between colors and ensure that you regularly refill your water jar with clean water.

CREATING HIGHLIGHTS

Many inexperienced watercolorists make the mistake of trying to cover every part of the paper with paint: in fact, with watercolor this is neither necessary nor desirable. The light-reflecting surface of watercolor paper provides a uniquely brilliant white which can be used to great effect, adding sparkle to your colors and allowing the painting to "breathe." Described below are some of the techniques used to manipulate the paint to create white highlights in a watercolor wash.

SEE ALSO
Watercolor paper, page 26
Pigment and color, page 108
Body color, page 109
Accessories, page 118

Creating a soft edge
Use damp paper or blend into the white area with a soft, damp brush.

RESERVING WHITE AREAS

The simplest way to create white highlights in a watercolor painting is to paint around them, thereby preserving the white of the paper, with its brilliant light-reflecting properties. Reserving highlights in this way requires careful planning, because it is not always possible to retrieve the pristine white of the paper once a color has been inadvertently applied.

When you paint around an area to be reserved for a highlight, the paint will dry with a crisp hard edge. For a softer edge, work on damp paper or blend colored edges into the white area with a soft, damp brush while the paint is still wet.

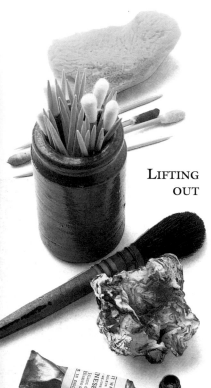

Lifting out wet paint
Use a soft brush, a sponge or a tissue for soft highlights.

LIFTING OUT

Another method of creating highlights is by gently removing color from paper while it is still wet, using a soft brush, a sponge or a tissue. This lifting-out technique is often used to create soft diffused highlights, such as the white tops of cumulus clouds. It can also be used to soften edges and to reveal one color beneath another.

Paint can be lifted out when dry by gentle coaxing with a damp sponge, brush or a cotton swab. Results will vary according to the color to be lifted (strong stainers such as alizarin crimson and phthalocyanine green may leave a faint residue) and the type of paper used (paint is more difficult to remove from soft-sized papers). In some cases, pigment may be loosened more easily using hot water, which partially dissolves the gelatin size used on the surface of the paper.

Lifting out dry paint
Use a damp sponge, brush or a cotton swab.

Using body color
Small amounts of body color can provide the finishing touches.

USING BODY COLOR

Some of the greatest watercolorists, from Dürer to Turner to Sargent, used touches of body color for the highlights in their paintings, with breathtaking results. As long as opaque parts of the painting are as sensitively and thoughtfully handled as transparent areas, they will integrate naturally into the whole scheme.

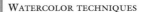

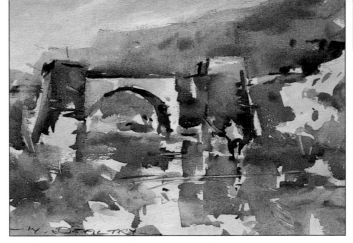

In this fresh painting, broad washes have been rapidly manipulated with a flat brush, simplifying the scene almost to abstraction, yet keeping its essential character. The unpainted areas give an impression of movement and changing light.

William Dealtry
NORTH YORKSHIRE STREAM
Watercolor on paper
6½ x 9in (16.2 x 22.5cm)
Brian Sinfield Gallery, Burford

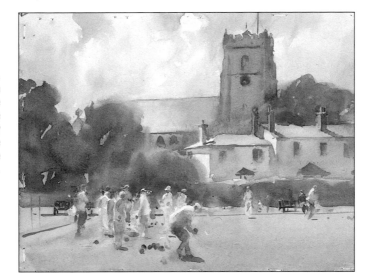

A quintessential country scene, Chamberlain's painting exudes an air of calm and tranquillity. The effect of sunlight glancing off the players' white shirts is skillfully wrought by means of a little judicious lifting out of color to create suffused highlights.

Trevor Chamberlain
BOWLS MATCH, SIDMOUTH
Watercolor on paper
9 x 12in (22.5 x 30cm)

Hercules B. Brabazon
(1821-1906)
CADIZ, 1874
Watercolor and body color on
tinted paper
10½ x 14in (26.2 x 35cm)
Chris Beetles Gallery, London

Although he did not receive public recognition until the age of 71, Brabazon's bravura technique and boldly conceived compositions placed him among the most progressive artists of his day. This painting is typical of his ability to pare down to the essentials of his subject. It is painted with transparent color on tinted paper, with rich, creamy accents provided by white body color overlaid with watercolor.

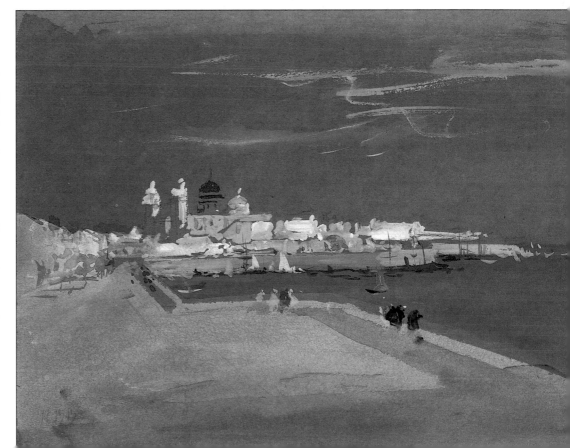

SEE ALSO
Watercolor paper, page 26
Brushes, page 112
Accessories, page 118

MASKING OUT

Because of the transparent nature of watercolors, light colors and tones cannot be painted over dark ones, as they can in oils or acrylics. Light or white areas must be planned initially and painted around. This is not difficult for broad areas and simple shapes, but preserving small shapes, such as highlights on water, can be a nuisance, as the method inhibits the flow of the wash.

One solution is to seal off these areas first with masking fluid, thus freeing yourself from the worry of accidentally painting over areas you wish to keep white.

Using masking fluid

Masking fluid is a liquid, rubbery solution which is applied to paper with a brush. It dries quickly to form a water-resistant film which protects the paper underneath it. When both the masking fluid and the surrounding paint are dry, the fluid can be removed by rubbing with a clean fingertip or with an eraser.

Masking fluid can also be used in the later stages of a painting, to preserve areas of any specific tone or color in a surrounding wash (make sure the area to be preserved is completely dry before applying the fluid).

Ideally, masking fluid should be removed from a painting within 24 hours of application, otherwise it will be difficult to rub off and may leave a slight residue.

If you intend to use masking fluid, choose a paper with a Not (cold-pressed) surface, from which it is easily removed; it is not suitable for rough papers, as it sinks into indentations and cannot be peeled off completely.

Highlights created with sandpaper

SCRATCHING OUT

Fine linear highlights, such as light catching blades of grass, can be scratched out of a painted surface when it is dry, using a sharp, pointed tool, for instance a scalpel or craft knife, or even a razor blade. Avoid digging the blade into the paper, and work gently by degrees.

DIFFUSED HIGHLIGHTS

A more diffused highlight, such as the pattern of frothy water on ocean waves or waterfalls, can be made by scraping the surface gently with the side of the blade or with a piece of fine sandpaper. This removes color from the raised tooth of the paper only, leaving color in the indents and creating a mottled, broken-color effect.

More delicate, muted highlights can be scratched out of paint that is not quite dry, using the tip of a paintbrush handle, or even your fingernail – Turner is said to have grown one fingernail long, especially for scratching out highlights from his watercolors.

Blades, abrasive papers and sharpened brush handles make useful highlighting tools

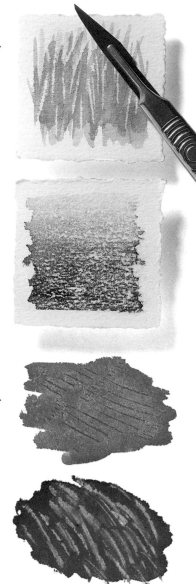

Scratched highlights and marks
The examples above show four ways to create highlights: (from top to bottom) scratching with a blade point; scratching with a blade edge; scraping with a blunt paintbrush handle; scraping with a sharpened paintbrush handle

Cleaning brushes

Masking fluid is tough on brushes – even with careful cleaning, dried fluid can build up on brush hairs over a period of time. Always use cheap synthetic brushes to apply fluid – not your best sable! The best method of cleaning synthetic brushes is to rinse them in lighter fluid and leave them to dry.

• Using masking fluid

Before using, shake the bottle to ensure the correct consistency. Too-thin fluid will not resist paint. Once opened, a bottle of masking fluid has a shelf life of around one year. After this, it will not work well. Excessive heat can make masking fluid unworkable. When painting in hot climates, store masking fluid somewhere cool, and work in the shade when applying it to paper.

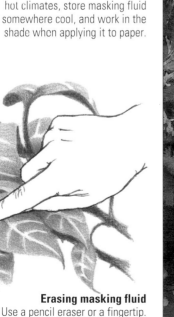

Erasing masking fluid

Use a pencil eraser or a fingertip.

Shirley Trevena
WHITE LILIES ON A
PATTERNED SCREEN
Watercolor and
gouache on paper
18¼ x 14¼in (45.5 x 35.5cm)

On the asian screen (see detail above), the patterns were painted with masking fluid before the dark washes were applied. The mask was then removed and the mother-of-pearl colors painted in.

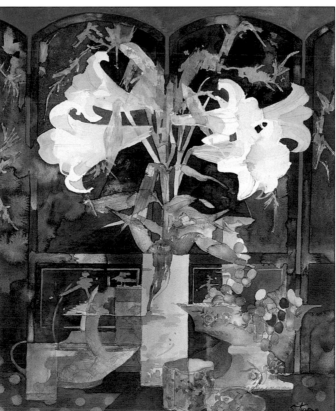

Masking-fluid effects

Masking fluid is an invaluable accessory to watercolor painting. Use it where you want light areas or highlights to appear in your picture. Apply paint over the masking fluid and then remove it (see left) to reveal the white of the paper or the previously laid color (above).

131

Textures & Effects

SEE ALSO
Pigment and color, page 108
Accessories, page 118
Wash techniques, page 120
Creating highlights, page 128

Pigment granulation
Some pigments show a tendency to granulate or flocculate, producing subtly textured washes, while others produce flat, even washes. An understanding of how different pigments behave will open up exciting possibilities for creating particular effects.

One of the attractions of watercolor is its freshness and immediacy – its power to suggest without overstatement. The experienced artist knows that, very often, magical things happen quite unexpectedly when water and pigment interact on paper; the paint actually does the work for you, producing atmospheric effects or patterns that resemble natural textures. A "bloom" appears in a wash, resembling a storm cloud; a wash dries with a slightly grainy quality that adds interest to a foreground; or a swiftly executed brushstroke catches on the ridges of the paper and leaves a broken, speckled mark suggestive of light on water.

"IN MY CASE, ALL PAINTING IS AN ACCIDENT. . . . IT TRANSFORMS ITSELF BY THE ACTUAL PAINT. I DON'T, IN FACT, KNOW VERY OFTEN WHAT THE PAINT WILL DO, AND IT DOES MANY THINGS WHICH ARE VERY MUCH BETTER THAN I COULD MAKE IT DO. PERHAPS ONE COULD SAY IT'S NOT AN ACCIDENT, BECAUSE IT BECOMES PART OF THE PROCESS WHICH PART OF THE ACCIDENT ONE CHOOSES TO PRESERVE."

FRANCIS BACON (1909-92)

SUBTLETY AND RESTRAINT

Because these effects occur naturally, they do the job without appearing labored. Of course, it is possible for the artist to take an interventionist approach and deliberately manipulate the paint or even add things to it, in order to imitate certain textures and surface effects. Some of these techniques are described below, but it is important to realize that, if they are overdone, texturing techniques can easily appear facile. Use them with subtlety and restraint, so that they are incorporated naturally within the painting as a whole.

GRANULATION

This is a phenomenon which often occurs seemingly by accident, yet can impart a beautiful, subtle texture to a wash. Certain watercolor pigments show a tendency to precipitate: the pigment particles of the earth colors, for example, are fairly coarse. As the wash dries, tiny granules of pigment float in the water and settle in the hollows of paper, producing a mottled effect. Only experience and testing will tell you how much granulation may take place. Some colors granulate only when they are laid over a previous wash; and granulation may not happen at all, or may be hardly noticeable, if paint is heavily diluted.

FLOCCULATION

A similar grainy effect is produced by pigments, such as Ultramarine blue, which flocculate: the pigment particles are attracted to each other rather than dispersing evenly. This causes a slight speckling which lends a wonderful atmospheric quality to skies and landscapes in particular.

Simply by experimenting with paints, and knowing which colors have this settling tendency, it is possible to effortlessly suggest textures such as weatherbeaten rocks, newly fallen snow, or sand.

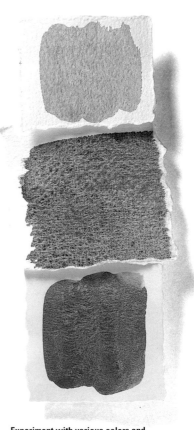

Experiment with various colors and makes to find out which pigments tend to granulate or flocculate

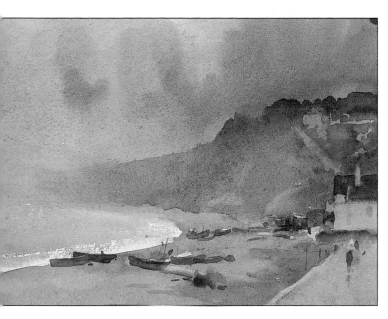

Trevor Chamberlain
RAIN AT BUDLEIGH SALTERTON
Watercolor on paper
7 x 10in (17.5 x 25cm)

Granulation of pigments
Certain watercolor pigments separate out, giving a granular effect which can be subtly descriptive and expressive.

In each of the three paintings on this page, the artists have made quite deliberate use of granulation. It enlivens the background wash in Patrick Procktor's portrait, while Trevor Chamberlain and Robert Tilling have used it to suggest subtle, atmospheric effects in the sky and landscape.

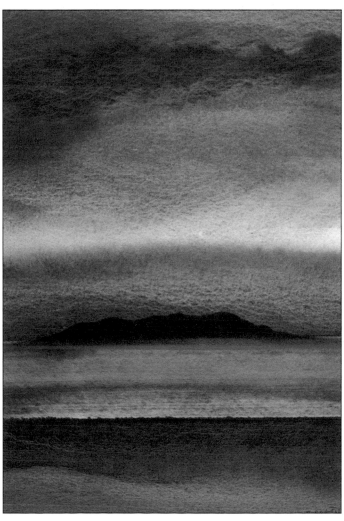

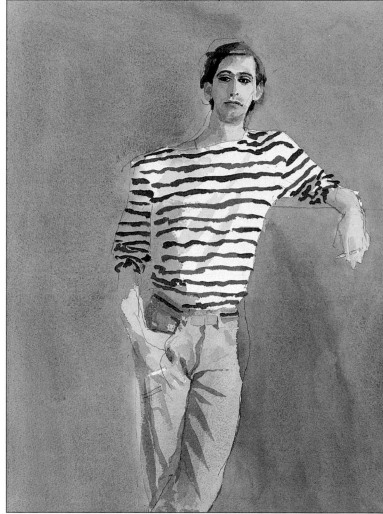

Robert Tilling
EVENING LIGHT
Watercolor on paper
26 x 20in (65 x 50cm)

Patrick Procktor
VASCO
Watercolor on paper
20⅜ x 14¼in (50.8 x 35.5cm)
Redfern Gallery, London

133

BLOOMS

Blooms, or backruns, sometimes occur when a wet wash is flooded into another, drier wash; as the second wash spreads, it dislodges some of the pigment particles beneath. These particles collect at the edge of the wash as it dries, creating a pale, flower-like shape with a dark, crinkled edge.

Although blooms are usually accidental – and often unwanted – they can be used to create textures and effects that are difficult to obtain using normal painting methods. For example, a series of small blooms creates a mottled pattern suggestive of weathered, lichen-covered stone; in landscapes, blooms can represent amorphous shapes such as distant hills, trees and clouds, or ripples on the surface of a stream; and they add texture and definition to the forms of leaves and flowers.

SEE ALSO
Watercolor paper, page 26
Brushes, page 112
Accessories, page 118
Wash techniques, page 120

Creating blooms
It takes a little practice to create deliberate blooms. Apply the first wash and allow it to dry a little. When the second wash is applied, the first should be damp rather than wet; if it is too wet, the washes will merge together without a bloom.

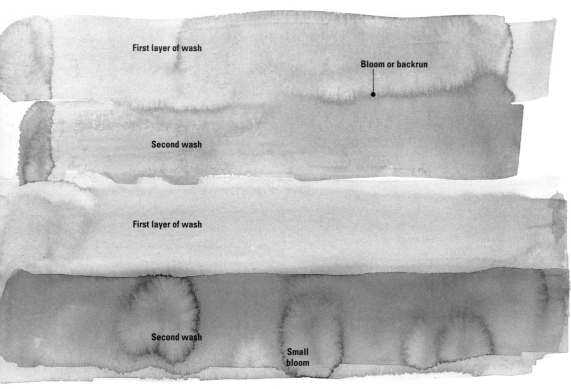

First layer of wash

Bloom or backrun

Second wash

First layer of wash

Second wash

Small bloom

Making small blooms
Small, circular blooms are formed by dropping paint from the end of a brush into a damp wash. You can also create pale blooms in a darker wash by dropping clear water into it.

DRYBRUSH

The drybrush technique is invaluable in watercolor painting, because it can suggest complex textures and details by an economy of means. Drybrush is used most often in landscape painting, to suggest natural effects such as sunlight on water, the texture of rocks and tree bark, or the movement of clouds and trees.

Moisten your brush with a very little water, and then take up a small amount of paint on the tip. Remove any excess moisture by flicking the brush across a paper towel or a dry rag before lightly and quickly skimming the brush over dry paper.

• Drybrush technique
This is most effective on rough-textured paper, where the pigment catches on the raised tooth of the paper and misses the hollows, leaving tiny dots of white which cause the wash to sparkle with light.

John Lidzey
INTERIOR WITH HAT
Watercolor on paper
18 x 12in (45 x 30cm)

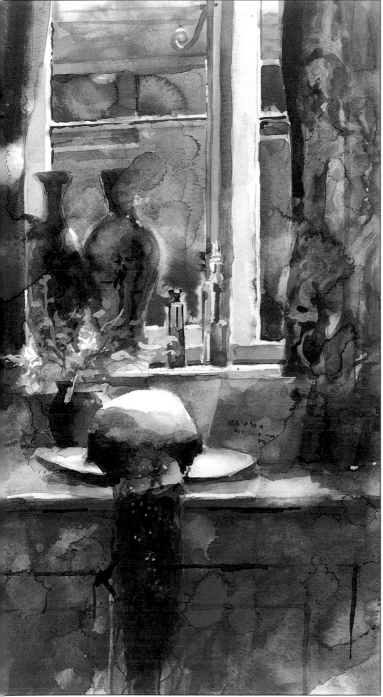

Unpredictable effects
The experienced watercolorist has experimented, and knows how to exploit the element of "happy accident" in the paint.

The mercurial, unpredictable nature of watercolor is one of its chief joys. In the still-life paintings on this page, both artists have used the descriptive potential of backruns to suggest textures and enrich the picture surface.

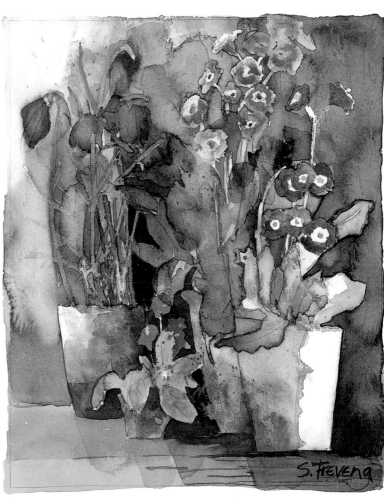

Shirley Trevena
FOUR FLOWERPOTS
Watercolor on paper
11 x 8⅜in (27.5 x 21.5cm)

SEE ALSO
Watercolor paper, page 26
Brushes, page 112
Accessories, page 118

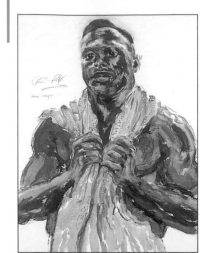

Hans Schwarz
GLAZZ CAMPBELL,
AFTER TRAINING
Watercolor on paper
32 x 22in (80 x 55cm)

Brushmarks and effects
Brushmarks and effects play a vital and expressive part in watercolor painting.

Hans Schwarz has used a bold and direct approach, the brushmarks following and sculpting the forms of the face and figure to produce a lively, energetic portrait.

John Blockley's painting method involves a continual and daring process. He makes some areas wetter than others, then dries only some parts with a hair dryer. He then plunges the painting into a bath of water; the dry paint remains intact, but the wet paint floats off, leaving areas of white paper lightly stained with color.

John Blockley
TABLE FLOWERS
Watercolor on paper
18½ x 15in (47 x 38cm)

USING SALT

Unpredictable effects can be obtained by scattering grains of coarse rock salt into wet paint. The salt crystals soak up the paint around them; when the picture is dry and the salt is brushed off, a pattern of pale, crystalline shapes is revealed. These delicate shapes are effective in producing the illusion of falling snow in a winter landscape, or for adding a hint of texture to stone walls and rock forms.

Although it may seem an easy technique, timing the application of salt requires practice. The wash should ideally be somewhere between wet and damp, neither too wet nor too dry. Applying salt to a wet wash will create large, soft shapes; applying it to a barely damp wash will produce smaller, more granulated shapes. Apply the salt sparingly to a horizontal surface, let it dry, and then brush the salt off.

Using salt
As salt crystals soak up paint, a pattern of shapes emerges.

USING A SPONGE

Painting with a sponge creates textures and effects which are often impossible to render with a brush. For example, a mottled pattern suggesting clumps of foliage or the surface of weathered stone may be produced by dabbing with a sponge dipped in paint. Use a natural sponge, which is softer and more absorbent than a synthetic sponge, and has an irregular, more interesting texture.

Using a sponge
Apply paint lightly with a natural sponge for textural effects.

WAX RESIST

A broken texture can be created by rubbing or drawing with a white wax candle or a colored wax crayon and then overpainting with watercolor. Wax adheres unevenly to paper, catching on the raised tooth and leaving the hollows untouched. When a wash of color is applied, the wax repels the paint, causing it to coagulate in droplets. The broken, batik-like effect created by wax resist can be used to suggest textures and surface effects, such as rocks, tree bark, sand, or light on water or grass.

This technique works best on a Not or rough surface. Skim a candle or wax crayon across the paper so that it touches the high points but not the indents, then apply your watercolors in the normal way. When the painting is completely dry, the wax can be removed by covering it with absorbent paper and pressing with a cool iron until the paper has absorbed all the melted wax.

Using a candle
Paint over rubbed- or drawn-on wax to create natural-looking textures.

USING TURPENTINE

In a variation on the resist technique, turpentine or mineral spirits can be sparingly applied to well-sized paper, allowed to dry slightly and then painted over. The paint and the oil will separate, creating an interesting marbled effect.

Turpentine, salt and wax can be used to create unpredictable textures

Using turpentine
Another version of the resist method involves applying turpentine.

GOUACHE

The term "gouache" originates from the Renaissance, when the Italian masters painted "a gouazzo" – with water-based distemper or size paints. The opacity of gouache and its matte, chalky appearance when dry, make it a quite separate and distinct medium from pure, transparent watercolor, but the equipment, supports and techniques used are similar for both media.

SEE ALSO
Watercolor paper, page 26
Pastel paper, page 32
Watercolor paints, page 104
Accessories, page 118
Acrylic mediums, page 156

PAINTS

The best-quality gouache paints contain a very high proportion of pigment; its density creates an opaque effect. The colors are therefore pure and intense, and create clean color mixes. Because the natural covering power of each pigment is not increased artificially, it varies according to the pigment. The less-expensive gouache ranges contain an inert white pigment, such as chalk or blanc fixe, to impart smoothness and opacity.

Availability of gouache
Standard-size tubes are convenient when painting outdoors, but jars of gouache are more economical for large-scale paintings.

Testing gouache
In terms of permanence, covering power and flow, gouache colors vary considerably from one manufacturer to another, and it is advisable to try out samples from different ranges in order to determine which are best suited to your method of working.

CHOOSING PAINT

Gouache paints are sold in tubes, jars and bottles, often labelled "designers' color." This refers to the medium's popularity with graphic designers, who require bright colors with a matte finish. A vast range of colors is available, but this includes some brilliant colors which are fugitive; while this does not matter to designers, whose work is of a temporary nature, these fugitive colors are not recommended for fine permanent painting.

COLOR MIGRATION

Certain dye-based gouache colors – lakes, magentas and violets – have a tendency to "migrate," or bleed through when overpainted with light colors. One solution is to apply bleed-proof white between layers, to halt any further migration. This is a very dense designers' color that may be classed as gouache.

Preventing color migration
Colors may be mixed with acrylic glaze medium, which converts gouache into paint with an acrylic finish that is flexible and water-resistant. It allows washes to be superimposed without disturbing those below.

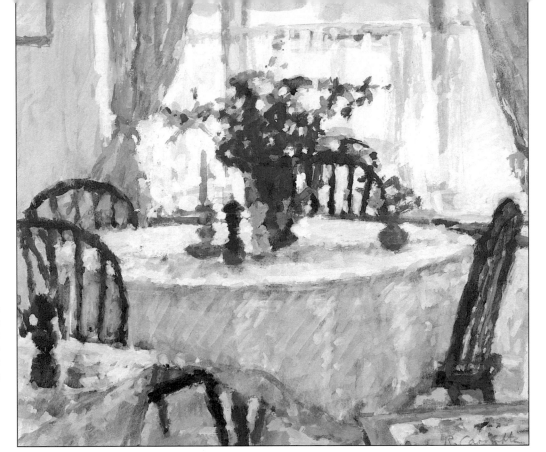

Rosemary Carruthers
WINDOW TABLE
(THE MOORINGS)
Gouache on paper
8½ x 9½in (21.2 x 23.7cm)
Llewellyn Alexander Gallery, London

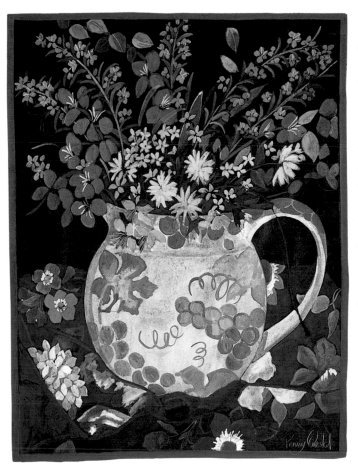

Penny Quested
STILL LIFE WITH FLOWERS
Gouache on Japanese paper
27 x 23in (67.5 x 57.5cm)

The versatility of gouache
Depending on your temperament as an artist, you can choose either to exploit the brilliance and opacity of gouache or to create soft, subtle effects.

Although gouache is used in much the same way as watercolor, the feel of a gouache painting is more solid and robust. This quality is exploited to the full in the still life (left), in which the exuberance of the flowers is matched by the artist's joyous, uninhibited use of color.

In contrast, the interior study (above) evokes a quiet, reflective mood. Here, the artist has used overlaid washes of semi-opaque color, softened with white. The matte, airy quality of the paint surface beautifully recreates the suffused light on the scene.

139

Basic Palette

As with the basic watercolor palette, this selection of colors will enable you to discover the basic characteristics of gouache paints. The selection may then be augmented by further colors from the range available, depending on the subjects you wish to paint.

SEE ALSO

Oils supports, page 12
Watercolor paper, page 26
Pastel paper, page 32
Pigment and color, page 108
Watercolor brushes, page 112

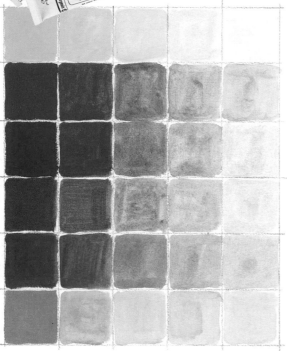

Gouache mixed with water

Gouache mixed with permanent white

Starting selection, from top to bottom

Cadmium yellow
Permanence excellent (ASTM I).
Lemon shades through to warm orange.
Mixes well, forming strong greens when mixed with viridian.

Cadmium red
Permanence excellent (ASTM I).
Warm orange-red to deep red.
A strong, pure pigment, excellent in mixes.

Ultramarine blue
Permanence excellent (ASTM I).
Deep blue with a slightly violet tinge.
When mixed with yellows, provides a useful, versatile range of greens.

Raw umber
Permanence excellent (ASTM I).
Brown with a slightly greenish-brown tinge.
Good for neutralizing other colors.

Viridian
Permanence excellent (ASTM I).
Cool, bluish green.
Retains its brilliance, even in mixes.

Yellow ochre
Permanence excellent (ASTM I).
Soft, golden yellow.
Tones down brighter colors in mixes.

Starting selection

All manufactured gouache colors are opaque and have a high degree of permanence; a starting selection is shown right. The colors can be mixed together and thinned with water (above left) to create transparent colors which look similar to true watercolor paint, or mixed with white paint (above right) to create opaque tints.

The ASTM (American Society for Testing and Materials) codes for lightfastness:

ASTM I – excellent lightfastness
ASTM II – very good lightfastness
ASTM III – not sufficiently lightfast

• Permanent white
Permanence good (ASTM II).
Cool white with good covering power. Include this color in your starter palette.

Edward McKnight Kauffer (1890-1954)
UNTITLED LITHO PRINT, 1919
30 x 44¾in (75 x 112cm)
Museum of Modern Art, New York

Posters were traditionally painted on board or stretched paper with gouache, tempera or cheap and impermanent "poster colors." Gouache colors were the first choice of graphic designers and commercial artists for many years. Their strong color and solid, velvety, non-reflective surface finish photograph well, enabling artwork to be converted accurately to print.

SUPPORTS

Since gouache is opaque, the translucency of white paper is not as vital as it is in watercolor, so it can be applied to a wide variety of supports. Lightweight papers should be avoided; the paint film of gouache is thicker than that of watercolor, and is liable to crack if used on a too-flimsy support. Gouache can also be used on surfaces such as cardboard, wood or primed canvas, so long as they are free from oil. You can also employ toned and colored papers, as used for pastel work.

BRUSHES

Watercolor brushes are normally used for gouache painting, though bristle brushes are useful for making textural marks. However, because gouache does not handle in the same way as watercolor, experiment to determine which type and size of brush best suits your technique.

Geraldine Girvan
PLUMS IN A GREEN DISH
Gouache on paper
16 x 12in (40 x 30cm)
Chris Beetles Gallery, London

This artist revels in the bright colors and strong patterns found in both natural and man-made objects. She finds that gouache is the perfect medium to give her the fluidity and richness suited to her interpretation of the subject.

Using toned paper
This can be highly effective; the surface acts as a mid-tone from which to work up to the lights and down to the darks, and also helps to unify elements of composition (see sketch below). If you intend to leave areas of the paper untouched, however, make sure you choose a good-quality paper which will not fade.

John Martin
UNTITLED SKETCH
(above)
Gouache on tinted paper
4 x 6in (10 x 15cm)

SEE ALSO
Wash techniques, page 120
Textures & effects, page 132
Gouache, page 138

Jane Camp
LAST CHUKKA
Gouache on paper
14 x 10in (35 x 25cm)
Westcott Gallery, Dorking

This is a marvelous example of the fluid and vigorous use of gouache to convey movement and energy. The beauty of the medium is its inherent ability to create appropriate textural marks, almost of its own free will.

Sally Keir
RED POPPIES
Gouache on paper
9⅜ x 10⅜in (24 x 26.5cm)

Although lacking the luminous effect of pure watercolor, gouache has a brilliant, light-reflecting quality that is ideally suited to flower studies. This painting has all the clarity and detail of botanical illustration, but the vibrant intensity of gouache colors keeps the subject alive in a way which many detailed flower paintings fail to do.

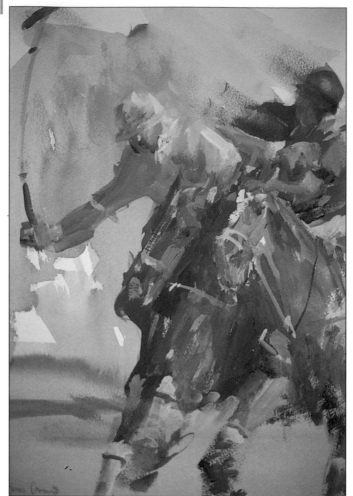

Making and using gouache impasto

The impasto technique is usually associated with oil or acrylic painting, but the addition of impasto gel turns gouache or watercolor paint into a thick, malleable paste. Mix the gel approximately half-and-half with the paint, and apply to the support with a knife or a brush to make textured effects.

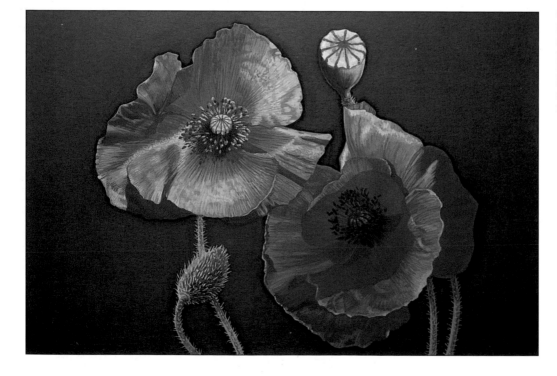

TECHNIQUES

Gouache is a somewhat underrated painting medium, considering how versatile it is. Like watercolor, it can be thinned with water to a fluid consistency, but its relative opacity gives it a more rugged quality, ideal for bold, energetic paintings and rapid landscape sketches. When wet, gouache can be scrubbed, scratched and scumbled, and interesting things happen as colors run together and form intricate marbled and curdled patterns.

WASHES AND TONES

Gouache is equally suitable for a more delicate, lyrical style of painting, in which washes of thin, semi-transparent color are built up in layers which dry with a soft, matte, velvety appearance.

With gouache colors, tones may be lightened either by adding white or by thinning the paint with water, depending on the effect you wish to achieve. Thinning with water gives gouache a semi-opaque, milky quality, while adding white gives a dense, opaque covering.

PAINTING DARK-OVER-LIGHT

Gouache is technically an opaque paint, so you can, in theory, apply light colors over dark. In practice, though, it is best to stick to the dark-over-light method, as gouache is not as opaque as oils or acrylics – in fact some colors are only semi-opaque. Gouache will completely cover a color if used very thick and dry, but this is not advisable, as it may lead to subsequent cracking of the paint surface.

SOLUBILITY

Because gouache colors contain relatively little binder, they remain soluble when dry, so an application of wet color may pick up some color from the layer below. This can be prevented by allowing one layer to dry completely before applying the next. Apply the paint with a light touch, and avoid overbrushing your colors.

Using white
There are two whites available: permanent white (sometimes called titanium white) and zinc white. Permanent white has the greater covering power; zinc white is cool and subtle.

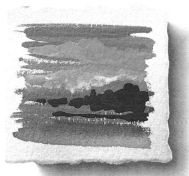

Added white

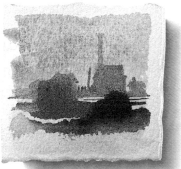

Thinned with water

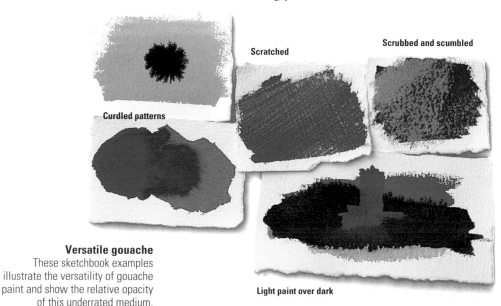

Versatile gouache
These sketchbook examples illustrate the versatility of gouache paint and show the relative opacity of this underrated medium.

Curdled patterns

Scratched

Scrubbed and scumbled

Light paint over dark

Lightening tones
The above examples demonstrate how gouache colors can be modified by adding either water or white paint.

143

EGG TEMPERA

Egg-tempera paint has a long and venerable history, and was universally used until the fifteenth century. Then a method of mixing oils into tempera pigments, to give them greater flexibility, eventually produced a pure oil medium which supplanted tempera.

SEE ALSO
Oils supports, page 16
Oils underpainting, page 99
Watercolor brushes, page 112

PAINTS

Tempera is a water-based paint made by mixing egg yolk with pigments and distilled water. As this mixture dries on the painting surface, the water evaporates, leaving a hard, thin layer of color which is extremely durable.

Prepared egg-tempera colors are available from a few manufacturers, although formulations vary. Daler-Rowney, for example, produce a range of egg-tempera paints, based on a nineteenth-century recipe for an emulsion made from egg yolk and linseed oil. The oil makes the paint slower-drying, more flexible and easier to manipulate, yet it remains water-thinnable. However, because the color range of ready-made paints is limited, many artists working in tempera prefer to prepare their own paints, using the vast range of color pigments available.

Pigments
Commercial color pigments suitable for making tempera paints can be purchased from art shops.

Basic palette
Manufactured-tempera colors are all relatively transparent, and all have a high degree of permanence. The colors cannot be mixed on the support. A starting selection would be similar to that described for gouache, but the technique for building up tones with small strokes (see right) means that the artist will develop a personal palette, depending on the subjects chosen.

The ASTM (American Society for Testing and Materials) codes for lightfastness:

ASTM I – excellent lightfastness
ASTM II – very good lightfastness
ASTM III – not sufficiently lightfast

Titanium white
Permanence excellent (ASTM I).
Include this color in your palette

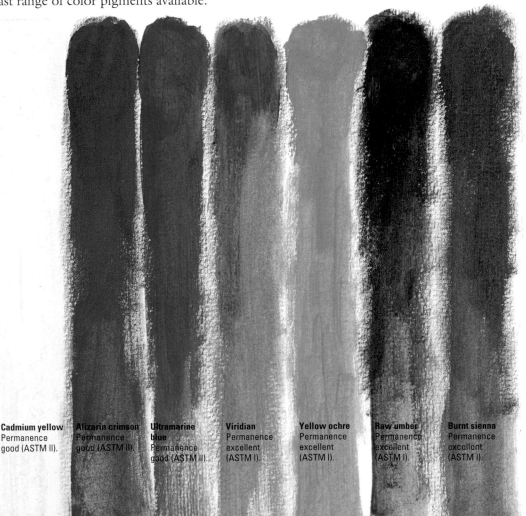

Cadmium yellow
Permanence good (ASTM II).

Alizarin crimson
Permanence good (ASTM II).

Ultramarine blue
Permanence good (ASTM II).

Viridian
Permanence excellent (ASTM I).

Yellow ochre
Permanence excellent (ASTM I).

Raw umber
Permanence excellent (ASTM I).

Burnt sienna
Permanence excellent (ASTM I).

David Tindle
STRAWBERRY
Egg tempera on board
23⅜ x 32½in (58.5 x 81.3cm)
Fischer Fine Art, London

As a painter in the quiet, Romantic tradition, David Tindle is concerned with small, intimate, domestic subjects. He uses pure egg tempera and a delicate and painstaking application of tiny hatched marks to portray the disembodying effect of light filtered through a curtained window, reducing solid objects to veils of luminous tone.

TECHNIQUES

Tempera is not a spontaneous medium, but is suited to artists who enjoy using a meticulous technique. The paint dries within seconds of application, so colors cannot be blended on the support as they can with other media. Instead, tones and colors are built up with thin color applied in glazes, or with tiny, hatched strokes. Any number of coats can be superimposed without the finished painting losing any of its freshness. Indeed, repeated layers of translucent color enhance, rather than diminish, the luminous clarity of tempera.

DIFFERENT "TEMPERAS"

Tempera paints are no longer made exclusively with egg, so the term tempera has also come to cover emulsions of various sorts. Some paint manufacturers on the European continent, for example, refer to their gouache paints as "tempera," so check carefully before buying.

SURFACES

Tempera can be used on a wide variety of supports, including canvas panels and paper, but the traditional ground is gesso-primed board, where the smooth, brilliant-white surface reflects light back through the paint, giving the colors extraordinary luminosity.

UNDERPAINTING FOR OILS

Tempera also makes a wonderful underpainting for oils. Applied to a white ground, the color gleams through each layer, giving a painting a deep, luminous glow.

• Brushes
Round sables or synthetics with a good point are the best brushes for tempera painting. The long-haired varieties, such as riggers and lettering brushes, are the most suitable; they hold more color and can be worked for longer than short-haired brushes. As tempera dries quickly, brushes must be washed frequently in distilled or boiled water.

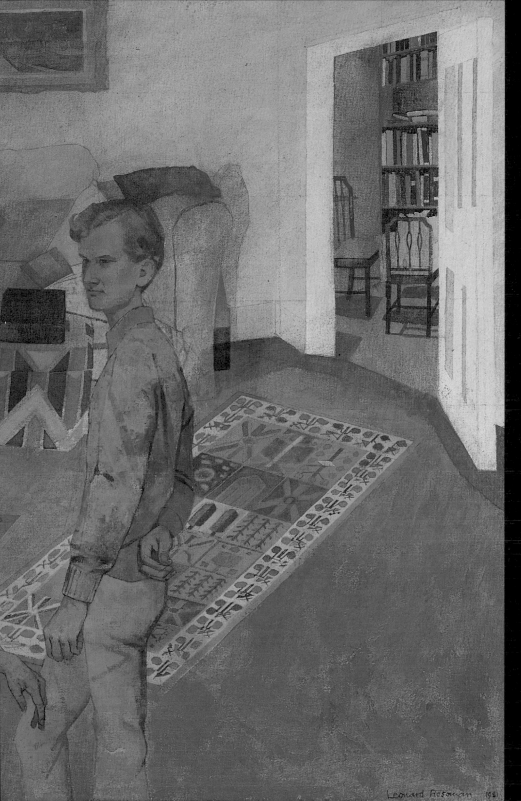

ACRYLICS *seem to divide artists into two camps. Those who dislike acrylics tend to compare them unfavorably with traditional painting media. Those who use acrylics, however, recognize that they are a unique medium in their own right.*

The most remarkable thing about these relatively new paints is their extraordinary versatility. Although oil, watercolor and gouache techniques can be used successfully with acrylics, the medium nevertheless retains its own distinct character and creative possibilities.

Leonard Rosoman
JAMES KNOX AND LUCY ABEL-SMITH
Acrylic on canvas
30 x 50in (75 x 125cm)
The Fine Art Society, London

PAINTS

Until the early twentieth century, artists had been working with the same painting materials for hundreds of years. Modern oil and water-color paints are essentially the same as those used by the old masters, and those changes and developments that have occurred have been slow and evolutionary. Then, in the 1940s and 1950s, acrylic paint burst upon the art scene. This new medium, based on a synthetic resin, had all the advantages of the traditional media and few of the drawbacks.

SEE ALSO

Oil paints, page 64

Pigments, page 68

Mediums, page 76

Brushes and knives, page 78

Palettes, page 84

Student-quality acrylic paints

QUALITY In recent years, the quality of acrylic paints has improved enormously. There is now a higher pigment content, the resin binder is more flexible, and a wide range of mediums is available for mixing with the paint, extending its versatility and expressive qualities. Though some die-hard traditionalists still regard them with disdain, acrylics are increasingly popular with all levels of painters.

COMPOSITION The name acrylic paint is derived from acrylate resin, the vehicle or binder in which the pigments are suspended. It is this synthetic binder, consisting of an emulsion of extremely fine particles of resin dispersed in water, which largely determines the differences in character and handling qualities between oil paints and acrylic paints.

The binder for oil paint consists of a vegetable drying oil, such as linseed or poppy oil, which dries by absorbing oxygen from the air. This is known as oxidative drying, and is a very slow process. Acrylic paints, in contrast, are physically drying, which means that they dry rapidly through evaporation of the water contained in the binder. As the water evaporates, the acrylic-resin particles fuse to form a fairly compact paint film in which each minute particle of pigment is coated in a film of resin. The result is a permanently flexible paint film which is water-resistant, does not yellow and reveals no signs of aging.

• Permanence
All acrylic colors, apart from fluorescent colors, are labeled either extremely permanent or permanent, which means that none of them will yellow, fade or darken with time.

ADVANTAGES The major advantages of acrylics are their permanence, their resistance to the effects of aging, and their flexibility. Unlike oils, acrylics do not yellow, embrittle, wrinkle or crack. Whereas oil paints harden as they dry, and the paint film becomes brittle as it ages, acrylics dry and harden quickly, but remain flexible and durable. Once dry, an acrylic painting on canvas can be rolled up, stored and re-stretched years later, with no danger of the paint surface cracking. Another advantage is that all colors dry at the same rate – unlike oil paints.

Students' and artists' quality
As with oils and watercolors, acrylics are available in both artists' and the cheaper students' qualities. Artist-quality acrylic colors vary in price according to the initial cost of their pigments, but they are considerably cheaper than oil paints. Student-quality acrylics are all the same price, but the color range is smaller. Expensive pigments are usually substituted with highly lightfast, synthetic organic pigments, and the pigment name is suffixed with "hue."

Artist-quality acrylic paints

• Acrylics and water

Acrylics are water-soluble when wet, which means no solvents are needed for diluting the paint or for cleaning brushes and palettes. Once dry, however, an acrylic painting is completely waterproof – useful when working outdoors, when there may be the risk of a sudden shower.

• Rapid drying

Acrylics dry rapidly and, because they dry insoluble, successive layers can be overpainted without danger of lifting the color beneath. This is a great advantage when using techniques such as glazing, scumbling and drybrush.

• Versatility

Acrylic is a highly versatile paint. Use it opaquely or diluted with water and/or medium for transparent washes. In addition to the more traditional techniques, it is ideal for mixed-media work, collage and textural effects, and can be diluted and used with an airbrush.

DISADVANTAGES

"The advantage of acrylic paint is that it dries quickly, but it has one disadvantage – which is that it dries quickly." This wry joke sums up the dilemma presented by acrylics: their fast drying time has advantages over slower-drying oil paints, but there are a few drawbacks. For example, brushes must be kept in water when not actually in use, to prevent paint from drying hard on the bristles. Paint also dries out quickly on the palette unless it is sprayed with water at regular intervals, or you use a special palette developed for use with acrylics.

The rapid drying time also means that the paint cannot be manipulated extensively on the support for a relatively long period, as is possible with oils. This is only a drawback if you like to work slowly, using smooth blending techniques; most artists choose acrylics because they enjoy being able to apply layers of color in rapid succession, without disturbing the underlayers.

Terence Clarke
CASTLEMORTON COMMON
Acrylic on canvas
36 x 36in (90 x 90cm)

Terence Clarke exploits the vibrancy and intense hues of acrylic paints. The fast-drying qualities of acrylics allow him to build up the body of paint quickly, using thin washes and glazes. Even with a restricted palette of five colors, plus white and pure black, he is able to achieve a vibrant, stained-glass effect.

COLORS

The range of acrylic colors is slightly restricted compared to that of oils or watercolors, because certain pigments, such as alizarin crimson and viridian, do not mix readily with the resin binder, and tend to curdle. In such cases, an alternative pigment is used. The range of colors and color names varies widely from one brand to another.

• Care of paint tubes
At the end of a painting session, it is worth making the effort to wipe all tube caps and screw heads with a damp cloth before replacing the caps. Encrusted paint builds up and prevents the cap from going on properly, allowing air into the tube, and the paint quickly dries out. Dried paint also makes it difficult to remove the cap next time you paint. If tube caps stick, you can usually loosen them by running them under hot water. Never leave the lids or caps off containers, as the paint will dry rock-hard within hours.

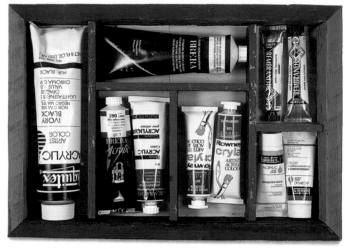

Buying acrylics in tubes
All colors are available in tubes, but the largest sizes are limited to the black and white ranges.

TUBE COLOR

The thickness of tube paint varies from brand to brand, but in general it has a soft, buttery consistency similar to that of oil paints. It retains the mark of the knife or brush, and is excellent for impasto techniques. Most acrylic colors are available in tube sizes ranging from approximately 0.75 fl. oz (22ml) to approximately 6.6 fl. oz (200ml).

Removing acrylic paint
Because acrylic paint is water-based, it is easy to wipe up spills and splashes when wet. Once dry, however, it is difficult to remove, especially from fabrics. It is therefore advisable to wear old clothes when painting, and to protect surrounding floors and furniture. Always keep a damp cloth handy, in case of accidents.

Jar-acrylic colors
Their fluid consistency makes jar acrylics ideal for large-scale paintings, and an extensive range of colors can be bought in all sizes.

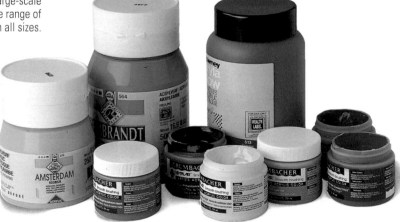

JAR COLOR

Smoother and more fluid than tube color, jar color is easily thinned with water and/or medium. This makes it ideal for watercolor techniques and for covering large areas of flat color. The colors dry to a smooth, even film, slightly more matte than tube color. The paint comes in wide-top tubs and jars or plastic bottles with nozzles, ranging in capacity from 2 fl. oz (59ml) up to 31.5 fl. oz (946ml); titanium white and Mars black are also available in 1 gallon (3.79 liter) containers.

• Mixing brands
Since each manufacturer uses a different chemical formula for making their paints, it is wise to stick to the range of a single brand of acrylics. If not, problems, such as curdling when mixing, insufficient adhesion and color changes on drying, may arise. Only acrylic paints based on the same sort of binder and of the same quality should be used in combination.

SEE ALSO
Supports, page 12
Mediums, page 156
Mixing colors, page 178

Liquid-acrylic bottles

Terence Clarke
THE BLUE WALL
Acrylic on canvas
36 x 36in (90 x 90cm)

Because the artist's working methods call for quite large quantities of paint, he prefers to use acrylics supplied in jars for economy and convenience, as well as for their fast-drying and smooth-flowing characteristics.

Color charts
Manufacturers' hand-painted color charts are the best source of information on the range and permanence of commercially made colors; charts made with printers' inks are not as accurate.

LIQUID ACRYLICS

Liquid acrylics flow readily from the brush and are similar to brilliant drawing inks – but whereas many colored inks fade on exposure to light, most liquid acrylics are permanent. They are supplied in bottles with dropper caps, and are suitable for wash techniques and fine-pen work. Liquid acrylics are made with an alkali-base resin, and can be removed using an alkali cleaner.

MIXING COLORS

Try to limit all mixtures to just two or three colors, to avoid muddied hues. Avoid mixing them too thoroughly – as soon as the color looks right, stop.

While the resin binder still contains water it is "milky" in color, so acrylic colors appear slightly lighter and more subdued in shade when wet than they do when dry. As the paint dries the binder becomes transparent, so the colors dry with a slightly deeper shade and full brilliance.

SUPPORTS

Acrylics can be used on a wide range of supports: paper, board, canvas, wood, metal, and even exterior walls. There is one important thing to remember, however, when choosing a painting surface: acrylics will not adhere to any surface which contains oil or wax. This fact rules out all canvas or board which has been prepared for oil paint, so check with your retailer that the canvas or board you buy is prepared with acrylic primer and not oil-based primer.

DRYING TIMES

Most undiluted acrylic paint applied thinly will dry in about 15 minutes, while thick layers of impasto may take more than a day before all the water has evaporated. In warm, humid conditions the paint takes a little longer to dry, and in hot, dry conditions it dries more rapidly.

• Extending drying time
If the rapid drying of acrylics is a problem for you, there are a few solutions: add a little retarding medium to the paint, to keep it workable for longer; use a plant-sprayer to spray a fine mist of water over the painting from time to time; or seal absorbent surfaces, such as paper and raw canvas, with matte medium before painting.

BASIC PALETTE

The selection of a palette of colors is largely a matter of personal preference, but often the initial temptation is to buy too many tubes. It is better to begin with a limited range of colors, adding to these gradually as your needs arise from experience. A broad spectrum of hues can be mixed from the colors shown here.

SEE ALSO
Permanence of pigments, page 170
Mixing colors, page 178

"ONE GREAT INCONVENIENCE THE STUDENT LABORS UNDER ARISES FROM THE TOO-GREAT QUANTITY OF COLORS PUT INTO HIS HANDS; . . . IT IS NOT UNCOMMON TO GIVE TWO OR THREE DOZEN COLORS IN A BOX, A THING QUITE UNNECESSARY."

EDWARD DAYES (1763-1804)

Cadmium red
Permanence excellent (ASTM I).
An opaque color with a very pure, bright, warm-red hue and strong tinting strength.

Permanent rose
Permanence excellent (ASTM I).
A very transparent color with a bright, pinkish-red, violet-tinged hue and very strong tinting strength. Mixes well with blues to make clear purples.

Yellow ochre
Permanence excellent (ASTM I).
A semi-opaque color with a soft, tan-yellow hue and weak tinting strength. An indispensable color for use in landscapes and portraits.

Cadmium yellow pale
Permanence excellent (ASTM I).
A fairly opaque color with a strong, sunny-yellow hue and strong tinting strength. Makes strong greens and oranges when mixed with blue and red colors respectively.

Phthalocyanine blue
Permanence excellent (ASTM I).
A transparent color with a cold, vivid blue hue, a green undertone and very strong tinting strength. A very strong color, for sparing use in mixes.

Ultramarine blue
Permanence excellent (ASTM I).
A transparent color with a deep, warm blue hue and strong tinting strength. The most versatile of the blues.

Burnt umber
Permanence excellent (ASTM I).
A fairly opaque color with a rich, warm brown hue and good tinting strength. Mixes well to produce a range of rich tones.

Titanium white
Permanence excellent (ASTM I).
A very opaque color with a bright, pure white hue and strong tinting strength. The only available acrylic white.

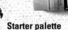

Starter palette

The ASTM (American Society for Testing and Materials) codes for lightfastness:

ASTM I – excellent lightfastness

ASTM II – very good lightfastness

ASTM III – not sufficiently lightfast

SEE ALSO
Mediums, page 156
Mixing colors, page 178

SPECIALITY COLORS

An ever-growing range of shimmering and metallic colors is now available from some companies, with decorative techniques in mind as well as fine-art applications.

COLOR RANGE These pigments, known variously as iridescent, pearlescent, or "interference" colors, are available in orange, red, blue, green, violet and gold, and are all durable. Made from titanium-coated mica flakes, they have a glittery appearance which changes according to the way the light falls on a painting or the angle at which it is viewed.

• PVA colors
Polyvinyl-acetate paints are a less-expensive alternative to acrylic paints, but the pigment is bound by a vinyl emulsion, so they tend to be inferior to real acrylics in quality and lightfastness. Although they are ideal for use in schools, avoid PVA colors if you are concerned about the longevity of your work.

Jacquie Turner
SAN FRANCISCO FROM
COIT TOWER
Acrylic on paper
43 x 56in (107.5 x 140cm)

In order to capture successfully the dazzle of light reflecting off the glass-and-metal structures in this modern cityscape, the artist used pearlescent and metallic colors in combination with conventional tube and jar paints.

Iridescent colors
The iridescents may be used singly, or combined with regular acrylic colors to produce luminous surface qualities. They are used to best effect on a dark background, especially black. Also available are iridescent mediums, which can be mixed into any of the ordinary colors to pearlize them. When applied to a white surface or over light colors, they "refract" their complementary color: interference green, for example, refracts red.

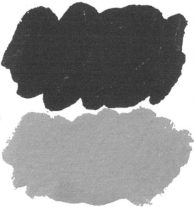

Fluorescent colors
These absorb ultraviolet light and emit visible light of a longer wavelength. As a result, they appear to fluoresce or glow. The effect, however, fades rather rapidly as the dyes are not stable. Fluorescent colors are not recommended for permanent painting.

153

CHROMA COLOR

Chroma color is a new type of water-based paint which is a development of the animation cell paint used for coloring cartoon films. Based on a superior type of acrylic resin, the paint can be used in the same way as acrylics – and watercolor, gouache, oils and ink – but with certain additional benefits.

SEE ALSO

Supports, page 12

Inks, page 54

Brushes and knives, page 78

Oils techniques, page 87

Watercolor techniques, page 120

Acrylic techniques, page 160

The language of color, page 172

VERSATILITY

Chroma color is similar to acrylic paint in that it is fast-drying, thins with water, and becomes waterproof when dry. The colors may be used directly from the container or diluted with water. They may be applied using any technique on virtually any support, with a brush, dip pen, painting knife or airbrush, in any thickness, from a heavy impasto to the lightest wash.

USING CHROMA

Chroma as acrylic
Tube colors have a smooth, buttery texture similar to that of acrylic paints, and can be used in the same way. They do, however, dry a little more slowly than acrylics, which can be an advantage. Because of their higher pigment loading, the colors tend to be stronger and more vivid, even when thinly diluted, and the tone values do not change as the paint dries.

Chroma as gouache
Used straight from the tube or bottle, Chroma is similar to gouache, in that it is highly opaque and dries to a velvety, matte finish. Unlike gouache paints, however, where not all colors are lightfast, Chroma colors do not fade. Another advantage that Chroma has over gouache is that it dries to a waterproof state, so overpainting can be achieved without the risk of color pick-up.

Chroma as ink
By adding water to jar or tube colors, Chroma can be used in the same way as a colored ink; the effect can be either opaque or transparent, according to the degree of dilution and the end result required.

Chroma as watercolor
Diluted even further than for ink effects, Chroma produces subtle, translucent washes which, unlike traditional watercolor washes, do not fade appreciably upon drying. Chroma colors dry insoluble, so it is possible to lay wash over wash without any danger of previous applications being disturbed. Once dry, however, Chroma colors cannot be lifted out to create highlights, as is the case with watercolor paints.

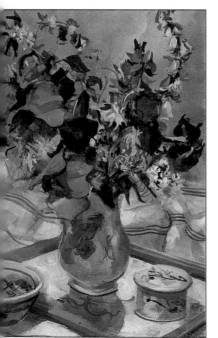

Sue Wales
IRIS AND FOXGLOVES
Chroma color on paper
21 x 14in (52.5 x 35cm)

Originally a watercolorist, Sue Wales uses heavily diluted Chroma color in the classic wet-in-wet technique. The bold washes are enhanced by the strength of the colors, which dry to the same shade as when they were applied.

Mediums
Chroma colors are supported by a range of mediums: a gel thickener for heavy impasto work, a retarder to extend drying times, and a gloss medium to give the paint a glossy sheen and increase transparency when applying glazes. A gesso primer and matte and gloss varnishes are also available.

Chroma bottles and tube

PIGMENTS The level of pigment loading is higher than is typically found in other water-based media, giving Chroma colors greater tinting strength and opacity. Currently, there are eighty colors in the range, all of which are non-toxic and completely lightfast.

DILUTION Chroma is capable of massive dilution: the colors retain their vibrancy and strength, even at 1 part paint to 500 parts water. The paints are highly concentrated, which makes them economical to use. Only a small amount of color is needed to produce a large amount of wash; when used as a watercolor, it is necessary to dilute up to seven times more than with traditional watercolors in order to achieve a wash of comparable strength.

BOTTLES AND TUBES The paint is supplied in two formulations: as a thick liquid in 1.66 fl. oz (50ml) bottles, and as a gel paste in 1.66 fl. oz (50ml) tubes. The liquid type is the better for wash techniques, as very small amounts of color can be dispensed from the nozzle. Tube color is more suitable for thick applications and heavy impastos.

Edwin Cripps
IRISES
Chroma color on canvas
36 x 48in (90 x 120cm)

In contrast to the watercolor method (see opposite), this large painting approaches a similar subject using a technique associated with oils. The artist painted the entire canvas black before underpainting the shapes in white; he then built up layers of glazes and used undiluted color to provide the final surface. The result glows against the background, and stands out with startling intensity.

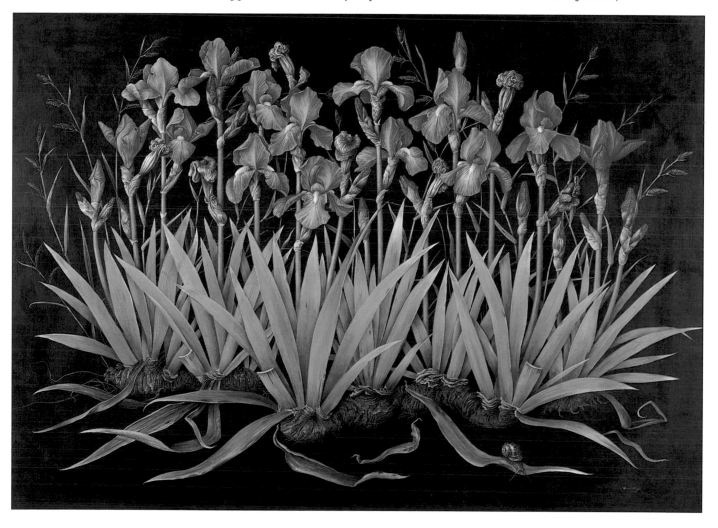

MEDIUMS

Acrylics dry to a flat, eggshell finish. However, acrylic mediums can be added to the paint, to produce a range of consistencies and finishes and to give the colors brilliance and depth. A medium will help thinly diluted paint maintain its adhesion and improve its flow and "brushability." Some mediums can be used to control the paint's drying rate.

MEDIUMS AND PAINT

Gloss medium
Acrylic gloss medium makes paint thinner and more fluid, and enhances color luminosity. It makes paint more transparent, allowing thin glazes to be built up and producing colors of exceptional depth and brilliance. The surface dries to a soft sheen.

Matte medium
This is gloss medium with the addition of a matting agent such as wax emulsion or silica. Used in the same way as gloss, it dries to a matte, non-reflective finish. Blend equal parts of gloss and matte mediums for a semi-gloss effect.

Gel medium
This paste-like substance thickens paint for prominent, textured brushstrokes and for impasto effects. It is used for collage work, as it increases the adhesive qualities of paint.

There are no special rules governing the use of acrylic mediums – unlike oils, where each paint layer must be more flexible than the one beneath. Acrylic paints and mediums are manufactured with the same emulsion base, so they dry at the same rate, and there is no danger of the paint cracking.

Add mediums to paint a little at a time, and mix well with a palette knife. You can further dilute the paint with water. Always mix colors before adding a medium.

• **Mediums as varnish**
Don't use gloss or matte mediums as a varnish to protect completed paintings. A layer of acrylic medium picks up as much dirt as paint, but cannot be removed for cleaning. Protect paintings with a removable varnish which can be replaced.

• **Mediums and brushes**
Acrylic mediums dry rapidly, so keep brushes in a container of water when not in use, or they will become stiff and unusable in a few minutes.

• **Oil mediums and acrylics**
Turpentine, mineral spirits, linseed oil, and other mediums and solvents for oil paints should never be added to acrylic paint.

Barry Atherton
ITALIANATE VASE
Acrylic gesso, pastel and gold and silver leaf on wood panel
53 x 41in (132.5 x 102.5cm)
New Academy Gallery, London

This rich, decorative image was produced by a complex technique. Barry Atherton pasted a sheet of handmade paper onto a wood panel with acrylic adhesive. He mixed powdered pigment into acrylic gesso to color it, and then applied the mixture to the support using brushes and knives. Gold and silver leaf were laid on top of the slightly textured, low-relief surface, and pastel was added.

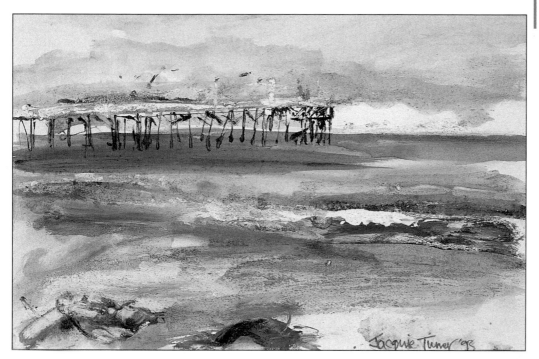

Jacquie Turner
THE OLD JETTY, SAN SIMEON
Acrylic on paper
30 x 42in (75 x 105cm)

For this sea-coast scene, Jacquie Turner mixed a little sand in with texture paste and paint, to provide an appropriately granular foreground. The sparkle of the waves is conveyed by small touches of silver-metallic paint.

Ceramic shards pressed into texture paste

A mixture of sand and acrylic paint

Iridescent tinting medium
This is a special-effects medium containing mica-coated flakes. When mixed with acrylic colors, it produces an iridescent quality.

TEXTURE PASTE

Texture, or modeling, paste is used for building up thick wedges of paint with a knife. It can be applied directly to a support, to build up a relief that can be sanded or carved when dry. Some pastes imitate the textures of stucco, sand or blended fibers. The paste can be mixed with color, or allowed to dry before being painted over in thin glazes.

Texture paste is ideal for collage work, as quite heavy objects can be embedded into it, and for imprinting, in which forms are pressed into the paste and then removed, leaving an indented pattern. A gritty or granular surface can be produced by mixing inert substances such as sand, sawdust or wood shavings with paste.

• Mixing texture paste
Texture paste lightens the color of paint, so allow for this when mixing colors. Use undiluted texture paste only on rigid surfaces such as wood or board; on flexible surfaces, such as canvas, use a mixture of equal parts of texture paste and gel medium.

Using texture paste
Apply the paste in layers no more than ¼in (6mm) thick, and allow each layer to dry before adding the next one. If the layers are too thick, the outside dries more quickly than the inside, resulting in a cracked surface.

RETARDING MEDIUM

This reduces the drying time of acrylic paint, enabling you to move paint around on a surface and to blend colors slowly and smoothly. It is available in liquid and gel forms; the latter holds more water, thus keeping the paint film open for longer. Mix the retardant in the ratio of 1 part to 6 for earth colors, and 1 to 3 for other colors. Too much retardant makes paint sticky and unpleasant to use. Add a very small amount of water to increase fluidity.

FLOW IMPROVER

Flow improver, or water-tension breaker, thins acrylic colors without reducing the color's strength or affecting the finish of dried paint. It improves flow properties, allowing flat, even washes to be applied over large areas.

BRUSHES AND KNIVES

All the brushes used for oil and watercolor painting – both natural-hair and synthetic-fiber – are also suitable for acrylic painting. Decorators' brushes are inexpensive, come in a range of sizes, and are invaluable for blocking in large areas of color.

SEE ALSO
Oils brushes, page 78
Oils knives, page 86
Watercolor brushes, page 112

SYNTHETIC-BRISTLE BRUSHES

Some manufacturers have developed synthetic-bristle paintbrushes specifically for acrylic painting (many artists also find them ideal for oils). These brushes are easy to clean, and are built to withstand the tough handling demanded by acrylics.

CARE OF BRUSHES

Because acrylic paint dries so fast, take extra care of your brushes. Be sure to moisten them with water before loading them with acrylic paint, otherwise the paint will stick to the dry bristles and gradually build up to a hardened film that ruins them.

Do not leave brushes soaking in a jar of water for long periods; the bristles become distorted when resting on the bottom of the jar, and the lacquer paint on the handle eventually flakes off. Lay brushes in a shallow tray of water, with the bristles resting in the water and the handles propped on the edge, clear of the water.

KNIFE PAINTING

The buttery consistency of acrylics makes them appropriate for knife painting. Again, the same painting and palette knives used for oils are suitable for acrylics, provided they are made of stainless steel and not ordinary steel. Easy-to-clean plastic knives are also available with acrylics in mind.

• Using oil-paint brushes
Brushes previously used with oil paint must be carefully cleaned, to remove all traces of oil or turpentine from the bristles before being used with acrylics.

Lay brushes in a shallow tray of water

• Cleaning solidified paint
If paint has solidified on your brush, try soaking it in methylated spirits for at least 12 hours and then working the paint out between your fingers. Wash the brush thoroughly in soap and warm water.

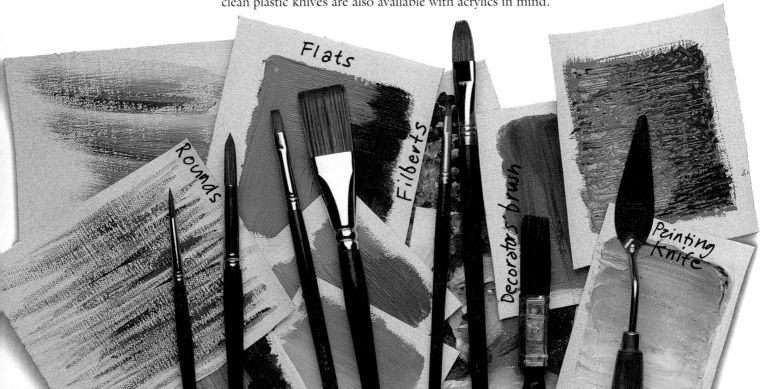

Flats

Rounds

Filberts

Decorators brush

Painting Knife

SEE ALSO
Oils palettes, page 84
Watercolor palettes, page 116

PALETTES

Wooden palettes, such as those used for oils, are not recommended for acrylic painting, as the paint gets into the porous surface of the wood and is difficult to remove.

HOME-MADE PALETTES

Use a plastic palette, or make one from a sheet of white melamine, an offcut of Masonite coated with acrylic primer, or a sheet of glass with white paper underneath. Many artists prefer these "home-made" palettes because there is no restriction on size. Paper plates are also useful, as they can be thrown away after use. For mixing very fluid washes, use disposable plastic containers, paper cups or metal muffin tins.

KEEPING PALETTES MOIST

Acrylic paints dry out rapidly on palettes, so keep them moist while in use by spraying them with water from time to time. Covering the palette with plastic wrap will prevent paints from drying out during a temporary break from painting. It is also a good idea to squeeze out only small amounts of paint at a time, to prevent waste.

SPECIAL PALETTES

Special palettes have been developed for use with acrylic paint, which keep colors moist and workable, so that you needn't constantly remix colors and discard dried paint. They work on the principle of osmosis, and consist of a lidded plastic tray lined with a sheet of absorbent paper and a sheet of membrane paper. In use, the absorbent paper is soaked with water and the sheet of membrane paper is laid on top. The colors are squeezed out onto the membrane paper and absorb moisture from the absorbent paper below, preventing them from drying out.

Making a moist palette
This improvised palette is quick and inexpensive to make, and solves the problem of paints drying out. Line the bottom of a shallow plastic tray or aluminum baking tray with three or four damp sheets of blotting paper or paper towel. Cover the damp pad with a sheet of greaseproof paper, patting it down so that it has contact with the damp surface. Use the greaseproof paper as your palette.
When the damp pad begins to dry out, remove the greaseproof paper and re-wet the absorbent paper. When you finish work, cover the palette with a sheet of plastic wrap, and your acrylics will be ready for use the next day.

Types of palette
Two commercial "moist" palettes (left and center) and an improvised palette, made with a sheet of glass over white paper (right).

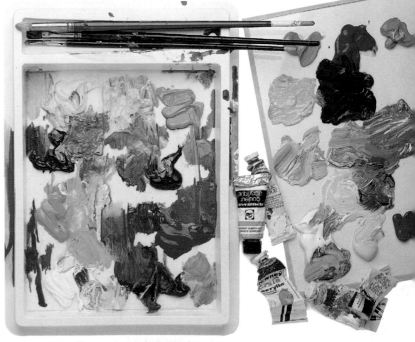

WASH TECHNIQUES

When acrylic paints are diluted with enough water and/or medium, they behave in a way similar to traditional watercolors and oils, producing delicate washes and glazes through which the white surface of the paper or canvas shines, enhancing the luminosity of the colors.

Acrylic washes
These examples show how underlying washes maintain their strength of tone through subsequent layers.

WATERCOLOR EFFECTS The main difference between acrylics and watercolors is that acrylic colors tend to dry with a smoother and slightly more matte finish than watercolors. However, once the color is dry, acrylic paint is insoluble and permanent. This means that successive washes of transparent color can be built up to achieve the depth of tone required, without disturbing the underlying colors.

Another advantage is that there is a wider choice of supports on which to work. All the traditional watercolor papers are suitable, and acrylic washes can also be used directly onto unprimed canvas, as well as gesso boards and other surfaces primed for acrylics.

• Controlling washes
One problem with watercolor is controlling a wash so that the color is evenly distributed. With acrylics, this problem can be solved by adding either flow improver or a little matte or gloss medium to a wash. This thickens the paint just enough to help it roll smoothly onto paper or canvas. Brushstrokes hold their shape better when applied with medium and water rather than water alone, and are easier to control. As with watercolors, fluid washes should be applied swiftly and confidently, and left alone.

Nick Andrew
CROWN
Acrylic on paper
18½ x 18½in (46.2 x 46.2cm)
On Line Gallery, Southampton

Nick Andrew's method of creating acrylic washes is to begin with very wet watercolor paper, and subsequently to spray a fine mist of water onto the areas where he is working, to keep them damp. This extremely liquid technique allows him to achieve subtle blends and diffusions of color.

SEE ALSO
Supports, page 12
Watercolor techniques, page 120
Paints, page 148

Keith New
PATH ACROSS THE COMMON
Acrylic and pastel on paper
33½ x 23½in (83.9 x 58.9cm)
Llewellyn Alexander Gallery, London

Spattering is an important part of
Keith New's paintings. He some-
times masks off parts of the surface
to use different spattering methods.
In this calm, monumental painting,
spatter was applied on top of
scratched and sandpapered acrylic
washes overlaid with pastel. Some
further pastel work was then
applied, to unify the various parts
of the image.

• Experimenting with spattering

Spattering is a random and fairly
unpredictable technique, so
experiment on scrap paper before
using it on a painting. Vary the
distance between the brush and the
painting surface to increase or
decrease the density of the dots. Try
spattering onto a damp surface, so
that the dots become softened and
diffused, or spatter with two or more
colors, one after the other.

Using a toothbrush
This method gives a fair amount of
control over how much is spattered.

SPATTERING

Spattering, or flicking paint onto a support, is an effective
means of suggesting textures such as sand and pebbles, or
sea foam. It can also be used to enliven and add interest to
a large area of flat color.

There are two methods of spattering. One is to dip an
old toothbrush into fairly thick paint and, holding it
horizontally above the painting surface, quickly draw a
thumbnail through the bristles. This releases a shower of
fine droplets onto the painting.

The second method is to load a paintbrush and tap the
brush sharply across your outstretched finger or across the
handle of another brush. This produces a slightly denser
spatter, with larger droplets of paint.

For either method, lay the painting flat on a table or
on the floor, otherwise spattered paint may run down the
surface. Use scrap paper to mask off parts of the painting
that are not to be spattered.

Using two brushes
A larger area can be spattered using
this technique.

GLAZING

SEE ALSO

Supports, page 12
Mediums, page 156
Optical mixing, page 178
Color harmony, page 183

"THE GREAT WAY TO PAINT WITH ACRYLICS IS THE VERY OLD-FASHIONED METHOD OF GLAZING WITH WASHES – WHICH YOU CAN DO WITH ACRYLICS, OF COURSE, MARVELOUSLY."

DAVID HOCKNEY (B. 1937)

The principle of glazing in acrylics is the same as for oil painting – successive thin, transparent washes create areas of glowing, translucent color. But acrylic is even better suited to the technique, since you don't have to wait long for each layer to dry. Because dry colors are insoluble, it is possible to build up many transparent layers to create colors with the brilliance and clarity of stained glass, with no danger of picking up the color beneath.

Glazing techniques

Paint for glazing can simply be diluted with water, but it dries to a dull, matte finish, and colors lose some of their intensity. Adding gloss medium gives much better results: it increases the transparency of the paint while retaining its binding qualities, enriches the colors and makes the paint flow more evenly.

Place the support horizontally so that the color doesn't run out of control, apply the glaze with a soft-haired brush and allow to dry.

Since a glaze is transparent, the effects are most noticeable when a dark color is laid over a light one, though you can subtly modify a darker color by glazing light-over-dark.

• Using transparent colors
For best results, restrict your mixtures to transparent colors. Glazing with opaque colors is less successful, as the colors appear somewhat muddy.

• Unifying with glazes
If colors and tones appear disjointed, a final glaze with a soft, transparent color, such as raw sienna, will help to pull the picture together so the elements harmonize.

• Modifying with glazes
Unsatisfactory color areas can be corrected with a thin tone of a different color. For example, a hot red can be toned down with a glaze of its complementary color, green (and vice versa). Again, if the background of a landscape appears to jump forward in the picture, a glaze of cool blue or blue-grey will make it recede.

Gigol Atler
SUFFOLK LANDSCAPE
Acrylic on paper
15 x 20½in (38.5 x 52cm)

In this dynamic painting, the artist used acrylics to combine the transparency of watercolor with the opacity of oil paint. He applied a cadmium-red wash over a white ground to provide an overall luminescence, and then built up the sky and land with a series of transparent glazes.

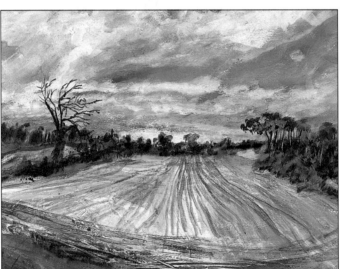

Raw canvas stained with thinned paint

STAINING

In this technique, raw, unprimed canvas is stained with acrylic colors thinned with water and medium to a creamy consistency. While the acids in oil paint will attack and destroy raw canvas in time, acrylics are non-corrosive, and so sizing and priming are not necessary.

Lay the canvas horizontally, and brush or pour the color on the surface. Colors may be manipulated by tilting the canvas or using sponges, squeegees, brushes or improvised tools. As unprimed canvas is porous: the thinned color will penetrate through to the back, and the paint becomes an integral part of the canvas.

• Acrylics for staining
Fluid acrylics are particularly suitable for staining techniques. You will find it helpful to add flow improver (water-tension breaker) to the paint used for staining. This improves the flow of the paint, making it easier to apply in flat, even washes over large areas. It also helps to maintain the brilliance of the color, which is often diminished when diluted in thin washes.

Barclay Sheaks
THE FRENCH MARKET,
NEW ORLEANS
Acrylic on Masonite
24 x 30in (60 x 75cm)

Glazing and staining
Using acrylics in washes allows you to build up a delicate paint surface with layered, transparent glazes, or to achieve rich, stained colors on canvas.

Barclay Sheaks used the brown of sanded-and-cleaned Masonite as an undercolor (right), and mixed paint and undiluted acrylic gloss medium for vibrant, luminous glazes.

Several layers of very thin, water-diluted paint were used by Brian Yale to stain raw canvas (below left); they provided a soft, matte surface for stenciling thicker paint.

The tactile quality of Paul Apps's painting (below right) was achieved using texture gel, overlaid with glazes. The thinned color settled in the crevices, accentuating the craggy texture of the thick paint.

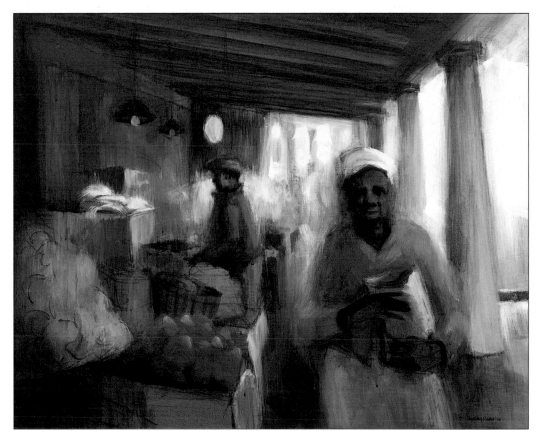

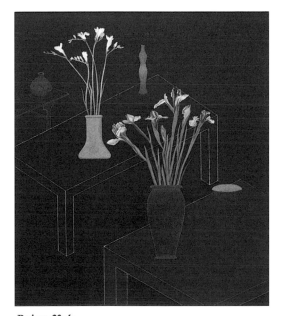

Brian Yale
JAPAN
Acrylic on canvas
46 x 40in (115 x 100cm)

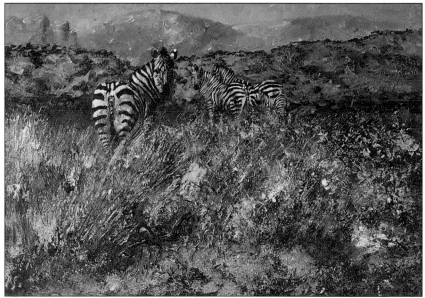

Paul Apps
ZEBRAS
Acrylic on board
17 x 24in (42.5 x 60cm)

TEXTURAL EFFECTS

Exploit the versatility of acrylics by building up rich and varied textural surfaces, using impasto, collage and mixed-media techniques.

SEE ALSO
Mediums, page 156
Varnishes, page 238

Using found objects
Learn to cultivate a scavenging mentality when considering making collages. Almost anything can be used!

COLLAGE

• Protecting collages
Apply a coat of matte or gloss picture varnish to a completed collage, or frame it under glass.

Acrylic gloss, matte and gel mediums all have excellent adhesive properties and dry transparently, so they are ideal for binding collage materials to a surface. Objects such as colored papers, tissue, aluminum foil, magazine cut-outs, fabrics, leaves, pebbles and weathered wood, to give a few examples, can be pressed into thick, wet acrylic paint or a layer of modeling paste.

• Embedding heavy objects
Lay your picture flat until the acrylic medium is dry; if you work vertically, the wet paste may slump, taking the objects with it.

• Developing collage
Collage composition can be developed with precise shapes, free shapes, or sculpted shapes with folded and crumpled forms. Objects can be painted before being fixed to the support, or the completed work may be enriched with acrylic colors and/or other media.

Jill Confavreux
TAIL ENDS OF SUMMER
Acrylic and collage on canvas
30 x 40in (75 x 100cm)

Collage exploits the contrasts of shape, color and surface texture between different materials. Jill Confavreux stuck tissue and water-color paper to thin acrylic washes, and then embedded leaf skeletons, to suggest peacock tails and leaves. This was glazed with gold acrylic paint, onto which crumpled plastic wrap was dropped. When the wrap was peeled off the dry paint, the final texture unified the painting.

Debra Manifold
STILL LIFE WITH MAT'S HAT
Acrylic and oil pastel on board
14 x 15in (35 x 37.5cm)

The mixed-media combination of acrylics and pastels is popular. Debra Manifold makes a bold acrylic underpainting, before working oil pastels on top. Further acrylic washes produce a wax-resist effect.

Donald McIntyre
COTTAGE BY THE SEA
Acrylic on board
20 x 30in (50 x 75cm)

The lively, impasted surface of this painting comes from the artist's use of paint straight from the tube. Even when applied in very thick layers, acrylic paint remains flexible and will not crack.

IMPASTO For impasto, use acrylic paint straight from the tube or diluted with a little water, matte or gloss medium, or a combination of any of these. The paint should be malleable, yet thick enough to retain marks and ridges left by the brush or painting knife. Paint can be further stiffened by mixing with gel medium or texture paste.

MIXED MEDIA Because it is so versatile and fast-drying, acrylic lends itself exceptionally well to mixed-media work. Artists often combine acrylics with watercolor, gouache and ink, and with drawing media, such as pastel, pencil and charcoal, as a means of extending their range of expression.

COLOR AND COMPOSITION

WHY IS IT *that some paintings draw us to them like a magnet, while others fail to capture* attention and interest? More often than not, the immediacy of a picture's impact is due to a strong, EXPRESSIVE DESIGN and a knowledgeable USE OF COLOR.

"ART" is not merely about representing the outward appearance of a given subject — it is just as much about selecting that subject's ESSENCE, accentuating it and holding it for the viewer's contemplation. ART FRAMES OUR VIEW of a scene and freezes the moment in an ordered BEAUTY of line and shape, FORM and SPACE, and COLOR and TONE.

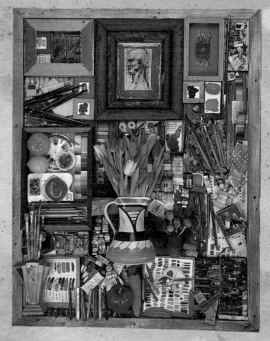

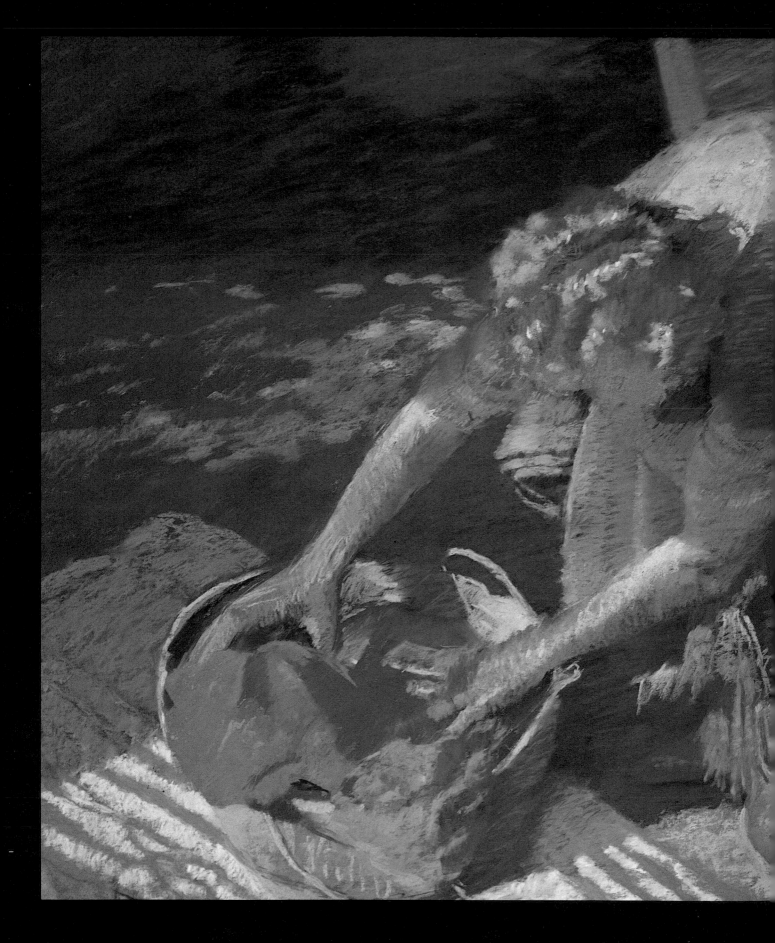

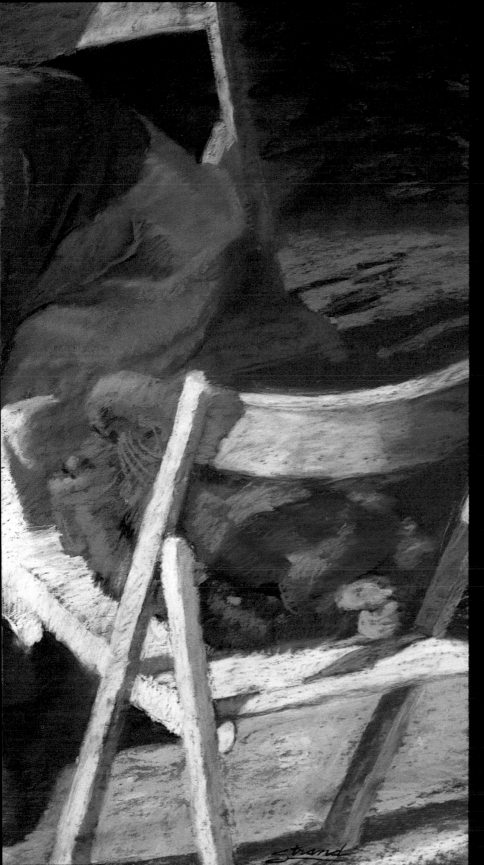

Because COLOR
is such a personal and
subjective area, it is perhaps
inappropriate to discuss it
in terms of rules and
theories. Nevertheless, to
paint well, it is important
for an artist to have some
understanding of how colors
behave and how they relate
to each other.
Knowing how colors affect
one another when mixed
together or applied side by
side, how they change under
different kinds of lighting,
why they fade and how they
can be used to re-create
form, shape, perspective and
mood, understanding the
optical effects of certain
color combinations and
their psychological impact –
all these are important if
you are to succeed in
making color do what you
want it to do.

Sally Strand
KNITTING
Pastel on paper
23 x 30½in (57.5 x 76cm)

PERMANENCE OF PIGMENTS

The permanence, or lightfastness, of a pigment refers to its resistance to gradual fading on exposure to light. This depends mainly on the chemical nature of the pigment; however, some colors which are lightfast when used at full strength lose a degree of lightfastness when strongly diluted or mixed in tints with white.

SEE ALSO
Oil paints, page 64
Watercolor paints, page 104
Pigments, page 108
Reading a paint tube, page 245

Pigment quality
All manufacturers identify their colors for lightfastness and permanence and will display the ASTM, star or alphabetical rating.

ASTM codes for lightfastness:

ASTM I – excellent lightfastness
ASTM II – very good lightfastness
ASTM III – not sufficiently lightfast

Common codes for permanence

∗∗∗∗ or AA
Extremely permanent colors

∗∗∗ or A
Durable colors, generally sold as permanent

∗∗ or B
Moderately durable colors

∗ or C
Fugitive colors

RANGE

The range of permanent colors is extremely wide, so it is possible to entirely avoid the use of fugitive colors, which fade on exposure to bright light, or only moderately permanent colors. Earth colors are the most permanent.

A few colors actually fluctuate, fading on exposure to light but recovering in the dark – Prussian blue and Antwerp blue are two examples.

LIGHTFASTNESS STANDARDS

The ASTM (American Society for Testing and Materials) system has recently been established for the accelerated testing of artists' colors, relating to 20 years of gallery exposure. This test represents the most absolute classification in use for artists' materials. The ASTM codes for permanence of pigments are shown on the right, and are used throughout this book.

MANUFACTURERS' CODES

Reputable manufacturers code their colors according to permanence, the code appearing either on tube or jar labels, or in catalogs and leaflets. Some also give information on toxicity, whether the colors are transparent or opaque, and whether they are susceptible to atmospheric pollutants. The codes for permanence on the right are the most commonly used.

Not all manufacturers use the same lightfastness standard. Some, for example, use British Standard 1006, also known as the Blue Wool Scale. Lightfastness ratings, therefore, vary between one brand of paint and another.

Typical permanent colors
Left to right: raw umber, raw sienna, yellow ochre.

Typical fluctuating colors
Left to right: Prussian blue, Antwerp blue.

Typical fugitive colors
Left to right: naphthol crimson, ruby red, reddish violet.

Forms of pigment
All colored painting and drawing media include pigments of varying quality; the selection below shows only a few of the hundreds of colors and tones available.

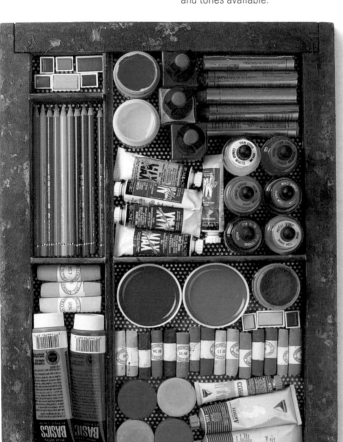

Choosing pigments
Good-quality materials, combined with sound technical practice in the preparation of supports and application of media, will help your work to survive the rigors of treatment and time.
Which pigments you choose is therefore an extremely important part of the process – it is always worth using only the best (usually identified in catalogs and on packaging as "Artists' quality"). Although these pigments may be expensive, the extra cost is well worth the investment.

Pigmentation and paint
This scene (above) shows the end of one phase in the manufacture of paint; the pigment has been selected, ground, mixed with the binder and milled for smoothness and consistency, with rigorous quality checks at every stage.
The paint is then packed into the various containers used — pans and tubes for watercolor, tubes and jars for acrylics, and tubes for gouache and oil paints — and dispatched to distributors and art-supply stores.

THE LANGUAGE OF COLOR

SEE ALSO

Mixing colors, page 178	
Color expression, page 182	
Color harmony, page 183	
Color contrast, page 184	

"THERE ARE HIDDEN HARMONIES OR CONTRASTS IN COLORS WHICH INVOLUNTARILY COMBINE TO WORK TOGETHER..."

VINCENT VAN GOGH (1853-90)

Knowing how to mix and use colors is crucial to the success of any painting. Yet, because color is essentially an abstract concept, many artists find it a difficult and bewildering area. This lack of confidence is largely the result of ignorance of the basic principles of color – here, as always, there are certain rules and guidelines to follow.

THE COLOR WHEEL

One of the most important "tools" for the artist is the color wheel. This is a simplified version of the spectrum, bent into a circle. It is an arrangement of the primary colors (red, yellow and blue) and the secondary colors (orange, green and violet), from which all others – including the greys, browns and neutral colors – are mixed.

PRIMARY COLORS

The primary colors are equidistant on the color wheel. A primary color is one that cannot be made by the mixing of any other colors. In theory, the primary colors can be mixed in varying proportions to produce every other color known, but in practice things are not that simple, because primary red, yellow and blue do not exist in pigment colors.

SECONDARY COLORS

A secondary color is obtained by mixing equal quantities of any two primary colors. Thus, blue and yellow make green, red and yellow make orange, and red and blue make violet.

TERTIARY COLORS

A tertiary color is made by mixing an equal quantity of a primary color with the secondary next to it on the color wheel. If you combine red with its neighbor to the right – orange – you get red-orange; if you combine red with its neighbor to the left – violet – you get red-violet.

By adjusting the proportions of the primary and secondary colors, you can create a wide range of subtle colors. Further intermediate colors can be made by repeatedly mixing each neighboring pair until you have an almost continuous transition of color.

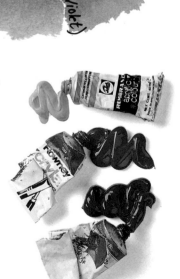

Names and colors
All artists' pigment colors, whatever exotic names manufacturers give them, are only permutations of those shown on the color wheel.

COLOR RELATIONSHIPS

There are two basic ways in which colors react with each other: they contrast or harmonize. It is possible to explore the relationships of colors according to their positions on the color wheel. Going around the wheel, you can see that those colors which harmonize are close to each other, and those that contrast are far apart.

Related colors
Colors adjacent to one another on the color wheel form a related, harmonious sequence. The closest relationships are between shades of one color, or between a primary color and the secondary which contains that primary, such as blue and blue-green or blue-violet.

Complementary colors
The colors opposite one another on the wheel are contrasting partners, called complementary colors. There are three main pairs, each consisting of one primary color and the secondary composed of the other two primaries: thus red is the complementary of green, blue of orange, and yellow of violet. These relationships extend to pairs of secondary colors, so that red-orange is complementary to blue-green, blue violet to yellow-orange, and so on.

If two complementary colors of the same tone and intensity are juxtaposed, they intensify each other. The eye jumps rapidly from one color to the other, causing an optical vibration that makes the colors shimmer.

Using complementaries
The apparent riot of color contained in this still life is, in fact, skillfully controlled by allowing two sets of complementary colors – red and green, and orange and blue – to predominate. The white areas act as a foil for the vibrant hues.

Peter Graham
JAPANESE GIRL WITH FLOWERS
Oil on canvas
24 x 30in (60 x 75cm)

DEFINING TERMS
The terms used to describe the properties of colors, such as "hue" and "tone," are often used inaccurately, or are misleading.

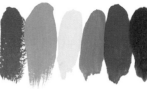

Hue
Hue is another word for color, and refers to the generalized color of an object. The word is used when describing close or similar colors: cadmium red, alizarin crimson and vermilion, all reds, are close in hue.

Intensity
Intensity (also referred to as chroma or saturation) refers to how bright or strong a color is. Vivid, pure colors are strong in intensity; pale, greyed colors are weak. A vibrant, intense color, such as cadmium red, will become less intense as white is added and it becomes pink.
The intensity of a color can also be reduced by mixing it with its complementary, which will make it become greyed.

Tone
Tone, or value, refers to the relative lightness or darkness of a color. Some colors are by nature lighter in tone than others; compare lemon yellow with burnt umber.

Tints and shades
When white is added to a color to lighten it, the resultant mix is referred to as a tint of that color. Shades are darker tones of a color, achieved by adding black.

SEE ALSO
Composition, page 188
Depth and distance, page 204

Depth and space
Because the eye perceives cool colors as being further away than warm ones, contrasts of warm and cool are used to create an illusion of receding space in landscapes. There is a strong impression of space in Terry McKivragan's painting. The foreground contains warm earth colors, which come forward; moving back to the horizon, the colors become progressively cooler and the tone lighter.

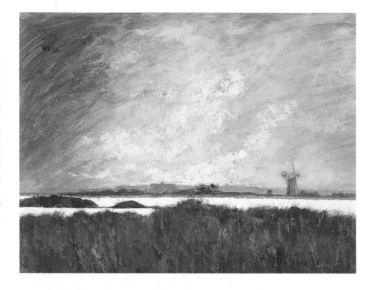

Terry McKivragan
NORFOLK BROADS
Acrylic on board
21 x 27in (52.5 x 67.5cm)

The effect of light
Each color has its own degree of warmth or coolness: for instance, lemon yellow is a cool yellow, while cadmium yellow is warm. The color of the prevailing light also determines the warmth of a color. Here, for example, late-afternoon light tinges every color with its warmth (except in the shadow areas, which are correspondingly cool).

Arthur Maderson
WINTER SUNLIGHT,
NORMANDY
Oil on canvas
28 x 34in (70 x 85cm)

WARM AND COOL COLORS

Colors are either warm or cool. Broadly, the "warm" colors are those that fall within the yellow-orange-red sections of the color wheel; the "cool" colors range through the purple-blue-green segments. Because warm colors appear to come forward in the picture space and cool colors seem to recede, opposing warm and cool colors helps create space and form in a composition.

174

Anthony Fry
ASHARAF, COCHIN
Oil on canvas
12 x 13in (30 x 32.5cm)
Browse & Darby, London

Color and design
The apparently casual design of this painting belies its strong organization. Using near-flat areas of vibrant color, creative of space and light, Anthony Fry arrives at a kind of pure harmony, the kind Matisse called "spiritual space."

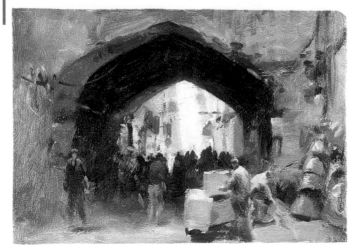

Trevor Chamberlain
TEHRAN BAZAAR
Oil on board
7 x 10in (17.5 x 25cm)

Tonal key

The tones and colors in a painting can be compared to musical notes. Too many different tones produce visual dissonance, whereas a controlled range of tones, keyed either to the light or the dark end of the scale, produces harmony and underlines the emotional message. Trevor Chamberlain's painting is an example of how a limited range of tones, massed into a well-structured arrangement, can lend strength and unity to a busy subject.

Tone and mood

Ken Howard is very much a tonal painter, and this early work derives its charm from its quiet statement and harmonious tonality of color. Like the great still-life painters before him, from Chardin to Mondrian, he manages to bestow, even on a simple arrangement of everyday objects, a sense of significance and dignity.

Ken Howard
STILL LIFE
Oil on canvas
24 x 20in (60 x 50cm)

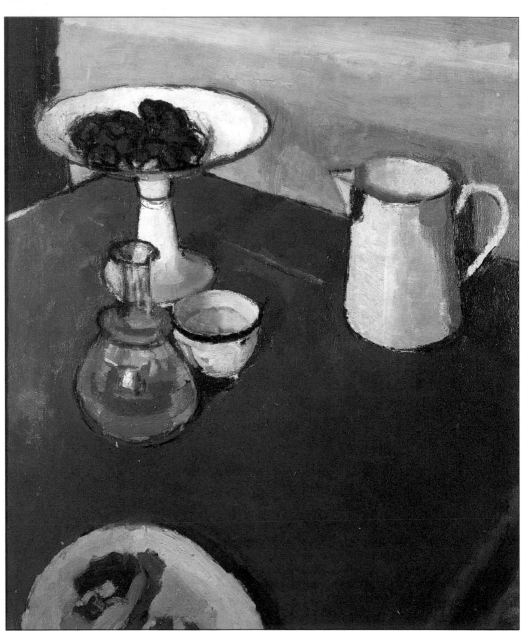

SEE ALSO
Defining terms, page 173

TONAL VALUES

The word "tone" tends to throw painters of all levels of experience into confusion. However, tone is an essential part of all painting and drawing, especially in achieving the effects of light on a subject. Tonal values are vital if you wish to model form, compose a picture well, and express mood and atmosphere.

Comparative tones
All blues are basically the same color, but cerulean blue is light in tone, while Prussian blue is darker.

UNDERSTANDING TONE

Tone describes the relative lightness or darkness of an area of color. Some colors are more light-reflective than others and appear to be lighter in tone – cerulean blue and Prussian blue are the same color, or hue, but the former has a light tone, while the latter has a dark one.

Tone can be easily understood when it deals with black, grey and white. However, it is hard to define tonally the hues and intensities of some colors. An object may have an intense, warm color, but that very warmth and intensity may make you think that the tone is lighter or darker than is actually the case.

Tones and colors are modified by adjoining colors, and a color that appears dark when alone on a white canvas may well seem to have a lighter tone when surrounded by other colors, and vice versa.

The effect of light
The tone of a color changes with the effect of light, and any color will exhibit a range of tones – the more a surface faces away from the light, the darker it becomes.

TONE AND DESIGN

The framework of light and dark areas that makes up a picture – the broad tonal pattern – is often what first attracts attention and provides an immediate introduction to the mood and content of that picture. If the tonal pattern is strong, it encourages a closer and more focused examination. Look at a wall of pictures in a gallery or exhibition; the pictures with a well-designed tonal pattern make the most impact on the casual viewer.

COUNTERCHANGE

Counterchange is the placing of light shapes against dark, and vice versa. It creates lively, interesting pictures, as the reversals of light and dark provide intriguing contrasts. Counterchange also gives movement and rhythm to a picture, leading the viewer from light to dark and back again. The great Dutch painters, such as Rembrandt and Vermeer, were masters of this technique, and used it to great effect, particularly in interior scenes.

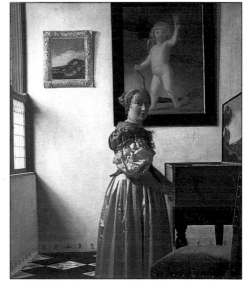

Jan Vermeer (1632-75)
A YOUNG WOMAN STANDING
AT A VIRGINAL
Oil on canvas
20½ x 17¾in (51.5 x 43.3cm)
National Gallery, London

MIXING COLORS

Learning to mix colors is the first step towards achieving a successful painting. Initially it is certain to involve some trial and error, but there are some general guidelines that will help you to achieve success.

SEE ALSO

Oil paints, page 67

Watercolor paints, page 108

Acrylic paints, page 150

The language of color, page 172

Broken color, page 181

Glazing, page 181

THEORY AND PRACTICE

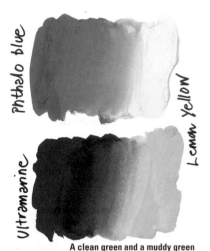

A clean green and a muddy green

The color wheel is of limited use to the artist when it comes to mixing actual paint, because pigments, unlike light, are not pure. In addition, pigments invariably have a slight bias towards another color.

Blue and yellow make green?

In theory, blue and yellow make green; but in practice, mixing any old yellow and blue could end up with mud. Ultramarine blue, for example, has a reddish undertone, while lemon yellow has a greenish one. These red-and-green undertones are complementary colors; when two complementaries are mixed they make grey – which is why the result is a muddy green.

To mix a clean green from blue and yellow, it is important to choose the right blue and the right yellow for the particular shade you want (see right).

Palette for "clean" colors
These colors, shown below left, give the widest range for mixing pure, clean colors.

Lemon yellow (green-shade yellow)

Cadmium yellow (red-shade yellow)

Cadmium red (yellow-shade red)

Permanent rose (blue-shade red)

Phthalo blue (green-shade blue)

Ultramarine blue (red-shade blue)

Viridian (blue-shade green)

Phthalo green (yellow-shade green)

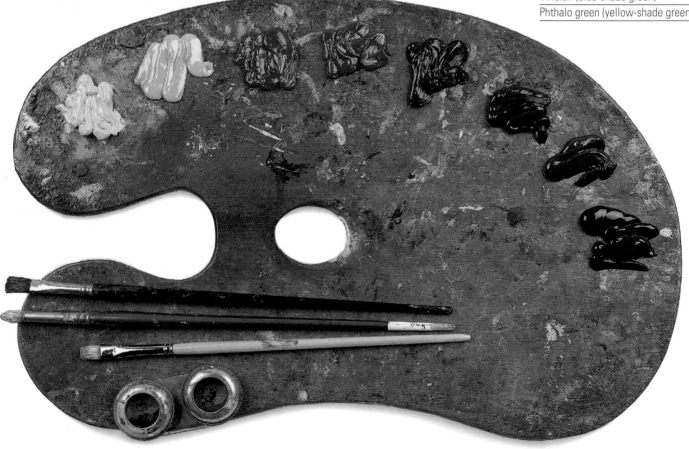

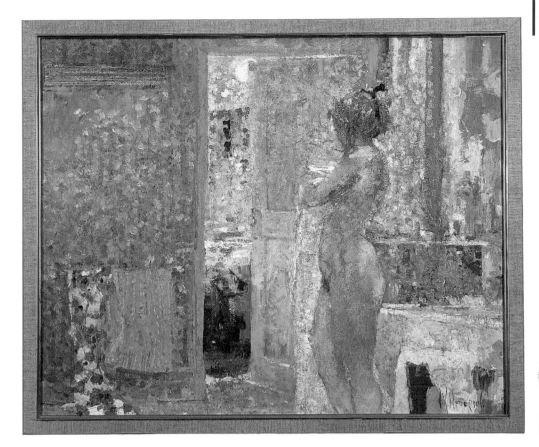

Optical mixing
Following the Impressionist tradition, Maderson creates a shimmering illusion of light with myriad flecks and dabs of juxtaposed color. The colors mix optically when viewed at a distance, and appear more vibrant than if they had been mixed together.

Arthur Maderson
FROM THE BATHROOM
Oil on canvas
26 x 32in (65 x 80cm)

Modifying colors
If a color appears too strident, it can be toned down, either with a complementary color or with an earth color.

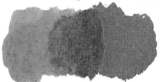

Tone down red and green with raw umber

A red that is too hot can be cooled with a little green – and vice versa

Adding black to a color tends to dull it

Making greys
Complementary mixing produces neutral greys, more colorful than those which come ready-mixed as tube colors.

MIXING COMPLEMENTARIES

When two complementary colors are juxtaposed, they intensify each other. However, when they are mixed together they neutralize each other and form neutral greys and browns. Depending on the colors used and the proportions of each, it is possible to create a wide range of colorful neutrals.

Take complementary red and green, for example. By mixing these in varying quantities you achieve muted, earthy colors. Adding white to the mixture creates a series of delicately colored greys, which provide a marvelous foil for brighter, more vibrant colors. The greys produced in this way are more lively than the steely greys made by mixing black and white.

Violet and yellow mix together to form warm grey

Mix red and green together to make earthy brown

Add white to red-green mixtures to produce delicate greys

179

SEE ALSO

Oils palettes, page 84

Glazing, page 92

Wash techniques, page 120

Tonal values, page 175

Color harmony, page 181

Keeping colors clean
Make several dabs of each color on your palette rather than one large one. This makes it easier to keep colors – particularly the light ones – clean and clear.

PALETTE LAYOUT

Get into the habit of laying out colors on the palette in the same systematic order each time you paint. You will thus know where each color is without having to search for it, so you can concentrate on observing your subject.

Some artists arrange colors in the order of the spectrum, with red, orange, yellow, green, blue and violet running across the palette, and white and earth colors down the side. Others arrange their colors from light to dark, or align warm colors (reds, oranges and yellows) on one side and cool colors (blues, greens and violets) on the other. Whichever method you choose, stick with it.

Preferred layouts
The examples below show some of the methods employed by professionals for laying out color on their palettes.

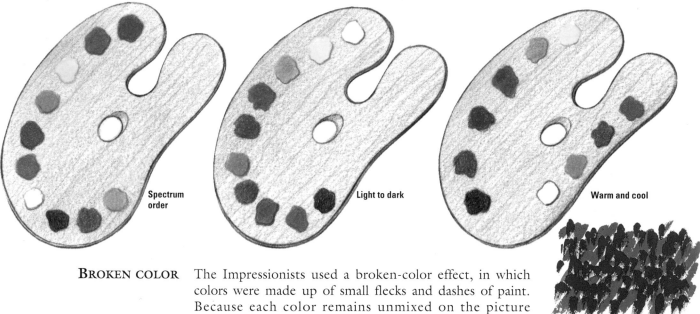

Spectrum order

Light to dark

Warm and cool

Broken colors blend at a distance

BROKEN COLOR

The Impressionists used a broken-color effect, in which colors were made up of small flecks and dashes of paint. Because each color remains unmixed on the picture surface, less light is absorbed than if the same colors were to be mixed on the palette. When viewed from an adequate distance, the colors blend, and have a vibrant, luminous quality.

GLAZING

Glazing is another way of producing optical mixes. For example, if you apply a blue glaze over a yellow ground, the green produced is much more lively than one produced by mixing blue and yellow pigments. Light enters the transparent film and is refracted from below, to produce a rich, glowing effect.

Base color modified with a transparent glaze

180

COLOR INTERACTION

Colors and tones should never be regarded in isolation, but in terms of how they relate to those around them. All colors and tones are influenced by neighboring ones; when two colors are viewed side by side, the contrast between them is enhanced or heightened. Each touch of color added to a painting alters the relationship of the colors already there: a bright color appears richer when placed next to a neutral or muted color; similarly, a dark tone appears even darker when placed next to a light one.

Bright colors seem richer next to neutral colors

HARMONIOUS PAINTING

Inexperienced painters often work on one small area of a painting until it is "finished," and then move on to the next area. This generally leads to a disharmonious and confused painting, because each color is unrelated.

It is better to work on all areas of the composition at once. Work from landscape to sky and back again, or from figure to ground and back again. Keep your eyes moving around the subject, assessing and comparing one color against another, one tone against its neighbor, and make adjustments as you go. In this way your painting will grow and develop, emerging finally as a homogeneous mass of color and tone. Painting is a continuous process of balancing, judging, altering and refining – which is what makes it so absorbing.

Dark tones intensify next to light ones

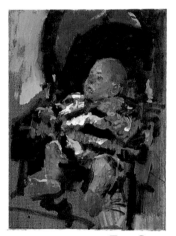

Tom Coates
STUDY OF A BABY
Oil on panel
14 x 10in (35 x 25cm)

In this unfinished painting (above), the subject and background are progressing at more or less the same pace. The artist constantly modifies the colors and forms of both parts of the work, keeping the image fluid and gradually moving towards an integrated statement.

Bright and neutral colors
Though a tiny shape, the windsurf board is very much the focal point of this picture. Surrounded by dark tones and neutral colors, the sharp accent of the white sail sings out with a piercing note.

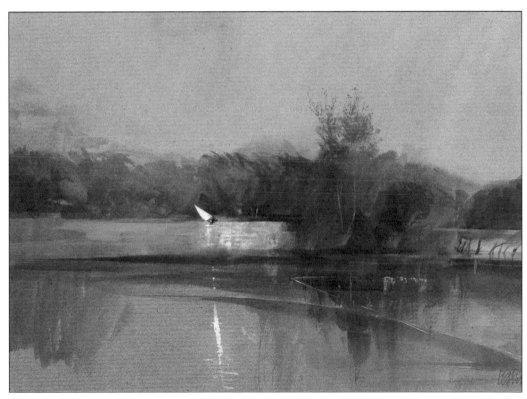

Leslie Worth
WINDSURFER ON BOLDERMERE
Watercolor on brown paper
9 x 11½in (22.5 x 28.7cm)

COLOR EXPRESSION

One of the most important aspects of color is that it is emotive – it stimulates all our senses, not just our eyes. Color can be used to suggest and to accentuate the mood of a painting, as well as create an emotional response in the mind of the viewer. It can be used directly and dramatically to provoke a strong response, or in a more subtle way.

SEE ALSO

The language of color, page 172

Tonal values, page 177

Color contrast, page 184

Color and mood
Len Tabner has held a lifelong fascination with the sea. In this stunning image, he conjures up the elemental drama of wind, sky and water with a palette of dark and brooding colors. Interestingly, if you cover up the bright orb of the setting sun, much of the impact of the image is lost.

Len Tabner
GREY DAY, SUNSET
Watercolor and conté crayon on paper
31 x 53in (77.5 x 132.5cm)
Thos. Agnew & Sons, London

USING COLOR TO SUGGEST MOOD

Colors can trigger a flow of images, sounds and emotions. Blue makes us think of sky and sea, mountains and streams. Depending on the context in which it is used in an image, it can denote freshness and lightness, or melancholy and alienation. Yellow conjures up images of sunshine and summer flowers – but it can also be a strong, harsh, acidic color.

Warm (red and yellow) colors denote vitality, life, vigor and strength, and demand a strong emotional reaction from the viewer. Cool (blue and green) colors impart more passive, restful emotions.

The tone of the color, and its intensity, also play a part. Red is a vital, dynamic color (any fully saturated red object in a painting will immediately attract attention, regardless of its size). It can become desaturated by being mixed with white until it is a soft, romantic pink. The pale, desaturated blue that is associated with coolness and tranquillity can be so vibrant in its pure state that it has as strong an effect as red.

Fully saturated red

Mixed with white and desaturated

COLOR HARMONY

Harmony is possibly the most subtle and evocative of all the reactions between colors, and can be used with great effect to create mood in your paintings. While contrast is dramatic and emphasizes the subject, harmony is gentle and easy on the eye.

HOW COLORS HARMONIZE

There is harmony between those hues which lie on the same section of the spectrum or color wheel – between yellow and green, for example. Colors with the same characteristics will be in harmony when placed together.

Orange-brown and yellow very often have the same warm quality, and harmonize well. This combination is frequently found in nature – the reds and browns in an autumnal scene, for instance – as is the yellow-green harmony of a spring landscape.

DOMINANT HUE

Although harmonious schemes are often the most pleasing and easy to handle, the very unification which makes them harmonious may make them monotonous. Enough variety of tone and intensity prevents monotony, and places emphasis on one dominant hue. This hue can dominate through tonal contrast, intensity, or the space it occupies in the picture.

COMPLEMENTARY ACCENTS

A harmonious scheme can also be enlivened by the introduction of complementary accents. Such accents, if brilliant, have power even when used in small amounts. A small touch of red in a green landscape, for instance, can add zest to an image.

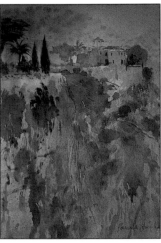

Grenville Cottingham
EARLY MORNING IN SIMI
Watercolor on paper
15 x 11in (37.5 x 27.5cm)

Harmony and light
At certain times of day and in certain weathers, colors which normally contrast appear to be in harmony.

Diffused light desaturates colors, weakening their strength and brilliance so they seem more in accord. This harmonizing effect is evident in both Keith Roper's and Grenville Cottingham's very different landscapes, in which the colors are keyed to a unified level of tone and intensity, underlining the tranquillity of each scene.

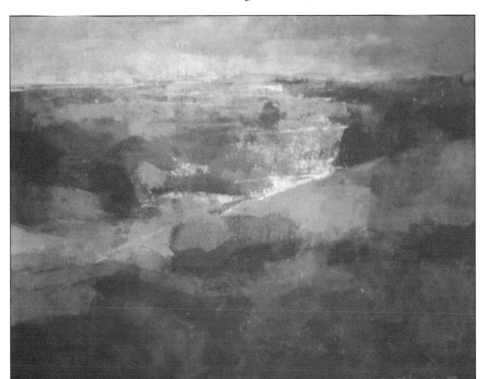

Keith Roper
WILTSHIRE
Gouache and pastel on paper
12 x 15in (30 x 37.5cm)
Kentmere House Gallery, York

COLOR CONTRAST

When colors of opposite characteristics meet, they create impact. The Renaissance painters used light-dark contrast; the Impressionists exploited contrasts of warm and cool color, and of complementary colors; again, Turner used intensity contrast, playing pure tints against neutrals.

SEE ALSO

The language of color, page 174
Tonal values, page 177
Color expression, page 182
Composition, page 188
Focal points, page 190
Landscapes, page 206

COMPLEMENTARY CONTRAST

When complementary colors are juxtaposed, they enhance each other, producing a very vibrant visual sensation; each color seems brighter against its neighbor than it would on its own.

To give one example, blues and greens contrast with their complementaries, orange and red. The success of this contrast depends very much on the proportions: equal amounts of the colors can create a jarring, unpleasant effect, but a small amount of red in a predominantly green area can be very exciting.

The most intense sensation of color contrast comes from complementary colors which are equally matched in tone and intensity. If, however, there is a notable tonal difference between the colors, the contrast is less dramatic or dynamic.

The complementary (violet) and split complementaries of yellow

Red flecks on an area of green, its complementary color

SPLIT COMPLEMENTARIES

Absolute complementaries do not have to be used, and near, or "split" complementaries are often more pleasing to the eye than true ones. Split complementaries are those which are separated by the true complementary; for example, violet is the true complementary of yellow, while blue-violet and red-violet are its split complementaries.

Juxtaposed complementary colors

Sophie Knight
CHINA BOWL WITH FRUIT
Watercolor on paper
22 x 30in (55 x 75cm)

This still life demonstrates an effective use of complementary colors. Notice how the artist introduces the complementary, blue, to make the warm yellows appear brighter and more luminous.

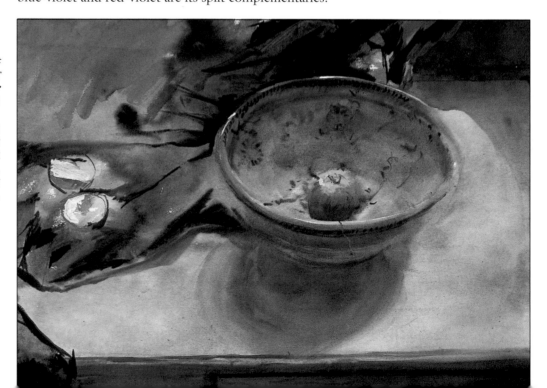

COMPOSITION AND CONTRAST

The rules of composition apply when dealing with color contrast. It is important that the area of greatest contrast in the picture draws the eye to it, so make sure that strong contrast occurs at the focal point of the picture, otherwise it will be a distracting influence. Employing equal areas of strong, contrasting colors results in a confusing image. Achieve a balance by varying the proportions of the contrasting colors.

INTENSITY CONTRAST

Saturated colors appear more brilliant when placed alongside neutral colors. A painting dominated by neutral tones may be enhanced by placing areas of pure color near the center of interest, to capture the eye and hold the attention. In the same way, a colorful subject is enhanced by restful neutral passages.

TONAL CONTRAST

Tonal contrasts have considerable visual impact; the attention of the viewer may be attracted by strong contrasts of tone before the emotional expression of the color itself is felt.

TEMPERATURE CONTRAST

All colors have familiar associations. Reds and yellows conjure up sunlight and fire, and we connect blues and greens with snow, ice and water.

Contrasts of warm and cool color have several applications in painting. A color that is predominantly warm usually expresses joy, energy and forcefulness; cool, subdued colors are used to express moods ranging from calm and tranquillity to sadness and despair.

Intensifying colors
Neutral colors make saturated colors appear more brilliant.

Rembrandt van Rijn (1606-69)
SELF-PORTRAIT AGED 34
Oil on canvas
40¾ x 32in (102 x 80cm)
National Gallery, London

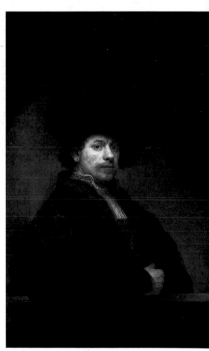

Chiaroscuro
Rembrandt was a master of chiaroscuro – the contrast of light against dark – not only as a compositional device, but also to heighten tension and drama.

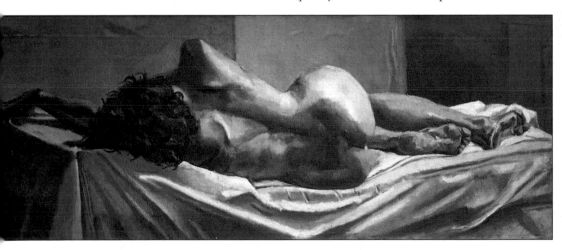

Desmond Haughton
SUE
Oil on canvas
18 x 47in (45 x 117.5cm)

Form and space
Contrasts of warm and cool color can be used to describe form and to create the illusion of space and depth. Here, the limited palette of warm and cool colors gives sculptural modeling to the figure. Note the warm tones on the model's shoulders, calves and buttocks; by contrast, bluish-violet tones describe the indented plane of the small of the back.

The COMPOSITION or design of a picture can be compared to the foundations of a tall building. Without this solid, underlying framework, the whole thing would collapse. Even the simplest subject needs to be composed so that it fits effectively within the confines of the picture space and – most importantly – so that it emphasizes the message behind the work.

Len Tabner
HAWTHORN
Watercolor and pastel on paper
22 x 30in (55 x 75cm)
Thos. Agnew & Sons, London

COMPOSITION

SEE ALSO
Tonal values, page 177
Color harmony, page 183

"COMPOSITION IS THE ART OF ARRANGING IN A DECORATIVE MANNER THE VARIOUS ELEMENTS AT THE PAINTER'S DISPOSAL FOR THE EXPRESSION OF HIS FEELINGS. . ."

HENRI MATISSE (1869-1954)

Before embarking upon a painting or drawing, it is important to step back and evaluate your subject, not only as a series of objects occupying three-dimensional space, but also as a flat pattern – a "jigsaw puzzle" of interlocking shapes, colors and tones – that adds up to a balanced design.

VISUAL BALANCE

One of the most important goals in composing a picture is achieving visual balance. In other words, the various elements that make up the image – lines, shapes, colors, tones and textures – must be arranged with care.

Artists and critics have put forward many theories about this balance. The ancient Greek philosopher, Plato, expressed succinctly what good composition is all about. He stated that "composition consists of observing and depicting diversity within unity"; in other words, a picture should contain enough variety to keep the viewer interested, but this variety must be restrained and organized to avoid confusion and disunity.

Christa Gaa (1938-92)
STILL LIFE WITH INKWELL
Watercolor on paper
8 x 11in (20 x 27.5cm)
New Grafton Gallery, London

Unity and diversity
Unity is achieved by introducing elements that relate to and echo each other, such as the bottles and bowls in this still life. These visual links are effective, because the eye finds related forms more satisfying than unrelated ones. However, notice how Christa Gaa has also introduced diversity – without distracting from the overall unity of the composition – by choosing objects that differ in size in shape, and by varying the spaces between them.

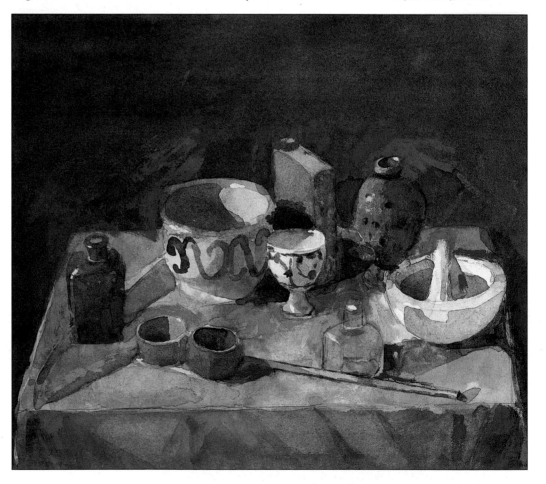

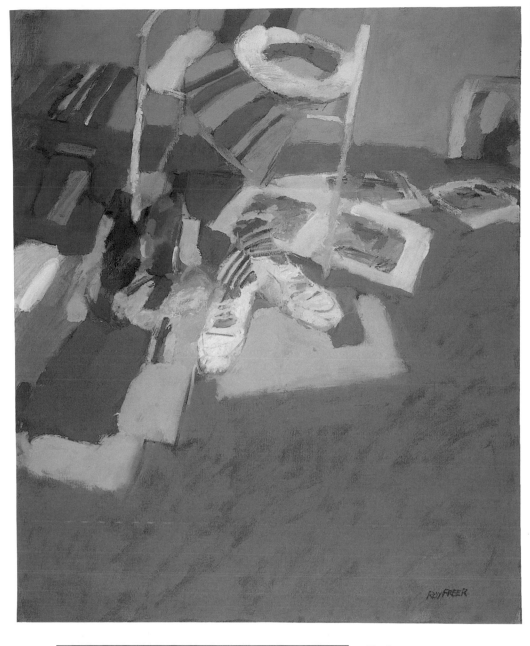

Asymmetry

Formal symmetry lends balance to an image, but lacks excitement. An asymmetrical arrangement, on the other hand, maintains visual equilibrium while setting up dynamic tensions and rhythms. Asymmetrical composition can be likened to an old-fashioned scale, in which a small but heavy metal weight on one side can balance a much larger pile of objects on the other. In this painting, for instance, there is a counterpoise between active and passive space; the busy clutter of objects serves as a strong attraction, but is held in check by the large, simply stated foreground.

Roy Freer
SKY BLUE
Oil on canvas
48 x 40in (120 x 100cm)

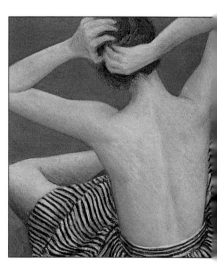

Positive and negative shapes

The positive shapes of objects in a picture are important, as are the negative shapes created by spaces around and between those objects. This picture works on two levels: as a representation of the subject, and as a two-dimensional design of interlocking shapes.

Elsie Dinsmore Popkin
NUDE WITH STRIPED SKIRT
Pastel on paper
10 x 10in (25 x 25cm)

Rhythm

Rhythm in a painting or drawing plays the same role as rhythm in music; it draws the different elements together and imparts the composition with a distinctive mood. These bending figures are grouped into a beautifully controlled central design, in which shapes, patterns, lines and colors repeat and echo each other. This sets up a rhythm which unifies the picture.

John Martin
VINEYARD WORKERS
Watercolor and gouache on pastel paper
8 x 6in (20 x 15cm)

189

CREATING A FOCAL POINT

SEE ALSO
Color contrast, page 184

> *"DOES A PICTURE NEED A FOCAL POINT? INDEED IT DOES, JUST AS A MEAL NEEDS A MAIN DISH AND A SPEECH A MAIN THEME, JUST AS A TUNE NEEDS A NOTE AND A MAN AN AIM IN LIFE. . ."*
>
> JOHN RUSKIN (1819-1900)

A representational picture should have one main subject — a focal point to which the viewer's eye is inevitably drawn. Thus, when planning your composition, your first question should be, "What do I want to emphasize, and how should I emphasize it?"

Trevor Chamberlain
RAILWAY VIADUCT, WELWYN
Watercolor on paper
10 x 7in (25 x 17.5cm)

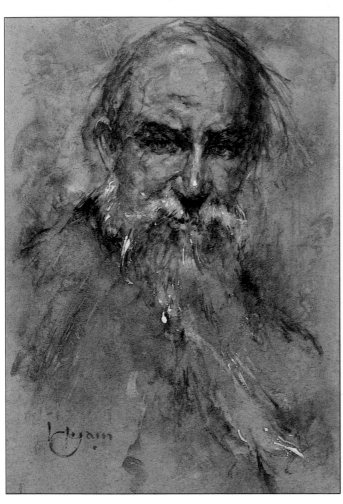

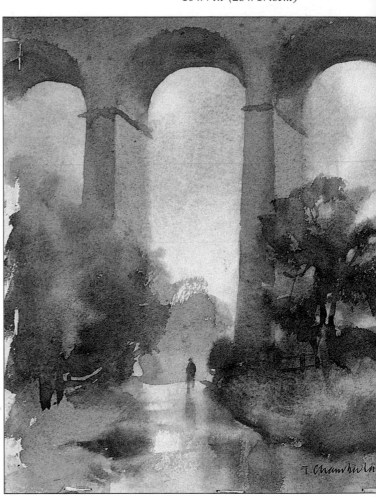

Michael Hyam
STUDY OF JOACHIM
Pencil and watercolor on paper
9 x 5in (22.5 x 12.5cm)

Creating emphasis
Stressing one element is partly a matter of subordinating the others, for example by keeping the background less detailed and distinct than the foreground. The lyrical beauty of this portrait study derives from the "lost-and-found" quality of the drawn and painted marks. The sitter's face is the focus of attention, and it is here that Michael Hyam concentrates more detail and color. The looser treatment of the other elements emphasizes the modeling of the features by contrast.

Focusing attention
There are several devices which the artist can use to bring attention to the center of interest, such as placing more detail in that area, or more intense colors, contrasting shapes, or tonal contrast. When a human figure is included in a composition, the eye is inevitably drawn to it – even when, as here, the figure is dwarfed by its surroundings. Notice how the focal point – a dark tone against light – is framed by the arch of the viaduct, giving it further emphasis.

Leading the eye

When we look at a picture of any kind, we instinctively look for a visual pathway to guide us through the composition and make sense of it. If the elements in the picture are not connected in a pleasing and rhythmical way, we soon lose interest because the picture has a fragmented, incomplete feeling.

Creating lead-ins
The drama of this scene is accentuated by the forceful directional lines of the sand dunes. The eye is propelled back in space to the focal point formed where the silver light on the water meets the dark tone of the coastline.

Annabel Gault
EASTON BROAD
TOWARDS SOUTHWOLD
Oil on canvas
6⅛ x 7¾in (15.3 x 19.8cm)
Redfern Gallery, London

The rule of thirds
To give the focal point maximum visual impact, take care to place it carefully within the confines of the picture space. A traditional way to produce a balanced, satisfying composition is to use the "intersection of the thirds." This formula is based on mathematical principles of harmony and proportion, and has been used by artists for centuries.

Using the rule
Mentally divide the picture area into thirds, horizontally and vertically, and locate the center of interest, and any secondary elements, at or near the points where the lines intersect. This simple principle produces well-balanced, comfortable compositions that are easy on the eye.

Counterchange
The placing of light shapes against dark, and dark shapes against light, is another means of creating visual pathways through a picture; the eye is attracted by these strong contrasts and will jump from one to the next. Remember, however, that the greatest contrast should be reserved for the center of interest, so keep tonal contrasts elsewhere in the painting relatively subdued.

Valerie Batchelor
COTSWOLD VILLAGE
Watercolor on paper
11 x 14in (27.5 x 35cm)

Compositional shapes
These sketches show several different ways to break up the picture space in a pleasing way and help you to organize the elements so that the viewer's attention falls where you want it.

Alison Musker
VICOLO DELLE RIFORME
Watercolor on paper
14 x 6¾in (35 x 16.8cm)

A tall narrow format like this is certainly unusual, but here it is appropriate to its subject, underlining the haunting quality conveyed by this pared-down image.

Lucy Willis
INTERIOR, ZABID (below)
Watercolor on paper
17 x 25in (42.5 x 62.5cm)
Chris Beetles Gallery, London

Sally Strand
GIRL WITH MOTHER BENDING
Pastel on paper
14 x 11in (35 x 27.5cm)

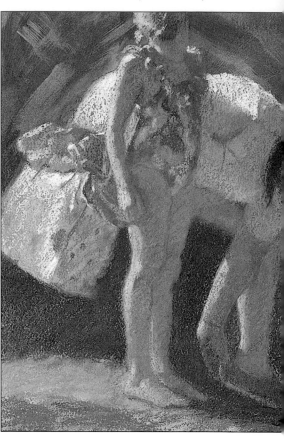

Cropping images
Sally Strand's figure compositions (above) are always natural and unposed, conveying the effect of the snapshot. Deliberately cropping the figures at the edges of the frame brings the viewer in close for more intimate contact with the subject.

Maintaining tension
Lucy Willis's pictures seldom settle for the obvious. Here, the figure on the right is walking out of the painting, apparently flouting the convention that the viewer should be led into the picture, not out. Yet why is the eye held so firmly within the picture space?
First, the vertical line of the door serves as a brake to the outgoing figure; then that figure is counterpointed by the small figure in the corner, creating a spatial "push-pull" sensation which keeps the eye moving around the image.

SEE ALSO
Composition, page 188

BREAKING THE RULES

Composition is an important aspect of painting, but an over-reliance on mathematical and geometric formulas may result in images which, though competent, are safe and predictable. As Cézanne once said, "When I start thinking, everything's lost."

"KEEP YOURSELF FREE FROM FORMULAS."

JEAN-BAPTISTE GREUZE (1725-1805)

Square format
This format is used less frequently than landscape or portraits, yet it has a stability which is attractive to the eye. It is no more difficult composing a square-format picture than a rectangular one, even when the subject is a landscape, and it is worth experimenting with formats.

John Martin
STILL LIFE WITH WATERING CAN (above)
Oil on canvas
12 x 12in (30 x 30cm)

INSTINCT AND INTUITION

It is the unexpected and the personal that make an image memorable, and often it is better to let your creative instincts dictate when to follow the rules – and when to deliberately flout them.

The "rules" that govern painting and drawing should be taken only as guidelines for producing an acceptable image. Although they are useful for the new painter, with experience you will find that good composition is largely a matter of observation, instinct and intuition.

FORMATS

As a general rule, a horizontal format is the most appropriate shape for the broad sweep of a landscape, while an upright format is the usual choice for portraits (hence the terms "landscape format" and "portrait format"). But a more arresting image may often be produced by reversing these principles.

Breaking away
One of the main reasons why the rectangular-picture format dominates all others is the Renaissance convention that "a picture is a window opened on the world and then painted by an artist." The contemporary artist, less bound by convention, realizes that the rectangular format is just one of many shapes you can use for a picture.

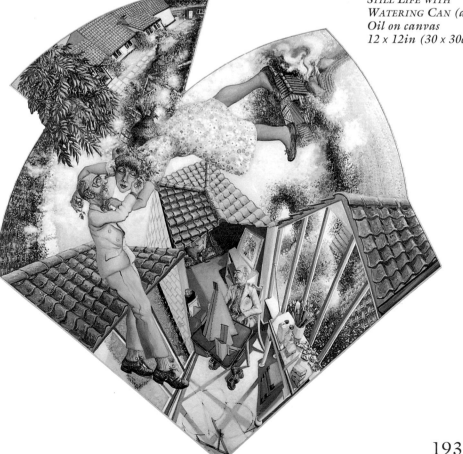

Anthony Green
THE THIRTIETH WEDDING ANNIVERSARY
Oil on board
63 x 59½in (157.5 x 148.8cm)
Piccadilly Gallery, London

DRAWING AND OBSERVATION

SEE ALSO
Pencils, page 38
Pen and ink, page 52

> "DRAW LINES, MANY LINES, FROM MEMORY OR NATURE; IT IS BY THIS THAT YOU WILL BECOME A GOOD ARTIST."
>
> JEAN-AUGUSTE-DOMINIQUE INGRES (1780-1867)

Drawing is a form of language, and is a learnable skill. Just as writing is made up of letters that make words that make sentences, so drawing starts with points that make lines that make shapes. Add light and shade to make three-dimensional shapes, and we start to compose – making shapes fit together in space.

A FIRM FOUNDATION

There are many reasons for practicing drawing. To begin with, it is a source of much pleasure and satisfaction; it also heightens our awareness, helping us to see colors and shapes anew. Most importantly, drawing is an excellent foundation for learning to paint. Indeed, if we rush headlong into painting without first developing drawing skills, our efforts are more likely to end in frustration.

ENJOY AND IMPROVE

Fear of failure is the thing that prevents many from learning to draw. But if you can ignore that little critical voice in your head that spoils the fun of drawing, you will begin to draw with ease, spontaneity and freedom.

ACCEPTING LIMITATIONS

The main thing is not to regard each drawing as a finished thing in itself. Accept the fact that, to begin with, many of your drawings will be failures, and just enjoy the sheer pleasure of the drawing process.

Sarah Donaldson
LIFE STUDIES
Conté chalk on paper
Various dimensions

Little and often
Drawing is like physical exercise; short sessions at regular intervals are of more benefit than a prolonged session every now and again. Even if you only have the time to draw for ten minutes a day, you will be amazed at how quickly your skills and observation improve.

Tom Coates
FIGURE AND PORTRAIT STUDIES (details)
Pencil and wash on paper

COMMUNICATION

Making a drawing is first about communication with yourself. When you look at an object, no matter how interesting, you only see it to a certain degree, whereas if you make a drawing from that object – even if you can't draw well – you will gain a much deeper understanding of what you see. The eye feeds the information to the brain, which analyzes it and feeds it to the hand, and the hand makes the mark that expresses your emotional reaction to what you see, and ultimately communicates it to others.

MISTAKES

In a wry remark about life in general, someone once observed, "Everybody makes mistakes. That's why they put those little erasers on the ends of pencils." When it comes to line drawing, however, an eraser can be a dangerous thing. If you draw in pencil, it is all too easy to erase an inaccurate line, only to redraw it in exactly the same position; you may spend so much time correcting that you stop looking at your subject and never get it right.

RESTATING

When mistakes occur, don't be afraid to leave them in and draw more accurate lines alongside. In other words, restate the lines. Drawing is a vital, changing process, a voyage of discovery. Feeling out forms and composition, adjusting and correcting, are vital elements in this process. On many master drawings, corrections and restatements are deliberately left evident, because they add to the vitality of the drawing; these are known as "pentimenti."

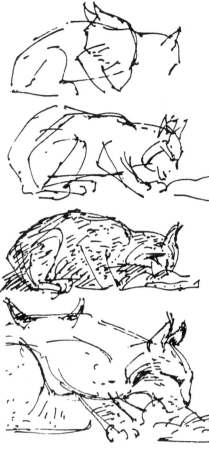

Richard Bell
EUROPEAN LYNX
(from a sketchbook page)
Pen and ink on paper

Retaining corrections
Think of each drawing as a battlefield, in which you are going to solve problems and learn something about the process of seeing. In fact, when you are learning to draw, your drawing should look like a battlefield, with mistakes and restatements visible. If your work is too perfect, with no corrections showing, you haven't been questioning what you are doing, and the result may be dull and lifeless.

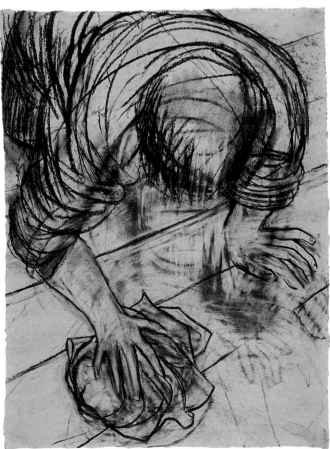

Sarah Cawkwell
FIGURE CLEANING
Charcoal on paper
30 x 22in (75 x 55cm)

Using a pen
It is very good discipline to practice drawing with a pen as well as with a pencil, so that when you make a mark you don't subconsciously think that you can rub it out if it's not right. With a pen you are forced to make a committed statement, and if it is wrong you have to make another one next to it – and you still have the marks that were wrong to compare with. In fact, you are more likely to get it right first time, because you tend to look properly and question what you are doing before you make a mark.

SKETCHING

SEE ALSO
Drawing papers, page 34

Despite the ubiquitous camera, most artists still prefer to carry a sketchbook and pencil with them. Because a sketch is the immediate result of observation, capturing a personal impression in a few essential strokes, it is an absolutely vital adjunct to, and preparation for, more considered studio work.

KEEPING A SKETCHBOOK

A sketchbook is an artist's most valuable piece of "equipment." It is the perfect place in which to improve your drawing skills and powers of observation, and to develop new ideas. It is also a place to note and record anything of interest, and as such becomes a valuable storehouse of visual references.

A sketchbook also helps to build up your confidence; rapid and frequent sketching aids you to express more intuitively what you feel and see. With a sketchbook and pencil, you can catch life on the wing.

ANYTHING GOES

A chance arrangement of objects on the breakfast table, a transitory effect of light; anything can be noted down rapidly and later used as the basis for a later composition – or simply for the sheer joy of observing and recording something pleasurable to the eye.

THE ARTISTIC PROCESS

The most interesting aspects of the work of any artist are often to be found, not in their finished paintings, but in their sketchbook drawings. Artists talk to themselves in the candor of their sketches, leaving immediate impressions as they jot down their reactions to the world around them.

For the onlooker, there is a fascination in looking at sketches, because it helps us to understand how that mysterious creature, the artist, actually comes by and shapes his or her inspiration. There is also, perhaps, a fascination with the unfinished rather than the complete, which appeals to the romantic in all of us.

Richard Bell, David Day, Simon Jennings, Anna Wood
SKETCHBOOKS (below and opposite)
Various drawing media on paper

These collages of artists' sketchbooks show the sheer variety of styles, occasions and intentions to be found. Each is different, and each is a document of one particular artistic moment.

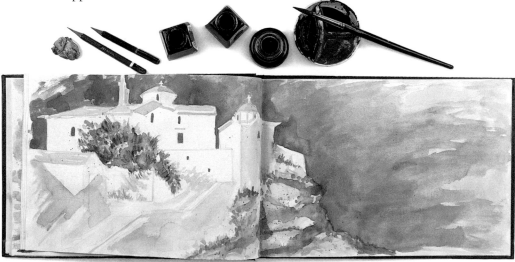

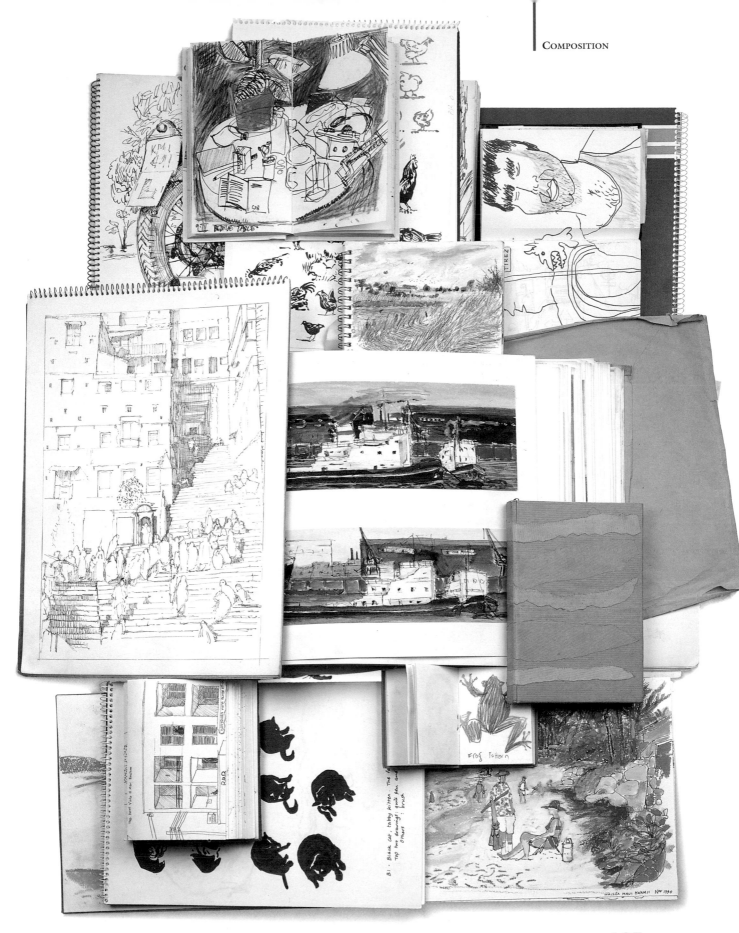

SUBJECTS AND THEMES

THE ARTIST IS BLESSED *with a special pair of eyes — eyes that find beauty and meaning in the* MUNDANE AND THE ORDINARY *as well as in the* STRIKING AND EXTRAORDINARY. *They reveal to us things that we may have encountered before but have not* SEEN.

There is an infinite variety of subjects and ways to depict them — those represented in the following pages are no more than the tip of the iceberg. THEMES *and* INSPIRATION *for drawing and painting are literally everywhere — you will probably find one right now, just by turning your head and looking. As Picasso once said, "*I DON'T SEEK, I FIND."

It is not necessary to search for "picturesque" LANDSCAPE subjects; some of the most memorable paintings are of simple, everyday scenes. Begin with the places you know best, and try to uncover those things that awaken an emotional response in you. When you spot something that gets the adrenaline going, paint it there and then if you can, or at least make a sketch of it. Don't pass it by, thinking there might be greener pastures around the corner. That first moment of seeing is unique and cannot always be recaptured when you return to the subject at a later time.

Annabel Gault
INVERLUSSA BAY II
Oil on canvas
40 x 61in (102 x 153cm)
Redfern Gallery, London

WORKING ON LOCATION

Though some artists paint landscapes in the studio, based on imagination and memory, the vast majority prefer to paint nature "en plein air." Although you may have to work quickly to catch a fleeting light effect, this sense of urgency inevitably has the result of injecting a spark of vitality into your work.

SEE ALSO

Canvas, page 12

Watercolor papers, page 26

Drawing papers, page 34

Watercolor paints, page 104

Easels, page 234

"THE LANDSCAPE IS IMPORTANT, MORE IMPORTANT THAN ANYTHING ELSE."

JOAN MIRO (1893-1983)

PLEASURES AND PITFALLS

Painting in the great outdoors does have its pitfalls; you may have to contend with changing light, uncertain weather and with curious onlookers, not to mention dust, leaves and bugs falling into your paint. But these problems are far outweighed by the pleasures of being in direct contact with nature. You are aware not only of the colors, forms and textures around you, but also of the sounds and smells, and your painting can only benefit as a result.

STUDIO PAINTING

Another approach is to start the painting in the field and complete it back at the studio. This gives you the best of both worlds, because the essential character of the scene is captured on the spot, and you can refine and develop it at your leisure and in comparative comfort. Similarly, sketches and color notes made on location can form the basis of a studio painting.

Viewfinders
When confronted with the world outdoors, you will find a cardboard viewfinder useful, as it helps you focus in on parts of the scene in isolation from the overall view. Close one eye and look through the frame, moving it toward and away from you until the subject is framed in a pleasing way. Study the whole area within the frame, and consider the balance between shape and mass, tone and color. The viewfinder will also enable you to judge angles and perspective in relation to the rectangle of the frame.

To make a viewfinder, take a piece of black or neutral-colored cardboard, about 5 x 4in (125 x 100mm). Cut a window in the center about 3 x 2in (75 x 50mm), or in the same proportions as your support.

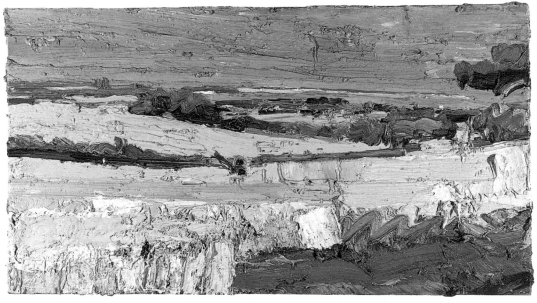

George Rowlett
ACROSS CORNFIELDS
(RED TRACTOR)
Oil on canvas
36 x 66in (90 x 165cm)

George Rowlett always paints his landscapes outdoors, recording his direct response to nature. He may do a little polishing or adding impasto back in the studio, but is careful to avoid a tight, labored result.

OUTDOOR EQUIPMENT

Equipment for a painting trip in the field needs careful planning. If you are trekking across country on foot, you don't want to carry unnecessary materials; on the other hand, nothing is more frustrating than to discover, halfway through a painting, that you have forgotten something vital.

Looking out for yourself
Consider your own comfort. In summer, take a wide-brimmed hat to ward off glare from the sun, and plenty to drink. You may even need sunscreen and insect repellent. In winter, wear lots of layers, thick socks, waterproof shoes and fingerless gloves; cold and damp can get to you surprisingly quickly when you are immobile for long periods. These suggestions may seem obvious, but any physical discomfort could spoil your concentration and turn what should be a pleasant day out into a bitter test of endurance.

The working position
Always stand so that your support is in the shade, not in full glare of the sun, otherwise you will find it impossible to judge tonal values correctly. Try to find a sheltered spot in breezy conditions; it is very difficult to paint when your support is flapping around in the wind.

Box easel
A box easel combines an easel and paintbox, and can be folded up into a case for carrying. Although heavier than a sketching easel, it does have the advantage of greater stability.

Pochade box
The word pochade comes from the French, meaning "quick sketch." A pochade box is very useful for painting in oils outdoors. It incorporates a box that holds paints and equipment with a slide-out palette, and a lid that can hold several small boards. The lid acts as an easel, holding the board on which you are painting. There is a thumbhole in the base of the box so that it can be held like a palette, or you can sit and rest it on your lap.

Paintboxes
For ease of carrying, some paintboxes have compartments for brushes, paints, solvent and the like, with the lid deep enough to take a board or canvas. These can be expensive, however, and many artists find a plastic tool box or fisherman's tackle box just as good.

Stool
A small canvas folding stool is light enough to carry. If you prefer to work standing up, it can be used to hold your palette, brushes, and so on. Some types have built-in zippered pouches, so the stool itself becomes part of the kit.

Prepared supports
If you paint in oils or acrylics, keep a supply of small prepared canvases and boards ready for when you wish to paint outdoors.

Support size
Avoid working on too large a scale. A support measuring up to 16 x 20in (40 x 50cm) is a good working size. Any larger than this, and you spend too much time just trying to get enough paint onto the canvas; you may not finish the painting, and return home frustrated.

A disposable palette
When painting in oils outdoors, avoid the chore of cleaning your palette by covering it with plastic wrap, taped to the back, before laying out your colors. At the end of the day simply remove the plastic, wrap up the leftover paint and carry it home.

Watercolors
For watercolor, a box of pan paints is more practical than tubes. A pad or block of paper gummed around all four edges is easier to carry than a board and paper, and the gummed edges help to reduce wrinkling when wet washes are applied. Carry a supply of clean water in a plastic bottle. If you paint sitting down, use a plastic tub tied to the apex of the easel to hold your painting water, thus making it easy to reach.

Sketchbook
Always carry a sketchbook so that useful material can be quickly recorded and stored for use at a later date.

Sketching easel
A folding sketching easel has telescopic legs which can be adjusted to an appropriate height. Because it is light, and thus easy to carry, it is also vulnerable to sudden gusts of wind. Stabilize it by suspending a heavy weight from the apex of the legs, or by tying the legs to tent pegs pushed firmly into the ground.

Carrying wet oil paintings
When carrying wet oil paintings home, protect them from smearing by using double-pointed canvas pins as spacers and a second board or canvas. Push the pins into the corners of the painting, then place another board or canvas of the same size over the picture and push it onto the pins. The pins hold the two canvases apart, so there is no risk of smearing the paint.

DEPTH AND DISTANCE

SEE ALSO
The language of color, page 172

"You should get away from the intoxication of real light and digest your impression in the reduced light of a room. Then you can get drunk on sunshine again."

Pierre Auguste Renoir
(1841-1919)

One important element in a realistic depiction of landscape is a sense of receding space. The most important means of depicting depth is through perspective. By choosing the right viewpoint or arranging objects in a certain way, it is possible to encourage the eye to move from foreground to background, thus heightening the experience of spatial depth.

LINEAR PERSPECTIVE A basic rule of linear perspective dictates that parallel horizontal lines receding into the distance – roads, fences, an avenue of trees, plowed furrows in a field – will appear to converge at a vanishing point on the horizon. Depicting the lines or curves of roads, rivers and so on into the distance in this way gives a sense of depth to a picture.

ATMOSPHERIC PERSPECTIVE This phenomenon is noticeable when looking out over a landscape; as the landscape retreats further from you, colors become cooler and bluer, so that distant trees, fields and hills turn from yellow-green to blue-green to blue. In addition, contrasts of texture and tone become progressively weaker. This is an optical illusion caused by water vapor and dust particles in the air, which partly obscure colors and forms in the distance (this effect is not so apparent in countries near the Equator, where the light is much brighter).

Translating this effect into pictorial terms, strong colors and tones in the foreground appear to come forward, and weak tones and cool colors appear to recede. The effects of aerial perspective can therefore greatly enhance the feeling of receding space in a picture.

Overlapping forms
Overlapping shapes, such as hills and trees, create the illusion of depth because the eye perceives one as being behind the other, and thus further from the eye. Here, the eye is encouraged to move back in space, not only by the hills, but also by the subtle S-curve of the road.

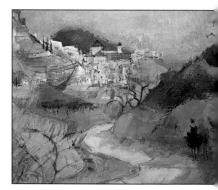

Joan Elliott Bates
MOUNTAIN ROAD WITH MULE
Oil paint and oil pastel
on paper
15½ x 19½in (39 x 48.5cm)

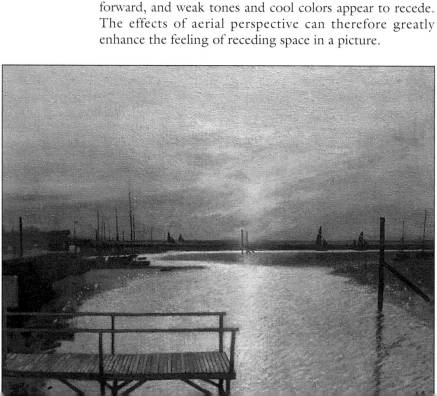

Perspective
Derek Mynott has created a strong feeling of place and atmosphere, as well as space and recession, in this painting. Both atmospheric and linear perspective come into play; space is carefully constructed through a marvelous relationship of warm and cool tones, and the strong shape of the foreground jetty pushes the distant view back in the picture plane.

Derek Mynott (1926-94)
THE JETTY
Oil on canvas
19 x 22in (47.5 x 55cm)

Leslie Worth
WINTER SEA
Watercolor on paper
21 x 29in (52.5 x 72.5cm)

Horizon line

Placing the horizon line either high up or low down "throws" the eye from foreground to background, creating a dramatic sense of space. Here, the sky occupies most of the picture space and the scene is distilled to its essence, allowing the watercolor medium itself to evoke the immensity of sea and sky.

Using scale

Including a prominent foreground object in the composition of a landscape automatically provides an illusion of depth. We instinctively compare the size of the foreground object with the size of features further away, particularly if the object is of known size, such as an animal or human figure. In this painting, the tall palm tree breaks the boundaries of the frame, exaggerating the illusion of space even further.

Derek Menary
TOWARDS LYONESSE
Acrylic on paper on panel
16 x 24in (40 x 60cm)
On Line Gallery, Southampton

Unusual viewpoints

This quirky picture breaks all the "rules" of perspective, but the very high viewpoint gives us a thrilling sense of space, as though we were seagulls wheeling above the land and sea, stretched out below us like a pictorial map.

Anna Macmiadhachain
CHASING THE HERRING
Acrylic on cardboard
10 x 13½in (25 x 34cm)

WEATHER

A large part of the pleasure and excitement to be gained from landscape painting comes from observing and recording the fascinating interaction between the permanent features of the land and the transient effects of weather, season and light at different times of day.

SEE ALSO
The language of color, page 172
Depth and distance, page 204

George Rowlett
WALKING TO RIPPLE CHURCH
Oil on canvas
36 x 36in (90 x 90cm)

Stormy weather
To portray the drama of storms, you can either let the medium itself suggest wind and rain in a graphic or symbolic way, or you can imply the effects of weather.

George Rowlett gives an expressionistic interpretation of rain lashing down, using diagonal lines slashed into thick oil paint with the end of a paintbrush.

Sophie Knight gives free rein to watercolor washes on damp paper, to suggest scudding clouds and swaying trees. The upward thrust of the dark line of trees creates much of the drama.

Sophie Knight
SEASON'S CHANGE
Watercolor on paper
22 x 30in (55 x 75cm)

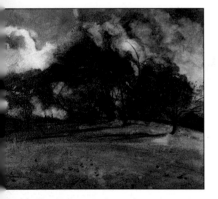

Fog and mist
Fog and mist are characterized by delicate, insubstantial effects, muted colors and indistinct forms, which require a sensitive treatment. Below, the weak winter sun breaks through the mist, suffusing everything with its warmth. The delicate shapes of the trees counterpoint the misty sky.

Jacqueline Williams
LETTER TO BENEDIKT
Oil on canvas
45 x 36in (112.5 x 90cm)
Brian Sinfield Gallery, Burford

Bright sunshine
Although it might sound contradictory, shadows play an important role in conveying an impression of bright sunlight. Juxtaposed with cool, shadowy areas, the sunlit areas in this painting appear more intense.

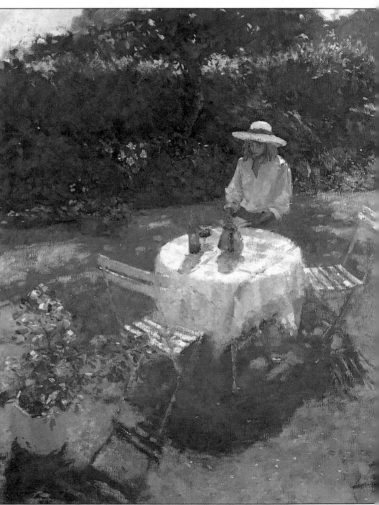

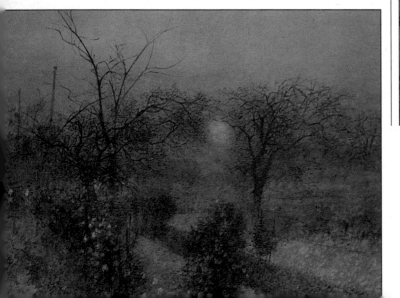

Derek Mynott (1926-94)
WINTER SUN
Oil on canvas
16 x 22in (40 x 55cm)

THE SKY

The sky is an elusive, ever-changing subject, difficult to capture on canvas or paper. Yet, because it determines the overall mood of a picture, it is important to treat it as an integral part of the composition of a landscape.

Sunsets
The sky at sunset takes on a radiant glow which even the brightest pigment colors can never hope to match. The artist must use cunning and skill to create the illusion of radiant light. One way is to interweave the warm colors of the sun with cool blues, greys and violets. The warm colors will appear more vibrant in contrast.

Simie Maryles
SUNSET IN SUMMER, BACKSHORE
Acrylic and pastel on board
22 x 18in (55 x 45cm)
Lizardi/Harp Gallery, Pasadena

Sky colors
Always use a variety of colors to create an interesting sky. Here, the artist weaves small patches of blue, violet, orange and creamy white, to create an impression of vibrating light. The dry paint is loosely dragged and scumbled, giving movement to the clouds. The same colors are repeated throughout the picture, enveloping the scene in a homogeneous light.

Arthur Maderson
TOWARDS CWMCHWEFRN
Oil on canvas
32 x 38in (80 x 95cm)

Sky perspective
The laws of perspective apply to the sky just as they do to the land. Think of the sky, not as a vertical backdrop to the landscape, but as a huge dome stretching across the horizon. Due to the effects of atmospheric perspective, the sky appears brightest and warmest directly overhead, and becomes increasingly cooler and paler in color as it nears the horizon. Clouds seem smaller, flatter and closer together as they recede into the distance, often merging into a haze at the horizon – they also become cooler and greyer.

Jacqueline Rizvi
LONDON PANORAMA (above)
Watercolor on paper
16 x 14in (40 x 35cm)

Cloud edges
Pay careful attention to the edges of clouds, so that they blend naturally into the surrounding atmosphere. Most clouds, particularly those in the distance, are soft-edged, and this effect can be achieved by blending the edges or by scumbling over them.

Nicholas Wegner
BURY HILL (detail, above)
Oil on canvas

Len Tabner
REANCHORING SEA EXPLORER
Watercolor on paper
27½ x 37½in (69 x 93.5cm)
Thos. Agnew & Sons, London

The sea
The sea is a favorite haunt of artists, whatever the weather. Not only is there a special quality of light there, but the variety of possible painting subjects is as diverse and fascinating as any to be found inland. You can choose to portray the elemental forces of nature in the wide-open spaces of sea and sky, as Len Tabner has done here, or use it as a background to natural and man-made forms.

SEE ALSO
Working on location, page 202

WATER

The solidity of land and structures finds a fascinating contrast in the ceaseless motion and activity of water. Even the smallest eddies, undercurrents and ripples disturb a placid surface, and effectively portraying water adds vitality and sparkle to any picture.

Nick Andrew
ELODEA
Acrylic on paper
18 x 18in (45 x 45cm)

Flowing water

Water, like the sky, is an elusive subject, constantly on the move. Highlights and shadows appear and disappear; waves break and re-form. It can be hard to capture such transient effects without losing the sense of movement. Don't try to "freeze" the motion, but make a few carefully placed marks or brush-strokes to convey an impression of movement and fluidity.

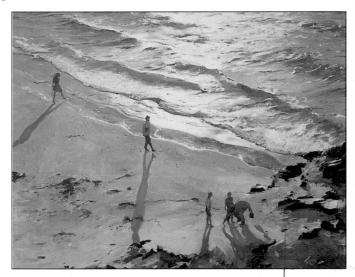

D. J. Curtis
EVENING SHADOWS,
ARISAIG (above)
Oil on canvas
24 x 30in (60 x 75cm)

Beaches

Beach scenes offer a rich array of ideas for David Curtis, who is fascinated by the play of light on rock pools and wet sand at low tide, punctuated by the dark shapes of backlit figures (above).

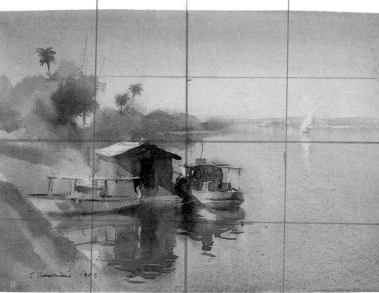

Still water

This beautiful painting expresses the quiet stillness of early morning. The water is painted broadly and with a minimum of detail, using wet-in-wet washes on damp paper. A few calligraphic brushstrokes convey the foreground reflections.

Trevor Chamberlain
EARLY, STILL MORNING ON
THE NILE
Watercolor on paper
10¼ x 14¼in (25.5 x 36cm)

209

TREES

Trees are an important feature of many landscapes, and it will help your painting enormously if you take the trouble to go out and sketch trees in all seasons, and to observe their individual shapes and growth patterns.

SEE ALSO

The language of color, page 172

Drawing & observation, page 194

Working on location, page 202

Depth and distance, page 204

Proportions
A simple method for establishing the correct proportions of a particular tree is to compare the width of the foliage with its height from base to crown, and to note the proportion of the visible trunk to the overall height of the tree.

RENDERING FOLIAGE

Attempting to draw or paint every leaf will inevitably lead to a tedious and lifeless image. Most artists look for the major shapes made by clumps of foliage and for changes in foliage density, carefully recording any gaps that reveal the background. All this prevents a tree from looking like a flat cut-out, while conveying its unique character.

Sophie Knight
PORTRAIT OF A TREE
Watercolor on paper
30 x 27in (75 x 67.5cm)

Tree gestures
Paintings of winter trees can so easily appear stilted. This is not the case in Sophie Knight's painting, in which she portrays the branches with whirling, whiplash strokes. In capturing the essential "gesture" of a particular tree, she has indeed painted its portrait.

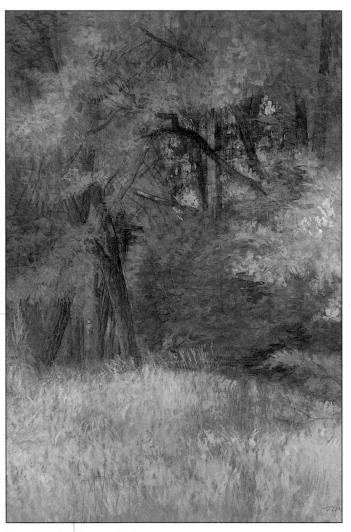

Basic shapes
However unusual or distorted it may be, the shape of any tree can be simplified to a basic geometrical shape or a combination of shapes. This applies equally to bare winter trees and to those with their full summer foliage.

Jacqueline Rizvi
HAMPSTEAD HEATH
Watercolor and
body color on paper
24 x 16in (60 x 40cm)
New Academy Gallery, London

Capturing the effects of light
Changes in light alter a tree's appearance dramatically. Here, for example, the strong side-lighting of afternoon sunlight creates very clear shadows and emphasizes the tree's three-dimensional qualities. The texture of the foliage is built up with soft, feathery strokes that imply movement of the leaves.

SIGNS OF LIFE

Although not appropriate in every landscape, the inclusion of figures, animals or buildings introduces a narrative element which can bring a scene to life.

Figures and animals
If they are incidental to the main subject, figures and animals should be stated in simple terms, using a minimum of brushstrokes or marks.

When painting groups of animals (or figures), make sure they are well composed within the picture space. Here, the foreground cows form an interesting grouping that breaks up the line between light and shadow. Note how some blurring around the edges of the forms prevents them from looking wooden.

Trevor Chamberlain
EVENING SUN, GOLDINGS
Oil on board
6 x 8in (15 x 20cm)

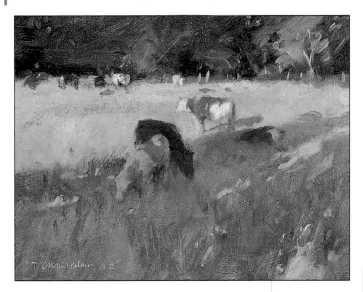

Valerie Batchelor
HENHOUSES
Oil on canvas
9 x 11in (22.5 x 27.5cm)

Valerie Batchelor conjures up a lively impression of a flock of chickens. Detail is minimal, but light and shadow succinctly model the forms of the birds.

In Peter Graham's exhilarating beach scene, the figures are little more than dots and dashes, yet they read as people. Their size in relation to their surroundings also provides an indicator of scale and, because the eye is instinctively drawn to elements of human interest, they draw us into the picture.

Peter Graham
BOULEVARD DE LA PLAGE
Oil on canvas
12 x 16in (30 x 40cm)

URBAN LANDSCAPES

Towns and cities are the natural environment for the majority of people, and they are therefore the most accessible artistic subject. The urban landscape has plenty to inspire the artist with an eye for shapes, patterns and textures.

SEE ALSO
Working on location, page 202

CONTRASTS

There are many fascinating contrasts to be explored in urban environments: between glorious architecture and humble houses and shops; between wide vistas and narrow alleys; and between the fixed solidity of buildings and the color and motion of people going about their business.

Penny Quested
UDAIPUR PALACE
Gouache on Indian paper
35 x 25in (87.5 x 62.5cm)

The intimate landscape
You will find a wealth of inspiration in "the intimate landscape" – a small architectural detail or a single façade can be just as fascinating as a sweeping vista. Here, for example, Penny Quested emphasizes the two-dimensional, decorative qualities of the building, rather than portraying it realistically.

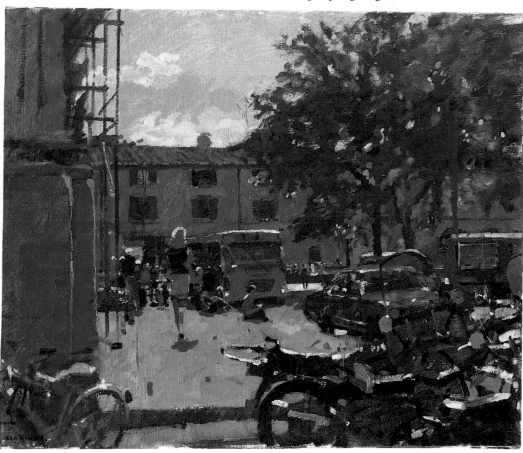

Ken Howard
PIAZZA SAN MARCO, FLORENCE
Oil on canvas
20 x 24in (50 x 60cm)

There is a temptation to become nostalgic when painting outdoors, and modern contraptions, such as cars, are "edited out" because they are not picturesque. However, as this painting proves (above left), light can transform even the most mundane view. Ken Howard's subjects are almost invariably backlit; this simplifies forms and tones, and produces haloes of light around people and objects.

Industrial settings
There is beauty and drama to be found even in factories, shipyards and other industrial complexes. In this scene (right), hazy sunlight envelops quarry workings, reducing them to a series of semi-abstract shapes.

D. J. Curtis
QUARRY WORKS, WARMSWORTH
Watercolor on paper
31 x 22½in (77.5 x 57cm)

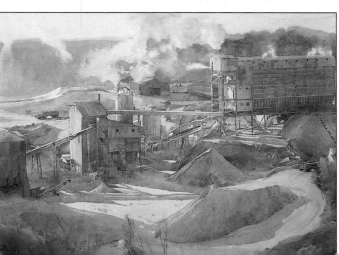

SEE ALSO

Depth and distance, page 204

Lighting, page 233

INTERIORS

As with a landscape or townscape, an interior can be either the setting for human activity or the subject of a painting in its own right. Either way, interior scenes hold a particular fascination because they provide a glimpse into other people's lives – they are the acceptable equivalent of peeking into a window as we walk along the street.

"THE ARTIST IS A VOYEUR. . ."

LEONARD ROSOMAN (B. 1913)

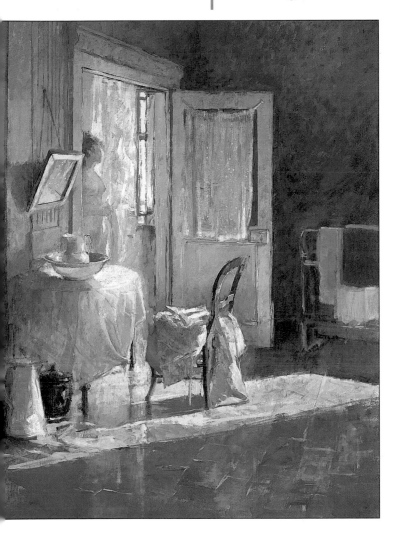

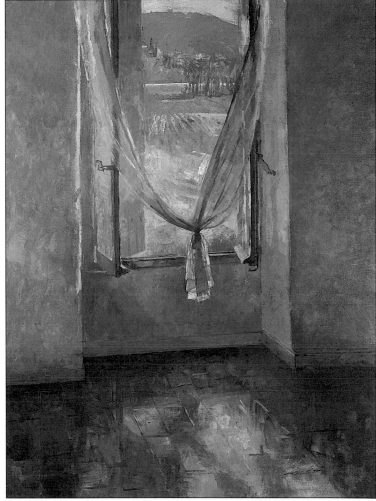

Observing light

One of the most exciting aspects of painting interiors is the way in which mood and atmosphere can alter dramatically, depending on the light. Here, strong sunlight shining through a window creates wonderful contrasts between the cool darkness of cast shadows and the high-key luminosity of reflected light bouncing off the walls, floor and objects within the room.

Jane Corsellis
THE GREEN BATHROOM
Oil on canvas
36 x 32in (90 x 80cm)
New Academy Gallery, London (both paintings)

Inside, looking out

An interior scene takes on a whole new dimension when you include the additional space seen through a window or an open door. By depicting part of the interior as well as what can be seen outside, Jane Corsellis creates an intriguing double image – a frame within a frame. The inclusion of a distant view glimpsed through the window also opens up the picture space and increases the feeling of space, drawing the viewer deeper into the picture.

Jane Corsellis
WINDOW OVERLOOKING THE LOIRE
Oil on canvas
48 x 36in (120 x 90cm)

There are obvious practical advantages in choosing to concentrate on STILL LIFES. They are convenient to set up, and give you the freedom to work at your own pace and to learn about color, form, composition and space. You have complete control over subject, lighting and viewpoint, and there are none of the uncertainties of landscape painting, with its changing weather and light.

Because of their familiarity, our homes and immediate surroundings are often overlooked as suitable areas of inspiration, yet even the most mundane of everyday, household objects can inspire exciting compositions.

Ben Nicholson (1894-1962)
STILL LIFE WITH JUGS AND MUGS
Oil on canvas
15 x 21¾in (37.5 x 54.5cm)
Browse & Darby, London

SETTING UP

Experiment with the viewpoint and the choice and arrangement of objects before settling down to paint a still life. If you are happy with the design of your group, the chances are you will feel more confident when working.

SEE ALSO
The language of color, page 172
Composition, page 188
Focal points, page 190
Using a viewfinder, page 202

BALANCE, VARIETY AND CONTRAST

Because a still life is essentially static, it is vital to compose it in such a way that it is balanced, yet contains enough movement and energy to keep the viewer interested. Try to ensure that similar shapes and colors are echoed throughout the picture, knitting the diverse elements together. At the same time, introduce variety through the use of subtle contrasts – angular and flowing shapes; patterned areas and flat passages; light and dark tones; bright and muted colors.

Space and viewpoint

Don't be afraid to experiment with the viewpoint and the spaces between objects. These three paintings each represent highly individual, yet effective, approaches to composition and arrangement.

Peter Graham has chosen an overhead viewpoint, which emphasizes the two-dimensional pattern. The energetic colors and visual activity are carefully planned, with each shape and color finding an echo in another part of the picture.

Peter Graham
BALTHAZAR'S FEAST
Oil on canvas
47 x 59in (117.5 x 147.5cm)

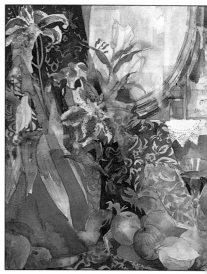

Shirley Trevena
BLUE VASE OF LILIES
Watercolor and gouache on paper
14½ x 19¼in (36 x 48cm)

Creating rhythm

Rhythms and tensions lead the eye around the picture. Group objects so that they overlap and cast shadows onto each other, and arrange drapery so that its rhythmic curves and folds form links between the objects. Shirley Trevena's strong rhythms and patterns (above) activate the entire picture space, making her painting come alive.

Liam Spencer extends the composition and space of his painting by including a hint of the room itself. Sunlight coming in through the window lends atmosphere to the setting.

Liam Spencer
TABLE WITH STILL LIFE
Oil on board
12 x 16in (30 x 40cm)
Kentmere House Gallery, York

THEMES

The most successful still lifes generally have a kind of theme, one which has inspired the artist and which forms the basis of a naturally harmonious picture.

KEEP IT SIMPLE

Visual links
When setting up a still life, make sure you select objects that "look right" together.

Andrew Hemingway's pastel painting (below right) is a sensual delight, displaying his masterly grasp of texture and form.

Andrew Hemingway
CHERRIES AND GOOSEBERRIES
IN OLD PLANT POT (right)
Pastel on velour paper
8½ x 8⅜in (21.5 x 21cm)

Roy Freer (below) chooses objects for their formal abstract qualities: the contrasts and affinities of shape, color and texture they display when grouped. He regards his still-life subjects as "a series of colors, directions and forms before they are bowls or bottles."

The choice of objects for a still-life picture is limitless, and the danger can lie in including too large and random a selection, resulting in a disjointed arrangement.

Try to focus on what interests you as an artist. Do you enjoy experimenting with different color interactions, or the textural contrasts of fruits and vegetables, wood and glass? Or are you more interested in the abstract elements of the subject – shape, tone and color, pattern and rhythm? Whatever your chosen theme, remember that a few objects, casually arranged, can have more impact than a large and complex set-up.

Roy Freer
BLUE BOTTLES
Oil on canvas
24 x 20in (60 x 50cm)

John Lidzey
OPEN WARDROBE
Watercolor on paper
21 x 15in (52.5 x 37.5cm)

Found groups
The best still-life subjects are often found rather than made. A kitchen table after a meal, a jumble of discarded flowerpots in the corner of a garden – even an untidy wardrobe in the corner of a room (above) is a "still life" – such subjects are often naturally grouped in a way that is more interesting than they would be if deliberately arranged. Found groups have a randomness that is not only refreshing, but which also encourages us to look anew at the commonplace and the everyday.

Food and drink
Kitchenware and foodstuffs are a traditional still-life theme. Shirley Trevena reinforces the unity of theme by using repeated shapes and colors.

Shirley Trevena
FISH ON A PLATE
Watercolor on paper
14½ x 19¼in (36 x 48cm)

BACKGROUNDS

Like the sky in a landscape, the background of a still-life group is as important as the group itself and not merely something to be "filled in" at leisure afterwards.

Roy Freer
TABLE, CHAIRS AND TRAINERS
Oil on board
30 x 48in (75 x 120cm)

Liam Spencer
MILK JUG AND ORANGES
Oil on wood
18 x 14in (45 x 35cm)
Kentmere House Gallery, York

Using color
You could choose not to have a realistic background at all – just a colored area which sets off the group to maximum effect (above). Avoid large areas of flat color; use broken color, scumbling and glazing to keep the color lively.

Using fabric
Draped fabric is an ideal way of introducing color and texture to the background, and can be chosen to complement or contrast with the objects in the group. Its folds and drapes also set up implied linear rhythms which activate the picture surface (above).

Wide vision
On an ambitious scale, you could widen your field of vision to include part of the room, or place the set-up on a windowsill so that the view beyond provides the backdrop.

Geraldine Girvan
STUDIO MIRROR
Watercolor and
gouache on paper
25 x 19¾in (62.5 x 49.5cm)
Chris Beetles Gallery, London

SEE ALSO
Lighting, page 233

LIGHTING

When setting up a still-life group, it is a good idea to experiment with the angle and direction of the light. It is best to keep the lighting simple, preferably from a single source.

John Lidzey
HALL TABLE WITH LAMP
Watercolor on paper
21 x 15in (52.5 x 37.5cm)

NATURAL OR ARTIFICIAL LIGHTING?

Natural light is the best option, as the color values remain true, but of course it will alter radically as the day progresses. Unless you have a north-facing studio, you will need either to adopt a rapid, alla-prima approach to painting, or work in a series of short sessions at the same time each day.

Artificial light is both constant and controllable, but tungsten light makes colors appear warmer than they really are. Special "daylight-simulation" bulbs are now available; these reproduce northerly light, which is "colder" and truer to daylight. Fluorescent tubes diffuse shadows and highlights.

Artificial light
A pool of warm lamplight in a cool, shadowy interior sets up an intimate mood in this picture (right). Including the light source itself as part of the group is a clever touch.

Natural light
There is no reason why you can't paint a still life outdoors. The simple charm of this row of potted plants on a windowsill is heightened by the lacy patterns of shadows cast by a nearby tree.

Derek Daniells
WINDOWSILL, SUMMER
Pastel on paper
13 x 18in (32.5 x 45cm)

Ken Howard
SPRING LIGHT, MOUSEHOLE
Oil on canvas
24 x 20in (60 x 50cm)

Simplicity and light
A vase of daffodils on a sunny windowsill is
transformed by the light behind it, shining through the
translucent petals; it is as if they were lit from within.

FLORAL GROUPS

Flowers beguile us with their delicate blooms and their wonderful colors, shapes and textures. Yet, of all still-life subjects, flowers probably contain the most potential problems for the inexperienced artist.

SEE ALSO
The language of color, page 172
Color harmony, page 183
Composition, page 186
Setting up, page 216

INTERPRETATION

The main difficulty is one of interpretation. Flowers are living forms that are open to a certain amount of freedom in their treatment; but if this is carried too far – at the expense of good draughtsmanship – the result may be a meaningless blur of color. On the other hand, there is an equal risk of producing an image so carefully rendered that it is robbed of life.

DRAWING AND OBSERVATION

The answer lies somewhere between these two extremes. It is necessary to simplify to some extent, but to do this you need to understand the form and structure of flowers. The more thoroughly you understand your subject, the better the result will be. Fill your sketchbook with studies of plants and flowers, observing their leaf shapes, the way petals overlap, and the essential "gestures" of blooms.

ARRANGING FLOWERS

It may be tempting to go for an ambitious arrangement, but it is wiser to start with a simple bunch, or even a single bloom. Arrange flowers so they fall naturally, adjusting them so that you create different head levels and the flowers face in more than one direction. Decide on a color theme that will give harmony to the picture.

Dynamic composition
Avoid placing a group of flowers in the center of the picture – moving it off-center injects movement and dynamism into the composition. Note, here, how the artist uses the sinuous lines of foliage to direct the eye around the painting.

Penny Quested
HEART-SHAPED BOX
Gouache on Japanese paper
30 x 20in (75 x 50cm)

Choosing the right vase
A tall vase of flowers can cause compositional problems, because it leaves a blank space on either side of the subject. Here, the artist solves the problem by introducing strong tonal contrasts in the background. The eggs are carefully arranged to break up the foreground space and complement the flowers.

Andrew Hemingway
VASE OF WHITE ROSEBUDS
AND QUAIL EGGS
Pastel on velour paper
19½ x 25½in (49 x 64cm)

Despite the advent of photography, there is a continued fascination with THE HUMAN FORM among artists, and the traditions of portrait and figure painting are as strong today as they ever were. There is some truth in the old adage that "if you can paint people well, you can paint anything." However, it is not essential to know about anatomy in order to paint or draw the human form successfully. More important are an inquisitive eye and a willingness to keep practicing, even if your first attempts are not successful.

Arthur Maderson
VERLAYNE RECLINING
Oil on canvas
32 x 44in (80 x 110cm)

SEE ALSO
Drawing media, page 38
Watercolor materials, page 104

> *"IT IS NOT BRIGHT COLORS BUT GOOD DRAWING THAT MAKES A FIGURE BEAUTIFUL."*
>
> TITIAN (C. 1488-1576)

FIGURES

Representing the human figure is one of the most challenging of artistic disciplines, as well as the most fascinating. In addition to individual studies, figures may form the central element in a narrative picture, or the focal point in a landscape or interior.

SKETCHING FIGURES

Confidence in drawing depends on careful observation. Carry a pocket sketchbook with you and take every opportunity to sketch people – in cafés, on public transportation, at the beach. By watching people and sketching them frequently, you will gradually build up a store of visual information about physical shapes, body language and facial expressions in a variety of situations. Translating this information from eye to hand to paper becomes easier the more you practice.

Broad and flowing lines
Charcoal or pastel encourage a broad sweep that captures the overall balance and weight of the body and implies movement (see opposite).

With watercolors and a large, soft brush, you can flow the paint around body shapes and the drapes and folds of clothing (below).

Tom Coates
MODEL ADJUSTING HER DRESS
Watercolor on paper
20 x 12in (50 x 30cm)

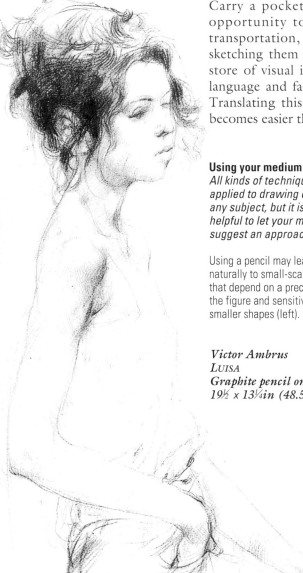

Using your medium
All kinds of techniques can be applied to drawing or painting any subject, but it is often helpful to let your medium suggest an approach.

Using a pencil may lead you naturally to small-scale drawings that depend on a precise outline of the figure and sensitive detailing of smaller shapes (left).

Victor Ambrus
LUISA
Graphite pencil on paper
19½ x 13¼in (48.5 x 33cm)

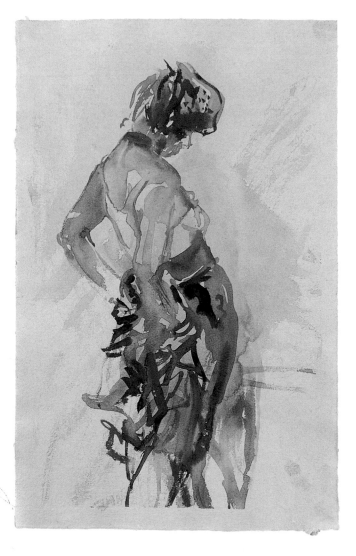

ACTION AND POSE

A "lifelike" figure looks as if it could move. Capturing the energy and dynamics inherent in the human form is largely a question of the right choice of pose and the vitality of the drawn and painted marks.

GESTURE

It is important to notice the internal rhythms of the figure, whether in motion or in repose, and how the outer shapes respond to movement. If you can capture the essential gesture of the pose by defining the telling angles and directions of the body, the energy of the whole figure is naturally implied.

EXPRESSIVE MARKS

The other important aspect of pictorial movement is the energy and impact of the marks you make. A single mark outlining a leg will make it look static, but a series of loose, fluid lines will generate energy. Let your hand follow the contours of the figure instinctively, so that the pressure of pencil, chalk or brush echoes its flow and direction. You will not achieve a "finished" image in this way, but you will learn a lot about how the human figure works.

Keep your distance
It is important not to stand too close to the model. Set up your easel at a distance of about 6ft (2m), positioned so that you can see the whole figure without moving your head too much.

Dynamic drawing
When drawing from life, be bold and work with the rhythm of the figure's movements. Using bold lines and smudged tones, Rosemary Young captures the essential gesture of the pose without freezing it.

Rosemary Young
THREE STANDING NUDES
Charcoal on paper
Various dimensions

Relaxed pose
Tom Coates took the opportunity to draw his model while she took a break during life class. Her unselfconscious gesture has an easy naturalness and a sense of implied movement often lacking in a formal pose.

Tom Coates
REST PERIOD
Pastel on paper
40 x 30in (100 x 75cm)

FIGURES IN CONTEXT

SEE ALSO
Composition, page 188

Pictures of figures in a setting are always interesting because of the "story-telling" element. Families and close friends create relaxed, informal groupings; people passing to and fro in streets and parks create dynamic, woven patterns; and the human presence brings interior scenes to life.

FOCUS OF INTEREST The main thing to decide when depicting people in a setting is how the balance works between the two components. Are the figures the absolute focus of interest, while the setting is just a background? Or are the people merely details of the situation as a whole?

On this depends the way you frame the image, where the figures are positioned within the frame, and their relative scale. The larger and more central they are, the more they will dominate the composition.

Body language

The way people interact – leaning towards or away from each other, gesturing or actually touching – can express a lot about a given situation. As you watch people together, look for the characteristic shapes and gestures they make; compare the easy intimacy of the old men in Arthur Maderson's painting (below) with the stiff, self-enclosed postures of the couple, together yet apart, in Carole Katchen's picture (left).

Arthur Maderson
FROM THE BACK OF A LORRY
Oil on canvas
10 x 11½in (25 x 29cm)

Carole Katchen
NO RELATIONSHIPS, PLEASE
Pastel on paper
21 x 29in (52.5 x 72.5cm)

PORTRAITS

Painting a portrait involves more than simply getting the physical features right. It is also about getting under the skin of your sitter and revealing something about his or her personality and inner self.

"A PORTRAIT IS A PICTURE IN WHICH THERE IS JUST A TINY LITTLE SOMETHING NOT QUITE RIGHT ABOUT THE MOUTH."

JOHN SINGER SARGENT (1856-1925)

CREATING A LIKENESS

The definition of a portrait is that it is a likeness of an individual. You might reasonably suppose that this lies in drawing the facial features correctly. But going too quickly to the detail can prove restrictive. You may find you have made a portrait in which many details are broadly correct, but they do not add up to a personality.

As a rule of thumb, always work from the general to the particular. Start by sketching out the basic framework of the face or figure, looking for the dominant angles, masses and shapes. Only when these are correct should you start on the finer details. As you draw, keep checking against the sitter to see that each feature is correctly positioned in relation to the other. For example, how wide is the mouth in relation to the width of the face? What is the distance between the shoulder and the knee?

Lighting
Light models form and can give emphasis to the important features of a portrait. It is best to pose your model in relation to a single, direct light source, such as a window or lamp, and let the light fall obliquely across the face to emphasize its contours and curves.

In Michael Hyam's sensitive portrait (far right), light striking the face creates descriptive lights and shadows which not only define the modeling of the features, but also lend atmosphere and mood.

Ken Paine's pastel portrait (right) throws the emphasis on the chiaroscuro effect of strong light and dark tones.

Ken Paine
THE JAZZ MUSICIAN
Pastel on paper
28½ x 22in (71 x 55cm)

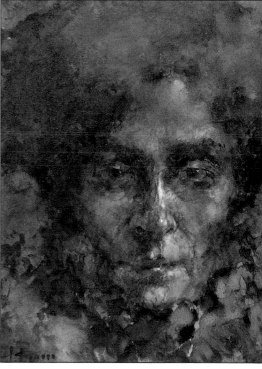

Michael Hyam
STUDY OF MOLLY HYAM
Pencil and watercolor on paper
10 x 7in (25 x 17.5cm)

PERSONALITY

It pays to spend time planning a portrait, because every aspect of the image – the sitter's pose, the background, lighting, color scheme and composition – has a part to play in expressing the personality of the subject.

SEE ALSO
The language of color, page 172
Composition, page 188

BACKGROUNDS

Backgrounds play a supporting role in most portraits, but they still require some thought. Think of the background setting as an integral part of the portrait, implying something about the sitter's character by its colors, tones, and any specific details it might contain.

A well-planned background should maintain the focus of attention on the sitter, and the shapes, tones and colors within it should balance and complement the overall design. Features such as doors and windows provide useful horizontals and verticals which focus and contain the subject and strengthen the pictorial design.

Setting and props
Painting subjects in their own environment or surrounded by familiar objects puts them at ease and gives you the opportunity to tell more of a "story" about what the person is like. Here, Barry Atherton has painted the newscaster Julia Somerville in relaxed pose, surrounded by the tools of her trade.

Barry Atherton
PORTRAIT OF JULIA SOMERVILLE
Pastel and collage on paper
48 x 36in (120 x 90cm)
New Academy Gallery, London

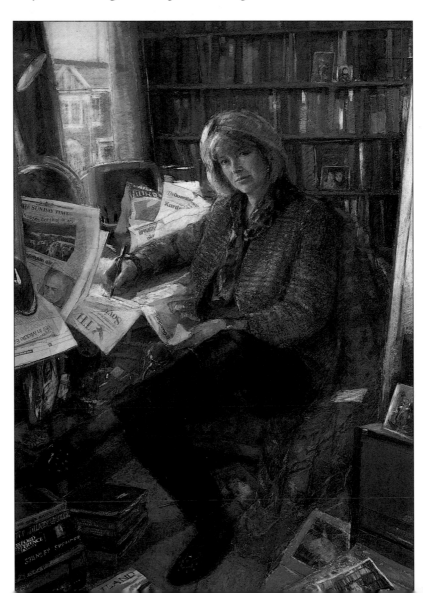

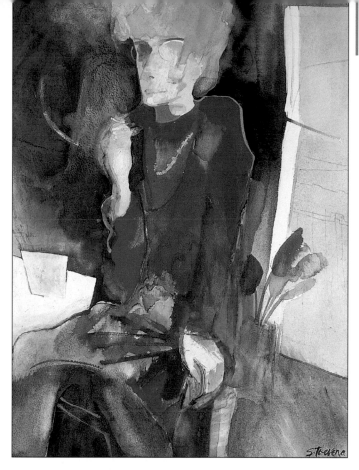

In Shirley Trevena's witty painting, the features are barely discernible. Yet everything about the picture — the pose, the composition and the character of the painted marks — conveys the uncertain mood of the sitter.

Shirley Trevena
THE DILEMMA OF WHAT
TO PAINT
Watercolor on paper
19¼ x 14¼ in (48 x 36cm)

The pose
We all express our personality through facial expression and "body language." Look for any distinguishing features, gestures and mannerisms which are unique to your sitter and try to bring these out in your painting.

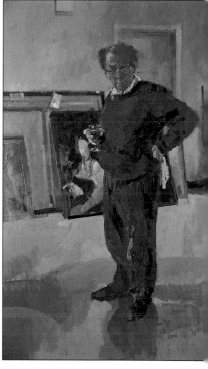

Hans Schwarz's self-portrait of an artist at work has a refreshingly "unposed" feel. The attitude of the sitter, along with the strong colors, brisk technique and strong compositional lines in the picture, all indicate that this is a person with a forceful character.

Hans Schwarz
SELF-PORTRAIT
Gouache on paper
50 x 40in (125 x 100cm)

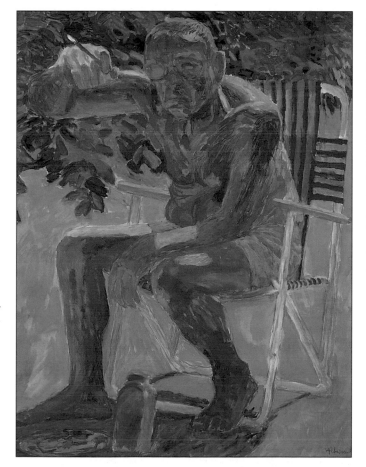

Tom Coates's portrait of a fellow artist has an altogether different feel. Here the mood is mellow and relaxed, and Coates achieves a telling likeness by capturing the sitter's typical pose and expression.

Tom Coates
WILLIAM PACKER *(above)*
Oil on canvas
60 x 44in (150 x 110cm)

229

THE STUDIO

WHETHER YOUR WORKPLACE *is a large, airy* STUDIO, *a spare room, or even a corner of a room or a* KITCHEN TABLE, *it is important that it should be* COMFORTABLE, *well-lit and properly* ORGANIZED. *Whatever your circumstances, selecting and using the right* EQUIPMENT *will enable you to concentrate on painting or drawing.*

In addition to being the place where you CREATE *art, the studio area is most probably where you will* STORE *it and* PROTECT *it from damage and the elements.* VARNISHING, *using fixative, and* MATTING *and* FRAMING *are not only methods of preserving artworks, but also ways of* SHOWING *them off to their very best advantage.*

STUDIO ORGANIZATION

SEE ALSO
Canvas, page 12
Watercolor paper, page 26
Drawing media, page 38

"CONCERNING THE LIGHT AND PLACE WHER YO WORKE IN, LET YR LIGHT BE NORTHWARD, SOMEWHAT TOWARD THE EAST WHICH COMMONLY IS WITHOUT SUNE, SHININGE IN. ONE ONLY LIGHT GREAT AND FAIRE LET IT BE, AND WITH-OUT IMPEACHMENT, OR REFLECTIONS, OF WALLS, OR TREES."

NICHOLAS HILLYARD (1547-1619)

It goes without saying that your studio should have adequate lighting and ventilation, but there are no hard-and-fast rules about the way to organize your studio equipment. The main requirement is that you should be able to reach everything comfortably and conveniently, with the minimum of effort. The more mobile your set-up, the easier it is to adapt it to changing light conditions, different subjects, and both sitting and standing working positions.

Improvising storage
A metal wine rack can be used to store wet oil paintings – useful if you don't have the space for a wall-mounted painting rack.

STORING PAPER

Paper should be stored flat in a dry place, wrapped in clean paper to protect it from dust and light. Watercolor paper, especially, should be protected from dampness, which can activate impurities, producing areas that won't take color.

STORING CANVASES AND BOARDS

To prevent canvases and boards from warping, store them upright in a dry place. A painting rack is easily built from lengths of 1 x 2in (25 x 50mm) lumber, and can be used to store both unused canvases and unfinished paintings.

STORING DRAWING TOOLS

If pencils, crayons and sticks of charcoal are thrown together in a drawer, they will become disorganized and may break or chip. Stand them end-up in a pot or jar, or keep them in a box. Another place to store them is in groups in the separate compartments of a plastic cutlery tray for easy access.

Handy brush holder
If you use a lot of brushes, this simple device will keep them all neatly at hand and prevent them from rolling off the table onto the floor. And because they are propped at an angle, they are easier to pick up when needed. Cut a series of V-shaped notches along the upper surface of a length of 1 x 1in (25 x 25mm) wood. Lay it on your painting table and rest the brushes in the grooves, with the bristles protruding from the edge.

EQUIPMENT LAYOUT

The surface on which you lay out your paints, palette and other equipment may consist of an ordinary table, or a trolley with wheels or casters for mobility (an old tea trolley or tea wagon is ideal – the shelf underneath is useful for storing equipment you are not using all the time). For easy access, it should be placed at right angles to your easel or work surface.

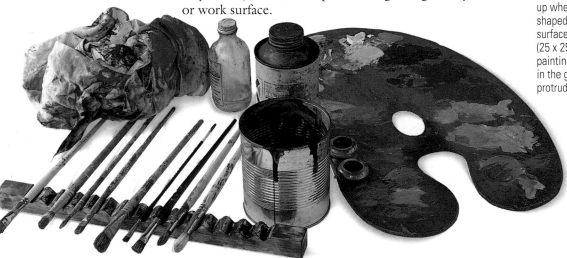

LIGHTING

Simulating daylight

If you have to make do with artificial lighting, lamps fitted with daylight-simulation bulbs are the best alternative. These blue-tinted light bulbs simulate north light, which allows perfect color matching and is relaxing to the eyes. Daylight-simulation fluorescent tubes are also available; they are inter-changeable with standard fluorescent tubes.

Good lighting is crucial to the successful execution of creative artwork – without it, you will have problems seeing clearly and rendering colors accurately. The type of light and its source are also important in protecting your eyes from strain.

Natural light

The best natural light for drawing and painting is cool and even, with no direct rays or changing shadows. A room with north-facing light is ideal (south-facing in the southern hemisphere). It offers indirect light, largely reflected from the sky, that remains constant during the whole day. North light is also neutral in hue, since it has none of the yellow cast of direct sunlight.

Harsh light can be cooled and subdued by covering the window with thin gauze, cotton drapes or a shade.

Artificial light

In addition to altering the color values of objects, artificial light tends to cast rather harsh shadows. While a painting done in natural light will look fine under artificial light, the reverse is not always true.

An ideal studio

A well-organized studio frees your mind to concentrate on painting instead of searching for materials and equipment. The entire studio below was designed around inexpensive, ready-made furniture. The strong plywood boxes and wall-hung shelving take care of storage requirements, and the worktable can be raised to a convenient height if you prefer to work standing up.

John Martin
MORNING STUDIO, BRIGHTON
Oil on canvas
18 x 24in (45 x 60cm)

Their own studio features in many an artist's work. John Martin, for example, has painted this same studio on many occasions, forever fascinated by the different light that falls through the window.

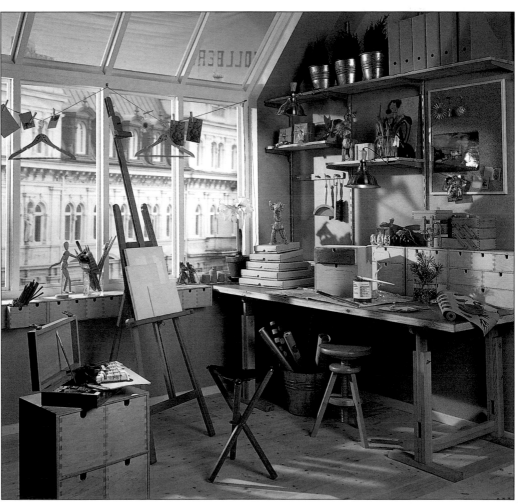

EASELS

SEE ALSO
Working on location, page 202

From the various styles and sizes of easels, your choice will be dictated by the space you have for working, whether you work mostly indoors or outdoors, and by the scale on which you work.

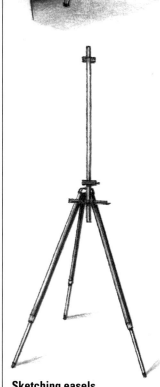

• Easel positioning
Position your easel so that the light source is slightly behind you and coming over your left shoulder if you are right-handed, and vice versa. This way, your hand won't cast a shadow across the working surface.

Table-top easels
The table-top easel provides a useful, compact support for smaller paintings and drawings, and can be folded flat for storage. There are various designs, from a simple collapsible tripod to a sturdy frame that folds flat when not in use, and which can be set at different angles. Wooden easels are sturdier than the aluminum versions.

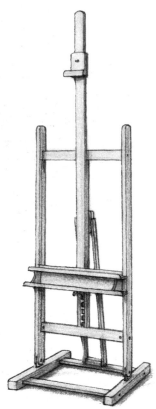

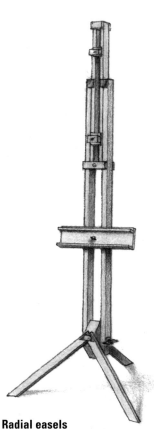

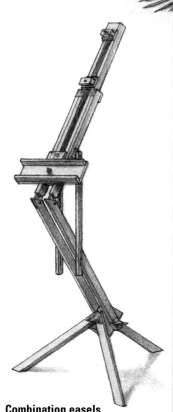

Studio easels
A heavy-duty studio easel is expensive and cumbersome, but provides a sturdy support for work on a large scale. The painting rests on a ledge that also forms a compartment for holding paints and brushes, while a sliding block at the top holds the painting firmly in position. The height is adjustable. Some models are on wheels or casters so that they can be moved around the studio.

Radial easels
If you have limited space, the compact radial easel provides a reasonably firm, but less expensive, alternative to the studio easel. Sturdy and versatile, it consists of a central pillar with adjustable tripod struts. The central joint tilts back and forward so you can angle your work to avoid glare, and the height is adjustable for sitting or standing. It can be folded for easy storage when not in use.

Combination easels
A folding radial easel and drawing table combined, the combination easel can be locked in any position between vertical and horizontal. In the horizontal position the easel becomes a flat working surface that will hold a large drawing board.

Sketching easels
The tripod-style sketching easel is lightweight and easily portable, and is suitable both for outdoor work and for small-scale work indoors. Available in aluminum and wood, it has telescopic legs to enable you to work at a convenient height, and the pivoted central section can be tilted to a horizontal position. It can be folded away when not in use.

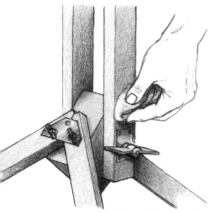

Ken Howard rejects the conventional portrait by painting his studio as an extension of himself. He revels in the brushes, jars of thinners, props and paraphernalia that gradually take over every artist's studio, conveying the relaxed atmosphere in which he chooses to work.

Ken Howard
SELF-PORTRAIT AT ORIEL
Oil on canvas
48 x 40in (120 x 100cm)

Maintaining easels
Wooden easels benefit from treatment with furniture oil or wax polish, particularly in damp conditions. Keep wing nuts treated with light oil or Vaseline.

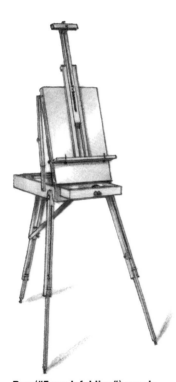

Box ("French folding") easels
The wooden box easel is sturdier than an ordinary sketching easel, but equally portable. It combines a palette, a deep drawer for storing paints and equipment, a collapsible easel and a carrier for canvases, all of which can be folded up into one compact unit, complete with a strong carrying handle.

235

PROTECTING ARTWORK

All too often, pictures are stored in damp basements or leaking attics, or hung in rooms with inappropriate or harmful lighting. They are often displayed or stored away without any means of protection. A few simple precautions can do much to preserve your pictures in the best possible condition – having labored with love and time on an artwork, it makes sense to look after it.

SEE ALSO

Charcoal, page 44	
Pastels, page 46	
Oil pastels, page 48	
Conté crayons, page 50	
Drawing accessories, page 59	
Mats and frames, page 240	
Health and safety, page 244	

Unframed pictures
Pictures that you want to keep, but not frame, should be stored in a safe place, such as a portfolio or plan chest.

AVOIDING DAMPNESS, LIGHT AND HEAT

Keep all artworks away from damp and humid conditions, which encourage mildew, and also from excessively dry conditions. In addition, avoid extreme temperature changes, such as those caused by room heaters, radiators or draughty windows.

Some of the greatest damage to pictures is done by strong, direct light, which can fade colors and discolor varnishes. In strong sunlight, or under spotlights, heat can be equally damaging, so display your pictures, particularly works on paper, away from direct sunlight and in diffused artificial lighting.

STORING WATERCOLORS AND DRAWINGS

Unmounted watercolors and drawings should not be left unprotected for long, and should be stored in a safe place until you can have them framed. They should be stored flat in large drawers or a plan chest, or at least in a portfolio, interleaved with sheets of waxed paper, cellophane or acid-free tissue, to prevent them from rubbing together and becoming smudged. A heavy board laid on top will prevent any lateral movement. Do not stack too many drawings on top of each other, as this may compact and damage the surface pigment.

It is not a good idea to roll up and store drawings that have not had fixative applied (see opposite), as the pigments tend to drop off or smudge.

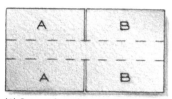

(1) Cut out four shapes.

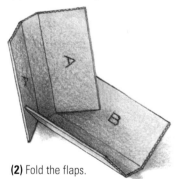

(2) Fold the flaps.

TRANSPORTING PAINTINGS

If you need to transport framed paintings, you should protect the corners of the frames by padding them with plastic foam or bubble-wrap, or with cardboard sleeves. This will also prevent the paintings from leaning flat against each other in storage.

To make cardboard sleeves, cut out four shapes as shown (**1**), making the space between the parallel dotted lines slightly larger than the width of the frame. Fold flaps A and B and tape them closed (**2**). Fit the sleeves over each corner and tape them to the backing or glass (not the frame, as it may damage any surface decoration) to keep them in place (**3**).

(3) Fit and secure the sleeves.

PROTECTING DRAWINGS

Drawings executed in a friable medium, such as charcoal, pastel, conté crayon and chalk, are easily smudged; and when they are framed, there is a danger of pigment particles drifting down under the glass and soiling the mat board.

FIXATIVE

To prevent these problems, this kind of drawing should be protected with fixative. This is a thin, colorless varnish which is sprayed onto the picture and fixes the pigment particles to the surface. It is most commonly available in aerosol spray cans, which are the most convenient method to use. Alternatively, there are mouth diffusers which have a mouthpiece, through which you steadily blow a fine mist of fixative.

Spraying a drawing with fixative requires a delicate touch; it should be applied sparingly, as a couple of light coats are better than one heavy one. It is worth practicing on pieces of scrap paper until you discover how to produce a fine, uniform mist without getting any drips on the paper. If you hold the spray too close, it will saturate the surface and may run and streak your work.

Always work in a well-ventilated area, to avoid inhaling too much of the spray.

• Protecting oil-pastel drawings
Unlike other pastels, oil pastels do not require fixing, because the blend of pigments, fat and wax never fully dries. For this same reason, it is inadvisable to apply varnish over oil pastels; should you need to remove the varnish at a later date, it will take most of the oil-pastel color off the surface with it. The most effective and lasting protection is to mount oil-pastel drawings under glass.

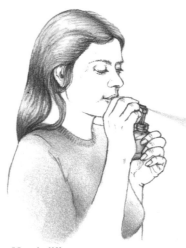

Mouth diffusers
These have a mouthpiece through which fixative is blown.

Spraying directions

Applying fixative
Pin your finished work vertically and hold the atomizer at least 12in (30cm) away from the image, pointing directly at it. Begin spraying just beyond the left side of the picture. Sweep back and forth across the picture with a slow, steady motion, always going beyond the edges of the picture before stopping (see right). Keep your arm moving so that the spray doesn't build up in one spot and create a dark patch or start to drip down the paper.

Protective framing
The way you present artwork not only displays it to best advantage but also protects it from pollutants and accidental damage. Below, the drawing is hinged from the top edge only, within a folded bookmat that holds the glass at a safe distance. A stiff backing board of Masonite or fiberboard keeps the drawing flat.

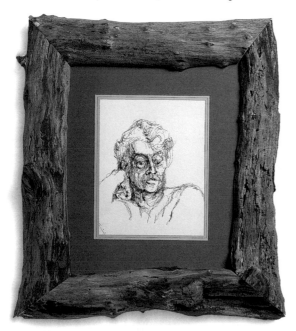

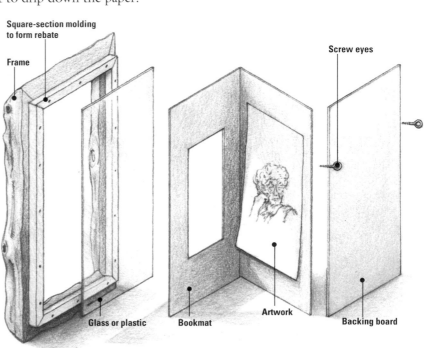

Square-section molding to form rebate

Frame

Screw eyes

Glass or plastic Bookmat Artwork Backing board

Varnishing Paintings

A layer of varnish gives the surface of a painting a uniform gloss or semi-matte finish that brings the whole picture together and enhances the depth and luster of the colors.

WHY USE VARNISH? If oil and acrylic paintings are cared for and cleaned occasionally, they don't necessarily have to be varnished. However, varnish will certainly protect the paint film from damage caused by scuffing, humidity, dust and atmospheric pollutants. The varnish itself will eventually be stained by these elements, which is why a removable varnish is preferred by restorers; when it becomes dirty or cracked, it can be removed with solvents and replaced.

NATURAL VARNISHES Natural damar varnish, composed of damar resin and mineral spirits, enhances colors with minimal gloss and yellowing; it does not crack or bloom (become opaque). Natural mastic varnish, with mastic resin and turpentine, dries to a high gloss. However, it does have a tendency to darken, crack and bloom.

SYNTHETIC VARNISHES Synthetic-resin picture varnishes, such as those made from ketone, are preferable to traditional natural-resin varnishes. Whereas varnish was once quite likely to darken and crack, modern versions can be relied upon to be non-yellowing and tough, yet flexible enough to withstand any movement of the canvas without cracking.

Simon Jennings
LEAVES OF GRASS
Acrylic on cardboard with Cryla varnish
17¾ x 23¾in (45 x 60cm)

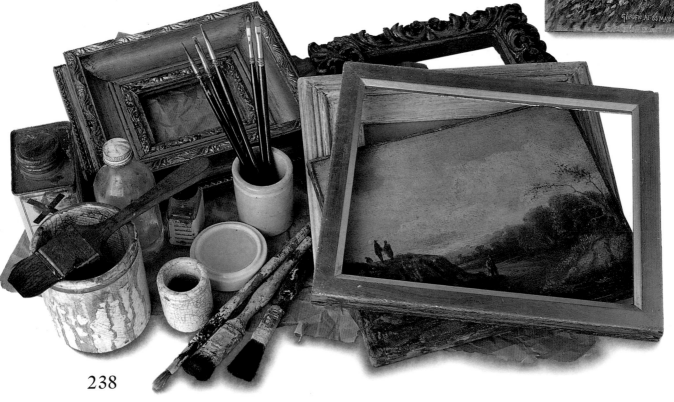

VARNISHING OIL PAINTINGS

It is very important that an oil painting is completely dry before final picture varnish is applied; this can take anything from six months to a year, perhaps more for thickly impasted paint. Oil paint expands and contracts as it dries, and premature varnishing may cause cracking as varnish is less flexible than oil paint. Retouching varnish, however, can be applied as soon as the paint is touch-dry – normally within a few days. This will protect the surface until it is dry enough for final varnishing.

VARNISHING ACRYLIC PAINTINGS

Despite popular belief to the contrary, it is as advisable to varnish completed acrylic paintings as oils; although acrylic dries waterproof and as tough as nails, it picks up dirt just like any other kind of paint. A coat of varnish gives your painting extra protection and also enhances the brilliance of the colors. It evens out any differences in gloss when the paint dries, caused by mixing varied amounts of water or medium with the colors.

Do not use acrylic mediums as a final varnish, because they cannot be removed when dirty. Always use a proprietary acrylic varnish, which dries quickly to a clear film that can be cleaned easily with mild soap and warm water. It can be removed, if required, using mineral spirits. You can buy gloss or matte varnish, or mix the two to create a pleasing semi-matte finish.

Acrylic paintings can be varnished as soon as the paint is dry, which normally takes a couple of hours at most.

Applying varnish to oils and acrylics

Varnishing should be done in a warm, dry, dust-free, ventilated room. Avoid varnishing in damp or humid conditions, as this may cause the varnish layer to turn hazy.

Ensure the painting is free of dust and grease (**1**), then apply the first thin coat of varnish with a broad, soft-haired brush, preferably a varnishing brush. Stroke the surface smoothly and evenly, working in one direction, to avoid creating air bubbles (**2**). Leave to dry overnight, then apply a second coat at right angles to the first (**3**), unless you are using a matte varnish, in which case brush in the same direction as before. Leave the picture in a horizontal position, protected from dust and hairs, until the varnish has dried hard.

Varnishing acrylics
A coat of varnish not only intensifies colors, but also unifies the finish of an impasted acrylic surface.

Varnishing paintings made with oil-paint sticks
Once the paint is thoroughly dry, traditional oil-paint varnishes may be used. There is a special isolating varnish, which may be applied 6 to 12 months after completion; this first-stage varnishing is followed 24 hours later by the application of a finishing varnish. The dual process involved enables the finishing varnish to be easily removed at a later date, if required, with mineral spirits or turpentine.

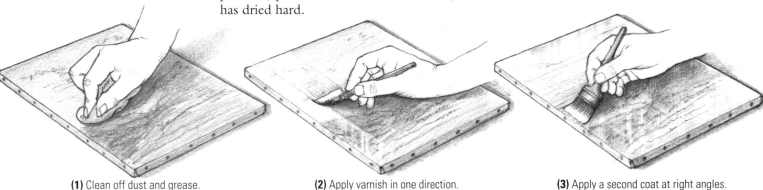

(1) Clean off dust and grease. **(2)** Apply varnish in one direction. **(3)** Apply a second coat at right angles.

239

MATS AND FRAMES

Protecting artwork, page 237
Varnishing paintings, page 238

"THE CHIEF MERIT OF FRAMES IS TO BE IN PROPORTION TO THE WORK THEY SERVE; TO BE SIMPLE, AND SUITABLE FOR THE WORKS AND THE LOCATIONS."

FRANCESCO MILIZIA (FL. 18TH CENTURY)

When selecting a frame for an artwork, your choice will be affected by personal taste, prevailing fashions and the type of image being framed. The one golden rule, however, is that the style and color of the frame should complement and enhance the image but should not attract too much attention to itself.

BASIC CONSIDERATIONS

A well-chosen frame not only enhances the appearance of a painting or drawing, it also protects and conserves it. Unless you already have some experience of framing, this task is best left to a professional framer. But whether you frame your own work or not, there are certain aesthetic points to consider when choosing the style and color of the mat and frame.

Mat board
Made from thick board faced with bonded paper, mat board is available in a range of colors, some with subtle decorative finishes and textures. You can either buy sheets of mat board and cut your own window mats, or have it done professionally. Cheaper mat boards are made of unrefined woodpulp, which contains acids that can be harmful to works on paper. Except for temporary framing, always choose museum board, which is acid-free and won't yellow or fade with time.

FRAMING WORKS ON PAPER

Watercolor-based paintings, pastels and drawings are fragile and vulnerable to surface damage. Most of these pictures are framed under glass and are surrounded by a window mat – a wide "frame" of thick paperboard. The mat serves two purposes: first, it acts as a buffer between the picture and the glass, allowing air to circulate. If the paper is in contact with the glass, condensation may build up and eventually damp stains and spots of mildew – known as "foxing" – may stain the surface of the paper. In the case of drawings, the mat also prevents the glass from crushing the surface pigment and compressing the paper's texture.

Integral painted frame *(P. Quested)*

The other function of a mat is to provide an aesthetically pleasing border around the picture and a clean, finished look. It also provides a kind of breathing space – a sympathetic surrounding that separates the image itself from the hard edge of the frame. The window aperture is cut with a beveled edge, which prevents sharp shadows from falling on the image and creates a recess which leads the eye into the picture.

Close framing *(B. Yale)*

The width and color of the mat will exert a considerable influence on the impact of a picture, so it is important to make a careful choice. Works on paper, for example, are traditionally surrounded by a wide mat and a narrow frame, an arrangement which enhances the delicacy of an image. However, since every piece of artwork is different, the same "rules" do not always apply, and it pays to cut strips of mat board and experiment with different mat widths and colors until a particular drawing or painting seems to sit comfortably in its surroundings.

Double mats
A double mat has a "stepped" effect which gives an added touch of opulence to the picture. Both inner and outer mats can be of the same color, or complementary or contrasting colors can be used. Sometimes the inner mat is gilded or decorated while the outer mat is left plain.

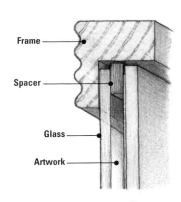

Frame

Spacer

Glass

Artwork

Spacers

Where you feel a mat is inappropriate to the type of picture being framed, keep the glass and picture surface separated by inserting spacers between the front rebate of the frame and the glass. Spacers are narrow strips of wood (or museum board, in the case of works on paper).

Width of mat

The margins of the mat must be in pleasing proportion to the image. Generally, a small image looks more impressive with a wide mat, which gives it added weight and importance. For example, for an image measuring 12 x 9in (30 x 22.5cm), margins of 4-5in (10-12.5cm) are suitable. A large painting with bold shapes and colors, on the other hand, looks better with a narrow mat.

It is usual for the base of the mat to be slightly deeper than the remaining sides – between ¼in (6mm) and ¾in (18mm) is enough in most cases, depending on the size of the picture. This is to prevent a visual illusion in which an equal bottom margin appears narrower than the other three, and the image appears to be dropping out of the frame.

Selecting a color

Generally speaking, a cream or neutral-colored mat is the most sympathetic choice for watercolors and drawings, or perhaps one which subtly echoes one of the dominant colors in the image. The mat may be embellished with narrow wash lines drawn around the inner edge, either in gold or in a color that complements the colors of the mat and the work.

Though in some cases a richly colored mat might be appropriate, its color should never overpower the image. If, for example, the mat is of a lighter key than the lightest tone in the picture, or deeper than the darkest areas, you tend to see the frame before the picture.

FRAMING OIL PAINTINGS

Oil paintings are more robust and less prone to damage than works on paper, so they don't need to be framed behind glass. Indeed, they are better left unglazed, to avoid distracting reflections and allow the texture of the paint surface to be more readily appreciated.

FRAMING ACRYLIC PAINTINGS

With acrylic paintings, you have the choice of framing as for an oil painting or a watercolor, depending on the size of the painting and the technique employed. For example, a plain, narrow frame may be appropriate for a bold, abstract painting, but a traditional watercolor frame with a wide mat might suit a delicate painting that involves wash techniques.

FRAME INSERTS

Just as works on paper may be enhanced by a window mat, more substantial mediums not under glass may be set off by a frame insert, or "fillet." This is a thin frame molding, either gilded, painted, or covered with cloth, which provides a separation between the outer frame and the picture surface. Most framing shops sell a range of ready-made frame inserts, or you can make them yourself.

Frame with insert *(S. Jennings)*

Flat frame and inner fillet *(J. Elliott Bates)*

Narrow frame with wide mat *(Print)*

Inset canvas with box frame *(G. Rowlett)*

241

FRAME MOLDINGS

The choice of frame molding is as important as the choice of mat, and the two should ideally be chosen together. A well-chosen molding can give even a mediocre painting a feeling of purpose and authority, while an inappropriate one can actually ruin a good picture.

When choosing a molding, it is vital to consider its width, color and design in relation to the picture itself. Look for moldings that complement rather than dominate your pictures. As a general rule, simple moldings are usually best for delicate works on paper, more ornate ones for oils and acrylics. Highly elaborate moldings tend to distract the viewer and draw attention away from the picture.

Width of molding

If your picture contains small, delicate areas or is surrounded by a wide mat, then choose a narrow frame. If the picture is large and contains strong colors and shapes, it will look more imposing with a wide frame and no mat, or a very narrow one.

Color and design

The color of the molding should harmonize both with the colors in the painting and with the mat. Generally, a frame with a color of a similar or slightly darker tone to the overall tone of the painting works best.

The character of the picture itself should be the touchstone of the design you choose – whether the image and colors can take, for example, a heavy, architrave molding or a simple, flat one.

• Glazing a picture

There are two kinds of glass to choose from: ordinary and non-reflective. Ordinary picture glass is best – non-reflective glass is more expensive, and tends to cast a matte sheen over the picture, robbing it of its freshness and textural beauty.

Types of molding

Framing shops have a bewildering array of frame moldings on display. The designs fall into traditional/classic and contemporary categories. Below and right, an assortment of moldings.

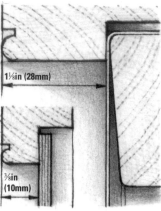

1⅛in (28mm)

⅜in (10mm)

Ideal depths
To conserve and protect your work, the molding should ideally be at least 1⅛in (28mm) deep for a stretched canvas (diagram, top) and ⅜in (10mm) deep for a work on paper (diagram, above). It is also important to choose a molding that has a rebate deep enough to accommodate the thickness of the work, plus glass and backing board, if they are required.

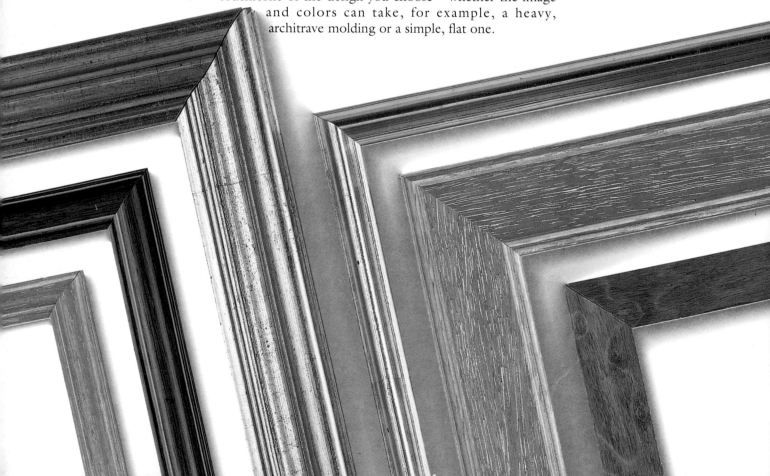

REFERENCE
& INDEX

HEALTH AND SAFETY

Manufacturers of art materials pay a great deal of attention to current safety legislation; most manufacturers' catalogs provide reasonably detailed information on safety, toxicity and the like, and the products themselves are generally clearly labeled (see left).

However, safety legislation differs from country to country, and there is no single international classification for all art materials, which basically means that a substance regarded as hazardous to health may be withdrawn or substituted in one country but not another, depending on the legislation.

Some of the most determined opposition to changes in the composition of paint has come from artists who fear that modern substitutes cannot give them the same results as traditional (but possibly more hazardous) pigments, such as cadmiums, lead chromes or cobalts. Manufacturers, however, put a vast amount of time, money and research into finding alternative materials that approximate the original as closely as possible, in order to comply with ever-more-stringent laws.

In the end, the decision of what to use and how to use it must be made by each individual artist, and the best way to work safely is to be well informed about the materials you are using. Read the catalogs, check the labeling, and don't be afraid to contact the manufacturers if you are concerned about a product's safety or quality.

Above all, follow the manufacturer's instructions where printed. Making art is many things – creative, fun, inspiring, frustrating – but it need not be hazardous to your health.

Highly flammable
Products bearing this international label have a flash point of below 70°F (21°C). The containers should be kept closed when not in use, and should not be left near sources of heat or ignition. Do not breathe the vapor or spray, and keep the product away from children.

Harmful/Irritant
This international label is used to mark products classified as either harmful or irritant; each classification has its own particular warnings. In both cases, do not breathe the vapor, and keep the product away from children. Avoid contact with skin and eyes, and wash thoroughly after use.

Health label (HL)
This American label, from the Art and Craft Materials Institute (ACMI), means that the product has been reviewed by an independent toxicologist under the auspices of the American Society for Testing and Materials (ASTM).

CP
An American label, again from the ACMI. "CP" stands for Certified Product, in which the contents are non-toxic, even if ingested, and which meet or exceed specific quality standards.

AP
Another American label from the ACMI, "AP" means Approved Product, one in which the contents are non-toxic, even if ingested.

Interpreting labels
These are the hazard labels you are likely to see on art products. Familiarity with their meanings will enable you to evaluate standards and possible hazardous use at a glance, and to use and store materials with minimum risk.

244

READING A PAINT TUBE

It is well worth knowing the characteristics – permanence, lightfastness, transparency, and so on – of the paints you use. Although there may appear to be a bewildering amount of coded information on a standard tube of paint, this is actually quite simple to decipher, and the ability to "read" a tube will help you choose the right paint.

The tube shown below is a composite, but all the information on it can be found on different tubes; each manufacturer's catalog provides further details particular to its brands.

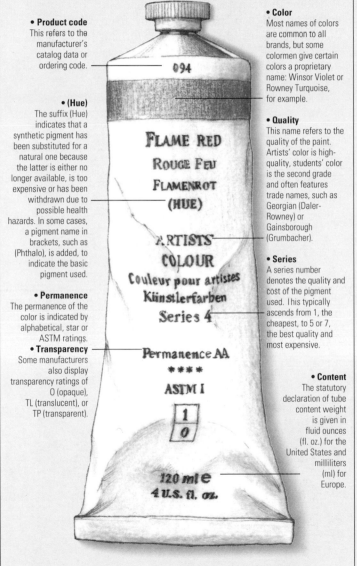

• Product code
This refers to the manufacturer's catalog data or ordering code.

• (Hue)
The suffix (Hue) indicates that a synthetic pigment has been substituted for a natural one because the latter is either no longer available, is too expensive or has been withdrawn due to possible health hazards. In some cases, a pigment name in brackets, such as (Phthalo), is added, to indicate the basic pigment used.

• Permanence
The permanence of the color is indicated by alphabetical, star or ASTM ratings.

• Transparency
Some manufacturers also display transparency ratings of O (opaque), TL (translucent), or TP (transparent).

• Color
Most names of colors are common to all brands, but some colormen give certain colors a proprietary name: Winsor Violet or Rowney Turquoise, for example.

• Quality
This name refers to the quality of the paint. Artists' color is high-quality, students' color is the second grade and often features trade names, such as Georgian (Daler-Rowney) or Gainsborough (Grumbacher).

• Series
A series number denotes the quality and cost of the pigment used. This typically ascends from 1, the cheapest, to 5 or 7, the best quality and most expensive.

• Content
The statutory declaration of tube content weight is given in fluid ounces (fl. oz.) for the United States and milliliters (ml) for Europe.

Codes and symbols
In additional to the above, some products carry other coded information to indicate transparency, mixing potential, safety information, and so on. The manufacturer's catalog gives details.

GLOSSARY OF TERMS

In addition to the many everyday words used to describe art materials and techniques, there are equally as many that are unique. Most of the specialized words and terms used in this book are explained here, plus some others which you will come across in further reading.

A

Acrylic paint Any paint containing acrylic resin, derived from man-made acrylic or propenoic (derived from petroleum) acid.

Alkyd resin A synthetic resin used in paints and mediums.

Alla prima (Italian for "at the first") Technique in which the final surface of a painting is completed in one sitting, without underpainting. Also known as *au premier coup*.

ASTM The American Society for Testing and Materials. An internationally recognized, independent standard for certain paint qualities, adopted by most manufacturers.

B

Balance In a work of art, the overall distribution of forms and color to produce a harmonious whole.

Binder A liquid medium mixed with powdered pigment to form a paint.

Bistre A brown, transparent pigment made by boiling beech-tree soot.

Bleeding In an artwork, the effect of a dark color seeping through a lighter color to the surface. Usually associated with gouache paint.

Blending Smoothing the edges of two colors together so that they have a smooth gradation where they meet.

Bloom A dull, progressively opaque, white effect caused on varnished surfaces by being kept in damp conditions.

Body color Opaque paint, such as gouache, which has the covering power to obliterate underlying color. "Body" also refers to a pigment's density.

Brushwork The characteristic way each artist brushes paint onto a support, often regarded as a "signature"; used to help attribute paintings to a particular artist.

C

Casein A milk-protein-based binder mixed with pigment to make paint; most often associated with tempera.

Chiaroscuro (Italian for "clear-obscure") Associated especially with oil painting, this term is used to describe the effect of light and shade in a painting or drawing, especially where strong tonal contrasts are used.

Cissing The effect caused when a water-based paint either does not wet the support enough to adhere effectively, or is repelled by the surface. Also known as crawling or creeping.

Cockling Wrinkling or puckering in paper supports, caused by applying washes onto a flimsy or inadequately stretched and prepared surface.

Composition The arrangement of elements by an artist in a painting or drawing.

Contre-jour (French for "against daylight") A painting or drawing where the light source is behind the subject.

Copal A hard, aromatic resin, used in making varnishes and painting mediums.

Crosshatching More than one set of close parallel lines that crisscross each other at angles, to model and indicate tone. *(See also* hatching.*)*

D

Damar A resin from conifer trees, used in making oil mediums and varnishes.

Dead color A term for colors used in underpainting.

Diluents Liquids, such as turpentine, used to dilute oil paint; the diluent for water-based media is water.

Distemper A blend of glue, chalk and water-based paint, used mostly for murals and posters, but also sometimes for fine-art painting.

E

Earth colors These colors, the umbers, siennas and ochres, are regarded as the most stable natural pigments.

Encaustic An ancient technique of mixing pigments with hot wax as a binder.

F

Fat Used to describe paints which have a high oil content. *(See also* lean.*)*

Filler In painting, the inert pigment added to paint to increase its bulk, also called extender; or the matter used to fill open pores or holes in a support or ground.

Film A thin coating or layer of paint, ink, etc.

Fixative A solution, usually of shellac and alcohol, sprayed onto drawings, particularly charcoal, chalk and soft pastels, to prevent their smudging or crumbling off the support.

Format The proportions and size of a support.

Fresco (Italian for "fresh") A wall-covering technique which involves painting with water-based paints onto freshly applied wet plaster. Also known as *buon fresco.*

Fugitive colors Pigment or dye colors that fade when exposed to light. *(See also* lightfast *and* permanence.*)*

G

Genre A category or type of painting, classified by its subject matter – still life, landscape, portrait, etc. The term is also applied to scenes depicting domestic life.

Gesso A mixture, usually composed of whiting and glue size, used as a primer for rigid oil-painting supports.

Glaze In painting, a transparent or semi-transparent color laid over another, different color to modify or intensify it.

Grain *See* tooth.

Grisaille A monochrome painting in shades of grey, or a grey underpainting.

Ground A specially prepared painting surface.

Gum arabic A gum, extracted from certain *Acacia* trees, used in solution as a medium for watercolor paints.

H

Hatching A technique of modeling, indicating tone and suggesting light and shade in drawing or tempera painting, using closely set parallel lines. *(See also* crosshatching.*)*

Hue The name of a color – blue, red, yellow etc. – irrespective of its tone or intensity. *(See also* Reading a paint tube, *page 245.)*

I

Impasto A technique of applying paint thickly by brush, painting knife or hand, to create a textured surface. Also the term for the results of this technique. *(See also page 248.)*

Imprimatura A primary coat of diluted color, usually a wash, used to tone down or tint a white canvas or other support before painting.

Intensity The purity and brightness of a color. Also called saturation or chroma.

K

Key Used to describe the prevailing tone of a painting: a predominantly light painting is said to have a high key, a predominantly dark one a low key. In modern mural painting, the key is the result of scratching and preparing a wall surface ready for the final layer of plaster – similar to "tooth."

L

Landscape format A painting or drawing wider than it is tall. *(See also* portrait format.*)*

Lay figure A jointed wooden mannikin which can ideally be moved into almost any pose or attitude, for studying proportions and angles, and for arranging clothing and drapery. Lay hands and horses are also available. *(See also page 248.)*

Leaching The process of drawing out excess liquid through a porous substance.

Lean Used as an adjective to describe paint thinned with a spirit such as turpentine or mineral spirits, and which therefore has a low oil content. *(See also* fat.*)*

Lightfast Term applied to pigments that resist fading when exposed to sunlight. *(See also* fugitive.*)*

Local color The actual color of an object or surface, unaffected by shadow coloring, light quality or other factors; for instance, the local color of a carrot is always orange, even with a violet shadow falling across it.

Loom-state Canvas that has not been primed, sized or otherwise prepared beforehand for painting.

M

Matière Paint.

Medium This term has two distinct meanings: the liquid in which pigments are suspended, for instance, linseed oil for oil painting, and acrylic resin for acrylic paints (the plural here is mediums). A medium is also the material chosen by the artist for working – paint, ink, pencil, pastel, etc. (the plural in this instance is media).

Mixed media In drawing and painting, this refers to the use of different media in the same picture – for instance, ink, watercolor wash and wax crayon – or on a combination of supports – for instance, newspaper and cardboard.

Mixed method The process of using oil glazes on top of a tempera underpainting.

Mural Also sometimes referred to as wall painting, this word describes any painting made directly onto a wall. *(See also* fresco *and* secco.*)*

O

Opacity The covering or hiding ability of a pigment to obliterate an underlying color. Opacity varies from one pigment to another.

P

Palette As well as describing the various forms of holders and surfaces for mixing paint colors, palette also refers to the artist's choice and blends of colors when painting.

Patina Originally the green-brown encrustation on bronze, this now includes the natural effects of age or exposure on a surface, such as old, yellowing varnish on an oil painting.

Pentimento (Italian for "repented") In an oil painting, this is when evidence of previous painting shows through the finished work when the surface paint becomes transparent. The word also refers to unerased attempts to fix a line or contour in a drawing or painting.

Permanence Refers to a pigment's resistance to fading on exposure to sunlight. (See also fugitive and lightfast.)

Pigments The coloring agents used in all painting and drawing media, traditionally manufactured from natural sources but now including man-made substances. The word is also used to describe the powdered or dry forms of the agents.

Plasticity In a two-dimensional drawing or painting, plasticity describes figures, objects or space with a strongly three-dimensional appearance, often achieved by modeling with great contrasts of tone.

Plein air (French for "open air") (See margin note, right.)

Portrait format A painting or drawing taller than it is wide. (See also landscape format.)

Primer Applied to a layer of size or directly to a support, this acts as a barrier between paint and support, and provides a surface suitable for receiving paint and mediums.

Proportion The relationship of one part to the whole or to other parts. This can refer to, for instance, the relation of each component of the human figure to the figure itself, or to the painting as a whole.

PVA Polyvinyl acetate, a man-made resin used as a paint medium and in varnish.

R

Recession In art, this describes the effect of making objects appear to recede into the distance by the use of aerial perspective and color.

Reduction The result of mixing color with white.

S

Sanguine A red-brown chalk.

Saturation The intensity and brilliance of a color.

Scumble The technique of dragging one or more layers of dryish, opaque paint over a bottom layer that partially shows through the overlying ones. (See right.)

Secco (Italian for "dry") A technique of wall-painting onto dry plaster, or lime plaster that is dampened shortly before paint is applied.

Sfumato (Italian for "shaded off") Gradual, almost imperceptible transitions of color, from light to dark.

Sgraffito (Italian for "scratched off") A technique of scoring into a layer of color with a sharp instrument, to reveal either the ground color or a layer of color beneath.

Shade Term for a color darkened with black.

Shaped canvas Any non-rectangular picture.

Shellac A yellow resin formed from secretions of the lac insect, used in making varnish.

Silverpoint A drawing method almost entirely superseded by the graphite pencil. A piece of metal, usually silver wire, was used to draw on a ground prepared with Chinese white, sometimes with pigment added to the ground. There was no possibility of erasure. Also called metalpoint.

Sinopia A red-brown chalk used for the preliminary marking-out of frescoes; also the preliminary drawing itself.

Size A weak glue solution used for making gesso and distemper, for stiffening paper, and for making canvas impervious before applying layers of primer or oil paint.

Size color A combination of hot glue size and pigments.

Sketch A rough drawing or a preliminary draft of a composition, not necessarily to be worked up subsequently. Sketches are often used as a means of improving an artist's observation and technique.

Squaring up A method for transferring an image to a larger or smaller format. The original version is covered with a grid of horizontal and vertical lines, and each numbered square is then copied onto its counterpart on a larger or smaller set of squares on a different support. Also known as gridding up.

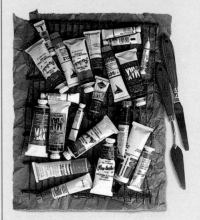

Matière Paint.

Plein air
(French for "open air") Term describing paintings done outside, directly from the subject.

Scumble
Dryish, opaque paint dragged over another layer of paint so that the underlying color partially shows through the top one.

GLOSSARY

Impasto
A technique of applying paint thickly by brush, palette knife or hand.

Lay figure and lay hand
Jointed wooden models which can ideally be moved into almost any pose or attitude.

Study A detailed drawing or painting made of one or more parts of a final composition, but not of the whole.

Support Surface or backing used for painting or drawing – canvas, board, paper, etc. – as opposed to the actual surface or ground (oil, gesso, etc.).

T

Tempering In painting, mixing pigments with tempera to produce a hue.

Thixotropic Stiff fluids which become liquefied when stirred, shaken or brushed.

Tint Term for a color lightened with white. Also, in a mixture of colors, the tint is the dominant color.

Tinting strength The power of a pigment to influence mixtures of colors.

Tone The relative darkness or lightness of a color, without reference to its local color.

Tooth The texture, ranging from coarse to fine, of canvas or wood (*See also* key.)

Traction In oils, the movement of one paint layer over another.

Traction fissure This usually occurs when the principles of painting "fat-over-lean" in oils have not been applied, leading to cracking of the top layer or layers of paint or varnish.

Tragacanth A gum, extracted from certain *Astragalus* plants, used as a binding agent in watercolor paints and pastels.

Transparency The state of allowing light to pass through, and of filtering light.

Trompe l'oeil (French for "deceive the eye") A painting, usually a still life with extreme, naturalistic details, aiming to persuade the viewer that he or she is looking at actual objects, not a representation of them.

U

Underpainting The traditional stage in oil painting of using a monochrome or dead color as a base for composition, overall tone and subsequent color glazes. Also known as laying in.

V

Value An alternative word for "tone," "value" is used mainly in the United States. The term "tonal value" refers to the relative degree of lightness or darkness of any color, on a scale of greys running from black to white.

Veduta (Italian for "view") An accurate representation of an urban landscape.

Vehicle A medium that carries pigments in suspension and makes it possible to apply them to a surface; sometimes called the base. The word also describes a combination of medium and binder.

Venice turpentine An oleoresin – the semi-solid mixture of a resin and an essential oil – derived from the larch and used primarily in making mediums and diluents for oil painting.

Verdaccio An old term for green underpainting.

Volume The space that a two-dimensional object or figure fills in a drawing or painting.

W

Wash A thin, usually broadly applied, layer of transparent or heavily diluted paint or ink.

Wetting agent A liquid – oxgall or a synthetic equivalent – added to watercolor paint to help it take evenly and smoothly on a support.

Whiting Ground and washed chalk used in making gesso and whitewash.

Υ

Yellowing This effect on oil paintings is usually caused by one of three reasons: excessive use of linseed-oil medium in the paint; applying any of the varnishes that are prone to yellowing with age; or – most often – an accumulation of dirt that embeds itself into the surface of the varnish.

DIRECTORY: ART-MATERIALS SUPPLIERS

The materials in this book are available at art-supply stores everywhere. The directory below is intended to help you if you have trouble finding the materials you want – if you are unable to purchase a particular art material, the distributors and manufacturers listed below will be able to put you in touch with your nearest supplier, and will be pleased to send you catalogs, information and advice on their products. You may wish to check the listings for regions other than your own; many of the larger retail stores have branches in several states.

RETAIL STORES

MID-ATLANTIC

Abstract, Inc.
3309 12th St. NE
Washington, DC 20017
(202) 526-8860

The Italian Art Store
84 Maple Avenue
Morristown, NJ 07960
(800) 643-6440

New York Central Art Supply Company
62 Third Avenue
New York, NY 10003
Retail (212) 473-7705
Tel. orders (212) 477-0400;
(800) 950-6111

Nyborgs', Inc.
517 N. Charles St.
Baltimore, MD 21201
(410) 727-5732

Pearl Paint Co.
308 Canal Street
New York, NY 10013-2572
(212) 431-7932; (800) 221-6845
[Stores in FL, GA, MA, MD, NJ, TX, and VA]

Taws Art Supply
1527 Walnut Street
Philadelphia, PA 19102
(215) 563-8742; (800) 551-2341

Utrecht Art and Drafting Supplies
33 Thirty-fifth Street
Brooklyn, NY 11232
(718) 768-2525
Also:
1250 Eye Street NW
Washington, DC 20005
(202) 898-0555
[More stores in CA, IL, MI, MA, and PA]

MIDWEST

The Art Mart Inc.
224 State Street
Madison, WI 53703
(608) 257-2249

Art Materials, Inc.
3108 Lyndale Ave. S.
Minneapolis, MN 55403
(612) 827-1866

Brudno Art Supply
350 W. Ontario
Chicago, IL 60610
(312) 787-0030; Fax (312) 787-3725

Dick Blick Art Materials
14339 Michigan Avenue
Dearborn, MI 48126
(313) 581-7063
[Stores in other states]

Morse Graphic
1938 Euclid Avenue
Cleveland, OH 44115
(216) 621-4175; (800) 362-1445; Fax (216) 621-0655

Rich's Art Supply and Framing Shop
3838 N. Cicero
Chicago, IL 60641
(312) 545-0271

Wet Paint Inc.
1684 Grand Avenue
Saint Paul, MN 55105
(612) 698-6431

NEW ENGLAND

Charette Favor Ruhl
31 Olympia Avenue
Woburn, MA 01888
(800) 367-3729; Fax (800) 626-7889
[Stores throughout the Northeast]

ROCKY MOUNTAINS

Boise Blue Art Supply
820 W. Jefferson
Boise, ID 83702
(208) 343-2564; (800) 343-3718; Fax (208) 343-0075

Guiry's, Inc.
2468 South Colorado Blvd.
Denver, CO 80222
(303) 758-8244; Fax (303) 756-3545

Lapis Arts, Inc.
South Dahlia Street
Denver, CO 80222
(303) 782-0255

Reuel's Art and Frame
370 S. West Temple
Salt Lake City, UT 84101
(801) 355-1713

SOUTH

Artsystems of Florida
1740 Semoran Blvd.
Winter Park, FL 32782
(407) 679-4700

Binders
206 Johnson Ferry Road
Atlanta, GA 30328
(404) 252-1203

Dixie Art Supplies
319 Magazine Street
New Orleans, LA 70130
(504) 522-5308

Griffin Supply Co.
633 Middleton
Nashville, TN 37203
(615) 254-3368

J & S Art Center
1220 N. Town East Blvd.
#246
Dallas, TX 75150
(214) 279-0200

Michael's Arts and Crafts
9616 North Lamar Blvd
Austin, TX 78753
(512) 835-2413
[Stores in other states]

Omni Art Supply Corp.
209 10th Ave. S.
Nashville, TN 37203
(615) 256-3344; Fax (615) 256-7799

The Palette
125 NE 26th Street
Miami, FL 33137
(305) 573-0980; Fax (305) 573-0992

Texas Art Supply
2001 Montrose
Houston, TX 77006
(713) 526-5521; Fax (713) 526-4062

SOUTHWEST

Arizona Art Supply
118 W. Indian School Road
Phoenix, AZ 85013
(602) 264-9514

Colorcraft Inc.
4759 East Speedway Blvd.
Tucson, AZ 85712
(602) 327-6553; Fax (602) 881-0007

Multicraft, Inc.
3233 E. Van Buren
Phoenix, AZ 85008
(602) 244-9444; Fax (602) 275-1135

DIRECTORY

New Mexico Art Supply Inc.
2510 Central Avenue SE
Albuquerque, NM 87106-3609
(505) 265-3733; Fax (505) 262-1752

WEST COAST/ALASKA/HAWAII

A/E Supplies
501 W. Fireweed Lane
Anchorage, AK 99503
(907) 277-2506; (800) 478-7806

Arch
407 Jackson Street
San Francisco, CA 94111
(415) 433-2724

Art Media
902 SW Yamhill Street
Portland, OR 97205
(503) 223-3724

Blaine's Art and Graphic Supply
2803 Spenard Road
Anchorage, AK 99503
(907) 561-5344

Daniel Smith Inc.
4130 First Avenue South
Seattle, WA 98134-2302
(800) 426-6740

FLAX Art & Design
1699 Market Street
San Francisco, CA 94103
(415) 552-2355
[Stores in other states, including FL, GA, IL, NY]

H.G. Daniels
2543 West 6th Street
Los Angeles, CA 90057
(800) 866-6601; Fax (800) 655-0271
Also:
1844 India Street
San Diego, CA 92101
(619) 232-6601

A Little Craft
619 Kapahulu Ave
Honolulu, HI 96815
(808) 732-0888

CANADA

Curry's Art Store
490 Young Street
Toronto, Ontario M4Y 1X5
(416) 967-6666

Pavillon Des Arts
1763 St.-Denis
Montreal, Quebec H2X 3K4
(514) 284-2911

MANUFACTURERS

BEROL
(graphite, charcoal, colored and water-soluble pencils; marker, fountain and fiber-tip pens; drawing supports and accessories)

Berol Corporation
105 West Park Drive
P.O. Box 2248
Brentwood, TN 37024-2248

CANVAS-STRETCHER SYSTEMS (general)

Masterpiece Artists Canvas, Inc.
1415-T Bancroft At Ingalis
San Francisco, CA 94124

Tri-Mar Enterprises Inc.
P.O. Box 455
Port Washington, NY 11050

Perma Colors
226 East Tremont
Charlotte, NC 28203

Tara Materials, Inc.
Dept. TR
P.O. Box 646
Lawrenceville, GA 30246

DALER-ROWNEY
(oil, acrylic, gouache and watercolor paints, brushes, supports and accessories; pastels; drawing supports; framing and matting equipment; studio equipment)

Daler-Rowney USA
4 Corporation Drive
Cranbury, NJ 08512-9584

FABER-CASTELL
(graphite, colored, water-soluble, charcoal and conté pencils; charcoal sticks; graphite sticks; marker and fiber-tip pens; pastels, technical pens; drawing accessories)

Faber-Castell Corp.
4 Century Drive
Parsippany, NJ 07054

FRISK (oil paints; pastels; watercolor and pastel-drawing supports)

Frisk Products USA Inc.
5240 Snapfinger Park Drive
Suite 115
Decatur, GA 30035

GAMBLIN (various paints)

Gamblin Artists Colors Co.
P.O. Box 625
Portland, OR 97207

GRUMBACHER
(oil, water-friendly oil, acrylic and watercolor paints, brushes and accessories; pastels)

M. Grumbacher Inc.
100 North Street
Bloomsbury, NJ 08804

Koh-i-noor Rapidograph
1815 Meyerside Drive
Mississauga, Ontario
Canada L5T 1G3

LIQUITEX (acrylic and oil paints and accessories)

Binney & Smith Inc.
1100 Church Lane
P.O. Box 431
Easton, PA 18044-0431

Binney & Smith (Canada)
40 East Pearce Street
Richmond Hill, Ontario
Canada L4B 1B7

MARKAL (oil-paint sticks and accessories)

Markal Company
P.O. Box 707
Oak Park, IL 60303

MARTIN/F. WEBER
(oil, acrylic and watercolor paints, brushes and accessories; charcoal; oil pastels; studio equipment)

Martin/F. Weber Co.,
2727 Southampton Road
Philadelphia, PA 19154

PEBEO (oil, acrylic and gouache paints, brushes and accessories; watercolor and drawing paper; drawing inks; studio equipment)

Pebeo of America Inc.
P.O. Box 373
Williston, VT 05495

PENTEL (watercolor paint; pastels; technical, marker and fiber-tip pens; graphite pencils)

Pentel of America Ltd.
2805-T Columbia Street
Torrance, CA 90503

PIGMENTS (also mediums, panels)

Fezandie and Sperlie Division; Benbow Chemical Packaging Co.
Hiawatha Blvd.
Syracuse, NY 13208

Guerra Paint and Pigment
510 East 13th Street and
Avenue A
New York, NY 10009

Hudson Highland Artist Materials
18 Pine Grove Avenue
Kingston, NY 12401

Kremer Pigments Inc.
228 Elizabeth Street
New York, NY 10012

PRO ART (papers)

Pro Art
P.O. Box 1417
Beaverton, OR 97075-1417

REXEL DERWENT
(graphite, colored, water-soluble, pastel, charcoal and conté pencils and accessories; drawing supports)

Colart Americas Inc.,
11 Constitution Avenue,
P.O. Box 1396
Piscataway, NJ 08855-1396

ROTRING (technical, fountain and art pens; drawing inks; pencils)

Koh-i-noor Rapidograph,
100 North Street,
P.O. Box 68
Bloomsbury, NJ 08804-0068

Koh-i-noor Rapidograph
1815 Meyerside Drive
Mississauga, Ontario
Canada L5T 1G3

SENNELIER
(oil and watercolor paints and brushes; pastels; inks)

Savoir-Faire
P.O. Box 2021
Sausalito, CA 94966

STRATHMORE (drawing papers)

Strathmore Paper Co.
South Broad Street
Westfield, MA 01085

TALENS (oil, acrylic and gouache paints, brushes and accessories)

The Morilla Co. Inc.
211 Bowers Street
Holyoke, MA 01040

WINSOR & NEWTON
(oil, acrylic, gouache and watercolor paints, brushes, including most other materials and equipment)

Winsor & Newton Inc.
11 Constitution Avenue
PO Box 1396
Piscataway, NJ 08855-1396

INDEX